427730

D0303373

WITHDRAWN FROM LIBRARY STOCK

BEYOND THE FRAME

'Deborah Cherry is one of the foremost feminist analysts of historical visual culture. She has researched and produced a lively, readable and timely study which relocates the feminist impulse as a critical and central thematic of nineteenth-century British middle-class culture. She carries her considerable erudition and theoretical fluency with intellectual grace, producing a vitally important historical reconfiguration of gender, class and race as contradictory and troubling forces. This book will become a benchmark of feminist scholarship.'
Griselda Pollock, *Professor of Social and Critical Histories of Art, University of Leeds*

'Deborah Cherry provides an eloquent history of the crucial connections between Victorian women artists, the new visual culture and nineteenth-century social struggles over women's rights. New readings of gender and urban space, the public reception of Harriet Hosmer's *Zenobia*, and the cultural work of British women in Algeria make this an important contribution not merely to art history, but to cultural history generally.'
Whitney Chadwick, *Professor of Art, San Francisco State University*

Beyond the Frame rewrites the history of Victorian art to explore the relationships between feminism and visual culture in a period of heady excitement and political struggle. Artists were caught up in campaigns for women's enfranchisement, education and paid work, and many were drawn into controversies about sexuality. This richly documented and compelling study considers painting, sculpture, prints, photography, embroidery and comic drawings as well as major styles such as Pre-Raphaelitism, Neo-Classicism and Orientalism. Drawing on critical theory and post-colonial studies to analyse the links between visual media, modernity and imperialism, Deborah Cherry argues that visual culture and feminism were intimately connected to the relations of power.

Deborah Cherry is Professor of the History of Art at the University of Sussex. Her previous publications include *Painting Women: Victorian Women Artists* (Routledge, 1993).

BEYOND THE FRAME

Feminism and visual culture,
Britain 1850–1900

Deborah Cherry

London and New York

First published 2000
by Routledge
11 New Fetter Lane, London EC4P 4EE

Simultaneously published in the USA and Canada
by Routledge
29 West 35th Street, New York, NY 10001

Routledge is an imprint of the Taylor & Francis Group

© 2000 Deborah Cherry

Typeset in Bembo by RefineCatch Limited, Bungay, Suffolk
Printed and bound in Great Britain by
Biddles Ltd, Guildford and King's Lynn

Deborah Cherry asserts the moral right to be identified
as the author of this work.

All rights reserved. No part of this book may be reprinted or
reproduced or utilised in any form or by any electronic,
mechanical, or other means, now known or hereafter
invented, including photocopying and recording, or in any
information storage or retrieval system, without permission in
writing from the publishers.

British Library Cataloguing in Publication Data
A catalogue record for this book is available from the British Library

Library of Congress Cataloging in Publication Data
A catalog record for this book has been requested

ISBN 0–415–10726–1 (hbk)
ISBN 0–415–10727–X (pbk)

SOUTHAMPTON INSTITUTE
LIBRARY SERVICES LTD

SUPPLIER BLACKW

ORDER No

DATE 2·7·01

For Joan Dorothy

CONTENTS

FIGURES

ACKNOWLEDGEMENTS

It is a great pleasure to acknowledge all those who have contributed to the making of this book. Let me begin by warmly thanking Jane Beckett, Carol Dyhouse, Kristina Huneault, Reina Lewis, Marcia Pointon, Elizabeth Prettejohn and Anna Robins for their wise criticism on all or parts of the typescript and Jill Beaulieu, Mary Roberts and Shearer West for their constructive comments on earlier versions. I owe a special debt of thanks to Lynne Walker, whose mapping of the west end of London has been inspirational, to Hazel Lintott of the Cartographic Unit at the University of Sussex for her skills in drawing the map, to Kate Perry for her knowledgeable guidance on the archives at Girton College and to Lois Drawmer, Janice Helland, Pam Hirsch, Lynda Nead and Jan Marsh for generously sharing unpublished material with me. Colleagues at Sussex, Craig Clunas, Jane Cowan, Maurice Howard, Liz James, Nigel Llewellyn, David Mellor, Partha Mitter, Michelle O'Malley and Evelyn Welch have offered productive directions, and Yvonne McGreal has made so much possible. Of the many people who have given help and provided material, I would particularly like to thank Geoff Bennington, Susan Casteras, Anne Christopherson, Meaghan Clarke, John Crabbe, Ann Dingsdale, Susanne von Falkenhausen, Tom Flynn, Peter Funnell, Viv Gardner, Tim Goad, Joanna de Groot, Catherine Hall, Katherine Hoffmann-Curtius, Rosemary Ind, Barri Jones, Alexandra Kokoli, Anna Lazou, Carol Mavor, Christopher Newall, Pamela Gerrish Nunn, Judy Oberhausen, Mary Poovey, William Ritchie, William Vaughan, Ana Vicente, Salah Zaimeche, all those collectors who wish to remain anonymous, and the participants at seminars and conferences where parts of this project have been presented.

Kim Sloan at the British Museum, Christopher Sheppard at the Brotherton Library, Philip Ward Jackson at the Conway Library, Penny Martin and David Doughan at the Fawcett Library, Vivien Knight at the Guildhall Art Gallery, Victoria Williams at Hastings Museum and Art Gallery, Ella Molenaer, Monique van der Pal and Mieke Ijzermans at the Internationaal Instituut voor Sociale Geschiedenis, Anne Thomson and Carola Hicks at Newnham College Cambridge, Mary Mackay and Julian Pooley of the Surrey History Centre, Hilary Diaper at the University of Leeds Art Collection, Gill Saunders at the

Victoria and Albert Museum, Jane Cunningham and Melanie Blake at the Witt Library, Malcolm Warner at the Yale Center for British Art, and Richard Green of York City Art Gallery and the Photographic and Design Service at the University of Sussex have all provided invaluable advice as well as kindly facilitating access or assisting with illustrations. I have benefited from the specialist knowledge of staff in numerous libraries and collections including the Beinecke Rare Book and Manuscript Library, the Bibliothèque Nationale de France, the British Library, the British School at Athens, Cambridge University Library, Castle Howard, Central Library Manchester, Christie's Images, the Stirling and Francine Clark Art Institute, the Forbes Magazine Collection, Guildhall Library London, Hampshire Record Office, the Houghton Library, the House of Lords Record Office, the Library of Congress, Local History Library Leeds, London Metropolitan Archives, National Museum of American Art, National Museum of Labour History, National Portrait Gallery, Penlee House Gallery and Museum, Raby Castle, the Royal Collections, Russell-Cotes Art Gallery and Museum, the Arthur and Elizabeth Schlesinger Library on the History of Women in America, Sotheby's Picture Library, Tate Britain, Wadsworth Athenaeum, West Sussex Record Office, and West Yorkshire Archives Service. Meaghan Clarke, Carolyn Dixon and Alicia Foster carried out research tasks efficiently. A substantial grant from the Leverhulme Trust enabled me to begin research; generous support from the Arts and Humanities Research Board and the University of Sussex facilitated its conclusion.

To Sandra Jones for her painstaking copy-editing, Diana Russell for proof-reading, Ann Hall for the index, and Juliane Tschinkel and Alistair Daniel for guiding the book through production, sincere thanks. Over years marked by deaths and upheavals, my commissioning editor Rebecca Barden has shown unstinting support which I am delighted to acknowledge. *Beyond the Frame* is dedicated to my mother, a silversmith. We shared an interest in searching out women's art and in discussing the conditions in which it is made and understood.

The author and publisher are deeply grateful to all those individuals and institutions who have granted permission to reproduce works of art and literary material. Every effort has been made to contact the copyright holders and to obtain permission to reproduce copyright material, but if for any reason a request has not been received, the copyright holders should contact the publisher.

ABBREVIATIONS

Individuals

AJ	Anna Jameson
AMH	Anna Mary Howitt [Watts]
BB	Barbara Leigh Smith Bodichon
BRP	Bessie Rayner Parkes [Belloc]
ED	Emily Davies
EF	Eliza [Bridell-]Fox
GE	George Eliot [Marian Evans]
HH	Harriet Hosmer
HT	Helen Taylor
MM	Mary Merryweather
JS	Julia Smith

Associations and journals

AJ	*The Art Journal*
ARA	associate member of the Royal Academy of Arts, London
ARWS	associate member of the Royal Watercolour Society
CCNSWS	Central Committee of the National Society for Women's Suffrage
EWJ	*The English Woman's Journal*
EWR	*The Englishwoman's Review*
ILN	*Illustrated London News*
LASM	London Association of School Mistresses
LLEA	Leeds Ladies' Educational Association
LNA	Ladies' National Association
LNSWS	London National Society for Women's Suffrage
MNSWS	Manchester National Society for Women's Suffrage
NSWS	National Society for Women's Suffrage
RA	Royal Academy
SFA	Society of Female Artists

SR	*Saturday Review*
WSJ	*Women's Suffrage Journal*
WSPU	Women's Social and Political Union

Archive collections

ALC	Autograph Letter Collection, Fawcett Library, London
ARAA	Archives of the Royal Academy of Arts, London
BCFP	Bonham Carter Family Papers, Hampshire Record Office, Winchester
BP	Bodichon Papers, Girton College Cambridge
CCP	Charlotte Cushman Papers, Library of Congress, Washington
CP	Cobden Papers, West Sussex Record Office, Chichester
DP	Emily Davies Papers, Girton College Cambridge
FC	Ford Collection, Brotherton Library, University of Leeds
GPP	Garnett-Pertz Papers, The Houghton Library, Harvard University
GEGHLC	The George Eliot and George Henry Lewes Collection, The Beinecke Rare Book and Manuscript Library, Yale University, New Haven
HBC	Blackburn Collection, Girton College Cambridge
HHP	Harriet Hosmer Papers, The Arthur and Elizabeth Schlesinger Library on the History of Women in America, Radcliffe College, Cambridge, Mass.
LSEP	Leigh Smith Estate Papers, London Metropolitan Archives, London
MGFC	Millicent Garrett Fawcett Collection, Manchester Central Library
PP	Parkes Papers, Girton College Cambridge
TMP	Taylor-Mill Papers, London School of Economics
WSC	Women's Suffrage Collection, Manchester Central Library

INTRODUCTION

In May 1880 members of the London and Westminster Tailoresses' Society marched in procession to central London carrying a yellow silk banner which they had made. Bearing an invitation to attend a National Demonstration of Women and a motto 'We're far too low to vote the tax / But not too low to pay', the banner signalled the active presence of working-class women as trade unionists and suffragists in the concerted call for enfranchisement in the Reform Bill of 1884. Calling for the vote and advocating action, the banner and procession spoke of and to a public world of urban demonstration. Some years later a painting by Emily Ford, resplendent in blue and gold, was presented by the prominent campaigner Millicent Garrett Fawcett to Newnham College Cambridge. *Towards the Dawn* (Figure 5.20) celebrated achievement and heralded a bright new future. In contrast to the tailoresses' magnificent street spectacle, painters, sculptors and purchasers of art supported the women's movement in the arena of high culture. What linked them was their participation in the visual culture of modernity and the importance which they gave to visuality and visibility.

Beyond the Frame explores the complex, subtle and volatile interplays between this new visual culture and an organised movement to change the asymmetrical relations of power between women and men. What is offered here is by no means a deductive model which will settle or fix the definitions of either feminism or visual culture, but an enquiry which shifts the ground of 'Victorian' art to set painting alongside sculpture, graphic and decorative art, photographs and reprographic prints, illustrated magazines and the pageantry of demonstrations to argue that the elite forms of fine art were shaped by and understood within a visual culture in which art collided with politics, visual representation with political representation. And that to explore visuality, modernity and imperialism is to consider the sexual politics of vision in the modern city and pictorial perception in a colonial theatre.

An increasingly visual culture developed in the second half of the nineteenth century with the rapid expansion of the art market and a dramatic increase in the number of exhibitions. A completely new medium, photography, with its own societies, literature and displays of work, was developed. A new kind of art

1

dealer set up in business, who purchased not just the art work but the rights to reproduce it. Changes in technology put into production fine art engravings, pictorial editions of novels and poetry, dioramas and panoramas, illustrated papers and comic magazines catering for diverse and heterogeneous publics: *The Illustrated London News*, *Punch* and *The Art Journal* were all founded in the 1840s. In the jostling, crowded, perplexing world of metropolitan modernity the visual assumed, and was ascribed, an increasing authority for telling differ-ences and marking distinctions: seeing was elided with knowing. By the end of the century, seismic changes had taken place. While the new life sciences validated the visual, particularly photography, in classifying social groups and racialising identities, an emphasis on aesthetic pleasure and personal response in the viewing of fine art gave rise to an ambivalence and uncertainty which displaced what had been understood as clear-cut, visible definitions.

Painting and sculpture as much as comic drawings became a battleground for intense debates about the role of women in contemporary society which equally intruded into reviews and critical writing. Few gallery-goers, art col-lectors, newspaper readers or casual browsers of the illustrated press or art magazines would have been unaware of a major movement which provoked contention as much in the columns of *The Art Journal* as on the pages of *Punch*. Feminism provided frames for viewing and interpreting, sometimes stated, at other times not. And visual culture brought feminists into the frame: illustrated magazines gave local activists a national visibility. Visual culture as well as the mediating work of critics and writers acted as *loci* of interaction, points of production for the making of meaning. Artists who took up the challenge of imaging women as subjects who could claim political rights and visual repre-sentation were not unmindful of illustrations in the national press. Activists too kept a watchful eye, cutting out and sometimes commenting on images which they pasted into voluminous volumes of cuttings.

In an outstanding analysis of feminist desire and the writing of art's histories, Griselda Pollock reflected on the problems of a project directed only to women artists, pointing out the importance of historical specificity and the differences between women.[1] *Beyond the Frame* is primarily but not always about women artists, and not exclusively about their art. Sometimes it matters to make that difference. In the nineteenth-century women's movements, women called on women for public support, maximising to the full contemporary discourses on the opposition of the sexes. And although men worked with women, in campaigns for the vote for example, a public position was taken up by fewer male than female critics and artists (one was Edwin Landseer, the well-known animal painter). In art historical literature of the late twentieth century, the category 'women artists', posed as an alternative to 'the artist' (a universalising category generally understood as masculine), only specifies a bin-ary difference of sexuality while evading all other kinds of difference between women. Masculinity and femininity were far from fixed definitions in a social formation charged by calls for women's rights in education, employment and

law as much as by women's 'speaking out' on masculine sexuality, domestic violence, child abuse or marriage; they were shaped by formations of race, ethnicity, imperialism, sexuality, age and class as much as by sexual difference. Identifying feminist allegiances and political alliances will shatter a complacency which might hope to include 'women artists' without too much disturbance into existing accounts of 'Victorian' art, named after a monarch notorious for her dismissal of feminism.

Increasing numbers of women worked as artists from 1850 to 1900. Writing as 'Leader Scott' in *The Magazine of Art* in 1884, Lucy Baxter associated their entry into the art profession with the rise of feminism: 'With emancipation there have come the desire and possibility of independence. New careers must be made for women and art opens a wide field to her.'[2] By the end of the century, women artists lent their names and national, even international, reputations to endorse the vote, higher education or social purity. Whereas for some this marked a limit, others partnered a career with campaigning. In between ardent involvement and decided opposition was a range of views, shifting and changing, often ambivalent, sometimes contradictory, factored in relation to other concerns such as temperance or vivisection, or a political allegiance: some were confirmed Tories, others were staunch Liberals or committed socialists. Art making and viewing did not take place in a neutral, ungendered realm but in a social formation riven by political conflict, racialising difference, class antagonisms and public debate. In exploring these issues it will be helpful to seek the broadest definitions of politics and of what Michel de Certeau has called the 'practice of everyday life', those modest rituals of daily activity and spatial experience all too often hidden from view.[3] Tracing the links, however, is by no means a straightforward process of identification. The archives of the women's movement and women's art are fragmentary and dispersed. Visual culture was by no means a deposit of pre-formed ideas or beliefs transferred from elsewhere, and feminism was a term that encompassed a diversity of interventions in discourse and culture.

Feminism was not a term used in England before 1895, but long before the end of the nineteenth century there were distinct and identifiable discourses concerned with the 'rights of women'.[4] Historians have identified distinct yet overlapping strands, including: egalitarian feminism which focused on equal opportunities and equal rights; social purity feminism, initially organised to secure the repeal of the Contagious Diseases Acts, but increasingly 'speaking out' on masculine sexuality and vice; and socialist feminism directed to changing the inequalities of class and economic relations. They have drawn attention to feminism's address to the dynamics of power, the breadth of its concerns and its national and regional geographies, its diffusion far beyond an organised movement. To speak of feminism then is to embrace a richness and diversity of dissent on which leader writers, magazine editors, family and friends, artists and critics were divided, their views shaped by visual culture as by reading, writing or conversation. Feminism included multiple perspectives

3

and dissonant desires: there were as many competing explanations as there were possible solutions. Discourses on sexuality and gender were tangled in contemporary views on the relations of race and class and shaped by narrations of nation and empire. Gayatri Spivak has emphasised the importance of identifying, situating and deconstructing these historical formations, wisely counselling against their adoption as templates for historical study.[5]

Feminist critics had much to say about art and artists, and indeed about visual culture. Many activists concurred that although there was 'no sex in art', there was a good deal of sexual discrimination in society. Journals profiled women practitioners and celebrated high achievers. The making of an 'author name' was essential for professional success and it was this public signature and reputation which endorsed the calls for equal rights or advocacy of women's issues. An emphasis on individual achievement, a hallmark of 'feminist individualism in the age of imperialism,'[6] as well as much nineteenth-century art criticism has had a long legacy, preceding a revival of interest in 'heroines' in more recent years.

The concept of visual culture introduces an expanded visual field. Chris Jenks defines it as '[w]ithin the academy . . . a term used conventionally to signify painting, sculpture, design and architecture; it indicates a late modern broadening of that previously contained within the definition of "fine art"'.[7] Irit Rogoff, however, perceives visual culture less in terms of broadening the objects of art history and more as a challenge. She provides an acute distinction between 'the information, desires and encoded values that circulate throughout every level of culture in the form of visual representations' and 'the epistemological fields of art history, film history and so on'. For Rogoff, the study of visual culture marks a departure from the conventional procedures of the discipline, displacing an approach based on connoisseurship and 'a good eye' for 'an understanding of embodied knowledge, of disputed meanings, of the formation of scholastic discourses of material value, of viewing subject positions within culture, and of the role of vision in the formation of the structures of desire'. As she signals, this reformulation engages the discussion of 'spectatorship *in* (rather than *and*) cultural difference' and investigates the intersections between cultural and sexual difference.[8]

Wide-ranging enquiries spanning the disciplinary fields of philosophy, political theory, visual anthropology, photography, film and cultural studies as well as art history have had the effect of re-locating the latter as one of several areas of study concerned with the visual.[9] A rush of publications on vision, the gaze and spectatorship in the 1970s and 1980s took place against what was perceived as a dramatic increase in images in the west, generated by new technologies, global capitalisation and a fascination with simulacra.[10] Feminist analysis provided powerful accounts of 'visual pleasure', 'women's look' (as spectator and as image) and 'sexuality in the field of vision', to cite influential studies by Laura Mulvey, Mary Ann Doane and Jacqueline Rose.[11] For Martin Jay, the project of modernity was achieved by the privileging of sight and the connections between visuality, knowledge and power.[12] Modernity has been the

subject of innumerable definitions and chronologies, its inception traced back to the sixteenth century. The second half of the nineteenth century, however, has been identified as a significant moment characterised by technological change, a sense of an acceleration and intensity of pace, the compression of space–time, mass production and mass culture.[13] All these factors assisted in making a visual culture which in its reach and diversity far exceeded its antecedents.

Debates on vision have had an impact on studies of imperialism, colonialism and travel, with enquiries into 'imperial eyes' and the 'colonial gaze', and a substantial literature on Orientalism. Although Edward Said's founding text did not engage with imagery, Linda Nochlin's path-breaking study initiated a welter of publications and exhibitions.[14] Debates about photography have recognised that visuality has been a significant force in the exercise of power and that vision is two way.[15] 'Gendering Orientalism' and the study of feminism and imperial culture have drawn attention to the ambivalence of western women in the colonial theatre.[16] Consideration here of British women in Algeria contributes to the growing understanding of relations between feminism, nationalism and imperialism, while opening out questions on visual culture and imperialism to discover an interplay that was oblique and tangential, complicit and uneasy.

Admitting the difficulties of demonstrating 'the involvements of culture in expanding empires, [of making] observations about art that preserve its unique endowments and at the same time map its affiliations', Edward Said argues that nevertheless 'we must attempt . . . [to] set the art in the global, earthly context. Territory and possessions are at stake, geography and power.' Discussions of the violence of culture enable a rigorous probing of visual culture *and* imperialism, landscape *and* power.[17] Gayatri Spivak's proposal that culture is generated in and by the violent fissuring between the existing society and the new imperial order assists an understanding of the work of art less as a product of a violence generated beyond or outside it, but rather as an integral element in 'the planned epistemic violence of the imperialist project'.[18] Jacques Derrida's reflections on framing as a field of force draw attention to a violent closure which subjects the work of art and its meanings to the pressures of restraint and regulation.[19] *Beyond the Frame* takes up these ideas to explore the visual representation of spaces and peoples in the chaotic and traumatic colonisation of Algeria. Framing did not only take place on the southern border of the Mediterranean but in the imperial metropolis; it is that force which compressed feminists on to the pages of *Punch* with a few deft strokes of the pen. If Derrida's difficult texts on framing seem far distant from and incommensurate with the works of art considered here this is in part because, as he explains, the institutions and discourses on the frame, which include the disciplines of art history and aesthetics, regulate what is intrinsic and extrinsic to the work of art. Moving beyond the frame elucidates the intricate and intimate connections between the work of art and social and political history, sexual politics, critical theory, and the trauma of colonisation.

Beyond the Frame includes artists working in (and shuttling between) Britain, Algeria and Rome, to trace European connections, North American affiliations, North African links and, crossing the boundaries of 'Victorian' art, to pursue an emphasis made by Gayatri Spivak that '[i]n post-coloniality, every metropolitan definition is dislodged'.[20] An attention to space is also shifting disciplinary concerns. Whereas some years ago W.J.T. Mitchell wrote of a 'pictorial turn' in visual studies, it is now possible to identify a 'spatial turn'.[21] Studies of gender and space are dislodging the hold of an ideology of separate spheres in the history of the middle classes which has juxtaposed a domestic, familial and dependent femininity to a masculinity active in the world of work and public spaces of the city. The recent interest in spatiality and 'the restless formation and reformation of geographical landscapes' has shaped the mapping here of London's west end and colonial Algeria. Current preocccupations with 'the social production of space' and the 'emplacement' of social beings have instigated enquiries into subjectivities shaped by spatial experience.[22] Spatiality and sociability were active in the making of meanings for works of art and visual culture. Public meeting rooms, exhibition galleries, dealers' shops, artists' material suppliers, women's classrooms at art schools and any number of feminist habitats were among the urban locations in which subjectivities were formed and interpretations essayed.

How then may the relations between feminism and visual culture be construed? *Beyond the Frame* has a loose but not binding chronological structure. Chapter 1 is concerned with the coincidence in the 1850s and early 1860s of the emergence of an organised women's movement, the prominence of women as professional artists and the development of the visual culture of modernity. Chapters 2 and 3 consider the shuttling of travellers, pictures and publications between London and Algeria, analysing feminist strategising in, writing about and picturing of what was then a French colony to pursue the dis/articulations between visual culture, modernity and imperialism. Discussion in Chapter 4 of Harriet Hosmer's *Zenobia* (exhibited in London in 1862) draws attention to the interplay between discussions about women and the racialising of difference intensified by the division of public opinion over American slavery and the Civil War. Taking as a convenient starting point the suffrage petition of 1866, Chapter 5 examines the prominence of artists in a number of campaigns, defining feminist politics broadly and not exclusively in relation to the well-publicised demands for enfranchisement within the democratic state. Enquiry into the relations between feminist politics and late nineteenth-century painting engages with ways of reading which push beyond explanations of feminist content or intention.

At times close connections between feminism and visual culture will be observed. The delineation of the independent working woman in modern-life painting of the 1850s paralleled calls for paid work. In 1860s the advocacy of women's higher education and medical training was accompanied by a flood of images dealing with women and learning, from the contemplative

interpretation of the sibyl to the fascinating and wilful sorceress whose spells are dangerous, even fatal, to men. The lampooning of feminists in comic magazines throughout the period suggests that print culture could carry political sentiments directly. But in elite forms these relations were slippery, ambivalent, contingent. Works of art were made and viewed within formal aesthetic conventions as well as a tangle of contending discourses. Their legibility to contemporary audiences depended on intertextuality, their relation to an unstable and tensile web of images and texts from which they were woven and within which they were interpreted. This intertextuality is proposed as a shifting set of 'framings' within which meanings were deferred and defied, claimed by some and refuted by others, conditional upon the social spaces of viewing. Allegory offers a subtle way of reading between texts, of catching at elusive, fugitive, indirect connections. It is allegory's supplementarity, its emphasis on the 'reciprocity' between image and text in a relationship in which both are mutually transformed, which enables encounters in which art is 'read through' a frame of feminist politics, and in which feminist readings may be sustained alongside other readings.[23] The readings proposed here oscillate between past and present: some of the frames will be those from a nineteenth-century agenda, while others are written through, and will be 'read through', the concerns of today. Both engage a feminist politics of reading which is, as Lynne Pearce suggests, 'an *interactive* and *implicated* process' tangled with desire.[24]

But if reading is restless in its search for meanings, allegory is treacherous. Its slipperiness gives rise to uncertainty: city squares and public museums are full of figures whose identity and meanings have slipped beyond intelligibility. Many other works of art have long since disappeared: coming to signify dead women and defunct causes, they have simply ceded place. If these are among the reasons which have delayed the inscription of feminism into the histories of 'Victorian' art as well as the accounts of visual culture in nineteenth-century Britain, it is also the case that the concerns of the present shape investigations into the past.[25] At a moment when feminism in the west is all too often being reduced to equality, studies of an earlier century testify to a complexity and contradiction in which the visual was an important arena of intervention and definition.[26] They also help to explain the priorities which have been given to the interests of middle-class white women.

Many studies of 'Victorian' art carefully screen out anything even mildly tinged with political debate and the women's movement is regularly evaded. Much has been invested in interpretations that do not challenge the asymmetries of power, either now or then. Major exhibitions and publications often decline to acknowledge women as artists, or minimise their contribution. If it is still so challenging to accept women's art as an effective presence in culture and women as active agents, it is perhaps not unsurprising that feminism remains beyond the frame, as a politics and as a heterogeneous discursive field for considering the work of artists, male or female. While social and political historians rarely include artists and generally consider visual culture to be illustrative,

7

there has been a general assumption in the discipline of art history that feminism's interventions in art and its literatures began around 1970. The rich diversity of the material presented here marks the beginning of a reconsideration of art works and images, spaces, debates and figures within a tensile web of social relations, knowledge and power. Bringing feminism into the frame generates not only new accounts of painting and sculpture but also new ways of interpreting visual culture. *Beyond the Frame* has been written to probe the interplays between feminism and visual culture, imperialism and sexual difference, and in the echo of the words of Walter Benjamin, 'every image of the past that is not recognised by the present as one of its own concerns threatens to disappear irretrievably.'[27]

1

ARTISTS AND MILITANTS, 1850–66

Artists and militants

On 16 July 1860 Laura Herford entered the schools of the Royal Academy after a brilliantly orchestrated campaign to secure the admission of women students to an institution which had excluded them since its foundation. She was, she remembered, greeted by Charles Landseer, the Keeper, 'good-naturedly, though awkwardly as if he scarcely knew what would come of it'.[1] What indeed? Increasing numbers of women artists were exhibiting and selling their work, newly visible not just as exceptional or outstanding performers, but as a collectivity to be reckoned with. And as a group they were making new demands and generating debate. A newly organised women's movement was equally demanding and equally provocative of contention and change. From this moment, women's art and feminism were inextricably intertwined: speech on the one invariably incited discourse on the other. Women claimed representation: in the world of work, in the profession of art, in civil society. When artists joined the women's movement, the politics of feminism connected to the practice of art.

The reasons for these links lay in part in the development of feminist languages. In speaking of the self, women spoke simultaneously of identity and difference. Feminism's project was to reorganise the asymmetrical relations of power between men and women so as to change the prevailing concepts of middle-class femininity which defined women as dependent and self-less. Feminists laid claim to a subjectivity which was self-conscious, self-motivated, self-reliant. In refashioning an ideal of liberal individualism developed by and for white middle-class men, feminist subjectivity was marked by class and differentiated by race. Gayatri Chakravorty Spivak has identified the 'militant female subject', local to the west and forged in relation to imperialism and nationalism (issues developed further in the next chapter). Her analysis, which 'situate[s] feminist individualism in its historical determination', contains a provocative suggestion, that the creative arts provided a fertile arena for feminist claims to individualism: '[T]he battle for female individualism was played out within the larger theatre of the establishment of meritocratic individualism,

9

indexed in the aesthetic field by the ideology of "the creative imagination".'
This proposition, developed in relation to the 'creative imagination' of Jane
Eyre (claimed by some as the quintessential feminist heroine), enables a link to
be made between feminist activists and woman artists.[2] Individualism flour-
ished in the nineteenth-century art world: the artist became an intense focus of
concern and, as Michel Foucault has put it, a 'primary means of classification'.[3]
Between 1850 and 1900, exhibition reviews moved from a leisurely stroll
round the gallery to the discussion of individual achievement. Magazines,
handbooks and catalogues increasingly carried profiles of artists, while feminist
papers featured biographical sketches of women practitioners.

The female militant as artist

By the later 1840s fine art offered singular possibilities for a professional career.
Harriet Taylor was convinced that the 'modes of earning their living' open to
her contemporaries '(with the sole exception of artists) consist only of poorly
paid and hardly worked occupations, all the professions, mercantile clerical,
legal & medical, as well as all posts being monopolised by men'.[4] Unitarian
beliefs and class-specific convictions of the value of work powered feminism's
push for paid employment for middle-class women in the following decade.[5]
Amateur accomplishment in drawing and watercolours could be turned to
advantage. Fine art offered independence, economic autonomy and, in the
words of Anna Mary Howitt, 'a life of aspiration', characterised by 'strength of
determination', 'earnestness and fixedness of purpose' and 'largeness of
vision'.[6]

In the earlier decades of the century the decision to become an artist had
been largely driven by family pressure and/or financial necessity. Eloise
Stannard grew up in an extended artist family in Norwich in which, as she
recollected, 'there was imposed on her the necessity of contributing to the
family exchequer'.[7] These pathways remained in place throughout the century:
contributing to the family finances was one of several factors which influenced
Anna Mary Howitt's writing and painting. But in the 1840s professional prac-
tice was also undertaken as part of a feminist commitment to paid work for
middle-class women. Young women in progressive families were given a sound
education, some access to art education, materials and studio space, and most
importantly the encouragement and confidence (in varying degrees) needed to
become professional artists. In accounting for Rebecca Solomon's pursuit of a
career, Monica Bohm-Duchen has emphasised the confluence of several fac-
tors: her father Meyer Solomon's prosperity; the influence of her mother,
Catherine Levy, an amateur artist; the example of her brothers, Abraham and
Simeon (both painters); and the formation of Anglo-Jewry in the first half of
the century. The Solomon family, she writes, was 'on the one hand loyal to its
Jewish roots and on the other anxious to succeed in English gentile society'.
Here 'artistic ambition and Jewish feminine respectability could co-exist'.[8]

Families of radical dissent produced many young women who became artists and activists: Barbara Leigh Smith (later Bodichon), Eliza Fox, Anna Mary Howitt, Emma Novello, Rosa Le Breton and Caroline E. Hullah grew up in a network of households connected by kinship, friendship, religious sympathy and strong interests in civil rights identified by social historians as a 'genealogy of reform'.[9] Laura Herford was a cousin of Bessie Rayner Parkes (to become the editor of *The English Woman's Journal*) and related to an extensive Unitarian network in Birmingham and London.[10] Educated in Unitarian schools in Cheshire and Warwickshire, she settled in London at the age of 18 to study art. Barbara Leigh Smith and Eliza Fox were both daughters of Radical members of Parliament, Benjamin Leigh Smith and W.J. Fox. Anna Mary Howitt was the daughter of the writers and editors William and Mary Howitt. What distinguishes them from contemporaries who maintained a distance from the women's movement was an early grounding in radical politics and their contact with women active in the feminist politics of the 1840s.

Reflecting on 'several remarkable women of an older generation', Bessie Rayner Parkes named as significant Harriet Martineau, Mary Howitt and Anna Jameson, singling out the latter, an art historian, 'for the influence she exerted, not only in her writings, but in her person'. According to Parkes,

> The department of intellectual activity in which she naturally took most interest was that of the artist; and a group of young women, who pursued art in one or other of its branches, were among her constant visitors during her sojourns in London.[11]

In turn, Jameson's views were questioned by younger friends whose politics drew them into public activism. Older writers and artists offered encouragement, instruction, support and examples of independent women who were outspoken on women's rights, social and political issues and cultural matters. Margaret Gillies, well connected in Radical circles of the 1840s and a consistent supporter of feminist initiatives in the following decades, offered tuition and advice to those wishing to study as artists. Harriet Taylor, whose stirring advocacy of work, autonomy and the vote for women was published in 1851, had earlier befriended the young Eliza Fox, sending her a gift edition of John Stuart Mill's *Principles of Political Economy* (which included the dedication tacitly acknowledging Harriet Taylor's co-authorship). Writing to Fox's father, Taylor explained,

> I sent it to Miss Fox because when I knew her in her early youth she appeared to interest herself strongly in the cause to which for many years of my life & exertions have been devoted, justice for women.

The gift strategically backed Eliza Fox's transition from art student to professional practice, for it was in this letter, quoted above, that Taylor wrote of men's

monopoly in the world of work.[12] Julia Smith, a close friend of Harriet Martineau and Elizabeth Jesser Reid (founder of Bedford College), put her weight behind the decision of her niece Hilary Bonham Carter to go to Paris for nearly a year, 'to make a great stride with her drawing there. . . . free from all home cares'. For her niece Barbara Leigh Smith she provided a rigorous course of study which included detailed commentary on demanding contemporary texts. She was relieved to see

> all the young women of [her] acquaintance getting hold of some occupation or at least feeling the want of it. Few sit down contented now, with the life that was considered to do very well in my young days, made up of *a little* music & *a little* drawing and a good deal of visiting.[13]

These cross-generational contacts facilitated the development of languages for speaking oppression, injustice and inequality which exploded into discourse in the 1850s. Sally Alexander has explained that 'Victorian feminism arose from a sense among many women of social injustice and grievance.'[14] These new languages enabled young women to fashion a sense of self, determine a career move and oppose reluctant parents: Eliza Fox insisted on making a transition from amateur accomplishment to professional endeavour; Emily Mary Osborn demanded and secured limited access to art training.[15]

By the later 1840s a women's art alliance had formed in London bringing together writers, painters, sculptors and students committed to women's practice of art and to feminist politics. The politics of friendship and the friendship of politics have for some years been recognised as central to the formation of the women's movement.[16] With its knots and breaks, slacks and tensions, and its fabric of interconnections, weaving provides a useful analogy for uneven and changing patterns and textures of friendship shaped by proximity and distance. Eliza Fox, Laura Herford, Anna Mary Howitt and Barbara Leigh Smith can be woven in time and again to places, moments and campaigns. For others, looser or temporary connections can be projected. Sarah Ellen Blackwell, sister of the physician Elizabeth Blackwell, a member of the extensive Blackwell family and cousin to Bessie Rayner Parkes, was in Britain in the later 1850s; joining the alliance, she brought invaluable experience from the American women's movement. Ties were made through portraiture, Eliza Fox, for example, painting a portrait of Harriet Martineau. Close links were established between those who studied together. Eliza Fox and Anna Mary Howitt, for example, attended Henry Sass's art school together, going every day from 1844 to 1847. In the early 1850s Anna Mary and Jane Benham studied in Munich and there was some possibility of Eliza Fox joining them. They were visited by Barbara Leigh Smith, touring Europe with Bessie Rayner Parkes. Parkes dedicated her volume of *Poems* of 1855 to Barbara Leigh Smith and she inscribed the opening poem 'The World of Art' to 'AMH and all true artists'. A poem of 1852

portrayed Leigh Smith and Howitt as two artists, one striding the landscape and one in her tiny room. Howitt exclaimed delightedly, 'What pleasure to find my dear little room set in such a sweet poetic setting and in such good and noble company.' The friends holidayed together, worked together, visited each other and consulted each other about their activities. On sketching expeditions Howitt advised Leigh Smith on technique: 'Anna Mary says my little oils are very good for 1*st* productions from nature[.] My landscape is very PRB.' In January 1856 on the Isle of Wight, Howitt read Heine to her, 'as we sat together here in our studio overhanging the stormy sea, after our day's painting'. Art and politics were inextricably threaded together. When Parkes accompanied Howitt and Benham on a sketching trip in the summer of 1853, she gathered material for a poem, 'Helen's Answer', which spoke of a woman artist's determination to succeed '[s]triving against the hindrance of time/And all the weight of custom'. Reporting their adventures to Marian Evans (George Eliot) in January 1856, Leigh Smith solicited her signature on a petition 'I have set going' to reform the laws relating to married women's property and requested the names of 'any Ladies to whom I can send sheets'.[17] On one of these excursions, Leigh Smith sketched Parkes astride a mountain gorge, holding her volume of poems. Parkes sports a short jacket and skirt, worn with sturdy boots, so much a hallmark of her personal style that she could relate a tongue-in-cheek story of an occasion when an admirer was deterred by her distinctive footwear: 'It was damp, & I (who always you know my dear always look to pure Kantian reason & not to female adornment) had put on my – Big Boots.' Reformed dress which certainly facilitated outdoor activities was also the subject of a humorous poem by Leigh Smith:

> Oh! Isn't it jolly
> To cast away folly
> And cut all one's clothes a peg shorter
> . . .
> And rejoice in one's legs
> Like a free-minded Albion's daughter.
> . . .
> When bodies are free
> Their spirits shall be
> Of a quite unknown elevation.
> And women who dare
> To show their feet bare
> Be a glorious part of the nation.[18]

Into these lines is distilled a heady brew of feminism and nationalism.

Writing of the friendships of these years, Howitt used the terms 'sister' and 'sisterhood'. *An Art Student in Munich* (a volume of recollections from her visit to Munich) cast Leigh Smith as Justina, 'my beloved friend out of England, the sister of my heart'. The book narrates an intense relationship between two

13

women painters, whose proximity is conveyed in the descriptions of their rooms, dedicated to painting and to living, neither exclusively workspace nor domestic interior: 'there stood two sister easels, and a sister painting-blouse hung on each: the casts, the books, the green jug with flowers'. From the sitting room, hung with their sketches, are glimpsed 'our two pretty little sister bed-rooms' in which

> a writing table, a pale green wall beyond, with a print of Raphael's upon it; an old-fashioned looking glass in a gilt frame, hung high, in German fashion; beneath it Justina's Highland landscape with its ruddy heathery foreground; on one side hangs a palette . . .

An earlier novella, *Sisters in Art*, tells the story of three women artists, Alice, Esther and Lizzie, who starts life as a tailor's daughter. The three live together, 'beloved sisters in friendship and art', and eventually open an art academy for women. When Alice is engaged to be married, Esther and Lizzie 'remain together teaching and working – sisters in love and unity – as SISTERS IN ART'.[19] Foundational to nineteenth-century feminist discourse, 'sister' and 'sisterhood' were drawn from familial relationships, women's religious communities and the moral languages of anti-slavery and philanthropy. They were slippery terms. Simultaneously invoking proximity and distance, they foundered on difference. Mrs Cohen, a benefactor who funds a women's academy, is described as a Jewess who 'has learned to look beyond her faith'. A project for communal living, put forward in *An Art Student in Munich* as a 'beautiful sisterhood of Art', was to comprise an inner and an outer circle, effectively differentiating and distancing the 'Art-sisters' from needlewomen and cooks.[20] This ideology of sisterhood propounded in the mid-nineteenth century and more recently in the 1960s and 1970s has been linked by Elizabeth Fox-Genovese to feminism's 'ideal of democratic inidividualism'. Predicated on visions of parity and equality, sisterhood affirms solidarity and commonality at the same time as it forecloses discussions of power between women.[21]

One of the most characteristic activities of the middle classes, networking, was central to gendered identities and experiences as much as class formation. These alliances brought together family and friends, commercial, professional, social and religious interests. As Catherine Hall has explained, an 'extensive network of voluntary associations redefined civil society and created new arenas of power and prestige'.[22] For men, networking created a formidable power-base which extended their influence and authority in the newly created public sphere, in the world of business as well as in culture and the arts. A group such as the Pre-Raphaelite Brotherhood, formed in 1848, is exemplary of such a homosocial, class-specific association: the alliance of artists and writers was professionally beneficial years after the group disbanded. The women's art alliance drew on the not inconsiderable organisational abilities of their class to forge a campaign in the interests of their sex. Directed less to professional

advancement, this 'sisterhood' was by no means as effective as the Pre-Raphaelite Brotherhood in promoting its women members, whose careers were fragile and insecure, launched on a little formal training, a few friendships with reviewers, depleted membership rights to professional societies, and not infrequently derailed by family responsibilities. Formed in a society with asymmetrical relations between the sexes, the women's art alliance differed profoundly from men's networks. Not only did it offer informal technical help and camaraderie, but politically and publicly it was dedicated to securing women's rights: to property including earnings from art for those who married, to paid employment and to art education.

The artist as female militant

The organised women's movement emerged in 1855 with the well-publicised and highly debated campaign to reform the laws relating to married women's property. The Parliamentary petition, drafted by Barbara Leigh Smith, contended that 'married women of education are entering on every side the fields of literature and art, to increase the family income by such exertions' and that 'professional women [are] earning large incomes by pursuit of the arts'.[23] With Anna Mary Howitt and Eliza Fox she worked hard to secure signatures, supportive publicity and national debate. The alliance with older women was invaluable; as Judith Johnson indicates, these seasoned campaigners, able to withstand public notoriety and public abuse, 'represented staid, middle-aged respectability'. Anna Jameson was highly involved and gave invaluable advice.[24] Fox approached Harriet Martineau, from 1852 a leader writer for the influential liberal newspaper, *The Daily News*. Responding that she did not know anyone who might sign, Martineau offered, 'with pleasure do anything to help this rational object. W*d* you like, or not, to have it noticed in the newspapers now – or soon, – or not till the petition is presented?'[25] Of the seventy petitions with some 26,000–28,000 signatures which were presented to Parliament on 14 March 1856, one with more than 3,000 London signatures was sponsored by Leigh Smith, Fox, Anna Mary Howitt and Jameson together with the women writers Anna Blackwell, Elizabeth Barrett Browning, Geraldine Jewsbury, Elizabeth Gaskell, Mary Howitt, Jane Webb Loudon, and Martineau, and the actress Charlotte Cushman. Despite a strong coalition which included the Law Amendment Society and prominent supporters, this campaign initially foundered. But within ten years a broad movement with single-issue societies and specialist publications, like *The English Woman's Journal* (founded in 1858), had been created. Women artists soon turned their attention to the art world.

In 1859 a campaign was launched for increased access to vocational training. Neither the private art schools nor the Female School of Art (which made some provision for fine art) were under attack.[26] Rather, strategic advantage was taken of the imminent move of the Royal Academy of Arts to larger premises at Burlington House, off Piccadilly in central London (its present

home). Letters calling for the admission of women were published in the press; one was by Charlotte Babb who, like several of the petitioners, was to become a staunch suffragist. A petition signed by Jameson and thirty-seven women painters and sculptors was widely circulated and sent to the forty male Royal Academicians.[27] The petition pitched into sustained attacks on the elitism of the institution and criticism of its tuition and it coincided with the unsuccessful bids by the watercolour societies for accommodation at Burlington House, which challenged the privilege accorded by the Academy to oil painting, sculpture and architecture.[28] If the watercolourists were contesting the Royal Academy's definitions of art and the artist, how much more did women, already exhibiting in its galleries, question the masculine exclusivity of its membership? Laura Herford enlisted the support of Harriet Martineau, who reported that

> By this post arrives a letter & petition from a female artist, introducing herself in a business-like way, in order to get something done about the exclusion of female artists from the Royal Academy instruction. The present is the time for the move, she says . . . & begs me to help it on.

With her characteristic energy, she continued, '[h]ere I went into it'. Martineau drew attention to the exclusion of women students in her article on 'Female industry' in the *Edinburgh Review* of April 1859 and, as *The Times* had declined to print Laura Herford's letter, she canvassed support in *The Daily News*.[29] Jameson applied pressure in her introduction to the reissue of her lectures, 'Sisters of Charity' and 'The Communion of Labour', first given in 1855 and 1856. Extensively discussed in a wide range of publications, the campaign provided lively controversy for the wide range of papers for whom the 'woman question' was news.[30]

The signatories included many who were to be involved in feminist activism as well as those for whom the inscription of a name is the single mark of association. Eminent artists born between 1795 and 1810 were listed alongside those aged between 25 and 35 who were attracting critical notice. Others were just embarking on a career. Many were associated with the newly founded Society of Female Artists. Why did they sign? Those (and this would have comprised the majority) who had patched together an art training from the restricted facilities open to women, home tuition or occasional courses of lessons would have had some awareness of the sexual asymmetries of institutional provision. Anna Blunden and Sophia Sinnett may well have dissented from Ruskin's view that women would never achieve greatness in art; Ellen Blackwell, who undertook copying work for this august authority, undoubtedly dismissed his ideas.[31] That much was at risk in signing may be deduced from the absence of well-known artists such as Margaret Carpenter, Fanny McIan, Maria Harrison and Mary Ann Criddle (members of the Old Watercolour Society) as well as up-coming painters like Joanna Mary

Boyce and Mary Severn Newton. Illness or travel may have intervened. Although Fanny Corbaux, a distinguished miniature painter, was in favour, her name was not appended, constrained perhaps by a prolonged illness.[32]

The campaign soon entered feminist mythology, not as a concerted effort, but as Laura Herford's personal triumph. In 1871 *The Englishwoman's Review* commented in its obituary of this artist on '[t]he opening thus made by her, alone and unsupported', a view repeated five years later by Ellen Clayton, an art student and signatory in 1859, in her two-volume compilation, *English Female Artists*.[33] More recent accounts emphasise the uneven admission of women to the Academy and the institution's refusal to admit them to life drawing until 1893.[34] But two issues remain relatively unexamined: the tactics of the campaign and the strategy of petitioning. At first women drew attention to their demands for admission by attending the Royal Academy lectures. Between 1848 and 1852, Fanny Corbaux, Henrietta Ward, Eliza Fox and Anna Mary Howitt were among those recorded as present on these occasions.[35] Writing to Leigh Smith over this period, Anna Mary Howitt recounted,

> Did I tell you I went one night to hear Leslie. Lecturer at the Royal Academy. Oh! how terribly did I long to be a man so as to paint there. When I saw in the first room all the students' easels standing about – lots of canvasses and easels against the walls, and here and there a grand 'old master' standing around, a perfect atmosphere of inspiration, then passed on into the second room hung round with the Academicians' inaugural pictures, one seemed stepping into a freer, larger, and more earnest artistic world – a world alas! which one's *woman*hood debars one from enjoying – Oh! I felt quite sick at heart – all one's attempts and struggles seemed so pitiful and vain – . . . I felt quite *angry* at being a woman, it seemed to me *such a mistake*, but Eliza Fox, a thousand times worse [than] I said, 'nay rather be angry with men for not admitting women to the enjoyments of this world, and instead of lamenting that we *are* women let us earnestly strive after a nobler state of things, let us strive to be among those women who shall first open the Academy's doors to their fellow aspirants – that would be a noble mission, would it not?[36]

The feminine body is inserted into an institutional space acknowledged as masculine. Howitt's language is intensely corporeal: the easels at rest and the paintings against the walls are juxtaposed to the movement of the female figure 'stepping' into these rooms. The female body is both a barrier which 'debars' women's access and a force which will 'open the Academy's doors': the opening of closed doors was to have a longevity in the feminist imaginary (Figure 1.1).

The tactic at this stage was visibility and corporeality, the physical presence of women signifying their professional presence as artists. But in 1859 this

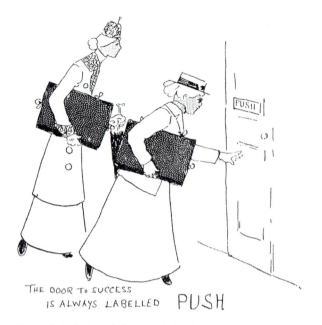

THE DOOR TO SUCCESS
IS ALWAYS LABELLED PUSH

Figure 1.1 Unsigned drawing, 'The door to success is always
labelled PUSH', 1900

embodiment of dissent was displaced by inscription: the inscription of a
demand on a petition, an approach which had been widely used in the anti-
slavery movement and in the bid to reform the married women's property
laws, and the inscription of a signature on Laura Herford's drawings in a form
which did not concede femininity. Why was this?

Laura Herford initialled the drawings which she included in her portfolio. As
the admissions officers did not ascertain from these marks that she was a
woman, she was granted a place and special provisions were quickly made. Not
only did Laura Herford come to stand in the place facilitated by her signature –
that is by signing her drawings with her initials she cloaked her sex and had
therefore been offered a place as a man – but she came to embody her signa-
ture. That is, she walked through the doors of the Royal Academy schools,
hitherto closed, to claim the place offered to her: she bodily filled that space.
The whole event of women's admission to the Academy schools thus turned
on the signature, also deployed in the accompanying petition.

The petition declared that 'no less than one hundred and twenty ladies have
exhibited their works in the Royal Academy alone, during the last three years',
so reiterating women's participation in professional practice. But its principal
charge was '[t]he difficulty and expense of obtaining good instruction'. The
petitioners therefore requested the Academicians 'to afford to women artists

18

the same opportunities as far as practicable by which they have themselves so greatly profited', instruction at the schools being free of charge.[37] It was advanced that women entering the profession 'without adequate preparatory study' were prevented from 'attaining the position for which their talents might qualify them'. Anna Jameson took another tack, appealing for the 'recognition of the principle of justice and equality'.[38]

This belief in education as the solution to occupational inequality was reiterated by Martineau: 'The artists have an unlimited field before them . . . [they] have it now in their power to ascertain whether there is any other than an educational barrier in the way of their attainment in excellence in painting and sculpture.'[39] But more was at stake for women pursuing a professional career. Bessie Rayner Parkes, writing in *The English Woman's Journal*, considered that 'none but a working woman herself can estimate the thousand hindrances placed in her path by society as at present constituted, and by the customs of society as a present imposed.'[40] Others emphasised masculine professional jealousy. In the early 1860s Sophia Beale, a young painter, reflected at length on some of the most urgent questions for contemporary feminism: would women achieve greatness, gain recognition, or attain equality? She drew on feminist languages of the period (in the journal and in Frances Power Cobbe's spirited defence of Harriet Hosmer's *Zenobia*, discussed in Chapter 4) to provide a powerful analysis of the relations of power/knowledge.

> Shall we any of us be able to prove to the world that women have brains, and given equal opportunities, can do as good work as men? How many of us will go under, as numbers of our brother brushes do? . . . Our theories are excellent. Given some brains, and an unlimited supply of love and enthusiasm, and an untiring energy and power of work, shall we not be able to move mountains, *i.e.* force open the doors of the R.A. for women students and women Academicians? Surely Art Schools opening for women ought to develop some painters superior to Angelika Kauffmann and Madam Moser? Poor dears! We shall at least know our craft better than they; but whether we shall overcome the mountains of prejudice, rivalry, and jealousy which have to be scaled, is another matter. There are women in France who equal their brethren; why should there not be here? At present women suffer disabilities as regards drawing from the Life; but if women painters were elected as associates of the R.A., *they* could superintend that class, and one more barrier would be removed from the feminine path to knowledge and distinction. . . . Will women ever be admitted to our Universities upon the same level as men? . . . The prejudice in these Islands is overwhelming, and so far, the enemy is somewhat justified in his narrow mindedness. Perhaps we have no woman painter who is equal to the best of the R.A.s; but I take it Sir Joshua Reynolds did not think the sentimental Angelika *his equal*?

Nor I imagine did he, in his inmost soul, think his R.A. *confrères* his equals! We have a woman astronomer; she is not and never will be a Fellow of the Royal Society. Why not?[41]

Beale's advanced views – she was in favour of women's suffrage as well as the opening of the Royal Academy and universities to women – were undoubtedly formed by an upbringing in a progressive Quaker family. Although she was not a signatory in 1859, it is likely that when she was an art student she encountered the feminist networks of mid-century London.

Geographies of art and feminism

In a richly documented analysis of women and urban space, Lynne Walker has demonstrated that from the 1850s the west end of London became 'the site of a women's community within the urban centre, based on the social networks, alliances and organisations of the women's movement'.[42]

One of the major breaks between the feminism of the 1840s and the organised movement of the 1850s was a metropolitan location, marked by the founding of a women's centre in the heart of the British capital to co-ordinate activities. That premises at 14a Princes Street, Cavendish Square had been secured by the summer of 1857 is indicated by a letter from Bessie Rayner Parkes to Harriet Hosmer that December: 'I have resolutely stuck to the little office where you called on me'.[43] It was from here that the *Waverley Journal* and its successor *The English Woman's Journal*, an employment register and the Society for Promoting the Employment of Women initially operated. The publication of this address in a friendly review which commended the *Waverley* and a 'tangible and practical' movement to improve the condition of women not only provided good publicity but emphasised the links between the movement and a central London location.[44] The Ladies' Reading Room was started in 'a small and not very convenient room' situated 'over the little office which the Journal originally inhabited'. A visitor in the summer of 1859 discovered 'some twenty ladies seated round the very primitive apartment'.[45] The Reading Room was founded by Bessie Rayner Parkes

> for the double purpose of collecting together all those magazines and papers in which literary women, and indeed all cultivated ladies, feel an interest . . . and also to be a place of rest and recreation to those innumerable women who are engaged in daily tuition, and other laborious paths of duty and bread-winning.

Open at first until 5 p.m. and then later until 10 p.m., the Reading Room also provided tea and coffee at a small charge. Popular from the outset, its seventy subscribers included 'many teachers and artists'.[46] At least one art work by

Bodichon was purchased for the room and when her collection of 'Sketches in Algeria and America' was shown at Princes Street in 1859, it was promoted as a particular attraction: 'Our lady readers who feel interested in the productions of their own sex would be gratified in making acquaintance with these works.'[47]

From December 1859 a 'large house' at 19 Langham Place just north of the intersection between Oxford Street and Regent Street became the home of the journal, various associations including the Society for Promoting the Employment of Women, a 'Register for Woman's Work', the Ladies' Reading Room and a luncheon room. In defending the premises as a 'respectable place of accommodation suited to a light purse and a solitary condition', Parkes asserted (quite at variance to Jane Welsh Carlyle, a campaigner for legal reform, who used to eat out alone at Harriet Verrey's restaurant in Regent Street) that '[n]o lady likes to go alone into a restaurant or a large confectioner's shop to procure a meal'.[48] Early in 1860 Parkes enthusiastically reported that eighty subscribers had enrolled for this 'very Queen of Clubs'. Not only were clubs, as Martha Vicinus has demonstrated, vitally important for independent women making a life in the city, but they were central to the growth of urban feminism.[49] Both locations provided a co-ordinating centre, a convenient meeting place and a sales point. Initial plans for 'a shop, for books, newspapers, stationery, drawings, etc.' were still under consideration in 1859.[50] According to the historian Jane Rendall, 'a small paper store, run on shareholding principles' was founded; in 1861 there was some discussion of 'enlarging it into a larger, new co-operative stationery store, managed by and employing women'. Copies of the journals and related publications were certainly on sale.[51]

The new address identified organised feminism with Langham Place.[52] It also associated it with London's west end, the site of the central institutions of masculine power and pleasure, numerous aristocratic town houses, and a wide variety of shops. As Lynne Walker comments, the west end was subject to a 'double mapping', by day an elegant shopping district and by night the haunt of prostitutes.[53] Also located here were exhibition venues, dealers' premises, print shops, auction houses, galleries and museums, art schools and artists' suppliers of the capital's rapidly expanding art world. An alliance between women artists and the women's movement developed in this densely populated but relatively circumscribed area (Figure 1.2).

A studio in central London was invaluable for an artist participating in the exhibition circuit or a portrait painter whose practice might rely on a location convenient to her sitters. Laura Herford, for example, lived a short walk away from Elizabeth Garrett (Figure 5.9). Herford chose Fitzrovia, an area of furniture makers and sellers, framemakers and gilders, art schools and suppliers, which was described by Ellen Clayton as 'redolent of art and artists'. With a wide range of accommodation, from the modest to the grand, residents included the president of the Royal Academy Charles Eastlake, the writer

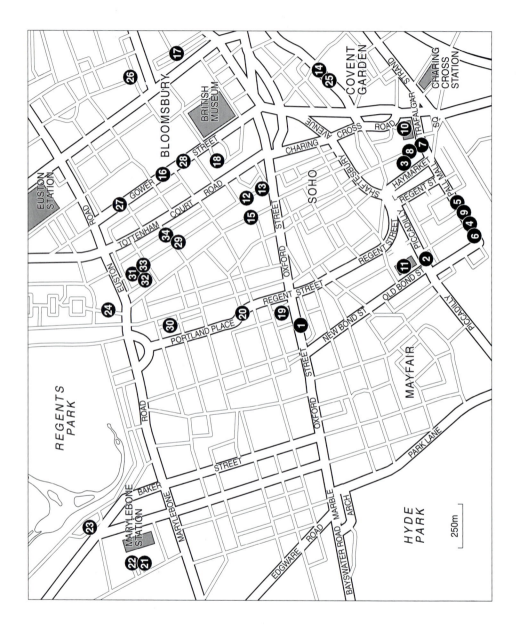

1. 315 Oxford Street, The Society of Female Artists, 1857
2. Egyptian Hall, 171 Piccadilly, The Society of Female Artists, 1858
3. 7 Haymarket, The Society of Female Artists, 1859
4. 120/1 Pall Mall, Ernest Gambart's exhibition rooms for showing French art, Rosa Bonheur's *The Horse Fair* and Barbara Bodichon's Algerian watercolours
5. 53 Pall Mall, galleries of the New Watercolour Society, later (Royal) Institute of Painters in Watercolour, and The Society of Female Artists, 1860–2
6. 48 Pall Mall, The Society of Female Artists, from 1863
7. 5a, later 6, Pall Mall East, Old Watercolour Society, later Royal Watercolour Society
8. Suffolk Street, Pall Mall East, Society of British Artists
9. 52 Pall Mall, British Institution
10. Trafalgar Square, National Gallery and, from 1837 to 1868, The Royal Academy of Arts
11. Burlington House, Piccadilly, The Royal Academy of Arts from 1868
12. 38 Rathbone Place, Winsor and Newton, artists' materials
13. 51/2 Rathbone Place, George Rowney, artists' materials, and from 1862 at 29 Oxford Street
14. 99 Long Acre, Charles Roberson, artists' materials
15. 79 Newman Street, art school run by J.M. Leigh and later Thomas Heatherley
16. 37 Gower Street, Female School of Art, 1852–60
17. Queen Square, Female School of Art, from 1861
18. Bedford Square, Bedford College, founded 1849
19. 14a Princes Street, premises of the *Waverley Journal*, *The English Woman's Journal*, the Ladies' Reading Room, and the Society for Promoting the Employment of Women
20. 19 Langham Place, from December 1859 premises of *The English Woman's Journal*, the Ladies' Reading Room, and the Society for Promoting the Employment of Women.
21. 5 Blandford Square, Barbara Leigh Smith Bodichon's town house
22. 18 Blandford Square, where Emily Davies stayed with her brother
23. 3 Sussex Place, Regent's Park, Eliza Fox, 1853–61
24. 5 Osnaburgh Street, Regent's Park, Sarah Ellen Blackwell, 1857–8
25. 108 Long Acre, Sophia Beale, 1860–7
26. 37 Bernard Street, Emily Mary Osborn, 1851–4
27. 30 Upper Gower Street, Emily Mary Osborn, 1855–64
28. 18 Gower Street, Rebecca Solomon, 1857–62
29. 50 Upper Charlotte Street, Rebecca Solomon, 1852–6
30. 23 Charlotte Street, Anne Bartholomew, 1843–62
31. 40 Fitzroy Square, Laura Herford
32. Southampton Street, Margaret Gillies at 17, 1850–1, and 6, 1852–61
33. Southampton Street, Margaret Tekusch at 17, 1845–53, and 5, from late 1850s to 1862
34. 26 Howland Street, Eliza and Mary Anne Sharpe, 1858–61

Numbered circles indicate approximate location; street numbers are given where known, but do not relate to the markers.

Figure 1.2 The west end of London in the 1850s–60s

Elizabeth Rigby Eastlake at 7 Fitzroy Square, and many others in its adjoining streets. Some, like Margaret Gillies, moved regularly within a narrow compass, settling at 6 Southampton Street, Fitzroy Square, from 1852 to 1861. Many connected to the women's art alliance were near neighbours. Margaret Tekusch was adjacent at no. 5 from 1858. The watercolourists Eliza and Mary Sharpe were to be found in Howland Street and the still-life painter Anne Bartholomew in Charlotte Street. A successful sale in 1855 enabled Emily Mary Osborn to add a studio to her residence. To the west Barbara Leigh Smith Bodichon was based in Marylebone; to the north, at Mornington Crescent, Mary Thornycroft and her family resided; and to the south Sophia Beale and her sisters had a studio at Long Acre.[54]

Feminist 'tactics of the habitat', indeed feminist habitats of the 1850s and 1860s, cannot easily be categorised.[55] Although there is little evidence of everyday spatial practices, a multi-purpose and overlapping use is indicated. These spaces were not empty containers, filled by ready-made subjects. Rather, space and subjectivity were mutually defining. Space may be understood as integral to the organisation of social relations and subjectivities, and subject-ivities as formed through encounters in and orderings of space. The redefining of urban spaces in a feminist 'tactics of the habitat' was central to the making of feminist subjects and sociabilities. Laura Herford lived and worked in rented rooms and a studio on the first floor of 40 Fitzroy Square, where she under-took her professional activities, staged studio showings and held 'open even-ings' to which clients and friends were invited.[56] Central London locations, whether substantial town houses or a few rented rooms, were not simply dwelling places; they provided studios, consulting rooms and meeting rooms for campaigners, as well as places for the discussion of art, literature and polit-ics.[57] Like their fathers, Bodichon and Eliza Fox deployed the family residence as a power-base; Elizabeth Garrett met Elizabeth Blackwell over tea at Bodichon's town house and was sent round to the nearby offices of *The English Woman's Journal*. During the years she over-wintered in Algeria, on her visits to London Bodichon continued to host soirées here for feminist activists and sympathisers.[58] In the house she shared with her father, just beyond the boundaries of the west end in Regent's Park, Eliza Fox held art classes for women in his library, large enough to accommodate several easels or drawing boards. Attended by Anna Mary Howitt, Barbara Bodichon, Laura Herford and others, these sessions became a springboard for the Royal Academy campaign.[59]

The practice of art as a profession demanded urban mobility: women art-ists necessarily travelled across London's west end from their dwellings and studios to museums, art classes, suppliers, framers, exhibitions and clients. Joanna Mary Boyce's (plans for) peregrinations were entered in a sketchbook which she used in the 1850s; here she recorded the address of a bookseller, Mrs Newman, in Westminster, and notes on several exhibitions in the season of 1856.[60] Certain urban sites became key meeting points for those interested

in women's art and women's politics. Signatories to the 1859 petition gathered at the British Museum and the National Gallery. Ellen Clayton recollected that in the later 1850s '[a]t both galleries she found several valuable friends', including Eliza and Mary Anne Sharpe and Laura Herford. She may also have met Ellen Blackwell, Caroline Hullah and perhaps Charlotte Babb.[61]

Those aspiring to be painters and sculptors would have encountered one another fairly regularly at the few fee-paying schools which offered tuition, and probably life-drawing classes, to women. Emily Mary Osborn and Susan Durant worked together at Dickinson's academy.[62] Margaret Tekusch, Eliza Fox, Henrietta Ward and possibly Florence Claxton were students at the academy run in the 1840s by Henry Sass and later by Francis Cary, celebrated by Eliza Fox as 'the only drawing school where at that date there was a possibility for girls to obtain any thorough art training'.[63] Francis Cary also conducted classes in 'drawing' at Bedford College, attended by Barbara Leigh Smith, Laura Herford and perhaps Eliza Fox.[64] Opened in October 1849 to provide an academic education for women and girls over the age of 12, Bedford was a significant point of contact. Julia Smith and Anna Jameson were both Lady Visitors, appointed to act as chaperones in lectures, to uphold decorum and enforce punctuality. Their decision that silence could only be maintained in the library is indicative that progressive women were by no means the meek, submissive beings of the deportment books.[65] In the 1850s the academy run by James Matthew Leigh offered women students a wide range of classes along with the use of an extensive collection of properties. Emily Mary Osborn, Anna Blunden, Sophia Beale, Laura Herford, Charlotte Babb, Rosa Le Breton and Louisa Starr all studied here, the last four being recommended by Leigh's successor, Thomas Heatherley, for admission to the Royal Academy schools.[66]

Whether their experiences at the Royal Academy fostered a radicalism in women students is not known. Three of the fourteen admitted between 1860 and 1863 – Laura Herford, Charlotte Babb and Rosa Le Breton – had signed the 1859 petition, while Constance Phillott, Louisa Starr and Edith Martineau were to become suffrage supporters. Janice Helland has discovered that friendships intensified when plans, resources, studios, art training and/or professional activities were shared. She warns, however, that a common institution will not guarantee friendship or even mutual regard, and it is likely that familiarity in London's west end prompted rivalry as much as companionship.[67]

A rash of images of middle-class women travelling across London, strolling on its streets and shopping erupted in the later 1850s and early 1860s (Figures 1.3–1.5). Middle-class women boarding and riding the omnibus were portrayed in the pages of *Punch* as well as in William Maw Egley's painting of 1859, *Omnibus Life in London* (Figure 1.3). An assortment of characters on the bus includes a young widow, a mother with her children, an older woman wrapped in a shawl and a young woman attempting to climb on board. Glances flitter.

The conductor looks in to see if there is space. The passengers observe one another. A mother solicitously regards her children under the gaze of an older man. A young woman studies her book, watched by the young man facing her, his cane to his mouth. People jostle and press against each other. This is the new metropolitan environment where classes and sexes mix indiscriminately in the crowds. It is a visual world where appearances matter and a glance may rest as much on the pictorial advertisements decorating the compartment as on another traveller. John Leech's 'A little farce at a railway-station' of the same year (Figure 1.4) mocks the attempts of a middle-aged spinster to negotiate the sexualised encounters of the modern metropolis. Requesting a ticket and asked 'Single [or Return]?', she retorts, 'Single! What does it matter to you, Sir,

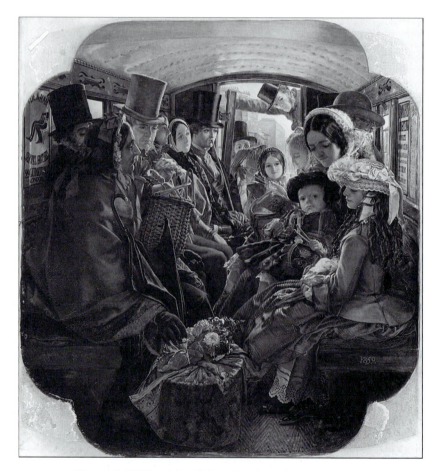

Figure 1.3 William Maw Egley, *Omnibus Life in London*, 1859

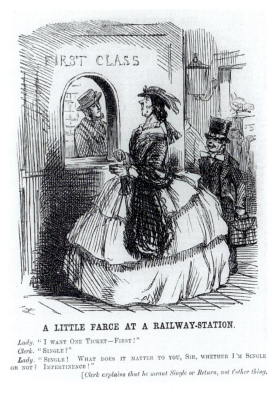

A LITTLE FARCE AT A RAILWAY-STATION.

Lady. " I want One Ticket—First ! "
Clerk. " Single ? "
Lady. " Single ! What does it matter to you, Sir, whether I'm Single
or not ? Impertinence ! "
 [*Clerk explains that he meant Single or Return, not t'other thing.*

Figure 1.4 John Leech,
'A little farce at a railway-station', 1859

whether I'm single or not? Impertinence!' Feminists argued for the independ-
ent mobility and safety of passage for the throngs of women who, according to
Bessie Rayner Parkes, 'trudge backwards and forwards', those 'innumerable
women who are engaged in daily tuition and other laborious paths of duty and
breadwinning' and 'innumerable ladies who come into town from the suburbs
to shop or pay calls, or to teach', whose daily business demands tramping the
'dreary London streets'.[68] Unchaperoned movement was part of the politics of
feminism. The writings of these years testify to passages through and across
London, on foot or by bus, to attend meetings and take up invitations. When
Anna Jameson summoned Bessie Rayner Parkes to visit, she recommended 'an
omnibus [which] leaves Oxford Street, corner of Argyle Street . . . & brings
you to my gate'.[69] Sophia Beale and her sisters delighted in wandering through
London's thoroughfares, by day and by night, to sample the transitory, sensory
delights and the unexpected pleasures of its ambivalent, restless spaces. In the
early 1860s they walked from their home to west end exhibition galleries, art
classes at Heatherley's and to study at the National Gallery and the British

Museum. Extending their urban, and bodily, pleasures, they were among the
first to attend women's swimming at their local baths: swimming was recom-
mended in an early issue of *The English Woman's Journal* 'as a delight for the
dweller in city confines, just passing from the hot and dusty streets'. Beale
considered that her most daringly unconventional activity was to eat hot
potatoes from a night stall in Charing Cross Road. Relishing the dripping
butter she commented, 'I fear our old lady friends would think this is as bad or
worse than swimming, for not only is it like men, but not a distinguished thing
to do even in the dark.'[70] Beale's rambling may be identified as that 'walking
in the city' undertaken by the 'ordinary practitioners' who live 'below the
thresholds at which visibility begins'. A spatial practice shaped by desire and
pleasure, it is that serendipity which Michel de Certeau contrasts with the
'imaginary totalisations' of maps and planners.[71]

Lynne Walker's title 'vistas of pleasure' opens up enquiry about the visual
spectacle and delights offered by the capital. In the 1850s and the 1860s,
London was a contested terrain, an extensive building site in which demolition
jostled with rebuilding, a domain of colliding representations, a locus for
imaginative as much as physical geographies, individual itineraries as well as
planned circuits of movement. Its spaces and populations were heterogeneous,
diverse and overlapping; urban identities were shifting, transitional and spatially
contingent. Under the pressure of rapid growth and migration, London
developed into a metropolis, characterised by its crowds of strangers, anonym-
ity, chaotic immensity and dangers.[72] Lynda Nead has compellingly argued that
as London was modernised so it was increasingly subject to visual definition; in
'speaking to the eye', a diversity of paintings, prints, maps, illustrated magazines
and guidebooks heightened a distinctly visual perception of the urban
environment and its inhabitants.[73]

Yet despite the paintings of Paddington railway station, the capital's parks
and pleasure gardens and its general post office, London's rapid transformations
often escaped the arena of elite culture, their transience more readily captured
in the fleeting and ephemeral forms of print and photography. Emily Mary
Osborn's *Nameless and Friendless* (Figure 1.5) was one of the few works by
women to address urban space at the mid-century. Concerned less with jost-
ling crowds, this is a painting about the sexualised encounters and economies of
the modern city, its spaces of pleasure, exchange and consumption. The setting
is an art dealer's shop in the heart of London's west end. A female customer
leaves, her escort carrying her purchases. Tall buildings and street traffic, includ-
ing her waiting carriage, can be seen beyond the open door. In the rain, passers-
by hurry, umbrellas aloft. One pauses to consider the wares on offer in the
window. Gazes shuttle, inside and outside, within and without: the appraisal of
the dealer, the regard of the shop-man, the predatory vision of the men about
town who glance from the print of a scantily clad dancer to the central figure
enveloped in her capacious wrappings. The target of so many looks, yet dis-
regarded by the departing purchaser, the artist looks down.[74] A woman's look

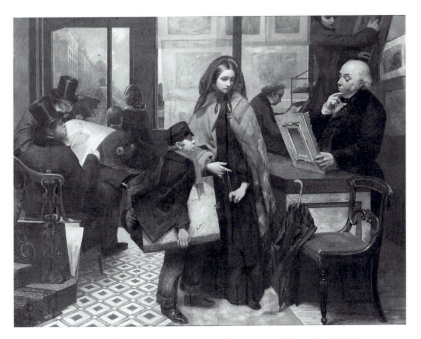

Figure 1.5 Emily Mary Osborn, *Nameless and Friendless*, 1857

(her gaze and her appearance) could be risky or even dangerous: an unwary glance, let alone that prolonged regard necessary for the production of art, might provoke unwanted scrutiny or unwarranted proposition. Feminist discourse on the capital's 'bald, blank streets' or the 'dreary London streets'[75] may not simply indicate a perception of London as unpictorial, as failing to offer visual delights. Rather, it might signal a necessary exclusion of urban sites and sights from women's vision as well as from the domain of their picture-making.

Shown at the Royal Academy exhibition in the summer of 1857, *Nameless and Friendless* was exhibited during a storm of contention which preceded the passing of the Obscene Publications Act in September. The controversies of that summer, which included the passing of the Matrimonial Causes Act and the failure of the Married Women's Property Bill, also encompassed debates about the presence and visibility of obscene publications on public sale in the London streets. In an outstanding analysis, Lynda Nead has argued that

> In the months leading up to the passing of this legislation, a debate emerged which focused on the spaces of the modern metropolis, the production of modern forms of visual culture and the possibility of transgressive forms of cultural consumption.[76]

What was at issue was control over metropolitan vision and the visibility of these visual commodities: 'the significance of obscene publications legislation, in the context of urbanisation, is that it focuses on the problem of "seeing"'. Anxieties about obscenity were focused on Holywell Street, as renowned for its sellers of obscene materials as its dealers in antiquarian and second-hand books and radical publishers. As Neal explains, the jostling of these attractions elicited fears that the boundaries between respectable and obscene purchases would become blurred. *The Daily Telegraph* was particularly concerned about the potential corruption to the young that a wander down Holywell Street might engender.

> It is positively lamentable, passing down these streets, to see the young of either sex – often we blush to say, of the weaker – and in many cases evidently appertaining to the respectable classes of society, furtively peeping in at these sin-crammed shop-windows, timorously gloating over suggestive title pages, nervously conning insidious placards, guilt-ily bending over engravings . . .[77]

But if national legislation and journalistic outcry pinpointed the locus of obscenity to a narrow street of old houses tucked away behind the Strand, Emily Mary Osborn's painting indicates the dispersal of potentially 'obscene' images; in a shop located in a neighbourhood of broad modern thoroughfares, the legitimate and the obscene are on sale side-by-side. The image of a scantily clad dancer, held by one of the seated male figures, was of a kind which could have been subject to prosecution as obscene: as Nead indicates, judgment given in two trials, which coincided with the opening of the Royal Academy exhib-ition in May, attended not to the most explicit materials but to 'regulating the boundaries of the obscene', and the policing of those representations which come 'closest to the limits of respectable culture'. In *Nameless and Friendless* the hazards of the metropolitan environment reside not in secret glances at trans-gressive commodities in the shop windows of a secluded street known to the cognoscenti, but in the frankly sexualised stares which rest first upon that which is usually beyond the frame of polite culture. The visual domains of the licit and illicit are no longer spatially separated but conjoined in an economy of vision. The two male customers who occupy themselves with perusal of obscene material have the rakishness and philandering leer associated with the 'swell', although they have none of his flamboyance or flashiness. If in a dis-course of work, these figures could be castigated as idlers, they could equally be read within the tourist literature on London, which featured such characters strolling through the city and enjoying its transient visual pleasures.[78] In the frame of this painting, they signify the dangers to respectable women of sexual harassment within the highly charged and highly ambivalent spaces of modern London.

Any account of the 'representation of space' and the 'representational space'

of mid-nineteenth-century women demands both a feminist theorisation of the mutual inscription of 'bodies/cities', and the rethinking of the orthodoxies of feminist and urban studies.[79] We take the latter first.

In the 1980s, feminist accounts of the formation of sexual difference relied on the ideology of the separate spheres, so much so that Amanda Vickery, in reviewing this literature, identified 'the systematic use of the argument of the separate spheres as *the* organising concept in the history of middle-class women'.[80] Social and cultural historians considered that this ideology assisted in uniting middle classes divided by religion, diverse in occupation, varied in wealth and dispersed geographically. Sexual differentiation, it was argued, was built on and shaped by differentiations of ideological and material space: to femininity was assigned the private domain of domesticity and the family, increasingly secluded in the suburban home; to masculinity was assigned the public world of work, politics and the city streets. As Griselda Pollock wrote in 1988,

> The mapping of the separation of the spheres for women and men on to the division of public and private was powerfully operative in the production of . . . the gendered social identities by which the miscellaneous components of the bourgeoisie were helped to cohere as a class.[81]

These arguments have been called into question from a variety of perspectives, including new approaches to Victorian masculinity as well as developments in historical geography which have reformulated the analysis of space in relation to time and social being to draw attention to the spatiality of social life . . . the actually lived and socially produced sites as well as the relations between them.[82] Accounts of women's access to urban space are currently undergoing revision. While Elizabeth Wilson has redrawn nineteenth-century London as a place of disorder in which working-class women could experience adventure and excitement,[83] Lynda Nead has emphasised the many middle-class women enjoying the ocular pleasures of a modern metropolis.[84] If deconstruction has been one of the tides shifting the sands beneath polarisations such as public/private, there is sufficient historical evidence now to support Lynne Walker's suggestion that '[t]he public/private dichotomy is oversimplified and the rigid separation of the spheres is overstated'.[85] Such research provides overlapping frames for the understanding of the ways in which feminist subjects, members of the middle classes yet with distinctive subject positions, used and transformed the spaces of the city.

Walking purposefully or wandering, trudging backwards and forwards, working and shopping: all these activities required a redefinition of the middle-class feminine body in a redefinition of city spaces to accommodate this body in its singularity and in its community. This was, in part, the project of the women's centre. It was the spacious premises and facilities of 19

Langham Place which provoked opposition. To understand something of the nature of these premises and the controversies they precipitated, it will be helpful to turn to Michel Foucault's outline of a history of spaces from the hierarchic medieval spaces of 'emplacement' to the relational heterogeneous spaces of modernity and his discussion of utopias and 'heterotopias', those spaces that have 'the curious property of being in relation with all the other sites, but in such a way as to suspect, neutralise, or invert the set of relations which they happen to designate, mirror, or reflect'. Heterotopias are defined as 'counter-sites, a kind of effectively enacted utopia in which the real sites, all the other real sites that can be found within the culture, are simultaneously represented, contested and inverted'. They are, Foucault suggests, of two kinds: those of crisis, associated with the sacred and rituals of bodily change, slowly displaced from the nineteenth century onwards by those of deviation, spaces for persons of deviant behaviour for which he cites incarcerating institutions such as hospitals and prisons. In contrast to utopias, which are 'sites with no real place', heterotopias may exist materially.[86]

As a counter-site for feminism, the centre at Langham Place may be characterised as heterotopic. Its members were certainly classed as deviant by some sections of public opinion: *The Saturday Review* denounced a 'strong-minded sisterhood' who congregated there and Ruskin wrote to object: 'I don't like your Ladies' reading room . . . at all.' Moreover, according to Foucault, heterotopias were closed sites, 'not freely accessible like a public place': '[t]o get in one must have a certain permission and make certain gestures'. Admission to the Ladies' Reading Room was by subscription or recommendation; Bessie Rayner Parkes stated that 'no qualification [is] demanded but that of education and undoubted respectability'.[87] This emphasis on the behavioural codes of respectable femininity points up not only an exclusivity of access to the Ladies' Reading Room, but the more widespread exclusivity of this group, allied by family, friendship and class.

One more metropolitan institution, and one with an unresolved relation to the women's movement, demands consideration. The Society of Female Artists was established in London in the winter of 1856–7 to showcase women's art. It had no fixed premises, hiring a variety of venues in the west end at odd ends of the season. Location was, however, all important, and when it moved from Oxford Street to the Egyptian Hall in 1858, *The Art Journal* acknowledged that it was now within the region 'consecrated to art', inside 'that circle wherein the majority of the Art-exhibitions have their fixed and well-known abodes'.[88] While some locations were preferable to others (the 1859 exhibition being staged in a gallery in the Haymarket), the society's exhibitions and events undoubtedly provided a meeting place for women in central London.

Although at times associated in public opinion with feminism, the society was not formally associated with the movement. Founded by Harriet Grote (a supporter of legal reform and women's suffrage), it was initially managed by

a group of relatively wealthy women. Its exhibitions, which provided an additional venue and saleroom for established artists and a sympathetic environment for fledglings, were supported by several prominent activists, particularly in later decades when the society sought to establish a professional identity. Louise Jopling's cover for the 1887 exhibition catalogue showed a woman artist in neo-classical dress holding a palette and brushes. The society offered membership rights when women were being squeezed out of the established societies, funding in times of need, a collection of studio properties and costumes and, in the mid-1860s, art classes in the study of the draped model. But it lent no support to the campaigns against the Royal Academy, nor gave any public commitment to changing the inequalities experienced by women artists. Its shows solicited considerable debate about 'women artists', not all of which was favourable.

The peripatetic appearances of the exhibitions at the cusp of the winter and spring seasons are indicative of its uncertain position in the art world and its economic fragility. Major funding and full-time management were needed to secure a permanent position and authoritative presence for a London gallery.[89] Mapping the geographies of women's art and feminism in London's west end must necessarily take account of the structural inequalities and the possibilities of women's access to venture capital and the skills of financial management – whether running a business as an artist, renting premises for living, working and socialising, managing a gallery, providing for a women's centre, or setting up a joint-stock company for *The English Woman's Journal*.[90] And while the projection of any cartography provides fixed points and 'imaginary totalisations',[91] an account of the urban geographies of art and feminism in London at the mid-century must necessarily take notice of movement to chart the shifting places and transient venues, as exhibitions, societies, journals, studios and residences continually relocated, and to map the irregular routes and unpredictable pathways traced by women travelling to and fro. Most of all it will acknowledge the force of Beatriz Colomina's assertion that 'the politics of space are always sexual'.[92]

Modern women, modern life

An increasingly *visual* culture developed during the middle decades of the nineteenth century. From the 1840s to the 1860s there was a rapid expansion of the art market and a dramatic increase in the number of exhibitions. A completely new medium, photography, with its own societies, literature and displays of work, was developed. A new kind of art dealer emerged, who purchased not just the art work but the rights to reproduce it. Imagery was widely available to a much wider public. Changes in reprographic technology put into production a broad range of fine art engravings, pictorial editions of novels and poetry, illustrated papers and comic magazines catering for diverse and heterogeneous publics: *The Illustrated London News*, *Punch* and *The Art Journal* were all

founded in the 1840s. New forms of visual material collided with one another, producing a multi-layered confusion. Viewing and 'reading' paintings and sculptures in an exhibition gallery took place within this diffused visual culture. In the jostling, crowded, perplexing world of metropolitan modernity the visual assumed, and was ascribed, an increasing authority for telling differences and marking distinctions.

Women artists took up the challenge of visuality and modernity to factor images of women as actors and agents, as independent subjects at work in a world where changing economic and social circumstances offered possibilities for paid employment which were, nevertheless, framed by the unequal relations of power. Visual culture became an exciting arena where new definitions of 'modern women' were put into play and contested. Whereas their encroachment on the professions was firmly rebutted in humorous magazines, the artists made their interventions in a distinctive and highly contested form of painting which came to prominence in these decades, namely modern-life painting.

In 1856 Emily Mary Osborn exhibited the first in her series of paintings of modern women. *Home Thoughts* (Figure 1.6) was shown at the Royal Academy in 1856 with a short verse:

Figure 1.6 Emily Mary Osborn, *Home Thoughts*, 1856

One heart heavy, one heart light;
Half in Day and half in Night
This globe forever goes.
One wave dark, another bright
So life's river flows.
And who among us knows,
Why in this stream, that cannot stop,
The sun is on the waterdrop
The shadow on another.[93]

The poem with its contrasts initiates the emotive tow of this carefully balanced composition. A standing child is placed at the very centre (her chin on the median point). A second attracts notice precisely because of her marginality; seated in the window enclosure, she is almost hidden from view yet from her vantage point she observes the scene played out centre stage, in which the standing child is being attired in her outdoor wear, preparatory to going home. Directly addressed by the curiously knowing glance of the child at the centre, the viewer is also drawn to an engagement with the marginalised child in a visual move which may be compared to the beginning of Charlotte Brontë's *Jane Eyre*. Writing of 'the beautifully orchestrated opening' to the novel, in which the narrator retires to a window seat, tucks up her legs and withdraws behind a curtain, Gayatri Spivak has eloquently explained the address to the reader: 'Here in Jane's self-marginalised uniqueness, the reader becomes her accomplice: the reader and Jane are united – both are reading.'[94]

The displacement from the centre to the edges allows for the insertion, close to the right-hand margin of the painting, of another figure who is neither a governess, a charity school teacher, nor a mistress of a dame school (figures who haunted the exhibition rooms of the previous decade). This is an independent teacher who presides over a schoolroom whose ordered space could not be more different from the domestic disorder threatening to engulf 'the Parliamentary Female' in John Leech's drawing (Figure 1.9). Neat in her dress and methodical in her movements, she attends to a pile of books while transacting with a client: the economics of education are as present as its academic requirements. The layering of space, used to such effect the following year in Osborn's *Nameless and Friendless* (Figure 1.5), is lucidly described: the schoolroom opens into a hallway and beyond. The map on the far wall, the actions of the figures, and the views through the door and the window all suggest an exterior world, removed from the poignant drama taking place in the room. The standing figure draws on her gloves, the child at the centre is being dressed in outdoor wear, her box is given by the maid to the coachman. Inside and outside are mutually defining; spaces intersect.

An oil study (somewhat larger than the finished painting) (Figure 1.7) indicates an extensive reworking during the making of the picture. The final composition has been simplified by bringing the main figures into line in the middle

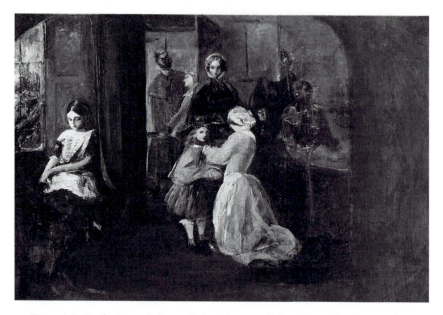

Figure 1.7 Emily Mary Osborn, *Going Home*, study for *Home Thoughts* [1855–6]

ground, and by rearranging the central group. The woman in the bonnet and cloak is moved to the right, to dislodge associations of the earlier arrangement of this group with Leonardo's *The Virgin and Child with St Anne*, seen in reverse.[95] In the sketch, the child at the window seems absorbed in thought rather than watchful. At the right, the composition remains unresolved. Although the borders of what will become a map are lightly outlined and the seated figure at the table is sketched in, a standing figure has been worked over and in parts painted out. This study is equally concerned with the disposition of light – from the window and the open doors, on to the seated child's pinafore, the central child and the maid kneeling to adjust her cape; all are broadly touched in. But once again the right-hand side is indeterminate, the outlines of the figures and the table barely visible. This most troubled area indicates something of the difficulties in representing the independent teacher, and the disturbing significations of a self-reliant, middle-aged and middle-class woman. Surviving evidence of the artist's practice suggests that she worked and reworked motifs and groupings – the reverse of this study has numerous sketches for a major composition which, if it was realised, has not yet come to light. An oil study on panel for *Nameless and Friendless* probably indicates the artist's preference for all the major players to be in place before she began work on the canvas for exhibition. By contrast to the sketch for the previous year's picture, this small-scale study is highly finished, its meticulous detail rendered in glowing paintwork. While it differs from the exhibited painting in several respects, notably the tile-work on the floor, the arrangement of the prints in

the window, and the face of the principal figure (which becomes less conventionally pretty and more dejected), the composition is substantially that of the final work.[96]

Nameless and Friendless portrays an indigent gentlewoman whose dark dress signifies a recent bereavement, probably that of the parent who supported her. A pictorial precedent was the governess. From Richard Redgrave's *The Poor Teacher* of 1843 to Rebecca Solomon's *The Governess* of 1854 or Osborn's painting of 1860, this usually slight, sad young woman could evoke sympathy and sorrow in spectators.[97] Mourning dress, pale drawn features, a slender figure, tapering fingers, downcast glance as well as an air of youthful fragility and vulnerability were among the visual signs of the 'distressed gentlewoman' who worked not from choice but from financial necessity. On seeing *Nameless and Friendless*, *The Art Journal* lamented the trials and tribulations of 'a poor girl [who] has painted a picture'.[98] The image of the 'distressed gentlewoman' helps to dissipate the picture's challenge: its portrayal of female artist engaged in negotiating an economic transaction, however diffidently. Like Florence Claxton's *Scenes from the Life of a Female Artist* sent to the Society of Female Artists in 1858 (now untraced), Osborn's painting challenges contemporary depictions of women artists as amateurs. She depicts a painter laying claim to financial reward and to the recognition of her professional name, that signature on which her reputation depends. A modern image for modern times, the painting's modernity lies in the imaging of a world of work, economic exchange and sexual danger at the heart of the capital, and the intrusion of a middle-class woman worker into these unpredictable spaces.[99]

Osborn's renditions of the professional artist and the independent teacher were made by revising the codes of modern-life painting, by changing its characters and relocating it away from its more familiar domestic haunts to those of commerce and education. To deal with an extensive range of women's paid and unpaid work, Florence Claxton pushed modern-life painting to its limits, almost beyond the frame of high culture. In 1861 she exhibited *Women's Work: A Medley* (Figure 1.8) not at a major venue such as the Royal Academy of Arts, or at her preferred outlet, the Society of Female Artists, but at the Portland Gallery, one of the many exhibiting venues which flourished in the rapid expansion of the London art world.[100]

At the dead centre of the painting is a seated man. Two young women practise their accomplishments, another gazes at her reflection in a mirror. Behind him, on either side of an image of the golden calf, are family groups. To the right, a woman in brilliant yellow consults lengthy tabulations; she is closely watched by two professional men. Three governesses crowd around a small child in the left foreground, while on the right a woman is slumped on the ground before a closed door. The only figure to escape the pit-like centre of the painting is an artist who, having scaled the wall, sits sketching landscape; another attempts to follow her. In a fissure in the wall, an imperious figure points out to a group of indigent gentlewomen a view of sea, ship and shore.

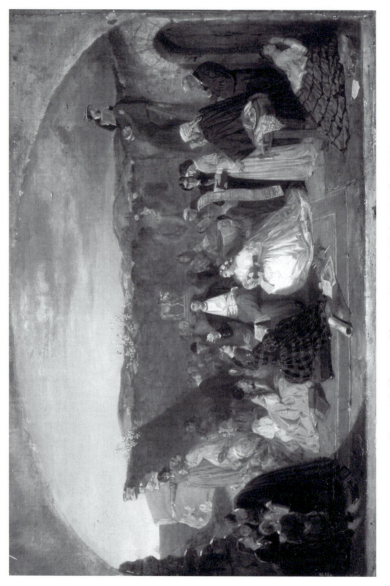

Figure 1.8 Florence Claxton, *Women's Work: A Medley*, 1861

In recent art historical literature, this painting has been considered to be both indicative and unusual. For Jan Marsh *Women's Work* signals changes already under way to the 'world of women and art at mid-century'.[101] Susan Casteras, by contrast, deems it one of 'the most soul-searching, acerbic and incisive paintings about the plight of contemporary womanhood', and judges it Claxton's 'masterpiece'.[102] But what frames this painting, so troubling to its contemporary audiences and so problematic now, is its relation to mid-century feminism. Its title immediately links it to the advocacy of paid work for middle-class women. As *The Saturday Review*, a staunchly conservative paper, complained, '"Women and Work' is now a cry of the day".'[103] Yet, neither the campaigns for women's rights nor debates about contemporary women could be simply translated into visual form from texts or polemic which preceded them or were to be found elsewhere. Nor was it the case that there were 'feminist' themes which could be unequivocally read off or into the painting. Nevertheless, in *Women's Work* and its critical reception, women's art, modern-life painting, feminism and contemporary definitions of womanhood and sexual relations were brought into conjunction in unpredictable and unresolved ways.

Women's Work may be categorised as a modern-life subject. But there is no attempt to provide any rationale for this assembly of diverse personages, such as that provided by crowd scenes in metropolitan, countryside or seaside locations. In Frith's *The Railway Station* of 1862, G.E. Hicks's *The General Post-Office: One Minute to Six* of 1860 or Egley's *Omnibus Life in London* (Figure 1.3) pleasure, business or travel account for an unlikely collection of figures and enable pointed contrasts between them. Claxton's setting, moreover, is not an identifiable place. Both inside and outside, it combines elements of the drawing room and urban architecture with a landscape of rolling hills and white cliffs, reminiscent of the southern British coastline. A central enclosure of a ruined, stony pit, its floor patterned with a carpet and engraved flagstones, contains most of the figures, all of whom, however, are positioned in relation to it.

In the exhibition of a painting, complex relations were engaged between the image and those texts that accompanied it (the title, catalogue quotation and/or commentary) and those that it might solicit (such as press reviews). By the later 1850s viewers and critics were speaking of 'reading' pictures, prompted by the accretion of incident which suggested the mid-century novel, and the written explanations which sometimes accompanied them.[104] Mid-century paintings not infrequently included written texts to suggest a narrative or to indicate a moral conclusion. Claxton's inter-texts certainly offer commentary: the music is headed 'fa-la-la', the educative text offered by the governesses to the small boy reads 'bread, brat, and pun'. Legible words on the long scrolls include 'tracts', 'single women', 'district', 'charity' — keywords in the discourse on women's philanthropic mission. Flagstones on the ground are carved with words, the most prominent of which is 'Ennui'; a word borrowed from French to convey boredom, lassitude and a lack of fulfilment, it provides a threshold to the figural groups. Claxton also provided a quotation in the catalogue from

Aesop's Fables and, taking up a relatively new publicity strategy adopted by art dealers and print sellers,[105] she issued an explication:

> The Four Ages of Man are represented: in the centre youth, middle age and old age reposing on an ottoman, infancy being in the background; all are equally the objects of devotion from surrounding females. The 'sugar plums' dropping from the bon-bon box represent the 'airy nothings' alone supposed to be within the mental grasp of womankind. A wide breach has been made in the ancient wall of Custom and Prejudice, by Progress – Emigration – who points out across the ocean. Three governesses, seen in the foreground, ignorant apparently of the opening behind them, are quarrelling over one child. The upright female figure to the right is persuaded by Divinity, and commanded by Law, to confine her attention to legitimate objects. Another female has sunk, exhausted, against a door, of which the medical profession holds the key; its representative is amused at her impotent attempts, he does not perceive that the wood is rotten and decayed in many places. An artist (Rosa B.) has attained the top of the wall (upon which the rank weeds of Misrepresentation and prickly thorns of Ridicule flourish), others are following. The blossom of 'forbidden fruit' appears in the distance.

Deceptively descriptive as this piece of writing is, Claxton's commentary provides neither a key to the painting nor a total explanation. It at once identifies the easily recognisable figures of the governess and the artist, and makes interpretations, identifying, for instance, the 'prickly thorns of Ridicule'. At times, as in the reference to 'obstacles', the barriers of 'Custom' and 'Prejudice', the language echoes that of *The English Woman's Journal*.[106] Most importantly, however, this exegesis signals the discontinuous levels of representation in the painting: the portrait of 'Rosa B.'; the representative, such as the governess or the member of the medical profession; and personification, 'Progress – Emigration'. If this painting does contain a portrait of a living artist, there is certainly some hesitancy in deciding between Rosa Bonheur, an international star in the art world and in feminist circles, or Rosa Brett, then unknown, and exhibiting as 'Rosarius'.[107] While Claxton's commentary would have set limits to contemporary understandings of her picture, by no means could it contain all the interpretations generated by its spectators. It would have been quite possible to read against the grain, or to disregard Claxton's remarks altogether.

The portrayal of the artist could have been read in several conflicting or coincident ways: as an image of ladylike sketching, a well-circulated sign since the eighteenth century for amateur accomplishment; in relation to a feminist politics of outdoor activity; as a feminist icon of professional achievement; as a delineation of the respectable working woman. Claxton had considered the predicament of the woman artist in a series which she sent to the Society of

Female Artists in 1858. For Bessie Rayner Parkes it provided 'fit commentary on the whole exhibition':

> there is the 'ladies class', the studio, the woodland wide-awake, all the aspirations, difficulties, disappointments, which lead in time to successes. The little dog barks with all the hidden meaning of a dog in a fairy tale; the plaster head on the shelf winks with a certain dry amusement at its mistress, who is represented as painting a picture of the ascent to the Temple of Fame: the picture is rejected, and the disconsolate young painter is seen sitting in comical despair, gazing at an enormous R., chalked on the back.[108]

Whereas in this earlier series, the sequence assists a narrative and the reference to Angelika Kauffmann's *The Artist Choosing between Music and Painting* (in which the latter signals the temple of fame on a distant hill, makes a witty reference to the aspirations to success held and achieved by this founding member of the Royal Academy), in *Women's Work* the figure of artist is equivocal, as are many other characters in this painting. Although the lawyer and the divine are recognisable from their professional dress, there is some indeterminacy here; Susan Casteras hazards that the man offering the scroll is perhaps 'a solicitor or political candidate trying to sell the woman empty promises in return for some favor from her'.[109] Claxton's commentary suggests that the divine may be encouraging the woman beside him to 'confine her attention to [the] legitimate objects' of philanthropy and those social and Christian duties of 'woman's mission' which could be accommodated within conventional definitions of respectability. But even so, this is not to conclude that such an identification would be made by all viewers, nor that this image would be accepted in identical or even similar ways.

Many figures remain puzzling. Claxton's text suggests that the slumped figure in the right foreground has something to do with women's failure to enter the medical profession. This is curious on two counts, at least. Although Harriet Martineau had protested in 1859 that 'it [is] still almost impossible for an Englishwoman to qualify herself for treating the diseases of women and children', by this date Elizabeth Blackwell (an American who qualified in Paris) had given a series of lectures and published her views, Elizabeth Garrett had begun her training (though not without difficulty and some opposition) and the wider question was under discussion. In visual terms the figure departs from prevailing visual protocols for middle-class femininity, evoking instead the unrespectable woman or the prostitute, and thus suspicions of deviancy and impropriety.[110] The vignette has none of the bodily activity which dynamises the feminist imagery of opening the closed doors into the world of art seen in Figure 1.1 and in the letters already quoted by Anna Mary Howitt and Sophia Beale on the admission of women to the Royal Academy.[111]

Susan Casteras's assessment of *Women's Work* as 'a truly exceptional image

that safely disguises its deviancy in the medium of satire' immediately raises questions as to the nature of that satire.[112] The differentiations and inter-relations between satire and parody, helpfully explored by Linda Hutcheon in relation to art of the late twentieth century, may be useful here. Hutcheon defines parody as an intra-mural art, concerned with inter-textual citation and ironic inversion which 'historicizes by placing art within the history of art'. In these terms, Claxton's earlier work, *The Choice of Paris*, with its mish-mash of references to Pre-Raphaelite art and artists, may be readily identified as a parody. Hutcheon characterises satire as extra-mural and inter-social, directed to the ridicule of vices and follies and the reform of society and manners; at the same time, like parody, 'its representation is always of another discursive text'.[113] *Women's Work* has elements both of satire and of parody; delighting in the ironic inversion of parody it lacks the certainty demanded by satire, predicated as it is on an assurance that a transparent message will be readily and unequivo-cally grasped by a constituency united in its ridicule of an agreed target. To mid-nineteenth-century publics, prints were distinct from painting: in their visual codes, sites of encounter, histories and forms of address as well as in the pleasures and desires attached to them. Prints could be viewed as an effective domain for direct social satire whereas the high cultural form of painting was considered exempt (grounds on which Claxton would run into trouble with her reviewers).

Any move to interpret Claxton's painting in terms of contemporary debates on women's rights needs to be made with care so as not to collapse the differ-ing registers of visual culture, text and politics and to account for a spectrum of responses. An extract from *Aesop's Fables* in the exhibition catalogue may have prompted feminist interpretations:

> A forester meeting with a lion, a dispute arose as to who was the stronger. They happened to pass a statue of a man strangling a lion. 'See there,' said the man, 'what better proof can you have of our superior-ity?' 'That,' said the lion, 'is your story. Let us be the sculptors and we will make the lion vanquish the man.' Moral: no one is fair witness in his own cause.

As a threshold to the painting's potential meanings, this extract suggests both an inversion of convention and the value of culture in articulating argument. Some of the painting's visual tactics might have suggested a feminist critique of familial devotion. The scene as a whole with its worship of the false idol of the golden calf has resonances with Thomas Couture's neo-classical depic-tion of the decadence of the Roman empire to suggest a society collapsing into ruin.[114] The image of professional men debarring women echoed a recurring theme in feminist writing of the later 1850s, whether *The English Woman's Journal*'s assault on 'men, whose whole social, artistic, scientific and business arrangements are based on the exclusion of women' or Harriet

Martineau's denunciation of male prejudice in *The Edinburgh Review*.[115] Yet feminism was by no means a homogeneous discourse, and disputes arose over issues like emigration. Widely promoted from the 1840s by official bodies and specialist associations and hailed by enthusiasts like Claxton as 'progress', emigration was recommended in the journal. The historian Vron Ware acknowledges this advocacy as 'a feminist response to the increasing demand from middle-class women for new forms of employment', while noting that 'the question of organised emigration remained a problematic one for feminists'.[116]

Claxton's painting may be situated within feminist pressures for paid work for middle-class women: it cast an unenquiring glance at domestic servants and skirted the debates about the suitability of work for married women. Margaret Tekusch's *The Wife* provided a rare image of a working mother, one that countered the paintings of women tending cradles and breast-feeding babies which regularly appeared in exhibition rooms.[117] In 1858 at the exhibition of the Society of Female Artists, Bessie Rayner Parkes was delighted to discover 'a small and exceedingly lovely' painting by Tekusch 'in which a dainty young matron, habited in the costume of the last century, sits copying law papers for her husband, while with the left hand she amuses her baby in its cradle'.[118] The scene was set in the previous century, although the occupation, copying law papers, was promoted at Langham Place.

Claxton's visual strategies were unusual and owed more to drawings for comic magazines than the conventions of elite culture: features and bodies are sharply drawn, gestures are pronounced. Claxton had worked as a graphic artist from 1859. In devising *Women's Work*, she may have reworked not only visual codes but the composite imagery of contemporary prints and comic drawings which could include a quite extraordinary concatenation of incidents, all in varying ways contributing to a common theme or subject: the subtitle *A Medley* may be indicative in this respect. The year before she had exhibited an extraordinary painting, *The Choice of Paris: an Idyll*, at the Portland Gallery (also published as a full-page engraving with a lengthy explanation)[119] which pasted together figures and groups from recent Pre-Raphaelite imagery similarly redrawn in the manner of comic prints.

Comic papers quickly developed a repertory of images to address the new claims for women's rights. As Diane Atkinson explains in *Funny Girls*, equality has often been a laughing matter.[120] From sympathy to outrage, ridicule to self-mockery, cartoons translated campaigns and campaigners into visual form. Before the organisation of formal campaigns, British radicalism, Owenite socialism, Chartism and the American women's congresses put women's demands for civil rights, suffrage, education, employment and legal reform into public debate. One of few sketches before 1866 to lampoon women's demands for the vote was Cruikshank's '"The Rights of Women" or the Effects of Female Enfranchisement' (the frontispiece for *The Comic Almanack* of 1851). The electors ignore the serious if unattractive candidate in favour of the

handsome Sir Charles Darling, waving banners festooned with rosettes and ribbons which proclaim 'Husband and Wife Voters', 'Sweet Heart Voters', call for 'Parliamentary Balls Once a Week' and contrast 'Ugly Old Stingy' to the 'Ladies' Champion'.[121] A woman Member of Parliament is depicted in John Leech's drawing 'The Parliamentary Female' (Figure 1.9). Busy at her desk, she is regarded by a numerous family headed by her husband dandling a baby who asks her: 'Can't you take us all to the Play to-night?' Without looking up, she replies: 'How you talk, Charles! Don't you see that I am too busy. I have a Committee to-morrow morning, and I have my speech on the Great Crochet Question to prepare for the evening.'[122] For those already persuaded of this vocation for women – Radicals such as Mary Howitt were already convinced[123] – the image might provide a vision of industry and dedication. Alternatively the inversion of parental responsibilities and domestic disorder – papers, petitions and reports overflowing from her untidy desk – could all be construed as signs of deviancy, a neglect of maternal and familial duty portending a greater social chaos. It is the accompanying text, in which 'the mistress of the house' declares her dedication to 'the Great Crochet Question', that helps to secure such a reading: the woman MP will fret (get in a crochet or fretful ill-temper) about a seemingly inconsequential matter of domestic craft, hardly a matter of national significance. Yet while this scrap of dialogue acts as a border, it does not conclusively contain the possible meanings for the image.

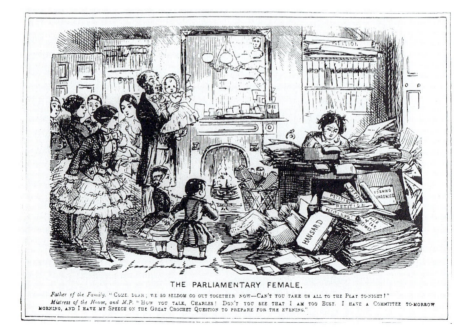

THE PARLIAMENTARY FEMALE.

Father of the Family. "Come, dear; we so seldom go out together now—can't you take us all to the Play to-night?"
Mistress of the House, and M.P. "How you talk, Charles! Don't you see that I am too busy. I have a Committee to-morrow morning, and I have my speech on the Great Crochet Question to prepare for the evening."

Figure 1.9 John Leech, 'The Parliamentary Female', 1853

The MP's hair is unkempt; her children wear short layered skirts and leg-gings, and, in a style not dissimilar to that adopted by the well-known feminist actress, Charlotte Cushman, they adopt jackets of masculine cut together with a shirt front and bow tie. The *Punch Almanack* for 1853, entitled 'The Ladies of Creation', included two more drawings of women in men's jobs. Barristers stalk the streets near Chancery Lane and a huddle of policewomen decline to intervene in a street brawl outside a gin palace. They are dressed in short skirts and narrow trousers, sporting above the waist adaptations of professional dress or uniform, such as the Peeler's buttoned jacket and tall hat. By this date leg-gings, narrow trousers and loose bloomers were familiar markers for the femi-nist – on the stage, on music covers and in pottery figurines as well as in comic drawings.[124] The image of a woman 'wearing the trousers' has had a long history in western European visual culture and a deeply ambivalent relation to women's challenges to masculine power. By portraying women in men's jobs and in mocking their abilities to carry out that work, these drawings preyed on anxieties about what would happen if conventional gender roles, deportment and attire were inverted. They played into and helped to create deep-seated fears about changes to the relations between men and women initiated by middle-class women's incursion into the public world of professional work and civic governance. The vision of a future peopled with female doctors, lawyers, insurance agents, accountants, artists and teachers which inspired the ladies of Langham Place provoked an equally intense sexual antagonism.

Comic papers were particularly concerned about the disturbance of marital relationships. A series on 'husband-taming' was published in *Punch* in the later 1850s. In 'Husband-Taming' a woman in a riding costume presents her female audience with an example of a submissive husband dandling a baby (as in 'The Parliamentary Female').[125] A tangle of disquieting anxieties, centring around fears of uppity women and an inversion of sexual relations, were woven into and unravelled from these images. Horse-breaking could conjure terrors of an unbridled feminine sexuality, of women out of, or even beyond, masculine authority, and equally of the necessity of disciplinary control. At the same time, women's skills in riding and their pleasures in this form of physical exercise could act as metaphors for autonomy. As Whitney Chadwick has argued, associ-ations between women and horses were 'inseparable from the complex system of signification through which femininity was produced and controlled'.[126] The relations between men and women were also figured in at least one cartoon about marital violence. A man, caricatured as a bounder and a bully, admonishes a woman in tears with words which attribute violence not to him but to her: 'Superior being (!) "You'll please to observe, Mum, that a Diworce is a much easier matter than it used to be – so none of your violence!"'[127]

Women's employment as graphic artists was delayed. Their incursion into the field has been dated to Florence Claxton's first drawings for a weekly illustrated paper in 1859.[128] A prolific illustrator, Claxton's comic sketches mocked the follies of fashionable society. A volume of 1871, *The Adventures of a*

Woman in Search of Her Rights, poked fun at a skittish young woman who experiments with various occupations, including painting and medicine.[129] Claxton's published work, perhaps constrained by the demands of the market, seems to have done little to counteract popular stereotypes. A handful of drawings for private circulation made in the mid-1850s by Barbara Leigh Smith, or perhaps by one of her circle of family and friends, demonstrates a humorous yet sympathetic approach. In 'Ye newe generation', four women brandish between them an artist's palette and brushes, pen and paper, spear and umbrella (Figure 1.10). They wear short jackets or capes, unsupported skirts, wide-brimmed hats and stout boots, that sort of practical outdoor wear which the artist recommended in *Women and Work*. Though not exclusively worn by feminists, this form of attire was identified with 'strong-minded women'.[130] 'Ye newe generation' plays with the stark contrasts of print culture to provide an image of activists and workers: the writer and the artist are identifiable from the pen and brush, and the umbrella was to become one of the most circulated signs of the feminist campaigner, brandished at Mr Punch, John Bull and any other opponent of women's rights. 'Ye newe generation' is light-hearted and affectionate, by no means cruel or satiric. As a quick sketch executed on notepaper, it was subject to none of the visual codes which regulated publicly exhibited paintings or published illustrations. Nevertheless it demonstrates an acute observation, its image of the artist countering those innumerable vignettes of demure young ladies sketching as well as *Punch*'s lampooning of those who would

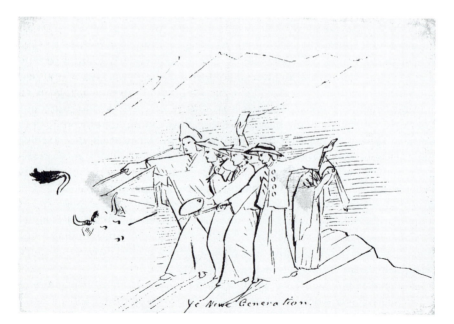

Figure 1.10 [Barbara Leigh Smith Bodichon], '*Ye newe generation*', *c.* 1854

aspire to the more serious endeavours of history painting. Attired in a hat with an exaggeratedly large brim, a short cape, and an unsupported skirt falling in soft folds, 'Miss Raphael makes a study for her grand picture, "The Day After the Deluge"', by sketching a Noah's ark arranged on the lawn before her.[131]

When first exhibited, *Women's Work* met with censure on the grounds that it transgressed the boundaries of high art. *The Spectator* commented,

> this specimen . . . is noticed in the hope of deterring others from the path Miss Claxton is pursuing . . . Sermonising on social topics is not within the province of Art . . . If an artist has a superabundant flow of misanthropy let him at least discover some more appropriate vehicle for its display than an oil painting.[132]

Claxton is perceived as a dangerous, detrimental and even corrupting influence on account of her dissenting views and her subject matter. Not only has she introduced 'social topics', but she has attempted to preach to her audience. The artist is reproached for contaminating high culture and for her cynical, even anti-social attitude.

The relation between high culture and 'social topics', broached by *The Spectator*'s reviewer, although never finally resolved during this century, had been thrown into crisis by the early 1860s. Although Emily Mary Osborn's *The Governess* was commended in 1860 for having 'made Art to exercise its highest privilege, that of a teacher',[133] there was at the same time a shift, neither widespread nor immediate, away from such moralising, which equally provoked anxieties among critics and viewers about art's public and ethical functions. Claxton's curiously hybrid painting crossed boundaries, not only between painting and prints, but between art and social concerns. The reviewer's disquiet, however, may not have been generated by the 'sermonising' so much as an address to women's rights and perhaps feminist viewers. The writer hoped that the artist would foster no imitators and produce no progeny. In common with the claims lodged against Harriet Hosmer (explored in Chapter 4), this hope doubled charges of unlawfulness upon matters of questionable issue and dubious conception.[134] To slur Claxton's painting as transgressive was to place it and its maker beyond the frame of polite culture. And it was also to register the profound anxieties generated by the challenges of feminism in the domain of modern visuality.

Writing women, art and feminism

The creation of a feminist press in the 1850s was a distinctive move, asserting the importance of debating women's interests and women's rights. More than this, feminist papers provided a forum in which key issues were identified and discussed, the social organisation of femininity and sexual difference interrogated, and feminist perspectives established on a variety of topics. *The English*

Woman's Journal (1858–64) pitched into a new and increasingly widespread form of communication offered by the monthly magazine, selling itself on a broad mix of features and the articulation of a position.[135] Its writings about art intervened in debates about that new critical category, variously called 'lady artist', 'female artist' and 'the ladies', the instability of its nomenclature registering some of the difficulties encountered by art writers in dealing with professional women. The journal advocated fine art as an occupation, published artists' profiles, reviewed exhibitions and discussed the standards by which women's art should be judged. Although short-lived, these infrequent art writings were significant, setting in place strategies which had a longevity beyond the journal's demise in 1864.

The journal was by no means the only publication to recommend art as a profession for women or to write of the need for dedication, specialist training and 'some kind of separation from the noise and bustle of the external world'.[136] Reflecting on 'female professions' in *A Woman's Thoughts about Women*, Dinah Mulock Craik considered art to be 'the most difficult – perhaps, in its highest form, almost impossible to women' on account of the 'course of education necessary for a painter' and the necessity of life-drawing.[137] But what differentiated feminist writing was its location in discourses on women's rights. As exemplary professionals, artists could be mobilised in the debates for paid work and vocational training. In 1856 they were singled out in demands for the reform to the laws relating to married women's property and the following year in plans for a periodical for working women. In contemplating the readership for the *Waverley Journal*, a precursor to the journal, Parkes included

> all women who are actively engaged in any labours of the brain or hand, . . .whether they belong to the army of teachers, . . . or to the realm of professional artists; or are engaged in any of those manual occupations by which multitudes of British women, at home and in the colonies, gain their daily bread.[138]

Early issues of the journal considered the openings for women in the art world. Writing 'on the adoption of professional life by women', Bessie Rayner Parkes, the journal's editor, advised that

> to become a good artist requires talent, industry and opportunity, and added to all these, a large share of that moral courage which dares to dedicate a life to one end, and sweeps aside, with deliberate calmness, the petty temptations, the accumulated distractions of domestic hours.[139]

The first exhibition of the Society of Female Artists she commended for helping 'to rouse the energy, concentrate the ambition, and support the social

relations and professional status of working women'. The exhibition would open 'a new field for the emulation of the female student, and also a wider channel of industrial occupation, thereby relieving the part of the strain now bearing heavily on the few other profitable avocations open to educated women'.[140]

Parkes resisted stereotyping either the artists or their contributions. *The Athenaeum*'s comments that women's art was 'essentially unimaginative, restricted, patient, dealing chiefly with Blenheim spaniels, Castles of Chillon, roses, first-borns . . . camellias, ball-dresses, copies and miniatures' were not untypical. Parkes did not consider that women were more suited to the painting of domestic scenes, commenting that although 'a singular sweetness and humour' characterised Tekusch's *The Wife*, 'yet there are many French male artists who paint with equal delicacy just such *scènes de la vie privée*, while Rosa Bonheur chooses bulls and horses', a point reiterated over a century later by Linda Nochlin. Parkes considered that the society exemplified major trends in contemporary culture.

> Perhaps the most noticeable thing about the intentions of these pic-
> tures is the way in which they reflect, not so much the ideas of any
> number of male painters, but the general aspect of English art at the
> present time. . . . There are the same portraits, landscapes, scenes from
> Shakespeare, old houses, animals and fruit. The ideas which appear to
> govern the ladies in their selection of their subjects are not one whit
> wiser or weaker than those which guide the gentlemen.[141]

The journal was not the only paper to express concern about the parlous state of British art. For *The Spectator*, the current show at the British Society of Artists demonstrated '[e]very man at his worst'.

> There is a peculiarly sodden and exhausted air about it – a flavour as of
> reboiled tea leaves. We have seen the same thing fifty times before, and
> not only the same, but less bad of its kind. . . . It is really depressing to
> think of Mr Clater, for instance, producing, for some thirty or forty
> years perhaps together, his annual crop of excessively ill-painted exhib-
> ited pictures, all of such subjects as 'Gossip on the Way – The Wedding
> Ring – News from India – Stirrup Oil – The Lovesick Lady – Going
> to School – Playing at Buttons'.[142]

Pleas for more elevated themes and an art that would exemplify national achievement were fuelled by class struggles over high culture, a growing imperialism and a competitiveness in Europe encouraged by international exhibitions.

In 1859, however, *The English Woman's Journal* berated the exhibition at the Society of Female Artists for its amateurishness.

> We are, however, compelled to observe that . . . it can hardly become
> the foster-mother of a noble school; and it is only too likely to make
> women believe they paint like artists, when they only paint like ama-
> teurs. Our first impression . . . was of a general pell mell of colours,
> blues, reds, yellows and greens, unpleasantly contrasted in every direc-
> tion, and an extraordinary preponderance of children and flowers.
> There is a total want of the finish and harmonious tones of the two
> Water-Colour Galleries, and of the intellectual brightness of the Royal
> Academy.[143]

No longer prepared to make excuses, the reviewer concluded by asking, 'why
Englishwomen who write so well, and have so much to express in writing,
should have so few thoughts at the ends of their brushes?'[144] If women's art
could be dismissed as a pastime or accomplishment, it immediately lost any
claims to be a professional undertaking and could no longer be considered in
feminist discourse. The society's uncertainty of purpose and its inclusion of
amateur work in the early years contributed to these anxieties. Did the exhib-
itions exist simply to draw attention to women artists, as the journal suggested
in 1858? Or, as its successor *The Englishwoman's Review* asked some years later,
were the shows organised to encourage young artists?[145] Many inside and out-
side feminism insisted that the Society should represent the best in women's
art, in which case significant contributions from leading women were needed.
Artists in search of establishment success sent their major exhibition pieces to
the Royal Academy or one of the watercolour societies rather than risk
marginalisation by showing at a minor venue; they supported the Society by
contributing smaller, less important pictures or sketches.

Writers in feminist papers and art columns alike insisted that publicly exhib-
ited work be of a professional standard; failure to achieve this level provoked
outspoken disappointment. Parkes lamented in 1865,

> To how few names can we look with pride! How few have attained
> that recognised position which is necessary, not for ambition's sake, but
> because, if they are to stimulate others, and to clear a new and beautiful
> field of labour for women, it can only be done by . . . definite
> achievement.[146]

Women's art was, she considered, characterised by 'sparkling incorrectness, ten-
der, misty imagination . . . ambition that overleaps itself' and deplorable habits
of imitation which yielded 'delusive reproductions of some admired master's
style'. Reviewing women's contributions to the Royal Academy in the next year,
the *Victoria Magazine* remarked that, apart from Henrietta Ward's *Palissy the
Potter* and a few other contributions, 'there is not a single woman's picture of
which we carry away a vivid impression'. Attacking the 'aimless sketches by
women on the walls', artists were advised to work harder and more seriously:

We should prefer seeing no pictures by women rather than these mere studies. If sketches of this kind satisfy the artists themselves they have evidently mistaken their vocation, and ought either to content themselves with lower, yet useful branches of art . . . or leave it alone altogether.[147]

As late as 1893, H.H. Robson writing in *The Englishwoman's Review*, still bemoaned 'mediocrity and weakness' and 'the failure of women, so far, to take any assured position amongst art workers'.[148]

The double bind was that if there was 'no sex in art', there was sexual difference in society. Arguing that women's art should attain and be assessed by generally accepted critical standards and not be assigned to a separate category, feminist writers nevertheless realised that women artists faced considerable inequality. In 1858 Parkes commented on 'the thousand hindrances placed in her path by domestic life as at present constituted, and by the customs of society as at present imposed', the paucity of art training and of the need for women 'to compete with the best painters without any reference to sex'.[149] This position was reiterated four decades later in *The Englishwoman's Review*, when H.H. Robson contended that '[i]t must be . . . possible for a woman to paint a picture which shall win immortality . . . creative genius at least belongs to no sex', admitting however that 'In the profession of pictorial art, as in that of literature, science, and politics, women still have an uphill battle to fight and some prejudices to overcome.' The claims of domesticity and low-grade art education were still campaigning issues at the end of the century.[150]

Throughout the period feminist papers put the case for women's professional recognition and their membership of the Royal Academy. *The Alexandra Magazine* in 1864 commented:

We claim for the female artists the credit of a very respectable position
by the side of the 'lords of the creation', and do not, for the life of us,
see why sex should be a plea for exclusion from privilege and honours
if deserved.

But the next sentence, that '[t]he works of Mrs Ward, the Misses Mutrie, Mrs Robinson, Mme Jerichau, Miss R. Place, etc., are well worthy of note, and compare favourably with those of some experienced male exhibitors', exemplifies some of the difficulties of feminist art writing.[151] While feminist papers could set out a clear position on social disadvantage, they found it hard to prioritise or praise women's art. Unable to articulate a distinctively feminist approach, reviews were often directed to an ungendered reader.

By the closing decades feminists were increasingly wary of special pleading and separate provision. Florence Fenwick Miller commented in 1889 in her 'Ladies' column' for the widely read *Illustrated London News*,

51

the paintings of the foremost women artists will go to the Academy or the Grosvenor, or the New Gallery . . . the great human interests transcend sex limitations, and will not be successfully dealt with under such conditions as exclusively 'women's papers'.[152]

A feminist activist and suffrage speaker, Fenwick Miller published widely, by no means limiting her interventions to 'women's papers'. She argued time and again for 'that open competition of work without regard to sex which all good workers deserve and prefer'.[153] But this interventionist strategy could have its own contradictions. Writers like Fenwick Miller pushed for success in the art establishment and for membership of the Royal Academy, even when that institution was in decline and under attack at the end of the century. Henrietta Rae's vast canvas, *Psyche before the Throne of Venus* (1894), an academic history painting in the neo-classical style, was hailed by many feminists including Fenwick Miller as a pinnacle of achievement (Figure 5.14).[154] Acclaiming it as 'the most ambitious and successful woman's work yet exhibited' when it was first displayed in 1894, *The Englishwoman's Review* commented that

> The critics have decided that the Academy this year is even worse than usual; but from the women's point of view it is one of the best and most promising that has been noticed in this REVIEW. Women are more largely represented, and their canvasses better hung than hitherto, and many of their pictures have attracted well-merited attention.[155]

This lavish praise for women's contributions to an admittedly low-grade exhibition testifies to the incongruities at the heart of feminist hopes for success in establishment terms.

While there was little consensus on a feminist politics of reviewing, there was general agreement about the importance of biography. By the later decades biography and autobiography were among the principal strategies of art criticism and publishing. Lavishly produced, profusely illustrated, often two-volume, editions of the artist's life and letters were matched by profiles in art papers and general interest magazines; retrospective exhibitions, essays on artists' studios, along with a welter of *cartes-de-visite* and portrait photographs placed the artist at the centre of attention.

Profiles of campaigners and professional women (including artists) were regularly featured in *The English Woman's Journal* and they became characteristic of feminist publishing. Four essays on contemporary artists – Anna Blackwell on Rosa Bonheur and Henriette Browne, Matilda Hays on Harriet Hosmer, and Isa Blagdon on Félicie de Fauveau – were printed in the journal, as were occasional features on artists of the past.[156] The inclusion of these four essays, the first three in 1858 and the last (on Browne) in 1860, countered a studied neglect of individual women by the art press. None was included in

The Art Journal's long-running series on contemporary artists until 1864, when the first two, Henrietta Ward and Emily Mary Osborn, were considered.[157]

Anna Blackwell, who probably encountered Bonheur in France, recounted her life story, drew attention to her working methods (outdoor sketching in the summer, attending to several paintings simultaneously), discussed her successes and highlighted the discrimination which she faced – as a woman she had been refused the Legion of Honour. She dwelt on Bonheur's appearance, her figure, her hairstyle, her 'true artist's hands, small, delicate, and nervous; and extremely pretty feet':

> when you have watched her kindling eyes, her smile, at once so sweet, so beaming, and so keen, her expressive features irradiated, as it were with an inner light . . . you begin to perceive how very beautiful she really is.

The body is perceived as an index of character and of Bonheur's 'clear, honest, vigorous, independent nature'. Blackwell describes her simple day-clothes of black, grey or brown, without the 'usual articles of feminine adornment', and her work-clothes, 'a sort of round pinafore or blouse of gray linen, that envelopes her from the neck to the feet'. This discussion was a useful corrective not only to puerile comparisons between the dainty artist and her big picture but also to salacious comments about her cross-dressing. Bonheur's working attire was justified as 'a precaution she found it necessary to adopt, both as a convenience, and still more as a protection against the annoyances that would have rendered it impossible for her [to visit the horse-fairs and slaughter-house] in feminine costume'.[158] Yet as Parkes elsewhere in the journal reflected, such unconventionality was risky: 'how many painters who compose the Society of Female Artists would dare to imitate Rosa Bonheur in her convenient, we had almost said her *inevitable*, blouse?'[159] If working dress was to be defended on the grounds of practicality, the subject's femininity was not to be forsaken. Matilda Hays described Harriet Hosmer as

> a compact little figure, five feet two in height, in cap and blouse, whose short, sunny brown curls, broad brow, frank and resolute expression of countenance give one at the first glance the impression of a handsome boy rather than that of a young woman. It is the first glance only, however, which misleads one. The trim waist and well-developed bust belong unmistakably to a woman, and the deep, earnest eyes, firm-set mouth, and modest dignity of deportment, shew that woman to be one of no ordinary character and ability.[160]

The portrait oscillates tantalisingly between masculine and feminine, relishing multivalency and ambivalence. Short hair, favoured by several feminists

including Parkes, was also admired by Isa Blagdon in her description of Félicie de Fauveau.

Feminist biography did not shy away from domestic life and household arrangements. Indeed, lengthy descriptions of the studio set a precedent for art writing in the 1880s. Clear boundaries were drawn, however, and while Blackwell described the artist's working arrangements and her domestic arrangements, she admitted that much about Rosa Bonheur's 'inner personal life' could not be disclosed. The profiles of Hosmer, Fauveau and Bonheur emphasised romantic friendship. Blackwell attributed Bonheur's *bonheur* to the pleasures of her relationship with her 'old and devoted friend' Nathalie Micas, who was 'for many years Rosa's most intimate companion' and housekeeper. Isa Blagdon paid homage to Félicie de Fauveau's mother, brother and 'her intimate friend', the Baroness de Krafft. For Blagdon, Fauveau was exemplary of 'the single woman treading victoriously the narrow and thorny path which all women tread who seek to achieve independence by their own exertions'.[161] By contrast, the profile of Henriette Browne (published in 1860) emphasised that she was 'a devoted wife and daughter', an 'admirable housekeeper', a diplomatic hostess, a skilful needlewoman and an elegant dresser, who was to be commended for the retirement of her life and 'the privacy of her studio'. Blackwell, again the contributor, explains,

> she has always shrunk, with almost painful sensitiveness, from public gaze; remaining entirely aloof from the fascinating but stormy precincts of the 'artist-world', and leading in all other respects, the ordinary life of a woman . . . in the higher walks of social existence.[162]

As Reina Lewis has indicated, the journal's emphasis on paid work collided with contemporary discourses on the 'lady'.[163] Blackwell's image of Browne, so at variance to the other portraits, may be located within an uncertainty in feminist writings which was developing at this date on the suitability of work for married women. One solution was to enhance domesticity; women's art was less threatening when framed by the family and contained within the home, as *The Westminster Review* had remarked in 1858: 'It leaves her, during a great portion of her time at least, beneath the protecting shelter of her home, beside her own quiet fireside.'[164]

All four profiles recounted life-stories. Rosa Bonheur's early years and training were considered at length: 'a wild, active, impetuous child, impatient of every species of confinement', she was 'reserved and gloomy' at school, miserable when put to work as a seamstress. She led an 'idle and aimless life' until a momentous change took place. When trained as an artist by her father, 'the desultory and purposeless child became rapidly transformed into the earnest, self-conscious, determined woman'. Hosmer's biography recounts a triumph over adversity. When a young woman, the sculptor's training in Rome was brought to an abrupt halt by her father's financial losses. 'The news came upon

her like a thunderbolt.' At first '[s]tunned and bewildered', she soon settled on 'industry and economy' to establish an independent and financially rewarding career. Fauveau, it is recounted, suffered on account of her strong political convictions.[165] Hard work, financial independence and professional success are all encoded as feminine and feminist. Weaving together Romantic notions of expressive genius and contemporary beliefs of the formative power of circumstance, these articles tell a story of a sovereign self who becomes self-motivated, self-reliant and focused on her art.

With their stories of successful endeavour, of difficulties overcome and unpropitious circumstances turned to advantage, these essays reworked and appropriated the discourses of individualism fashioned for bourgeois masculine subjectivity. Time and again feminist biographies tracked the relations and tensions between circumstance and self. In the first history of women artists to be published in English, Elizabeth Ellet stated:

> The aim has been simply to show what woman has done, with the general conditions favourable or unfavourable to her efforts. . . . More may be learned by a view of the early struggles and trials, the persevering industry, and the well-earned triumphs of the gifted, than by the most erudite or fine-spun disquisition.[166]

Entries in Ellen Clayton's *English Female Artists* of 1876 not infrequently told of the 'obstacles' which had to be overcome in the pursuit of art; the purchase of this approach today is evident in titles such as Germaine Greer's *The Obstacle Race*.[167]

That biography was considered an essential component of the journal is indicated by its announcement that an account of 'some celebrated or particularly useful woman' was to be included in every issue. More recently the feminist historian Martha Vicinus has argued that these publications provided important exemplars of pioneering independent women.[168] Elizabeth Ellet hoped that the entries in her volume, some borrowed from the journal, would 'inspire with courage and resolution any woman who aspires to overcome difficulties in the achievement of honourable independence'.[169] Artists profiled in the journal would probably have been known to readers: three had international reputations and had exhibited to acclaim in London. Henriette Browne's *The Sisters of Charity*, depicting two sisters of the order nursing a sick child, was exhibited at the French Gallery in London, following its success at the Paris Salon. Two were especially renowned in feminist circles. Hosmer, who met Parkes, Hays and Leigh Smith in Rome, visited the women's centre at 14a Princes Street in the summer of 1857 when in London for the exhibition of *Beatrice Cenci* at the Royal Academy (Figure 4.4). A feature on the sculptor, extracted from *The Daily News*, was reprinted in the *Waverley* under Parkes's editorship.[170] Hosmer and Rosa Bonheur had been profiled in the feminist *Almanach des Femmes*, printed in London in 1853 and 1854. The latter's career

was eagerly followed. Eliza Fox planned an expedition with Elizabeth Gaskell to see Bonheur's most famous work, *The Horse Fair*, when it was shown in London. Marian Evans (who published under the name of George Eliot) exclaimed: 'What power! This is the way women should assert their rights.' Several were to train with Bonheur and to visit her studio.[171]

Although these essays countered a general neglect of individual women artists, their approach was not uncontested. Anna Jameson was concerned about the adulatory nature of the account of Hosmer, writing to Bessie Rayner Parkes that the article was

> not sufficiently discriminative – too much in the style of a puff – you cannot give her too much praise – too much admiration – but *all* praise – *all* admiration – is all sugar – it will tell in America – but among judges of art it will injure her – I am anxious that women should not make your journal a vehicle for bepraising each other – but it is written with fondness & animation & will please no doubt.[172]

As Jameson acutely surmised, there were dangers in turning living artists into stellar heroines. She provided sound advice on the need for critical distance in feminist writing, especially when that writing was between friends.

The essays had a currency far beyond the journal. Elizabeth Ellet admitted to borrowing them for inclusion in *Women Artists in All Ages and Countries*: 'The biographies of Mdlles Bonheur, Fauveau, and Hosmer, are taken, a little condensed, from late numbers of that excellent periodical.' However, Ellet took the trouble to separate her project from any taint of feminism implied by an association with the journal. In charting '[t]he progress of female talent and skill', she drew attention to

> the increased freedom of woman . . . her liberation from the thraldom of old-fashioned prejudices and unworthy restraints, which, in former times, fettered her energies, rendered her acquisition of scientific and artistic knowledge extremely difficult, and the obstacles in the way of her devotion to study and the exercise of her talents.

But here she drew a line, and the passage with its telling use of parentheses is revealing.

> At the present time, the prospect is fair of a reward for study and unfaltering application in woman as in man; her freedom (without regarding as such the so-called 'emancipation' which would urge her into a course against nature, and contrary to the gentleness and modesty of her sex) is greater, and the sphere of her activity is wider and more effective than it has ever been.[173]

The conclusion is unequivocal: feminism is unnatural. This language would occur time and again in the writing about women artists who, in the words of *The Art Journal*, 'give way to ambition' and are 'snared aside from the paths of nature'. Ellet concludes by remarking that if female artists are more numerous, there are far fewer examples of 'pre-eminent ability' or 'original genius'.[174]

Ellet's caution indicates some of the risky associations of feminism in the 1850s. The imputation of a taint of deviancy, implied in an accusation of 'strong-mindedness', could damage an artist's reputation and simultaneously belittle achievement. At the turn of the 1860s, several women began to exhibit history painting, deemed to be the highest form of art and therefore a highly disputed arena for women's cultural intervention. To many critics, women's arrival in this elevated category was troubling and transgressive, as *The Art Journal*'s comment on Rebecca Solomon's *Peg Woffington's Visit to Triplet* (RA 1860) made clear: 'This is really a picture of great power and in execution so firm and masculine that it would scarcely be pronounced the work of a lady.'[175] In 1861 Emily Mary Osborn's *The Escape of Lord Nithsdale from the Tower in 1716* met with a mixed reception when shown at the Royal Academy. The painting portrays Lady Nithsdale assisting her husband, a Jacobite supporter, to escape by attiring him in female clothing. *The Art Journal* remarked that although the subject was 'a bold one for a lady', the artist has 'treated it with more strength and histrionic power than are usually ascribed to her sex'. Before praising the overall conception and the 'triumphant success' of Lord Nithsdale's head, the reviewer paused to reflect: 'Some of the artistic lords of creation, who succeed in treating such subjects with great feebleness, must begin to feel rather jealous, as they certainly ought to feel very much humbled, at being thus outstripped in their professional race.'[176] A mess of contradictions, the text struggles to deal with Osborn's painting and its inversions. The writer in *The Athenaeum* deplored the peer as 'an ugly, mean-spirited fellow' and castigated the whole for its 'commonplace, man-aping, conventional vulgarity'. This censure implied, and it is the slur of implication rather than the direct challenge of overt statement, an impropriety which was both unfeminine and artistically inappropriate. The work and the artist are both placed beyond the boundaries of respectability: this is the force of 'vulgarity'. Far from the gentleness and modesty commended by Ellet, the terms 'bold' and 'man-aping' resonate with the accusations of 'strong-mindedness'.[177]

These associations often occurred in reviews of the Society of Female Artists. On its opening in 1857, *The Athenaeum* thundered: 'We only hope that this Exhibition is no result of those ridiculous, wrong-headed pretensions which have led in America to almost a war of the sexes.'[178] The following year *The Illustrated London News* demanded: 'Is this the best way of maintaining the "rights of women" for them to withdraw in this declared manner from association and competition with their brother artists?' Drawing on a language already in use for satirising feminism, it continued, 'Why this petticoat republic?'[179] When agitation for the vote was under way, the links became even more

pronounced. In 1868 *The Art Journal* declared: 'It is evident that the innocent department of flower-painting will remain over-stocked until strong-mindedness impels women to desperate study from "the life".' A year later it reiterated: 'Ladies have always proved aptitude for the painting of flowers, and the pretty art is certainly more within their reach than those ambitious and arduous walks of the profession to which women clamorous for their rights now incline.'[180] From the mid-century to the *fin-de-siècle*, women's rights and women's art proved fertile ground for policing the boundaries of culture along the lines of sexual politics.

2

IN/BETWEEN THE COLONIAL THEATRE

Visuality, visibility and modernity

Shuttling, 'soul making' and the art of travel

In *The World, the Text and the Critic* Edward Said put forward a concept which has come to have a wide currency in post-colonial studies, that of travelling theory. Said explained that just as people travelled, so too did theory. As a move into a new environment is 'never unimpeded', this 'complicates any account of the transplantation, transference, circulation and commerce of theories and ideas'.[1] Theories, like visuality and modernity, are culturally, geographically and historically specific. Recent studies have also transformed the understanding of travel, Inderpal Grewal critiquing the term itself: 'as a universal form of mobility [travel] erases or conflates those mobilities that are not part of this Eurocentric, imperialist formation', such as migration, immigration, deportation, indenture and slavery.[2] Discussions of nineteenth-century travel and its cultural products (guidebooks, images, travel narratives, maps) have placed emphasis on the intersections between imperialism and visuality. Mary Louise Pratt's analysis of a visual trope which she called 'the monarch-of-all-I-survey' drew attention to the need for the imperial metropolis 'to present and re-present its peripheries and its others continually to itself'.[3] John Urry has traced the development of 'eyewitness observation' with its increasing visualisation of experience and the significance and complexity of 'the tourist gaze'.[4] Travel provided a means for understanding self, society and nation; indeed, Grewal emphasises that 'no work on travel can exclude the important matter of subject formation, ideology and imperialism'. Interrupting the binaries of self/other, home/away allows for an understanding that the 'space of colonial encounters' was located not just in 'the so-called peripheries, but in the colonial metropolis itself'.[5] This chapter and the one that follows track travelling feminists, theories and culture to explore the links between travel and subjectivity, visuality and modernity which were central to the imperial project.

In the second half of the nineteenth century, artists and activists travelled to Algeria, taking with them ideas about women, nation and race. In the colonial theatre, as in debates over slavery, they defined themselves by categorising others and by understanding difference in terms of race and ethnicity. Feminist

involvement in abolition is well known. Barbara Leigh Smith Bodichon's writings on slavery, prompted by a visit to the southern states of America in 1857 and 1858, were published in *The English Woman's Journal*, sometimes in tandem with features on Algeria.[6] Writing to Bodichon during her short period as editor, Emily Davies remarked, 'I don't think I should be afraid to insert an anti-South article. If we exist for anything surely it is to fight against slavery, of negro as well as other, women.'[7]

Writing at the height of a major controversy over American slavery in 1862, Davies restated a familiar link between the condition of women and of slaves. An attention to Algeria highlights the ways in which egalitarian feminism's calls for equal rights and opportunities for western women foreclosed equality *between* women. Feminist discourse was one of many narrations of nation in nineteenth-century Britain and *The English Woman's Journal* proclaimed an insular identity. Those wealthy enough to travel could explore what it meant to be a feminist in Algeria as well as Britain. A sense of freedom, distance and separation allowed them to reconceptualise (themselves as) militants and to plan their campaigns; those who stayed at 'home' could read about such exploits and view the paintings. For feminists, as for so many others, the Orient became the testing ground on which to examine the social position of women. Advocates of women's work concurred with imperial discourse on the 'degradation' of native women: Florence Nightingale's opinion of the 'hopeless life' of Egyptian women and Harriet Martineau's view of polygamy as a 'hell on earth' found echoes in essays on Algeria.[8]

To return to the 'militant female subject' is to return to Gayatri Chakravorty Spivak's powerful analysis.[9] For Spivak it is imperialism and the discourses of race which underwrote formations of subjectivity. The forces that shaped the western activist and her sense of herself as an autonomous subject simultaneously subjected the 'native female' to the relays of colonial and imperial power. As the militant claimed access to liberal individualism, native women were excluded. Spivak explains: 'As the female individualist, not-quite/not-male, articulates herself in shifting relationship to what is at stake, the "native female" as such (*within* discourse, *as* a signifier) is excluded from any share in this emerging norm.'[10] Feminist claims to individualism were pronounced in the 1850s. Evident in the artist biographies published in the journal, they also underwrote Emily Mary Osborn's exhibited painting of 1857, *Nameless and Friendless* (Figure 1.5): in offering her work for sale, the woman artist makes a bid to make a name for herself, a name on which to found a professional reputation.

In a complex passage Spivak explores the links between subject formation, activism and imperialism:

> what is at stake, for feminist individualism in the age of imperialism, is precisely the making of human beings, the constitution and interpellation of the subject not only as individual but as 'individualist'. This stake is represented on two registers: childbearing and soul making.

The first is domestic-society-through-sexual-reproduction cathected as 'companionate love'; the second is the imperialist project cathected as civil-society-through-social mission.[11]

Two related yet distinct registers are identified. The first, 'domestic-society-through-sexual-reproduction cathected as "companionate love"', takes as its arena sexual and familial relationships and it may be identified with the renegotiation of marriage as 'companionate partnership' and 'equal union'. The second register, 'the imperialist project cathected as civil-society-through-social mission', may be related to feminist projects to reform the position of women in contemporary society, in Algeria as much as in Britain.

Not so much an oppositional 'other', Algeria seeped into mid-century feminism, putting pressures on campaigning, discourse and practice. Polarised divisions between (near) east and west, coloniser and colonised will be of little assistance in coming to terms with the connections between Algeria, then a French colony, and the women's movement in Britain. Jacques Derrida's writings on the 'logic of the supplement' provide a way of approaching these often oblique, tangential and tensile relations. Dispensing with the arguments that meaning is produced through binary opposition in which one term is pitted against another, Derrida proposes that meaning is produced through *différance*, endlessly proliferating, continually deferred. The 'logic of the supplement' is a textual movement which destabilises and unsettles. Alluding to the double meaning in French of *supplément* as addition and replacement, Derrida writes in *Dissemination* that the supplement adds to and displaces the meanings in play, so loosening a structure of meaning achieved through binary oppposition. But more than this, the supplement is dangerous precisely because its textual movement is one of violence, fracture and interruption: 'Why is the supplement dangerous?' he asks. 'Its slipperiness steals it away from the simple alternative between presence and absence. *That* is the danger.' In intervening, pushing in/between, adding to and displacing, the supplement is a movement of violence, as Derrida's description with its suggestions of house-breaking, stealth and robbery emphasises. Derrida writes of

> that dangerous supplement that breaks into the very thing that would have liked to be able to do without and which allows itself to be simultaneously cut into, violated, filled and replaced, completed by the very trace through which the present augments itself in the act of disappearing into it.[12]

To bring Algeria into conjunction with western feminism and visual culture as a dangerous and unpredictable supplement is to destabilise the isolationist perspectives of their histories. At the same time, to locate British feminism and visual culture in Algeria is to acknowledge their part in what Spivak has identified as 'the planned epistemic violence of the imperialist project'.[13] The 'logic

of the supplement' refutes any separation between Algeria and Britain, between art and politics: what occurred in North Africa cannot be left beyond the frame.

When the Leigh Smith family visited Algeria in the winter of 1856–7, several reasons may have prompted the decision. Timothy Mitchell indicates that 'from its opening act of violence, European colonisation of the Middle East began to involve the new tourist industry'.[14] However, it was in the 1850s after the bloody genocidal wars which followed the French invasion in 1830, the surrender of the charismatic resistance leader the Amir ʿAbd al-Qādir in 1847 which ended the *jihad*, the localisation of resistance and the defeat of the Kabyle in 1857, that Algeria was transformed into a tourist destination. For the historian of the Maghreb, Abdallah Laroui, 1860 inaugurated years of poverty, famine, epidemics and natural catastrophes which brought hardship to the indigenous populations, while the enactment of harsh laws eroded religion and culture, language and heritage, property rights, education and employment.[15] Algeria became a popular winter health resort, and it was on these grounds that Marian Evans (George Eliot) hoped that 'this extreme application of "change"' would assist Bella's return to health.[16] The mildness of the climate, the cost of living, and the pleasures of outdoor sketching, riding, botany and photography as well as more exotic entertainments all attracted European visitors. The British Member of Parliament John Bright convalesced there that same winter. One of Europe's nearest colonies, Algeria was of particular interest to a network of Radicals, including Benjamin Leigh Smith (Barbara's father), Richard Cobden and John Bright who took up, as he noted in his diary, 'a new line of study – the impact of French commercial civilisation on old Mohammedan culture'.[17] English guidebooks speculated on the benefits of colonisation and Cobden combined sight-seeing and visiting with an investigation of the colony's commercial interests.[18]

On this visit Barbara Leigh Smith met Eugène Bodichon, a doctor and prolific author who has been identified as an active ideologue in the making of French colonial policy. Patricia Lorcin considers his writings to be both exemplary of 'the open ambiguity of attitudes in the nineteenth century' and 'a sample of some of the more extreme attitudes present in the colony'.[19] The following summer they were married. While they worked together on schemes of mutual interest, Bodichon pursued her career, campaigned and travelled independently. In this shuttling to and fro the couple developed an 'equal union' which Bodichon defined as a partnership between 'a man and a woman equal in intellectual gifts and loving hearts[,] the union between them being founded in their mutual work'.[20] This is the 'companionate love' which Spivak indicates is the first register for feminist individualism in the age of imperialism. In the colonial context, Christian monogamy accompanied a condemnation of polygamy and arranged marriages, seen as degrading to women, corrupting to the domestic unit, and the index of an immoral society.[21]

Bodichon may be classified as a 'settler', who was defined by David Prochaska as a third class, alongside temporary migrants (visitors and administrators) and

indigenous peoples, who made distinctive life-choices to live as Europeans, purchasing land and residing in cities, suburbs or settlements.[22] In 1859 she paid £800 for a house and an estate of 12 acres of land in the smart area of Mustapha Supérieur. Her sister Annie Leigh Smith purchased a house nearby, employing an architect who created neo-Moorish residences with materials salvaged from demolition in the old city. By the 1880s Algiers hosted a sizeable British community, an English club, library and churches.[23] Bodichon socialised with a network of friends and acquaintances: the artists Augustus Egg, Frederick Walker, Eliza Fox and Sophia Lady Dunbar, the architect of the Oxford Museum, Benjamin Woodward, and Unitarians who shared her family's interests in liberal causes and travel. Nevertheless her biographer, Pam Hirsch, suggests that she experienced a profound sense of isolation. If Bodichon found relief in the return south, she also expressed regret. In 1864 she informed Annie that '[i]t is rather hard, to live six months away from one's best sympathisers' which she glossed as her 'own country, relations and friends'. While 'home' as the space of belonging and return was identified with a specific place, it was also imagined as the community of the nation.[24]

A French national by marriage, Bodichon's relation to French colonialism was engaged and marginal. Initially sceptical, she declined to be presented to the wife of the Governor-General, 'as great here as the E[mpress] E[ugénie]', giving as her excuse a politics of dress: 'we belong to a set of women who never wear low dresses'.[25] Turning her attention to native women and arranged marriages, she affirmed:

> I renewed every vow I ever made over wretched women to do all in my short life with all my small strength to help them. Believing that as water finds it[s] level & the smallest stream fr.[om] the High Reservoir mounts everywhere as high as that high water[,] so that [the] freedom & justice we English women struggle for today will surely run some-day into these low places.

In contrast to Algerian women, oppressed and inferior, are those 'English women' celebrated with a nationalist pride. Their view of themselves as feminists shaped an exclusively philanthropic vision of native women. Contact with her husband's views intensified her concepts of racial difference and she wrote of Moorish women,

> like all people in a barbarous state they are simple and very much alike, you soon learn all that is to be known about their lives. The wife of a French workman is a thousand times more civilised than the richest Moorish lady.[26]

Although she took lessons in French (Figure 3.1), unlike her travelling companion Matilda Betham Edwards she did not, as far as is known,

study Arabic and her contact with the indigenous population was highly mediated.[27] As she became increasingly involved in colonial society, she supported philanthropy rather than official policy.[28]

Little is known about the Bodichon household and its organisation, which must have changed over the decades: her letters contain routine complaints about servants, French and Algerian. Tucked into a small envelope pasted into her autograph album are three photographs taken at the same sitting in the courtyard at Campagne du Pavillon (her house in Algeria) which date, perhaps, from the late 1860s. Two portray Hamet, who worked as a servant, one by himself holding a broom and a second with his employer; the third shows Bodichon alone[29] (Figure 2.1). The photographs are imprinted ambivalently with relations of power: whereas the seated European inspects a letter brought to her, the Algerian holds a broom or stands waiting. But he looks not at her but beyond her, declining to engage, regarding the viewer with an equal indifference. In a compelling analysis, Rey Chow has suggested that colonial photographs participate in the 'commodification of "ethnic specimens" . . . as part and parcel of the "process" of modernity'. Such photographs do not simply document the historical presence or existence of the native. While they testify

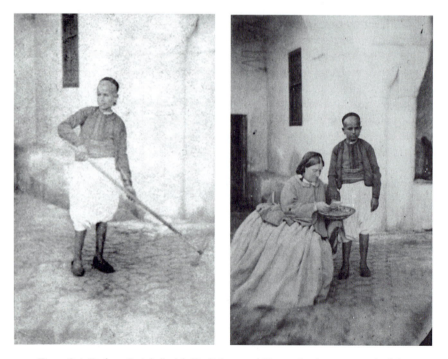

Figure 2.1 Barbara Leigh Smith Bodichon and Hamet in the courtyard of the Campagne du Pavillon, Algiers, *c.* 1865–70

to the defilement of the native by colonisation, they provide a register of the native's 'witnessing gaze', which exceeds and precedes colonisation, speaking of the moment before the colonisers arrived, before the native became image and so crossed the threshold of visuality. Rethinking the relations of power which surround such photographs, Chow concludes that they are criss-crossed by competing gazes. Thus, although Hamet has been summoned into the visibilities of the colonising gaze, the photographs also register a counter-field: as Chow has put it, 'it is actually the coloniser who feels looked at by the native's gaze'.[30]

The Maghreb became a pleasure ground, a textual resource, a site of desire and fantasy, and, significantly for feminist women, a space for personal fulfilment and freedom from the social conventions of 'home'. Masquerade became de rigueur, part of the experience of 'being there'. Living and working in Cairo for several years, J.F. Lewis, the watercolourist who specialised in images of the harem, distanced himself from other Europeans, considering that 'because he was away from evening parties, he need not wear white gloves, or starched neckcloths or read a newspaper'.[31] Eugène Bodichon fashioned himself as a privileged insider by adopting a burnous which he wore in Algeria and the west. Women travellers and writers too adopted oriental dress although, as Reina Lewis points out, western attire was retained as a marker of social and racial status: 'the pleasures of cultural cross-dressing must be forfeited when Western clothes [were] necessary to signal their Europeanness and inculcate respect or discipline'. Although Bodichon wore Arab vests over her blouses[32] and Parkes dressed up in a short jacket with a hood (the distinctive dress of men in Kabylia), thus adopting a cultural and gendered cross-dressing which was highly imperialist (Figure 2.2), in the photograph taken 'at home' Bodichon wears western dress, even though the full skirt and short jacket are years out of date (Figure 2.1).

Bodichon was an avid collector. Although she did not create an exotic interior on anything like the scale of Leighton House in west London, she adorned her country residence in Sussex with pottery and embroideries acquired in Spain and Algeria. Contemporaries reported that her house in Algeria was 'furnished after the Moorish style' and with a striking scarcity of furniture. This taste for an exotic simplicity was as much a feminist as an imperial marker. Bodichon wrote to her aunt early in 1859,

> I doubt if you would think the house 'nice' it is rough *very* . . . I am afraid of having a well appointed house[.] I believe I could not work if I had & I want my money for other things.

She identified cultural artefacts with differentiated racial groups, writing on 'Kabyle pottery' and sending examples to the Victoria and Albert Museum in London. She commended 'the singular beauty of colour and arrangement' of 'old Arab' embroidery but lamented that 'the taste of the English visitors made

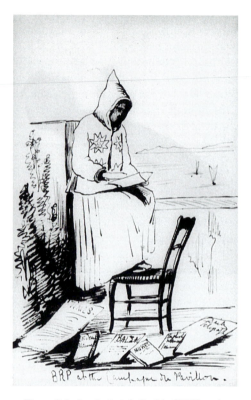

Figure 2.2 Annie Leigh Smith, '*BRP at the
Campagne du Pavillon*' [1857–61]

a great demand for them' so that it was 'difficult now to pick up good speci-
mens in any of the bazaars'.[33] While her views played into a developing
romance around the pre-colonial, her comments recycled a prevailing myth-
ology promoted by her husband that the Kabyles were settled, industrious and
socialised, as their arts and crafts demonstrated, and so more amenable to assimi-
lation than the nomadic, feckless and aggressive Arabs.[34]

Acquiring items for interior decoration and as studio properties was com-
mon practice among Orientalist painters who used them to create a life-style,
residence and workplace to enhance their specialisation and reputation. J.F.
Lewis travelled to Britain in 1851 laden with garments, musical instruments
and arms. As John Mackenzie notes, such goods were 'sometimes paid for,
invariably not'.[35] This global movement of objects, which included transporta-
tion to an imperial museum, has been investigated by Arjun Appadurai. In *The
Social Life of Things* he identifies the twin themes of 'commoditisation by diver-
sion' and the 'aesthetics of decontextualisation' in a process by which value 'is
accelerated or enhanced by placing objects and things in unlikely contexts'.[36]
Diverted from 'their customary circuits', objects from North Africa were

displaced into an increasingly diversified consumer market and exhibitionary complex in which they would have been admired for their aesthetic value as well as their origins outside Europe.

Numerous male French painters accompanied diplomatic and military missions and some, like Horace Vernet, owned property in Algeria. With no formal British colonies in the Near East until the 1880s, British artists (men and women) travelled independently, mostly to Egypt and Palestine. Some spent short visits, others opted for prolonged residence. As a speciality or variation to an established practice, oriental themes could be worked up in a studio in North Africa, London or Paris for exhibition and/or for publication.[37] By and large, women artists neither risked the entrepreneurial enterprise entailed in the production of illustrated volumes, nor were their Orientalist works viewed as major investments by publishers and dealers. Nevertheless Bodichon, Eliza Fox and later Emily Mary Osborn successfully exhibited their Algerian pictures and watercolours.[38] The former's Algerian views were often shown and sold through the dealer Ernest Gambart, who hosted at least three solo shows, in 1859, 1861 and 1864.[39] John Mackenzie attributes the success of a number of Orientalist artists to the French dealers, Goupil and Gambart, 'who fed their works in the appropriate directions and also increased their fame through the judicious use of photographs and engravings'.[40] There was undoubtedly a certain cachet for an exhibitor with, as Bodichon admitted, 'a French name' to be exhibiting French colonial scenes at the French Gallery in London's west end (see Figure 1.2).[41] And Gambart, whose reputation as a leading dealer was not made by supporting women artists except on rare occasions, was certainly astute enough to exploit the advantages.

A prolonged visit in the mid-1860s brought a change of direction to Eliza Fox's work. Mme MacMahon, the wife of the Governor-General, helped her to find subjects, rendering, in the words of a contemporary, 'much assistance in obtaining insight into the native Arab life' (see Figure 3.7). While colonial administrators often facilitated access for men, here the approach was made through elite female contacts.[42] Fox showed this work at the Royal Academy and with Bodichon at the German Gallery and the Society of Female Artists, where the two women had an impact on other exhibitors. In 1868 Ellen Partridge sent *Coffee Bearer*, a figure painting 'in the costume of Algiers, a work executed in the "Life Class" for ladies . . . instituted under the auspices of this society' and run by Eliza Fox. As costumes, probably including some from Algeria, were available for hire, a journey south was not even necessary and if a white model was hired, this was no more than the custom, dating back at least to the eighteenth century, in which westerners dressed up in oriental guise. The *Coffee Bearer* seems to have been a one-off, worked up from studies which suggested virtually ready-made small paintings. By the later 1860s the society's exhibitors demonstrated such a predilection for Orientalist subjects that *The Art Journal* remarked, 'These regions [of the Middle East] have been of late a

favourite resort of ladies, who appear intent upon outrivalling each other in the marvels they bring home to the amaze of less privileged eyes.'[43]

Bodichon's Algerian residence was a point of call for artists and travellers: when Sophia Lady Dunbar over-wintered in the mid-1860s, the two women worked together. Dunbar's *The Bay of Algiers* (SFA 1867) was 'acknowledged to proceed from Mme Bodichon's studio'.[44] Algeria became a resource for essays and paintings, a space for networking and strategising. Friends from Langham Place came to stay and one new member was recruited. Emily Davies recollected a momentous encounter in 1858,

> After making the acquaintance at Algiers with Annie Leigh Smith (Mme Bodichon's sister) – the first person I had ever met who sympathised with my feeling of resentment at the subjection of women – I corresponded with her and she introduced me to others of the same circle and kept me up to what was going on.[45]

Gertrude Jekyll, with whom Bodichon planned interiors and gardens for Girton College Cambridge and whose encounter with North Africa was to have such formative impact on her arrangement and selection of plants, was Bodichon's guest and sketching companion in the winter of 1873 to 1874 (see Figure 3.5).

Letters, publications, paintings and travellers shuttled north and south. Parcels of books, pamphlets and magazines were regularly dispatched to Algiers; newspapers were especially welcomed, for 'they constantly contain articles bearing on the Woman question'. A drawing of Parkes shows her surrounded by European books and papers, including *The English Woman's Journal* (Figure 2.2). Correspondence was full of campaigning, projects and new ideas. In the early months of 1857 Parkes reported plans for editing a journal and a scheme for a women's centre in central London where 'we can have our own book shop, & the beginning of a Club; room for exhibiting pictures . . .':

> Just the last few days we have been discussing a plan which I think we shall certainly put in execution, that of establishing a shop, for books, newspapers, stationery, drawings, etc. in London. . . . We should make it the place of sale for all our books & tracts, and advertise it well.

By the spring Parkes had secured the editorship of the *Waverley Journal* and the centre was opened at 14a Princes Street later that year (Figure 1.2). There was a scheme, probably unrealised, for handkerchiefs made by Muslim girls in Algeria to be sold there.[46]

Feminism contributed to the marketing of Algeria with the development of tourism and the display of colonial products at the Exposition Universelle in 1855. The 'world on exhibition' and an expanding consumer market promoted global shopping.[47] Algeria was quickly turned into texts: letters, essays and a

guidebook; sketches, drawings, watercolours and oil paintings. Within a week of her arrival in January 1857, Parkes dispatched essays to several magazines: her first impressions (with illustrations) were published in the *Illustrated Times* that spring and an account of Algerian households (also illustrated) included in *Once a Week* four years later.[48] Bodichon's study of Kabyle pottery was placed in the art press. Several pieces were aimed at a specifically feminist readership: contributions to the *Waverley Journal* were followed by a number of articles and reviews in *The English Woman's Journal*. *Algeria Considered as a Winter Residence for the English*, a guidebook compiled by Barbara Bodichon, was published at the offices of the journal in 1858 (see Appendix).

Although the references in the journal were by no means numerous, they offered a contrast to the staple fare. Dynamics of class, race and nation shaped narrations of English women who emigrated for work, 'English ladies' who travelled for pleasure, and Africans transported to American slavery. The presentation of Algeria as a series of visually pleasurable scenes would have appealed to a metropolitan community for whom the 'Orient' was entertainment. In her recollections Emily Davies left a tantalising note of a party at Bodichon's London town house in 1861 'at which there was a "Harem Scene"'. Her reminiscence suggests the interweaving of visual pleasure, theatrical spectacle and cultural cross-dressing which was involved in feminist Orientalism. A spectacular staging of the Orient was also provided a year later when Eugène Bodichon introduced at a party hosted by Parkes 'four Algerians, one a splendid Arab in his burnous, camel hair cord round his head'.[49]

Algeria also became a token of exchange between friends. Drawings and sketches were included in letters. Thanking her correspondent in April 1861 for three drawings of Parkes (one of which is Figure 2.2), Marian Evans was 'pleased to be remembered in this way and amused with the images of dear Bessie'.[50] At least two of Bodichon's watercolours were given to Parkes. Jane Cobden was presented with an oil painting, *Shepherd and Sheep*, and her sister Ellen Millicent Cobden with a watercolour of an 'Arab tomb'. If, as Kate Perry notes, the gifts marked a long association with the Cobden family based on radical politics and the women's movement, they also registered Algerian connections: Ellen travelled in Algeria in the early 1870s and her sister in the following decade.[51] Christina Rossetti owned two works by Bodichon, one of which, *Cactus*, was an Algerian subject. In August 1860 she wrote delightedly to thank her for her 'beautiful gift': 'It is the first picture I ever possessed and delights me as a fine painting, as the transcript of a wonderful scene, and as your handiwork and most kind present.' As Jan Marsh has noted, Bodichon's 'habit of bestowing works on others was . . . part of her networking style'. Four years later the painter presented the poet with another watercolour, requesting in return copies of her poems to circulate in the Portfolio, a literary and artistic society which operated in London and Algeria.[52]

Collections of Bodichon's watercolours were displayed and on sale at the Ladies' Reading Room and Parkes purchased an unidentified picture to hang

there. Parkes acted as Bodichon's agent, selling her pictures, promoting her work and even buying her paints. In spring 1861 she transported a case of pictures from Algeria to London, dispatched invitations and catalogues 'to every creature I could think of in the literary, artistic & fashionable world', dealt with purchasers and advised the artist that '[t]he whole of Langham Place . . . went to the private view and exulted!'[53] In a feminist 'tactics of the habitat', Bodichon displayed her art work at her London power-base. In 1874 she held a formal exhibition; at other moments, gallery secretaries were invited to inspect the contents of a projected show. For women friends an invitation to lunch was combined with an opportunity to view recent work. Christina Rossetti appreciated an 'offer of lunch and pictures'.[54] Her watercolours also graced the walls of Girton College. The first shipment arrived in 1870, and in 1891 she confirmed her gifts, 'always with the hope that they may be a source of pleasure to some of those who will come year after year'.[55]

Articles and pictures generated funds for feminist projects. Eliza Fox's Algerian works coincided with her participation in the suffrage movement. Bodichon, whose Algerian corpus comprises over a third of her exhibited work, poured money into the *Waverley Journal*, *The English Woman's Journal*, Bedford College London and Girton College Cambridge. There is some evidence to suggest that this money was income made from writing and painting rather than inherited wealth. She seems to have been financially successful: her 1861 show almost sold out at the private view.[56] A marriage settlement in equity gave her relative financial independence and the ability to make binding contracts, lend money, incur debts and conduct a business independently of her husband. While she was provided with an annual income, her earnings from art, 'any profits or earnings which may hereafter accrue . . . by reason of the carrying on or exercise by her of any business profession or pursuit', as well as her investment portfolio and her property were protected. An ability to dispose of her assets as she chose allowed her to make substantial donations to feminist causes. As Parkes wrote in her obituary, 'she was well endowed with fortune, and her paintings early commanded considerable prices; and of the money at her disposal she was a most liberal and conscientious guardian'.[57]

Modernity, visuality and visibility

Written in Algeria in the winter of 1856–7, *Women and Work* is a ragged, fragmentary text compiled by Leigh Smith (Bodichon) from quotations from contemporary newspapers, published articles and unpublished papers, held together as much by its narratives of individual endeavour as by its campaigning theme, work for middle-class women. Its broad scope encompasses employment in and the supervision of workhouses, prisons, reformatories, schools, sanatoria and hospitals, those institutions concerned with the management of life and characteristic of what Michel Foucault called the 'disciplinary society'. It draws on a well-established imperial voice to pronounce 'moral

supervision' as the role for the female militant in the colonial theatre. The themes that underlie the lengthy account of Algerian women and a school run by Mme Eugénie Luce are modernity and visibility: Algerian women are to be modernised by paid work and western dress.[58]

Sweeping assertions characterise Algerian women ('Moresques') as uneducated and illiterate, confined by 'their own debased ignorance' and 'the multitude of restrictions amidst which they exist'. With no manual skills, they lead an 'idle slovenly existence', victims (and hence to be pitied as 'poor creatures') of a 'religious and social tyranny' which includes arranged marriages and seclusion. The denigration of arranged marriages – 'the crowning affliction and degradation' of their lives – acts as a foil to the promotion of 'equal unions', and the charge of indolence resonates against the advocacy of work. At odds with the prevailing view that in certain areas Muslim women were freer than their western counterparts, this vision of constraint acts as a foil to western women's quest for freedom within a democratic system and Christian society.[59]

The pupils at Mme Luce's school were 'taught the language, and somewhat of the civilisation, of the conquering race', 'to read and write in a foreign language, to do the first few rules of arithmetic, to sew and to be proud of Mme Luce'. Religious instruction in Islam was given by a native woman assistant. Those skilled in needlework were assigned to a workshop where they 'executed work for the ladies of the place and earned in this way a considerable sum of money'. Through this work they would, it was hoped, 'appreciate the value of labour', 'conceive of their own sex as rational and responsible beings . . . think that they can earn money and support themselves', and recognise 'the eminent need in their own homes of neatness and order, and the power of making and mending their own and their husbands' clothes'. Although it was claimed that in Algeria sewing and industriousness would effect much-needed reform, careers in needlework did not feature on any feminist agenda for British women. Rather the recognition of the limitations of needlework and teaching prompted calls for new openings and opportunities. At the Portman Hall school (founded by Bodichon and opened in 1854 for working-class children), the curriculum included reading, arithmetic, French, drawing, music, elementary science, physiology, health and hygiene, as well as visits to museums.[60]

Neither the pupils, nor the assistant, nor the attendants who escorted the pupils to and from home are named in *Women and Work*, a denial which excludes them from the individualism espoused by western feminism. In later essays Parkes identified the assistant as 'Nefissa' and reported that in 1850 Nefissa Bent Ali (then 14 years old) and Aziya Bent Yahia, both pupils at the school, were sent for several months to Toulon where 'Abd al-Qādir and his family were imprisoned in the hope that 'their example and advice will gradually bring the wives and daughters of the ex-Emir to abandon their prejudices and modify the ideas which they keep up in the minds of their husbands'.[61]

Commenting on the account of the school, Bodichon concluded: 'Such was the human material which Mme Luce dared to conceive of as capable of being raised to something approaching the condition of her European sister.' Gathered together as 'human material', native women become objects for 'woman's mission to women'. While 'sister' announces kinship and community, it slyly inserts a racialised divide. A highly ambivalent term, it slithered between family relations, the Christian female orders, philanthropy and abolitionist calls for transcendent sympathy such as 'Am I not a woman and a sister?' Slipping in/between registers of meaning, destabilising and displacing those already in play, sisterhood offered an understanding of race relations founded less on equality and more on moral authority. In a text composed at a moment of intense racial tension provoked by the Indian National Uprising and British military campaigns in the sub-continent in 1857 and 1858 (see Figure 4.9), the double inscription of 'sister' was written through with what Sara Suleri has identified as the white woman's terror of native women: 'a fear of proximity rather than difference'.[62]

Women and Work is also about visibility and appearance. Dress and the body visually mark the perceived difference of Algerian women who 'dress up very fine upon occasion – gauze, silk, ribbons and jewels – and very shabbily and dirtily on other occasions in the *débris* of former splendour'. By contrast, the assistant teacher is commended because 'in all ways [she] looks like a French woman'. Distinctions are produced between the westernised Algerian ('not quite/not white'), Mme Luce ('not quite/not male') and the black attendants. An account is given of the unveiling of the assistant before French male officials. The narrator reports Mme Luce's view that the unveiling was a triumph for morality, modernity and Christianity.

> She always works against the veil, thinking, and truly thinking as it seems to us, that it is far from conducive to true modesty of bearing, which should be simple and straightforward, of that purity which 'thinketh no evil'.

This event was doubtless one of many which anticipated the public unveiling of Algerian women, presided over by the wives of army officers, which took place in May 1958. In *Studies in a Dying Colonialism*, written during the war of independence, Frantz Fanon traced 'a historic dynamism of the veil that is very concretely perceptible in the development of colonisation in Algeria'. The veil was adopted as a mark of tradition and as 'a mechanism of resistance' because 'the occupier was *bent on unveiling Algeria*'.[63] Reflecting on Fanon and on the politics of veiling and unveiling, Winifred Woodhull has concluded that to French colonisers who directed their efforts to the 'liberation' of Algerian women through education as well as through the regulation of private life and domestic mores, the veil became the border which marked the limit of the colonial project, the veiled women signifying not just illegibility but resistance,

the point beyond which colonisation could not proceed.[64] The rejection of enveloping dress and the adoption of western attire became the visual signs of the transformations wrought by colonisation. Whether in written texts or in the excessive visual imagery of unveiled/unclothed native women, unveiling, as Rey Chow has elucidated, registers a desire to discover the secrets of the Orient, the female body becoming the site on which this fantasy is projected and played out.[65] The reiterated desire to see beyond the veil was central to feminist concerns as well as the imperial project; for both modernity was secured through the visibility of native women. Native women were to be modernised by unveiling, western dress and paid work. The modernity of the west, fashioned against the perceived backwardness of colonised territories, was also to be measured by the introduction of alien visual systems. The visual became the domain in which distinction and difference could be visibly registered, minutely discriminated and authoritatively judged. As colonised peoples were brought into visibility, special emphasis was placed on unveiled women. Sara Suleri has explained that 'the availability of diverse tribes and social groups to the colonial gaze [was] most frequently measured in relation to the visual accessibility of their women'.[66]

Visuality and visibility generated tensions in feminist discourse; there was consensus neither on the veil nor on the sexual politics of vision in a colonial society. Although *Women and Work* promoted unveiling, the veil was associated by several other women travellers with female virtue, respectability and safety, and Parkes acknowledged it as integral to Islamic codes of propriety which, she considered, European women contravened. She remarked that an Algerian man 'turns his eyes studiously away from the English ladies and talks at them over his shoulder[,] as if he thought it was not respectable to look at their unveiled faces'. A disregard for such conventions is registered in a confrontation between two Arab men and a western woman sketched by Bodichon in a letter (Figures 3.1, 3.2). Parkes, however, could show greater sensitivity: she deplored '[a]n English lady, Mrs Hawkes, [who] gave great offence at Prince Moustapha's by drawing the women, they say she even drew the bride'. Despite this, two of her published essays were accompanied by drawings.

An occasional visitor, Parkes was sharply observant and outspokenly critical. Her writings register ambivalence, inconsistency, equivocation. If she was the author of the account in *Women and Work*, then its perceptions of Algerian women are hers. Her essay 'Algerine interiors' provides a familiar Orientalist vision of exotic women attired in glittering and richly patterned fabrics. An unattributed drawing of a dancer accompanies the remark that the entertainment 'might easily degenerate in character from the merely domestic performance which was exhibited to us'. Her astonishment at the courtesy, hospitality and domesticity of purdah women was by no means unique. Expressing common middle-class anxieties about dirt and disorder, she considered Algerian interiors to be 'ill-kept' and untidy: '[n]othing in Algeria is neat according to our English conception of the word'. Struggling to understand the relations

within the household, she conceded that they were secured by '[e]xtreme strictness of domestic law, and an utter absence of anything like the romance of affection'. But in matters of dress, Algerian women could be preferred. She contrasted the elegant composure of a woman in white, a 'haik, or square shawl being drawn round about her head and falling down over her person', to the wife of a French farmer, 'an odious specimen of colonial finery, wearing a tight polka-jacket of the most waspish dimensions'.[67]

From the acclaimed pictures of J.F. Lewis to travel writings, the harem exerted considerable fascination. Reina Lewis has demonstrated that women traded on their access to the *haremlik*, their intimate knowledge of secluded life and segregated spaces. In the work of painters and writers well-worn stereotypes co-existed with the fashioning of the harem as a space that was like and unlike their class-specific and nationalist concepts of 'home' – feminine, domestic and well-regulated.[68] Although feminist visions of the Orient overlapped, supplemented, drew on, matched and contradicted those by their contemporaries, neither Bodichon, nor Fox nor Osborn (so far as may be ascertained) exhibited pictures of the harem. *Women and Work* advocated that native women should quit its seclusion (often associated with privacy and safety) for the uncertain world of paid work and global enterprise. Tensions between desire and denial also characterised the paintings by Bodichon, Fox and Osborn which brought Algerian landscapes and figures into view, into the modern world of consumerism and visual culture.

THE 'WORLDING' OF ALGERIA
Feminism, imperialism and visual culture

Worlding

The climate is delicious[,] the sea & distant mountains more beautiful
than words & pencil can express & then the new vegetation & the new
animals[,] the wonderfully picturesque town & people give one so
much to do with one's 6? senses . . . I did not expect anything half so
wonderfully beautiful as I find. I never saw such a place! . . . I can't
draw [it in] the least. . . . The place intoxicates one.[1]

Visiting Algeria in the winter of 1856, Barbara Leigh Smith (Bodichon) put her
first impressions on paper for her women friends. She illustrated her cor-
respondence copiously, sending with this letter to Marian Evans pages of
sketches (Figures 3.1, 3.2). The recipient was delighted, relishing the 'wonder-
ful descriptions from Barbara Smith of the glorious scenery and strange pictur-
esque life she finds in Algiers' and the exuberance with which the artist 'dashes
down sketches with her pen and ink, making arrow heads to indicate the bark
of Jackals!'[2] Confessing to an overpowering seduction, this letter registers a
wonder at unexpected pleasures and sensory delight so often acknowledged by
western travellers. Yet desire oscillates with denial; seduction with repudiation.
As the writer admits, visual pleasure was accompanied by retraction: although
Algeria is picturesque, it is impossible to draw or paint. Equally impressed by its
mystery, strangeness and exoticism, the writer struggles with Algeria's
intractability, its resistance to visual representation. Algeria is perceived not so
much as oppositional to the west, but as beyond its frames of reference and
visual representation, despite or perhaps because of the artistic compositions it
offered.

This letter introduces the main themes of this chapter: an analysis of the
dramas of feminist subjectivity played out in the North African countryside
together with an interrogation of what will be termed 'pictorialising': a
distinctly visual and pictorial perception of Algeria.[3] It also announces the
irresolutions between desire and denial, seduction and repudiation, visuality
and opacity, which are threaded through images and texts made in and about

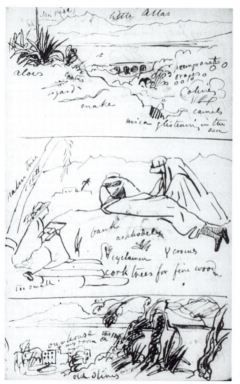

Figure 3.1

Figure 3.2

Figures 3.1 and 3.2 Barbara Leigh Smith Bodichon, Drawings
included in a letter to Marian Evans [George Eliot], 21
November and 8 December 1856

Algeria by a group of friends associated with the British women's movement. These materials are widely dispersed and while a few figure paintings are known through titles or an occasional reproduction, many more landscapes may be traced. The exigencies of survival have prompted an attention to land and landscape. In picturing Algeria as a far-distant and inaccessible place of secrecy, opacity and illegibility, as a landscape of ruins, a colourful and strange location under the sway of Islam, these writings and images contributed to the staple themes of 'Orientalism'.[4] This is not to attempt a totalising interpretation of 'Orientalism' but rather to pursue a micro-study of historically specific and geographically localised dis/articulations between contending fields of force brought to bear in the colonisation of Algeria. There was no close fit between feminism, imperialism and visual culture, but rather tensions, complicities and departures. Gayatri Chakravorty Spivak's concept of 'worlding', elaborated in articles and interviews in the mid-1980s, will open an enquiry.

In conversation with Elizabeth Grosz in 1984, Gayatri Spivak spoke of 'the notion of the worlding of a world on a supposedly uninscribed territory' and she continued,

> When I say this, I am thinking basically about the imperialist project which had to assume that the earth that it territorialised was in fact previously uninscribed. So then a world, on a simple level of cartography, inscribed what was presumed to be uninscribed. Now this worlding actually is also a texting, textualising, a making into art, a making into an object to be understood.[5]

An extended account in 'The Rani of Sirmur: an essay in reading the archives' (published in 1985) elaborated on 'worlding' as central to and formative of 'the planned epistemic violence of the imperialist project'. Spivak drew on an essay by Martin Heidegger which suggested that the work of art emerges in the conflict between earth and the world. Taking up the philosopher's assertion that this conflict is more than 'a mere cleft . . . ripped open' and his emphasis on 'the intimacy with which opponents belong together', Spivak explained the German word, *Riss*, not as a neutral interval or empty space, but in terms of 'the violent implication of a fracture'.[6]

Spivak's concept of worlding engages a double inscription: that which physically changes the land and the inscription of a visual culture which erupts from traumatic conflict. Landscape – that category of visual representation which transforms earth into world, land into visual culture – may thus be perceived as central to the western imperial project. A complex cultural concept, landscape restructures land for leisure and tourism as well as visual and spiritual refreshment, sensory pleasure and a pictorialising vision.[7] Equally important to the imperial project was the seizure, settlement and environmental alteration of land. Indeed, for Edward Said imperialism means '[a]t some very basic level . . . thinking about, settling on, controlling land that you do not possess, that is

distant, that is lived on and owned by others'.[8] Most post-independence histor-
ians of Algeria have agreed that it was on land that the violences of imperialism
and colonisation were enacted. Abdallah Laroui is emphatic on the effects of
punitive property laws which provided modern interpretations of Roman law:
'By confounding pasturage lands and uncultivated lands, jointly owned and
collective property, by unduly extending the limits of forest lands, the French
administration confined the indigenous population to smaller and smaller
territory.' Existing agriculture was decimated, the number of landless peasants
increased, and indigenous populations sentenced to poverty and famine. Euro-
pean banks and corporations secured extensive control of land, introducing
profitable farming: with prices and products geared to the French markets,
great fortunes were made in wine and tobacco.[9]

In the decades of bloody and brutal war and resistance which followed the
French invasion of 1830, land was devastated by burning and scorching, seized
by force, confiscated, appropriated and reallocated. The military leader, Marshal
Bugeaud, informed the French National Assembly in 1840: 'Wherever there is
fresh water and fertile land, there one must locate *colons*, without concerning
oneself to whom these lands belong.' Land policies had a profound impact on
the already settled population: villages were torched to the ground, thousands
died and many were slaughtered or burnt alive; Algerian women were raped,
held hostage or auctioned as property to the troops. This policy was endorsed
by Marshal Randon, Governor from 1851 to 1858, who decreed that 'we must
leave the traces of our victory on the soil' to achieve the submission of 'these
rough/uncivilised populations who resist everything, except for the real mani-
festation of force'.[10] Time and again it was declared that 'The Arabs must be
prevented from sowing, from harvesting and from pasturing their flocks.' Land
assets were stripped though cantonment, mineral mining, deforestation, the
introduction of intensive agriculture for colonial markets, and the building of
roads and railways. The highly complex forms of land ownership and property
relations were destroyed, disposing of the beliefs that land was not a commod-
ity. Land was assigned to private ownership by European corporations and
individuals, like Bodichon. An inscription on a sketch made on her journey to
the interior in 1866–7, 'Saida/The Property the Commandant offered to sell
to Miss Edwards', suggests that land under military control was offered to an
English traveller.[11]

The ecology and appearance of the region were drastically altered by the
introduction of European plants, crops, animals and diseases as well as by the
new transport infrastructures. Existing species were seriously depleted and soil
structures were fundamentally changed by European systems of farming and
cropping. Schemes to create vast inland seas to irrigate the Sahara Desert
marked a high-point in colonial fantasies to 'tame the wilderness'. Barbara and
Eugène Bodichon were active in the environmental alteration: using seed
imported from Australia, they created extensive plantations of eucalyptus.
Feminist ecologists have recently pointed out that eucalyptus can be actively

harmful, encouraging the depletion of species diversity, a reduction in local knowledge, deforestation, soil erosion, a decline in soil fertility and a decrease in water retention. Vandana Shiva states in *Staying Alive: Women, Ecology and Development*, 'The eucalyptus . . . when perceived ecologically, is unproductive, even negative.' While these conclusions were unavailable in the 1860s, they illuminate some of the problems engaged by the global dispersal of species.[12]

All these transformations were not easily, rapidly or totally achieved. The historian Mahfoud Bennoune emphasises the uneven development of colonisation between 1830 and 1880 as it met with fierce resistance and was hampered by the inadequacy and incoherence of French agrarian, commercial and financial policies.[13] Colonial policies were held in tension between the contending interests of Europeans, between diverse fractions in French population, and collisions between indigenous social groups. And just as colonial authority was nowhere absolute, unchallenged or homogeneous, neither was there secure suturing between visual culture and colonial society.

In Algeria as elsewhere, invading armies were quickly followed by surveyors, archaeologists, geographers and artists. It soon became the *mise-en-scène* of a flood of paintings, engravings, illustrated publications and photographs. The visual forms of painting and photography were introduced with French colonisation and the 'allure of empire', as Todd Porterfield has shown, generated innumerable landscapes, scenes of combat, the harem, the *hammam* and the slave market, lion hunts and desert caravans.[14] So celebrated were the battle paintings of Horace Vernet that *The English Woman's Journal* claimed the colony to be 'the scene of those picturesque and bloody wars illustrated by [his] daring pencil'.[15] In a recent overview, Roger Benjamin has pointed to the influence of Delacroix's example and the 'Gérôme paradigm', the impact of Fromentin's accounts of his travels as well as his paintings with their dashing horsemen, wild landscapes and urban scenes, and the promotion of Orientalist art by Théophile Gautier.[16]

Tutored amateurs as well as holiday-makers with no known propensity for sketching turned Algeria's sites into sights. Visiting in the early months of 1857, Bessie Rayner Parkes spent her time writing articles about the colony, plotting feminist ventures in the UK, walking and riding. She informed Mary Merryweather, '[i]f the weather would but dry, I should paint a great deal both in the old Moorish town and in the exquisite countryside.'[17] Even the radical Member of Parliament, John Bright, convalescing there in the winter of 1856, took drawing lessons, never having drawn before, and he sketched the places and monuments he visited. As the editor to his diary comments, 'The topic bursts into his diary unheralded and unexplained. . . . There is no evidence that he pursued the study of drawing after he left.'[18] Guidebooks were profusely illustrated and utilised a markedly pictorial language. Illustrated publications increased, as did maps and charts, archaeological reports and pictorial histories with full-page reproductions of fine art prints and paintings. In the 1890s an

English handbook on 'artistic travel' claimed that Algeria held 'everything that an artist could desire'.[19]

This 'pictorialising' not only placed Algerian land and peoples within European visual systems, but rendered them intelligible within them. Pictorialising made the imperial project possible. Algeria appeared to offer a seemingly endless visual spectacle. Like ores and agricultural produce, high art paintings, popular prints and illustrated publications were caught into a world market of commodities.[20] While they provided cultural capital, fine art and tourism also generated objects for trading and investment, things that had a social life.[21] Spivak emphasises that the new imperial cartographies were not simply two-dimensional surfaces. They had material form and substance. What emerges from the violence of the rift between earth and world is 'the multifarious thingliness [*Dinglichkeit*] of a represented world on a map'.[22] This emphasis on the materiality of the object recalls her earlier words to Elizabeth Grosz, that 'this worlding actually is also a texting, textualising, a making into art, a making into an object to be understood'.[23]

Spivak has no hesitation in identifying 'the planned epistemic violence of the imperialist project'. Her re-reading of Heidegger proposes that elite cultural forms were generated within the traumatic chasm between the already existing society and the new imperial order. In the colonial setting, the work of art was, therefore, not so much an expression of ideology as a product of cultural violence. Spivak's analysis breaks new ground in thinking the relations between visual culture and imperialism. Linda Nochlin compellingly argued that the barbarity of colonial conquest, imaged in numerous battle pictures, was transferred to paintings of native cruelty and destruction,[24] and W.J.T. Mitchell contended that the 'medium' of landscape, though inextricable from imperialism, 'does not usually declare its relation to imperialism in any direct way', representing instead 'something like the 'dreamwork' of imperialism' and disclosing both 'utopian fantasies of the perfected imperial prospect and fractured images of unresolved ambivalence and unsurpressed resistance'.[25] Spivak's theories on worlding suggest that violence was not so much a pre-condition, pretext or adjunct to visual culture. Rather, violence was integral to the making of landscape, for it was the 'planned epistemic violence of the imperialist project' which transformed earth into world.

'a texting, textualising': feminist subjects in the landscape

Algeria was advocated as 'a new field of exploration' to that novel tourist, the travelling feminist. *The English Woman's Journal* reported the adventures of the

> English ladies [who] have spared ten days of their valuable time to see this African colony . . . hurry back as fast as steam can carry them to 'the native coal-hole', their glorious England; to their

district visiting, their parish schools, their societies, associations and what not.[26]

Algeria was recommended as a holiday location where 'English ladies can walk alone in the town and environs of Algiers with as great comfort and safety as at home'.[27] Feminist writings not only offered the colony as a land distinct and differentiated from 'home' and the metropolitan centre, but they provided practical advice: Bodichon's guidebook published 'a quantity of miscellaneous information of the kind especially useful to English ladies landing in the unknown territory of Algiers'.[28] Excursions, sight-seeing, sketching and enjoying the scenery were all recommended.

Algeria Considered pitched into a new and expanding market. Local competition included J.R. Morell's illustrated *Algeria*, Rev. J.W. Blakesley's *Four Months in Algeria, with Maps and Illustrations after Photographs*, Walmsley's *Sketches of Algeria during the Kabyle War*, several volumes by English ladies, and numerous accounts in French.[29] Its accounts of Algeria's history and geography, customs and costumes were liberally extracted from the writings of Eugène Bodichon. While citation was a familiar textual strategy, his publications were given an enhanced status: his 'long experience as a resident physician enables him to speak with authority'.[30] The last chapter rewrote the first-hand travel narrative to tell of the journeys, first impressions and exciting adventures of middle-class 'ladies'. Emphasis was placed on the hazards of the enterprise and the daring resourcefulness of the travellers, equipped with arms: 'The place is so wild, and the Arabs look so stern and unfriendly, that it is a positive comfort to know Hilda has a capital little pistol with her, and knows full well how to use it.' Like all travellers' tales in which Europeans encounter intemperate heat, 'barbarous' peoples, strange customs, savage animals, wild 'untouched' countryside and picturesque views, these stories are embellished with more than a dash of exaggeration.[31]

If the Orient promised men (sexual) pleasures unobtainable in the west, Algeria offered women an escape from social convention: drawings included with the letter cited at the outset of this chapter and made for private circulation (Figures 3.1–2) broke most of the visual and corporeal codes of feminine propriety. Colonial space promised to fulfil feminist desires for an unchecked liberty of movement. In territories secured by military force, 'safe' and 'civilised' became keywords, their guarantee the security of 'English ladies'. During the Indian National Uprising of 1857–8, white femininity became the sign of imperial and national stability: any dangers to the safety of British women were considered as threats to imperial control (see Figure 4.9). In the making of feminist arguments, these writers drew on imperial and nationalist discourses about femininity which were also being used to refuse women's rights: feminism, no less than colonial insurrection, was perceived as destabilising.

Images and writings usually featured the lone traveller. The feminist's bid for independence, like the western voyager's fantasies of solitude, was heightened

by minimising or omitting the guides who furnished itineraries, pointed out the sites and translated from Arabic.[32] By disappearing the chaperones, the western artist or writer became the sole channel through which travel was mediated into text. 'Alone' therefore sutured a feminist sense of self to the imaginative projections of solitude necessary for the westerner's dramatic encounter with what was perceived as the unknown and uninscribed. But in neither case were experience and vision unmediated. The protocols of visual and literary culture as well as the race relations of colonial society framed what western women could see, recount and paint.

The pleasures of walking and riding, viewing and sketching landscape were, along with artists' materials, suitable clothing and footwear, transported from Europe to North Africa. Sketchbooks and letters were filled with drawings of women whose outdoor activities as much as their costume of loose jackets or capes, unsupported skirts, broad-brimmed hats, and sturdy boots or shoes, identified them as feminists whose attire was to be differentiated from the tight bodices and full crinolines of aristocratic ladies (Figure 3.1). They imaged themselves striding across the countryside, gazing over promontories, sketching, adventuring on excursions, and racing on horseback over a beach (Figures 3.1–2). A picture (now lost) painted by Barbara for her sister Annie 'in recollection of Little Atlas', portrayed two female figures pausing at the side of a ravine in the mountains; the artist is on horseback, sketching.[33]

In her analysis of 'worlding', Spivak argues that the experience of landscape, of riding through, looking at and reporting on land, was central to the European concept of the sovereign self. Although Spivak is writing about masculine subjectivities shaped for the exercise of British imperial power in India, a saturation in sensation, scenery and self was equally formative for the female militant.

In the later 1840s and early 1850s a group of young women friends developed a feminist politics of landscape when the development of tourism was shifting the sex and class politics of travel. They shared sketching and study tours, admired the views, took walks and went swimming.

> we sent the car on someway & then bathed alternately, under the free air of heaven, in the most utterly crazy Dianalike way, with no Acteon save a Mountain Mutton or two . . . like grecian nymphs who never had any sense of propriety. I felt positively an ennobled human creature . . .[34]

This experience of landscape enhanced a sense of self as a working, writing, painting, seeing subject.

Five small pen and ink drawings now in Girton College Cambridge depict a female figure or figures in mountainous scenery. Although one was signed by Bodichon, the authorship of the others is uncertain. In 'Barbara Leigh Smith in the pursuit of art, unconscious of small humanity', the figure advances purposefully, carrying her sketching materials, oblivious of a small child standing in her

pathway. A storm rages in the mountains behind her, and the words 'lightning' and 'thunder' are inscribed on the top left and top right corners of the paper. Neither the tempest nor the child deflect the woman artist who strides out purposefully, her body thrust forward, her attire and deportment at variance to that expected of a young respectable middle-class woman. 'Barbara Leigh Smith in ye Breeze' portrays her standing on a promontory, clasping her sketchbook and gazing ahead at the mountains beyond, while in 'BLS absorbed' she stands on a rocky outcrop, contemplating the hills before her. Parkes is astride a mountain gorge, clasping her volume of *Poems* (first published in 1852). Remote mountains and 'sublime' scenery, whether in Britain, Europe or North Africa, set the scene for the projection of a feminist subjectivity which was self-motivated, physically active and creative.

Algeria offered a plenitude of visual delight and sensory pleasure which was readily turned into pictures. Pictorial views of the scenery are scattered through feminist writings on the colony. The guidebook emphasises the visual appeal of the location: '[t]he scenery of Algeria is very beautiful, and offers great attractions to the tourist and the artist', '[t]here is plenty to see and sketch in the environs [of Algiers]'. Views out of the windows of the house 'will furnish *me* with many a subject'. The eye-witness describes a 'picture which *I* saw some days ago', of 'the wild scene, the wonderful colour of the whole, [which] made as beautiful a little picture as *I* ever saw or conceived of' and of the 'ever varying compositions of olive, cypress, Moorish houses, aloes, cacti and before us groups of Arabs, *ad libitum* . . . backed by the blue sea'.[35] Bodichon's essay for the journal, 'Algiers: First Impressions', is a series of compositional vignettes: the town seen from the sea, views out of windows and from the terrace, extensive panoramas of the bay and surrounding countryside, all scenes familiar in French travel writing. Offsetting these sweeping vistas is the old city, '[e]nchanting and disgusting, dirty and poetical', into which the traveller 'must penetrate to see what is really African, Eastern, and *par excellence* Algerian'. Far distant from the modernisation under way elsewhere, the old city was best visited 'with the Arabian Nights in your hand, or rather in your head and heart, and you will be transported instantly to the times of the good Haroun Alraschid'.[36] But only fleeting glimpses can be given of 'flights of steps', 'dark alleys like tunnels', 'a beautiful square court, arched round about'. The sudden bursts of dark and light, the heightened juxtapositions between opacity and visibility, convey the recurring tensions between desire and denial, seduction and repudiation.

French travel writers also utilised a markedly pictorial language. Presenting their written descriptions in the form of letters and in the language of pictorial composition they readily employed terms like *esquisse* and *croquis* (sketch).[37] At the opening of Pauline de Noirfontaine's *Algérie: un regard écrit* of 1856, the author states her aim 'to trace in my notebook some random, unconnected and unframed sketches, just as one throws on one's palette thick and unmixed colours, unfinished and nebulous studies'. For Noirfontaine, too, Algeria offers

an inexhaustible storehouse of images; its ocular delights and pictorial offerings may be savoured by the sea or in the mountains where the traveller will arrive 'at the extremity of the plateau from where one would discover one of these pictures of local poetry that invite an artist to take up the brush'. As in 'Algiers: First Impressions', the city and the port are gathered into an extensive panorama, framed by the ever-changing surface of the sea and luxuriant vegetation. Noirfontaine lyricises Algeria's profusion of flowers and shrubs, as does Bodichon in her descriptions of 'bushes of myrtle, white scented heath (*circa arborea*), lavender, gum cistus, juniper and firs', and her watercolours of asphodels, acanthus and blue iris. Well-read in contemporary literature on the colony, Bodichon shared with her French contemporaries a distinctively pictorial way of seeing.

Un regard écrit, which may be roughly translated as 'a written look/glance', comprises six letters, all of which fashioned their author as a feminine subject for whom a painterly language best conveys her visual impressions and sensations. Distancing herself from professional practice ('it's the business of painters and designers to sketch the outlines of a beautiful landscape'), the writer is content 'to say things as I have seen them, as I have felt them, as they have offered themselves to me'. As a woman she can do no more than offer her own observations, since 'it is an accredited opinion that women only halt at the surface of things and are incapable of going deeply into anything', so wittily turning popular opinion to her advantage. Bodichon emphasises out of the ordinary visual pleasures and artistic compositions, a vision of North Africa through the frames of European landscape.

> I have seen Swiss mountains and Lombard plains, Scotch lochs and Welsh mountains, but never anything so unearthly, so delicate, so aerial, as the long stretches of blue mountains and shining sea; the dark cypresses relieved against a back-ground of a thousand dainty tints, and the massive white Moorish houses gleaming out from the grey mysterious green of olive trees; the foreground full of blueish aloes and prickly cacti . . .[38]

But the violence of colonisation could disturb this appreciation of Algeria's picturesque beauty. In an essay by Parkes on the conditions of working women, the closely argued prose abruptly gives way to an account of a solitary excursion in 'wild hills' and 'scented glens' to 'a ravine of the most beautiful and romantic description':

> It winds about among the steep hills, its sides clothed with the pine, the ilex, the olive, and with an underwood of infinite variety and loveliness. Wild flowers grow there in rich profusion, and under the bright blue sky of that almost tropical climate it seems as if anything so artificial and unnatural as our systems of industry could hardly exist for shame;

yet in that very valley young female children are at this very moment, while I speak and you listen, winding silk for twelve clear hours a day!

The vision of 'untrammelled nature' is abruptly displaced by the sight of a French-owned silk-winding enterprise. A matter of national concern in France, the silk industry had been revived by Empress Eugénie's choice of flowered silks and these fabrics, selected by Mme Moitessier for her second portrait by Ingres, became extremely fashionable in the Third Republic.[39] Confronted with 'what perhaps in Europe might never strike the heart with equal vividness', the narrator abandons lyrical description for dry irony to conclude that 'our modern civilisation is in some respects a very singular thing when the kind hearts of a great nation best show their kindness to orphan girls by shutting them up to spin silk at a machine for twelve hours a day from the age of thirteen to that of twenty-one'.[40] The colliding forces of the text, intense visual, corporeal and sensory pleasures, pity for the native women, concern for their working conditions, measured criticism of imperial exploitation, are held together by a narrating subject who recounts her sensations and reflects that 'whenever in after spring days I walked over the wild hills and scented glens of Algiers' she will recall what she has seen.

The feminist subject slipped between Algeria and Britain. Parkes's essay, with its first-person narration, was published in the journal, having been delivered as a paper at the National Association for the Promotion of Social Science in August 1861. A later paper by Bodichon described the excursions made by a group of 'English ladies [who] have spared ten days of their valuable time to *see* this African colony', and whose metropolitan modernity was juxtaposed to the historic queens, archaic sights and landscapes that are Algeria. The travellers will 'hurry back as fast as steam can carry them to 'the native coal-hole', their glorious England; to their district visiting, their parish schools, their societies, associations and what not'. But, she continues, two of them 'will often recall that beautiful picture, the blue sea seen through the ruined arches of Selena Cleopatra's aqueduct, as they walk together along the bald, blank, streets of London'.[41]

Such 'memorable views' might be steeped in pleasurable recollections of friendship and a productive exchange of ideas, a sense of autonomy, the novelty of tourism. They might be charged with differentiations between Britain's modernity and industrialisation and perceptions of Algeria as 'untrammelled nature', untouched, unspoiled, uninhabited. Equally they might be shot through with troubling sensations of difference and un/comfortable responses to colonisation. But most of all they were memorable as views, for what differentiated Algeria from the 'bald, blank, streets of London' was its pictorial disposition. The colony was perceived as artistically composed views: quick sketches of the scenery, glimpses out of windows, formal panoramas from high vantage points and extensive vistas of supposedly empty space. 'Worlding' involved 'pictorialising'.

Disavowing the violent dislocation of colonisation, this pictorialising fostered a two-fold disposition of land: into the artistically arranged landscape views of visual culture and into the new physical geographies of colonisation. Homi Bhabha's attention to the multiple significations of 'disposal' and 'the strategies that articulate the range of meanings from "dispose to disposition"' is particularly helpful.[42] According to *The Oxford English Dictionary*, disposal conveys several meanings in which power and regulation coincide, including the 'action of arranging, ordering or regulating by right of power or possession', 'action of disposing of, settling or definitely dealing with' and 'power or right to dispose of', where dispose may signify both making arrangements for and getting rid of. 'Disposition' may signify setting in order and arranging, to have at one's disposal, inclination, physical aptitude or constitution. Taking up these multiple significations in a discussion of colonial authority, Bhabha argues,

> Transparency is the action of the distribution and arrangement of differential spaces, positions, knowledges in relation to each other, relative to a discriminatory, not inherent, sense of order. This effects a regulation of spaces and places that is authoritatively assigned; it puts the addressee into the proper frame or condition for some action or result. Such a mode of governance addresses itself to a form of conduct that equivocates between the sense of disposal, as the bestowal of a frame of reference and disposition as mental inclination, a frame of mind.[43]

The seizure and cantonment of land, urban development, agri-business, European industries and their infrastructures all disposed of earlier forms of land use and ownership, while they disposed Algerian land into new arrangements. Ordered by a raft of laws and decrees, this 'regulation of spaces and places', which was as Bhabha suggests 'authoritatively assigned', changed the appearance of Algeria and the disposition of countryside, settlements and populations. Spatial reorganisation rendered the colony more accessible to view: roads and railways underpinned a flourishing tourist industry and tourist literature positioned readers and travellers as viewers.

This unsettling of land into landscape, into a category of western art, was achieved by the use of well-established procedures. Paintings, like letters and published accounts, depended on citationality and repetition. As Gayatri Spivak has put it, 'what is at stake is a "worlding", the reinscription of a cartography that must (re)present itself as impeccable'.[44] These artistic and literary protocols may be identified among the 'rules of recognition' distinguished by Bhabha as the characteristic procedures, forms and modes of address of colonial discourse, all of which call for common consent. In landscape painting, these 'rules' regulated the disposition of the scenery, provided points of view and offered authoritative frames of reference which allowed the strange to be presented within the familiar. Indeed, they are what enabled portrayals of land to be recognised as 'landscape'. In mid-century Algeria perceptions of land were thus

86

caught between, in Bhabha's words, a 'sense of disposal, as the bestowal of a frame of reference' and 'disposition as mental inclination, a frame of mind'. And yet neither western landscape nor colonial authority could remain untouched in this encounter. If Algeria was turned into pictures, the authority of western vision and western landscape was in this pictorialising process disturbed.

'a making into art, a making into an object to be understood'

The British community in Algiers included a number of artists who visited or settled in the colony. For some, like Fred Walker, a brief sojourn had little impact on exhibited paintings. Those who portrayed the country and its peoples preferred an exoticism factored from topography and description, at variance to the violence and sensuality favoured by their French counterparts. Paintings and watercolours visualised a recently colonised land, less for its col-onisers than for an educated middle-class market in London. The British press provided detailed coverage and comment on events in North Africa and regular features on the pleasures of travel and tourism. Denunciations of French brutality stirred up an intense nationalism as well as a sense of imperial superiority. Although the British declined the Amir ʿAbd al-Qādir's appeals for assistance, his long resistance, imprisonment and exile prompted a romantic sympathy for him.

Paintings and watercolours give little indication of the profound changes taking place within Algerian agriculture, the countryside and the built environment, or the transformation of social organisation, cultural and religious life. The images considered here portray a land before or after colonisation, rather than a society caught up in and traumatised by its chaotic intervention. What is brought into view is scenery without boundaries stretching far into the distance, that seemingly 'uninscribed' land which, in colonial discourse, is available for exploitation. Equally what is pictorialised may be construed as the aftermath of intervention, when hersdmen tend their flocks on the scrublands and hillsides to which they have been exiled. In contrast to the crowded scenes painted by many of her contemporaries, in Bodichon's works the native popu-lation is marginalised or diminished to give an impression of vast swathes of uninhabited and largely uncultivated land. It is the vacancy of these views which lends them to Spivak's analysis of the 'worlding of a world on a supposedly uninscribed territory'. Drawing on and extending the conventions of Euro-pean Orientalism, figure studies by Eliza Fox, Emily Mary Osborn and Ger-trude Jekyll depicted Algerians at prayer, conversing, dancing, playing games and in repose (Figures 3.5–3.7).

For British audiences, Bodichon's regular exhibitions of Algerian landscapes provided a pictorial gazetteer of the colony. *The Illustrated London News* wrote of her exhibition of 1864:

The drawings, like other series which have preceded them[,] represent scenes in Algeria, and comprise views of the towns and district about Algiers; of that angry sea, as it were, of hills and mountains, the homes of the hardy Kabyles; and of various points along the coast, with its azure Mediterranean and glowing golden shore; together with representations of forts, chateaux, villages and tombs; of the luxuriant growths of flowers, palms, aloes, prickly pears and giant plants of all kinds; and of the climactic phenomena and strange aspects of the sky from wind, rain, etc.[45]

But the artist's repertory was by no means as extensive or comprehensive as was here suggested. As a western woman, what Bodichon saw and could depict was as much shaped by the sexual and racialised formations of difference in the colony as by visual procedures. Some titles and works hinted at a particularity of place: Algiers, the Hydra Valley, the Plain of the Metijda, Point Pescade or the old walls of Mansoura. Others such as *Arab Tomb near Algiers*, *Cactus Grove*, *Interior Court of an Old Moorish House*, *The Province of Oran*, *Algiers* were decidedly imprecise and could work synecdochically. Tlemcen, the Gorge of the Chiffa in the Atlas Mountains, and the Roman aqueduct near Cherchel (see Figure 3.8) testify to a European predilection for locations already well known from guidebooks, tourist itineraries, antecedent imagery, colonial histories or archaeological reports. When views of Sidi Ferruch were exhibited in 1859 and 1861, reviewers explained that this was where the French had landed in 1830.[46] The proliferating repetition of sites was characteristic of travel culture; as Said has commented of Orientalism, it is 'after all a system for citing works and authors'.[47] Like many others, Bodichon screened out the *colonies agricoles*, although these settlements were extensively mapped in French histories and

Figure 3.3 Barbara Leigh Smith Bodichon, *Sisters Working in Our Field*, c. 1858–60

discussed in her own writing. She also neglected the mining areas featured in occasional engravings, preferring the bay and town of Algiers, perhaps the most represented scene in the colony.[48] By taking a distant view, her images like so many others strove to reconcile the visual disjunctions between French Algiers and the old city higher up the hill (Figure 3.3). The French attempted to reorganise the city of al-Jazaʿir by imposing a distinctive architectural style and a geometrical grid of streets and squares which demolished existing structures to 'establish a visual order that symbolised colonial power relations'. The city and its architectures became, as Zeynep Çelik has indicated, 'contested terrains in the confrontation between coloniser and colonised'.[49]

Bodichon's depictions of Telegraph Hill and the water tower near Algiers registered some of the changes taking place. An unusual subject in visual culture, the telegraph became (like the steamship) a sign of the proximity, convenience and modernity of Algeria. On her first visit Parkes counselled a correspondent to 'remember that tho' the distance between us is great, the steam communication makes it but little and they are talking of an electric telegraph over the Mediterranean! half an hour to London!'[50] Colonisation was transforming not only the landscape but also relations of space and time. In a compelling essay on time, space and the geometries of power, Doreen Massey has challenged David Harvey's views that the sense of increasing speed in the pace of life and the disappearance of spatial barriers, so that 'the world seems to collapse inwards upon us', were brought about by the expansion of capitalism and development of technology. For Massey, attentive to questions of gender and imperialism, 'time-space compression' was a distinctive and particularly local experience for the western traveller and colonist.[51]

While Bodichon occasionally depicted the fertile agricultural areas, her surviving works more commonly testify to a fascination with the desert, mountains and scrublands (Figures 3.4). Finished watercolours were enhanced by an

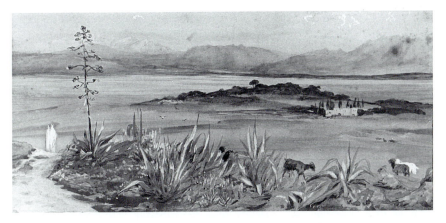

Figure 3.4 Barbara Leigh Smith Bodichon, *Near Algiers*, 1860s

elongated format and sketches were made across an opening to provide pan-
oramas of seemingly uninhabited, uncultivated land. If an expansive view was a
well-known aesthetic pleasure (as *The Art Journal* reviewer acknowledged when
enjoying the 'undulating sweep of the arid and far stretching plain' in *Tlemcen,
Oran*),[52] it also facilitated fantasies of possession and exploitation. Algeria was
perceived as an uninscribed, uninhabited earth awaiting intervention. This fun-
damental principle of European military, commercial and imperial desire was
restated in feminist papers as much as elsewhere. Echoing the imperialist senti-
ments of her husband that the Arabs were a feckless lot whose nomadic way of
life laid land to waste, Bodichon applauded

> civilisation, cultivation and population, [which] year by year, win more
> and more land from the enemy; and there is no doubt that all this fertile
> plain will, by and by, be, as it was in the old time, the seat of numerous
> and prosperous towns, and waving cornfields.[53]

Readers of the journal would have been familiar with such perceptions, Maria
Rye arguing for emigration on the grounds that 'the colonies, quite as much
our own though they are thousands of miles away, remain year after year
uninhabited wastes without man or beast.'[54] Matilda Betham Edwards's
account of an excursion made with Bodichon in 1866 and 1867 similarly
emphasised Algeria's wilderness:

> For the most part the country was uncultivated and uninhabited.
> There was no foliage excepting that of stunted olive, tamarisk and
> palmetto, and nothing to break the universal monotony but here and
> there a douar or Arab village consisting of a cluster of tents, held in by
> walls of wild cactus.[55]

That this emptiness was carefully staged in finished watercolours is indicated by
sketches made when travelling. On a page of a very small sketchbook Bodichon
noted with a few quick lines of a pencil the tents and fixtures of a settlement.
Written notes signal a human presence – 'early morning', 'all asleep in the
tents' – while the colour jottings point to future use in the studio. Yet surviving
watercolours, donated by the writer to Hastings Art Gallery, suggesting that
they date from this excursion, portrayed a space cleared of habitation or
cultivation.

While the infrequency of figures may be attributed to Bodichon's artistic
inexperience, there is in common with much Orientalist painting a general
impression of a population arrested in time and space. The native figures are as
immobile as the architecture they accompany. In *A Sketch in the Hydra Valley
near Algiers* one man reclines beside a tree while another is seated on the
ground; in *Roman Aqueduct, Algeria* a male figure stands still. Arrested in time
and in space, they are quite unlike their counterparts in the artist's British

scenes: in *The Sea at Hastings* two fishermen busy themselves beside a boat while in *Oxen and Silver Birch* two woodmen are at work.[56] Exceptions include herdsmen tending their flocks (as in Figure 3.4), and there is nothing of the animated exchange taking place in the fruit shop portrayed by Jekyll (Figure 3.5). Osborn's *An Algerian Mirror*, shown at the Grosvenor Gallery in 1883, in which a woman seated at the edge of a pool, deep in the shadows of a garden, contemplates her likeness in its mirrored surface (Figure 3.6), conveys the simplicity of a culture in which time passes imperceptibly and the still surface of water provides a reflection. Corporeal atrophy could play into an imperialist discourse on indolence which was, as Anne McClintock indicates, a discourse on work in which productive labour was allocated to Europeans.[57]

In racialised contrast and gendered opposition, movement is assigned to western women. In Bodichon's *Sisters Working in Our Field* (Figure 3.3) two members of the Order of Charity of St Vincent de Paul are portrayed working the land, whereas in another watercolour they are exercising a distinctly European privilege of moving at leisure.[58] This activity jars against the stasis of native figures and their forced displacement. Catholic sisterhoods, as Reina Lewis suggests, were surrounded by controversy. To British (but not French) gallery-goers, nuns recalled altercations about Catholicism and the Anglo-Catholic revival. They could also represent Christian Europe mythically united

Figure 3.5 Gertrude Jekyll, *Fruit Shops, Blida* [1873–4]

in opposition to heathen Islam. In feminist discourse they offered exemplars of 'women's mission to women', embodying the feminine values of charity and moral supervision. Henriette Browne's paintings of the Sisters of Charity were greatly praised by Anna Blackwell. Bodichon applauded the hospital, nursing and prison visiting of the Algerian house of the international Order of Charity of the Sisters of St Vincent de Paul.[59] But not everyone was convinced. In her indictment of the silk-winding factory, considered earlier, Parkes was sceptical about the involvement of the Sisters who superintended the child workers, and for one contributor to the guidebook 'Algeria [was] over-run with all orders of nuns and monks, they spring up in every new settlement like mushrooms and do not enjoy a very good reputation.'[60]

Titles of exhibited figure paintings such as Fox's *Return of the Caravan* (RA 1867) or her *Arabs at Prayer* (Figure 3.7) suggest mainstream Orientalism, as do the depictions of weddings, funerals and religious rituals of Fox's *An Arab Marriage* (RA 1871) or Bodichon's *Talking to the Dead*. With their attention to costumes and settings, Jekyll's street scenes and Fox's figure studies (Figures 3.5 and 3.7) participated in a widely held interest in 'manners and customs'. Proliferating racial typologies and hierarchies filled the pages of historical accounts and travel writings published in Britain and France. *Algeria Considered* presented the population as a series of visual types: races could be *visually* differentiated, minutely discriminated. Writing of the centrality of visuality in attempts to control indigenous populations, Bhabha notes, 'the bind of knowledge and

Figure 3.6 Emily Mary Osborn, *An Algerian Mirror*, 1883

Figure 3.7 Eliza Fox Bridell, *Arabs at Prayer* [1863–7]

fantasy, power and pleasure, that informs the particular regime of visibility deployed in colonial discourse', drawing attention to the tensions between desire and denial in the proliferation of colonial stereotypes.[61]

Eugène Bodichon wrote extensively on the distinctions between Arabs and Kabyle, his views contributing decisively to a racialised division in French colonial theory and policy between the latter, characterised as settlers who were amenable to the French civilising mission, and the Arabs who were not.[62] Although Barbara Bodichon accepted the Arab/Kabyle distinction and the premise of visual contrasts between them, her account of the Arabs has none of her husband's fantastic descriptions, underwritten by his medical authority, of a people with large necks, hairy skin and big feet whose anatomy registered their unreliable and dogmatic nature. Her essay 'Algiers: First Impressions' is flooded with pictorial perceptions from views of the harbour and the old town to the visual delineations of race.

> When the traveller is fairly and comfortably installed in his hotel on the Place . . . nothing can be more striking and amusing than the motley crowd which he will see from his window: there a mass of Arabs, perfect in their national dress, the long classical woollen drapery, white and flowing, the linen head covering bound round by a fillet of camel's hair cord; their faces, long, handsome, and expressive, their feet bare, and their hands and arms in continual action as they discuss. . . . Near them stands the Kabyle, who has taken kindly to French civilisa-tion, by his square face, his round head, and his blue eyes, you see at once he is quite a different creature from the Arab his neighbour. The Kabyle has bare legs and gaiters of skins, and what we remark of French civilisation is a sack, which he wears as a shirt. . . . Here stand a group of Spanish workmen in blue jackets and trousers . . . Moorish women all in white glide about like phantoms . . . a tall Negress, clothed in one long garment of dark blue cotton from head to foot, leaving her arms bare which are decorated as well as her feet with massive rings of gold.[63]

The jostling of races and cultures in Algiers, as well as the visual distinctions between them, was by no means limited to the travel writing but present in paintings, reviews, museum displays, exhibitions and scientific publications. This 'divisive deployment of the discourse of race' has been identified by Gayatri Spivak as a central strategy in 'worlding'.[64]

Algeria was visualised not only as an exotic location but also as a place of dereliction and decay. Bodichon's *Talking to the Dead*, a twilight scene with 'an intense feeling of quiet and solitude', pictured a woman mourning at a grave.[65] In *An Algerian Burial Ground* (with her sister Annie Leigh Smith),

> [w]omen and children, some veiled after the Eastern fashion, are huddled into a graveyard, itself a wilderness, overgrown with weeds,

palms and cactus. A festival in memory of the dead, is as here represented, usually a holiday in which joy and sorrow . . . in smiles and tears.[66]

Images of mourning were also to be found in recurring landscapes of graveyards and views of *marabouts*, the tombs of the saints. Of *The Hydra Marabout, after Sunset* shown at the French Gallery in 1861, *The Athenaeum* commented on

a solemn-looking country covered with shrubs, after the sun has gone down, leaving only orange bars in the sky; a ghastly white tomb stands in its lonely aisle of trees; the hills beyond look icy cold in their purple gloom.[67]

With only occasional scenes of mosques and tombs and no images of Koranic or Jewish education of the kind provided by Henriette Browne,[68] Islam's presence was minimised while other religions and popular cults which survived from the pre-colonial period were reduced to curiosities. The subject of Bodichon's *Negro Woman Sacrificing at St Eugène, Algiers* might have been lifted straight out of the guidebooks, which recommended 'Moorish women, with their attendant negresses . . . performing ceremonies savouring of sorcery and fetichism'.[69] Curiosity about these rituals was decidedly western: Parkes enjoyed viewing 'a pagan ceremony among the Arabs', and researching it in the library.[70]

When first exhibited, Bodichon's Algerian scenes were dismissed as untruthful. In 1858 *The Athenaeum* considered them to be 'glassy and grey in colour', conveying 'the effect not of heat but of cold'. The following year this paper judged her work 'raw, harsh and colourless', *The Arab Tomb near Algiers* having 'the fresh-grey bloom colour that an unpicked cucumber wears'. The artist was charged with disappointing the expectation that above all the Orient was colourful. Support came, not surprisingly, from *The English Woman's Journal* which hailed her studies as 'a faithful transcript of the country', its critic praising her 'boldness, truth and fidelity'. In 1861 Bodichon's solo show was well received. For *The Observer*, the 'principal charm' of her watercolours 'consists in their obvious fidelity to nature' and even *The Athenaeum* admitted that '[s]ingular as these appear, they have a truthfulness and consistency of expression which indicate their complete fidelity.' Some years later, Eliza Fox's figure paintings were similarly acclaimed as 'truthful'.[71] In analysing 'worlding', Spivak emphasises that the British in India claimed accuracy and authority for their maps. Challenged by photography's profession of exactitude, claims for the veracity of painting rested on Ruskinian discourses of truth to nature and for works by artist-travellers beliefs in the trustworthiness of first-hand experience.

Bodichon's landscapes relied not on detail but citation. *Roman Aqueduct near*

Cherchel, Ancient Julia Caesarea portrays the great bridge of a massive aqueduct built in the reign of Juba II, descendant of the royal house of Numidia (Figure 3.8). A daring piece of engineering, the aqueduct included a three-tier bridge of ten arches and a great bridge, pictured by Bodichon, 228 metres long and 26 metres high.[72] The artist considered the aqueduct to be of interest because of its associations with Cleopatra Selena, the wife of Juba II and daughter of Antony and Cleopatra.[73] For reviewers the portrayal of a crumbling ruin against the declining rays of a sunset evoked melancholy, *The Spectator* critic remarked:

> The profiles of the ruinous and deeply toned arches are strongly relieved against a sunset sky of greenish blue, falling into orange, and intersected by long bars of purple cloud. The solitary stork and the tall rushes gently blowing in the evening breeze, heighten the desolation of the scene.[74]

Far from the sublimity evoked by David Roberts's watercolours, this is a scene imbued with romantic sentiment. For British and French visitors alike, Algeria's history was in ruins, its monuments disintegrating: visiting Tipasa, one of its most famous sites, Richard Cobden noted the wreckage of the past scattered across the site.[75] In her now classic study of Orientalism, Linda Nochlin comments that '[n]eglected, ill-repaired architecture functions . . . as a standard topos for commenting on the corruption of contemporary Islamic society.'[76] Ruins, like disrepair, could suggest the dereliction of North African regimes and the corresponding need for firm western intervention to ensure, among other things, the preservation of an architectural heritage. This 'worlding' reduces Algeria to the vestiges of a glorious past, only the relics of which remain, so facilitating comparisons between ancient grandeur and recent decline. Visual precedents from imagery of the surviving monuments of Rome to the majestic painting by Hubert Robert of *Le Pont du Gard* (1787), which Bodichon may have seen at the Louvre, summon not the Ottoman empire

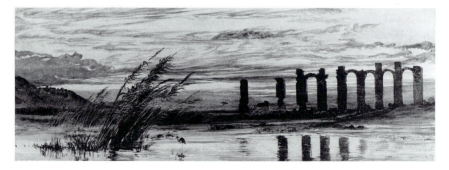

Figure 3.8 Barbara Leigh Smith Bodichon, *Roman Aqueduct near Cherchel, Ancient Julia Caesarea*, 1860s

whose three hundred years of dominion over Algeria ended in 1830; rather they (re)inscribe Algeria into a European history and artistic legacy. To portray Roman ruins was to locate the colony's far distant past, a move which not only disavowed the present but which demarked this land from the modernity of the west. But there was perhaps more at issue. Osman Benchérif considers that support for invasion and colonisation was justified as the repossession by Christian Europe of the ancient Roman empire in North Africa. In a long tradition of writing about the sacred mission of Christian Europe to restore the light of civilisation to the provinces of ancient Rome, Islam represents the forces of desecration and fanaticism.[77] In the broad spectrum of responses to Bodichon's watercolours, Roman ruins could well have evoked reflections on current events and the ancient past, as well as meditations on long-standing religious conflicts.

Like others before and after her, Bodichon drew on western pictorial conventions, making an eclectic and diverse use of the art of the past as well as contemporary British and French landscape painting. Through the laws of perspective and composition, the artist arranged land as landscape, invoking the weight and tradition of western art. Artistic precedents for the disposition of land into landscape may be included among the 'rules of recognition' defined by Bhabha as 'those social texts of epistemic, ethnocentric, nationalist intelligibility which cohere in an address to authority'. Bhabha argues that 'the acknowledgement of authority depends on the immediate – unmediated – visibility of its rules of recognition'.[78] In visual terms these 'rules of recognition' offered to make sense of 'a discontinuous and alien landscape'.[79]

Tried and tested compositional formulae recur. An artist with very little formal art education, Bodichon's unsophisticated technique exposes the making of landscape with particular clarity. Many watercolours rehearse well-known formats from the English watercolour tradition, examples of which she would have copied. Some use a pictorial format very loosely derived from the art of Claude Lorrain and his followers, in which the landscape is formally organised into contrasting bands of light and shade and in which trees or architecture frame or punctuate the scene to lead the gaze across and into the pictorial field. In *Roman Aqueduct, Algeria* a tall tree to the left introduces the aqueduct, a note of interest in the middle ground. Organised horizontally, a version of this arrangement could be pressed into service for the rendition of desert scenes and interior plains (Figure 3.4). Claude's landscapes had been reworked for more than a century to shape an allegory of the fluctuating fortunes of empire and a vision of an arcadia in which order was imposed on the mutability of the natural world.[80] These frames of reference also offered points of view: a high exteriorised vantage point for an extended panorama could facilitate imperialist fantasies of boundless possession. A lower viewpoint for towering mountains could inspire sensations of sublimity and awe. Other compositional frames extended accessibility: a path through a cactus grove, mimicking a winding trail through a woodland copse, invites the spectator to enter the

scene. Sweeping vistas of seashore and hinterland conjured memories of the glittering coastlines of the southern Mediterranean. Although the Bodichons owned at least two French Orientalist paintings, it was the work of the Barbizon artists – Corot, with whom she studied in 1864, and Hercules Brabazon, with whom she often painted – which shaped her compositions.[81] Algeria was visually encompassed within the artistic traditions of Europe. Such visual moves played into long-standing fantasies about the Maghreb: as a liminal area which could be a part of Europe, a boundary between two continents and/or Europe's other.

As well as visually pleasurable well-regulated pictorial fields, these visual formulae offered reinscriptions of history. Tlemcen (the capital of ʿAbd al-Qādir), Cherchel and the Gorge of the Chiffa were imaged as picturesque tourist sites rather than as a centre of resistance, a town occupied by the French in 1840 or a site of brutal conflict. Johannes Fabian has drawn attention to temporal distance as a mechanism of alterity: he argues that the invocation of an earlier time differentiates and distances the other from the present of the western spectator or reader. This timelag involves a 'denial of coevality' as well as a disinclination to acknowledge the colonial present successfully located beyond the frame.[82] Colonial violence was thus disavowed by the formal ordering of space and time and by the still, contemplative figures which offered scale to a monument or distance to a view. It was not only that, as Bhabha has indicated, 'colonial domination is achieved through a process of disavowal that denies the chaos of its intervention', but that the aesthetic became a central mechanism of this disavowal, a refuge from the threat of the other.[83]

To represent North Africa within the western conventions of landscape was not only to (re)inscribe it but to frame it within a pre-existing pictorial order. In *The Truth in Painting* Jacques Derrida indicates that the placing of a frame entails much more than the making of a container, an edge or a border. Framing, he contends, is a field of force, a violent enclosing which subjects both the inner field and the boundary to the pressures of restraint, demarcation and definition.[84] Taking up Derrida's insights, it can be argued that landscape painting attempted a violent enclosing of land within the frameworks of western aesthetics and visual conventions. Not only was painting generated in and by conflict (this is the central argument of Spivak's appropriation of Heidegger) but landscape's pictorialising denied the trauma of colonisation. The aesthetic was of paramount importance in the 'worlding' of Algeria, for it was one of the mechanisms which produced the work of art as art, which made it 'into an object to be understood' as art. Derrida proposes that 'a discourse on the frame'[85] defines and regulates what is judged to be intrinsic or extrinsic to the work of art as well as producing and delimiting the domain of the aesthetic. In commenting on Kant's theories of aesthetic judgment, Derrida contends that 'the value oppositions which dominate the philosophy of art (before and since Kant) depend . . . in their pertinence, their rigor, their purity, their propriety', on the *parergon*.[86] From the Greek, meaning 'around' (*par*) 'the work' (*ergon*),

the *parergon* is 'a hybrid of outside and inside'; akin to a frame or framing device, it is both part of the work and yet separate from it. Yet Derrida goes further to suggest the *parergon* as a 'formal and general predicative structure, which one can transport *intact* or deformed or reformed, *according to certain rules*, into other fields, to submit new contents to it'.[87] This suggestion assists the proposition here that landscape painting in the colonial context entailed a double framing: the formal presentation which made the image into an art object for aesthetic contemplation, and the visual framings of land within western visual systems and artistic protocols, within those formal structures which could be transported 'into other fields'.

Public exhibitions in the nineteenth century demanded that the work of art be presented within a frame; watercolours would have been additionally bordered by a mount, perhaps edged with gold. Framing was one of the principal means for transforming the art work into a finished piece suitable for public display, and artists often took considerable trouble with framing and often had frames made up to their own designs.[88] Bodichon's Algerian watercolours were not easily packaged and their presentation troubled Parkes, commissioned to prepare them for show (and sale) at the French Gallery in spring 1861. She wrote to Bodichon,

> I moved heaven and earth to get them ready . . . 3 only turned up at the last minute. . . . I was frightened out of my wits; however Ellen Allen found them & got them mounted & framed in time.[89]

As Parkes recognised, these watercolours could not be offered for public view without the appropriate container. Wrapping round the work, the frame acted as a border between what may be said to be inside and integral to the work of art and that which may be said to be extraneous to it. The frame isolates and delineates the object from others while making it like them. The separation enacted by the double framing of these landscapes, within the containers necessary for exhibition and sale and within artistic conventions of western painting, may be construed as a movement of cultural violence which disavows colonial violence.

Yet framing is a process that is not always or necessarily achieved; disjunctions occur, Derrida writes, when 'the frame fits badly'. It could be destroyed by the very forces that imposed it. Derrida writes of a 'gesture of framing, which, by introducing the *bord*, does violence to the inside of the system and twists its proper articulations out of shape'. At the same time this field of force pushes the devices of restraint along (with) the borderlines to breaking point, so much so that the frames split: 'a certain repeated dislocation, a regulated, irrepressible dislocation . . . makes the frame in general crack, undoes it at the corners in its quoins and joints, turns its internal limit into an external limit'.[90] The frame is much more than a simple division between inside and outside. A distinct entity in itself, a third component in what is otherwise a binary

opposition, the frame moves between both fields: seemingly fixed and rigid, it is both highly mobile and subject to movement and fracture. The very force of framing, the epistemic violence of imperialism, causes its dislocation. The setting of a *bord* or border not only marks a limit, but also precipitates the over-flowing of the boundary and of the meanings for the field delimited by the frame, thus *débordement*, a textual movement of over-spillage, dispersal and deferral. Framing could thus generate seepage, contamination, mutation, hybridisation as fields seemingly divided intermingled.

The framings of western visual culture worked as supplementary to produce landscapes that were neither Africa nor Europe, but comprised of an admixture of elements. Architectural motifs, such as the domed tombs of the saints of Islam, added to and displaced architectural fragments of ancient Rome. While pine trees and precipitous mountains are familiar elements in western landscape painting, the specific ranges and their disposition to the plains are geographic-ally distinct. Aloes, asphodels, cacti, palms, rushes and bamboo hint at a Medi-terranean or Maghrebi location, as do the herdsmen in local dress. These are hybridised landscapes forged in an encounter between several cultures and patched together from disparate, dissonant elements which in the logic of supplementarity jostle against, add to, replace and break into one another.

To identify these views as hybridised is to invoke Bhabha's powerful analysis of hybridity as 'the sign of the productivity of colonial power, its shifting forces and fixities' and as a register of the precariousness of its authority.[91] Bhabha accounts for the agility of colonial authority, its indirectness and dispersal into adjacent cultural forms such as the imagery produced by British women in Algeria. The hybridised forms of Bodichon's landscapes are by no means unique to the artist. Rather their tensions are those of the genre of topography in the colonial context: at once a portrayal of a specific location so as to be recognisable to its audience and simultaneously an art object framed by 'rules of recognition'. Running through the literary texts and visual images con-sidered here are equivocations of desire and denial, seduction and repudiation, visuality and opacity, irresolutions in the visual field between the familiar and the strange, home and away. The mutation of western artistic forms and fram-ings may also indicate a disruptive force within visual representation which calls authority into question. For Bhabha hybridity breeds uncertainty – there are no guarantees that authority will transfer in the colonial context – and it proliferates difference to an excess beyond representation. And it is that uncertainty of representation with which this chapter began.

4

HARRIET HOSMER'S *ZENOBIA*
A question of authority

Authorship and authority

In 1862 *Zenobia*, a statue by Harriet Hosmer, an American artist working in Rome, was sent to London for inclusion in the International Exhibition (Figure 4.1). Zenobia challenged the authority of the Roman empire, claimed territories from the Euphrates to the Mediterranean and with her leading general Zabdas invaded and conquered Egypt. She ruled Palmyra from 267 to 272 CE, first with her husband, Odenathus, and after his death as regent for her son, turning this caravan city and trading centre specialising in luxury goods, located between the coast and the valley of the Euphrates in what is now eastern Syria, into a centre for an expanding empire. Leading Hellenic savants, including Longinus, gathered there. Caught between the crisis of Roman empire, the challenge of the Persian empire and the religious ferment of the third century, Palmyra's expansion was tolerated until the Emperor Aurelian came to the imperial throne in 270. After defeating her forces in two battles and laying siege to Palmyra, he demanded submission; she refused, sending him an eloquent letter of defiance written in Greek rather than Latin. Having escaped from the besieged city, she was captured and taken to Rome, where she was paraded through the streets in Aurelian's triumphal procession.[1] Seven feet in height, the exhibited work, like the full-scale copies, has since disappeared, although a smaller version survives (Figure 4.2).[2]

In London as in America, Hosmer's statue met acclaim and dissension.[3] The critic of *The Art Journal*, J. Beavington Atkinson, considered *Zenobia* 'a noble figure, of queenlike dignity [in which] the carefully studied drapery pronounces the classic style'; it was 'a figure of command, with an elaborate cast of classic drapery'. Francis Turner Palgrave, author of the controversial *Descriptive Handbook to the Fine Art Collections in the International Exhibition of 1862*, was far more critical:

> We must point out that where the artist aims at individuality and fails, this failure is fatal to high rank in art. . . . Take Hosmer's 'Zenobia', where beside the conventional treatment of drapery, so little like

nature, and the display of polished ornament in the tasteless modern Italian style – neither attitude nor expression appear expressive of more than a proud, indolent woman, where we are led to expect a likeness of the gallant Queen of Palmyra.[4]

The exhibition focused attention on the current state of sculpture. Whereas Atkinson was optimistic and up-beat, Palgrave denounced extravagance, emptiness, the 'sweetly-pretty' style and contemporary neo-classicism. For him, Zenobia was a failure, not only on account of the drapery, decoration and smooth finish but also because of the sculptor's rendition of her subject. Worse was to come. Some months after the closure of the exhibition the most damning criticism was made: that Hosmer had not made the statue herself.

Responses to *Zenobia* depended on the range of visual imagery available to spectators, their ideological frameworks, social and geographical location, and their sexual positioning. In Britain *Zenobia* aroused controversy in a climate heightened by altercations over women's rights, their achievement in the arts and their position in contemporary society. The International Exhibition provoked dispute over ethics and aesthetics. Its opening dramatised the British monarch's virtual disappearance from public life, which in turned changed the meanings accruing to the image of a queen. While these considerations of sovereign power would have been of less interest in republican America, concerns about slavery and abolition preoccupied audiences on both sides of the Atlantic.

Art criticism, visual culture, feminism and race were complexly enmeshed in struggles over knowledge and power, at the centre of which were debates about women as subjects in and leaders of the polity. Recent feminist analysis has emphasised that authority does not reside in the person but that it is conferred by social and political structures and authorised by discursive fields. Kathleen Jones has written of 'the ways that specific constructions of masculinity and femininity figure in the arguments about what authority is and how one recognises it'. As she points out, '[i]dentifying these specific features depends on deploying some concept of gender. Yet gender is not a stable concept.'[5] In the second half of the nineteenth century sexual difference and race relations were highly contested: feminism's challenge was to a social order which routinely invested in masculinity the authority to legislate and govern, command and control. At the same time sovereign power was invested in a female monarch who was not known for her support of the women's movements. The debates surrounding Hosmer's statue of a queen touched on authorship as much as authority. These two concepts, as Gayatri Chakravorty Spivak has indicated, abut and collide:

The author . . . is not only taken to be the authority for the meaning of the text, but also, when posssessed of authority, possessed *by that fact* of

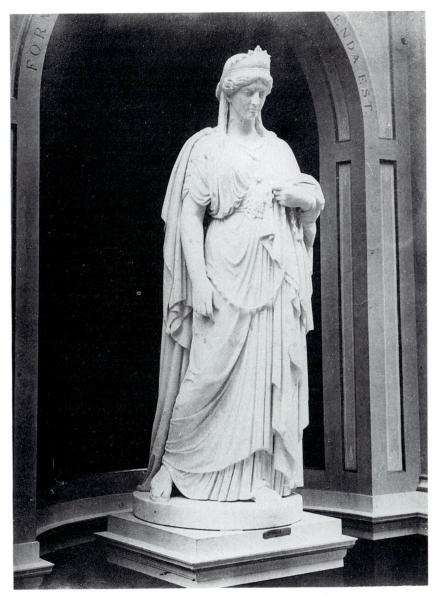

Figure 4.1 Harriet Hosmer's *Zenobia*, London, 1862

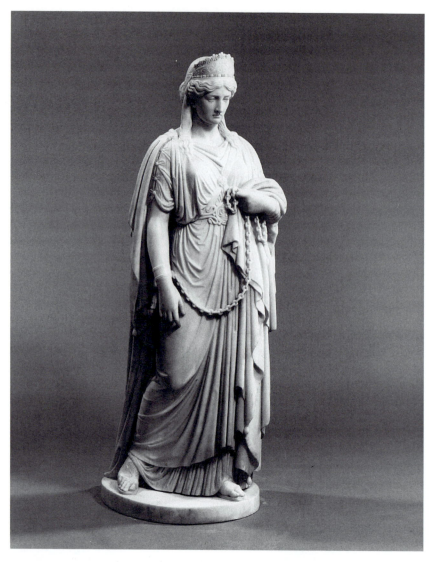

Figure 4.2 Harriet Hosmer, *Zenobia*, 1859

'moral or legal supremacy, the power to influence the conduct or action of others;' and when authorising, 'giving legal force to, making legally valid' (OED).[6]

Spivak's critical propositions on author(ity) offer an opening for an investigation of Hosmer's status and her statue: why was her standing as the author of her work so hotly contested? And what issues of authority and power were engaged by her work?

The making of a name and a statue

Hosmer's sculpture secured a prominent position at the exhibition. '[H]onored with a place at the back of the small Greek temple designed and decorated by Mr Owen Jones to serve as a setting for the celebrated tinted Venus of [John] Gibson' (Figure 4.3) it was, according to one contemporary, viewed by 'such a multitudinous throng as surged past that temple, day after day'.[7] The display, however, invited comparison between the work of the pupil and her eminent teacher, perhaps reactivating what Hosmer's mentor, the distinguished art historian Anna Jameson, referred to as 'the malignant accusations of some of your rivals in Rome – as to your having Mr Gibson "at your elbow" and all that', '[i]mpertinent & malicious insinuations' which she judged to be 'irritating to your self-esteem & offensive to your self-dependence'.[8] But it was not until some nine years later that far more damaging accusations were first published in a British paper. An obituary of the sculptor Alfred Gatley in *The Queen* in July 1863 stated that

> the unsullied honesty of his disposition forbade him to connive at any of those 'tricks of the trade' which are but too common among marble-mongers at Rome, and as he never stooped to sell work for his own which his own brain had not conceived, and his own chisel executed, Mr Gatley did not achieve during his lifetime what the world calls success.

Against this eulogy were set 'the more meretricious charms of ... "The Zenobia" – said to be by Miss Hosmer, but really executed by an Italian workman at Rome'. The contrast suggested that, as Hosmer had neither conceived nor executed work exhibited and sold under her name, her success had been gained by trickery and deception. In impugning her as a trader of mass-produced goods, the text invoked a subtle class distinction which displaced her from the category of the artist. *The Queen* was a new publication, light in tone and populist in approach. Keen to raise its place in the market, it may have created a scandal as one of a number of strategies to create brand identity, raise its circulation, and spice up its medley of fashion, embroidery and crochet patterns. Emily Davies, then editor of *The English Woman's Journal*,

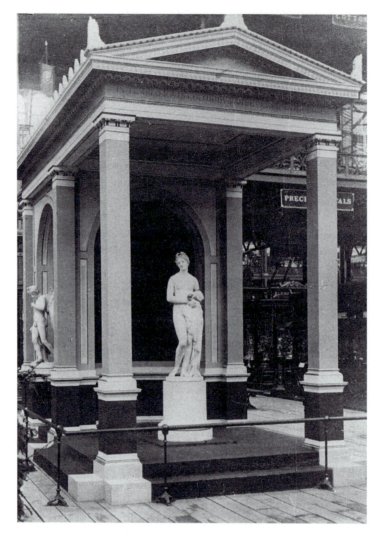

Figure 4.3 John Gibson's *Tinted Venus*, London, 1862

considered it 'a low kind of thing' which 'no educated person would think of looking at it but it suits the taste of inferior readers better that the Journal could ever hope to do'.[9] Six weeks later *The Art Journal* rehashed *The Queen*'s obituary of Gatley and the remarks on Hosmer, omitting however, the passage on 'the tricks of the trade'.

A furious debate ensued in and out of print. A letter from John Gibson, published in *The Queen* in December, only provided grist to the mill. Gibson confirmed that *Zenobia* 'was built up by my man from her own original small

model, according to the practice of our profession'. He continued:

the long study and finishing is by herself, like that of every other sculptor. If Miss Hosmer's works were the productions of other artists, and not her own, there would be in my studio two impostors – Miss Hosmer and myself.

To which the editor responded:

We can only say that we have heard it very freely borne witness to that Miss Hosmer does not model her statue herself, and that, to those who know her, she makes no secret of this; but that she claims the credit of design and direction.[10]

By 1863 Hosmer had an international reputation to defend. From 1852, when she had commenced her pupilage with Gibson, she had worked in the highly competitive arena and international art market in Rome. She exhibited her work on two continents. *Beatrice Cenci* had toured east coast America following a successful showing at the Royal Academy in 1857, favourable reviews and the distinction of an engraving and artist's profile in *The Art Journal* (Figure 4.4).[11] But a comment in *The Crayon* (a paper which circulated on both sides of the Atlantic) that *Beatrice Cenci* was 'conspicuous . . . for originality . . . [with] no copyism of any kind' suggests that intimations of plagiarism already troubled the reception of her work.[12] Initially Hosmer had hoped to silence malicious gossip 'not with my tongue . . . but with my fingers'. When the allegations entered print she put the matter in the hands of a London lawyer:

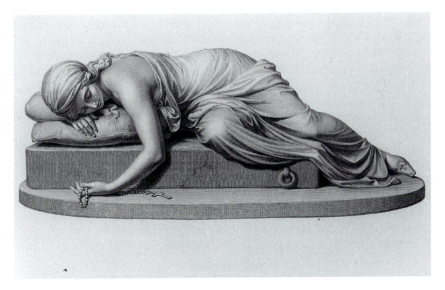

Figure 4.4 Harriet Hosmer, *Beatrice Cenci*, engraved 1857

I hope and trust I may soon be involved in a law suit. For seven years it has been whispered about me that I do not do my own work but employ a man to do it for me. This scandal has now reached the point when I am accused of being a hypocrite and a humbug.[13]

The action taken by her solicitors by letter and in a personal visit to the offices of *The Art Journal* brought public apologies. In December 1863 and again in June 1864 *The Queen* (repeating the allegations yet once more) stated that 'we believe there is not the slightest foundation for the assertion that Miss Hosmer is not the real authoress of the "Zenobia" and of the other works which have been executed under her name.'[14]

The Art Journal printed a letter from the artist, defending her practice. To refute accusations that a 'professional modeller does *all* my work', she stated that 'after the statue of Zenobia was set up for me, from a small model, four feet high, which I had previously carefully studied, I worked with my own hands upon the full-sized clay model during a period of eight months.' She acknowledged that 'the man who undertook to prepare the clay for me was not a professional modeller in clay, but one of the marble workmen in Mr Gibson's studio.' A note from the editor was appended: 'We believe that statement [about Zenobia's inauthenticity] to be entirely groundless, and manifestly unjust. . . . Readily and gladly we make to her the best and most simple amends in our power.'[15] *The Athenaeum* published a defence by her compatriot William Wetmore Story, who insisted on 'the utter falsity' of the accusation: 'The "Zenobia" was the product of Miss Hosmer's own mind and her own hands', Signor Nucci having assisted her 'in the first manual labour of putting up the irons and clay from her original sketch'. He continued: 'This work which required but a short time, once performed, the statue passed into the hands of Miss Hosmer, by which solely it was carried forward and completed.' Considerable negotiation took place outside the pages of the press. Beavington Atkinson privately informed Story that he had had nothing to do with reprinting the passage from *The Queen*, pointing out that he had commented favourably on *Zenobia* in his review of the International Exhibition. He did admit, however, that the allegations were not unknown to him, as Frances Power Cobbe had written to him about them in the summer of 1862. Her letter, which may have coincided with the writing of his review, certainly arrived while *Zenobia* was on show in London. Writing to Cobbe in 1864, he surmised that 'the obnoxious words were merely transcribed in carelessness and ignorance', concluding that 'The Art Journal is very foolish to fall into such scrapes as these.'[16]

Large pieces in marble were based on preliminary modelling by the artist. The small-scale clay-model, or *bozetto*, made by the sculptor was handed over to a professional modeller who in Hosmer's words, 'then enlarges that model, by scale, to any size the sculptor may require'. On its return to the studio, the sculptor worked on the full-scale model, after which it was dispatched to

specialists who made a plaster cast and carved the design in stone. Occasionally, but not always, the sculptor worked over the piece to give it its finishing touches.[17] Something of Hosmer's attention to *Zenobia* can be traced through surviving correspondence. The artist began researching her subject in 1857 and started work on the small model. As with earlier pieces, she commissioned photographs to document different stages to completion, which she sent to her mentors and friends.[18] In March 1858 she indicated that she was 'now busy with Zenobia'. Work progressed steadily and, by the autumn, she was 'busied with details of Drapery etc.' Commenting in October on a photograph which Hosmer had sent to her, Anna Jameson, who generously advised the younger woman having as she admitted 'embarked so much of pride & hope in you as an artist', made several suggestions:

> the helmet-like Diadem pleases me much as suggesting the warrior Queen (& the cuirass for the same reason) but the diadem is too low on the brow – thus taking from the value & dignity of the face – & that intellectual look which Zenobia had I suppose as indicative of her talents.

Before the end of the year Hosmer relocated from a small workroom within Gibson's spacious premises to 'a huge magnificent room' where she could expand her practice. The arrival here of 'a monstrous lump of clay, which will be . . . Zenobia' suggests that by December the production of the large-scale model was imminent, if not already under way.[19] When in spring 1859 Nathaniel Hawthorne visited her studio 'to see her statue of Zenobia', it was sufficiently advanced for him to judge it '[a] very noble and remarkable statue indeed, full of dignity and beauty . . . [T]he drapery is very fine and abundant; she is decked with ornaments . . . the chains of her captivity hang from wrist to wrist.'[20] Although 'as yet unfinished in the clay', the statue was ready for transfer to plaster by the summer. By August 1860, when Hosmer was in America, *Zenobia* was 'in the marble stage'.[21]

Delegation to specialist technicians enabled artists to participate in the increasingly spectacular public culture of sculpture. Carving was a slow, laborious business and when it was under way, the artist could be working on new pieces, evolving ideas, or participating in the international circuit. Personal appearances at international venues, networking and politicking to secure prestigious commissions, as well as protracted visits to clients' country houses and an extensive correspondence, were all part of professional practice, as was the presentation of an atelier in which labour was invisible: nineteenth-century glitterati did not want to be present at, or even observe, the mess of making. Sculptors often juggled several commissions at once, or worked simultaneously on several pieces at varying stages. In February 1857, for instance, when *Beatrice Cenci* was ready for shipping to London for exhibition, Hosmer reported that she had 'had a jolly winter' with a commission for a monument to Judith

Falconnet, and several orders for busts, *bassi-rilievi*, and portrait medallions, as well as copies of *Beatrice Cenci* and *Puck*.[22]

It was the carvers who carried out the production of multiples, so essential for a sculptor's financial and professional success. If a particular item was away on exhibition or had been purchased, a plaster version or smaller replica could be available in the artist's studio for inspection, commission or purchase. Celebrated works were repeatedly exhibited and, particularly in America, they were sent on tour to be viewed by thousands of spectators.[23] Six versions were produced of Hiram Powers' *The Greek Slave* (Figure 4.5). *Zenobia* existed in several formats, from the full-size versions (all now lost), a smaller replica (Figure 4.2) and a bust.[24] For women, the production of replicas of portrait busts and fancy pieces facilitated an independent career: Edmonia Lewis's sales of 100 plaster copies of her bust of Colonel Robert Gould Shaw funded her trip to Europe in 1865.[25] Nearly a decade earlier Hosmer sustained her father's sudden financial losses by issuing numerous replicas of *Puck on a Toadstool* (1856), earning her some $50,000. In spring 1858 she boasted '[h]e has already brought me his weight in silver'.[26]

The transformation of sculpture into a profitable industry depended on the employment of technicians, and a wide range of specialist modellers and carvers working for sculptors in London and Rome can be documented.[27] At the same time the necessary differentiation of the artist from the artisan could be effected by reference to academic theory which, by distinguishing the artist's invention from the manual execution of the work, validated the sculptor's early involvement and later distance from the processes of making. Story insisted that although Hosmer had employed Nucci, *Zenobia* was her own invention, 'the product of Miss Hosmer's own *mind* and her own hands'.[28] Early nineteenth-century accounts of Canova confirmed the role of assistants, whose example Hosmer cited when defending her procedures.[29]

By the early 1860s Hosmer's increasing employment of a large staff was cause for anxiety amongst her friends and acquaintance. In 1862 Charlotte Cushman considered that

> she really does very little of her own work. She can do it – but she is idle and being paid good prices she can afford to employ other people to do it for her – and she takes the credit and the profit.

And the following year she remarked,

> as to the work of her studio – She does less of it every day of her life – She has a modeller to work for her constantly – she directs him as to how she likes things to be – to be sure, but *she does not do it!*

Yet Cushman admitted that working without assistants was distressing Emma Stebbins: 'I never saw such crucifixion as Emma Stebbins goes through

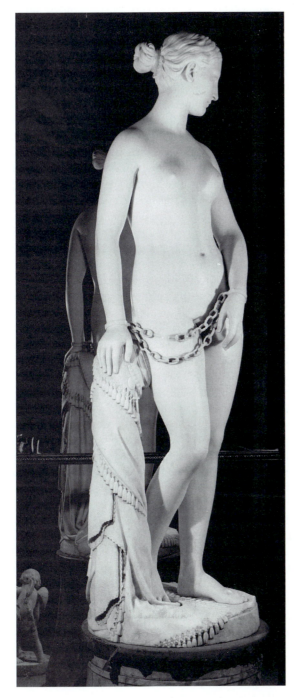

Figure 4.5 Hiram Powers, *The Greek Slave*, 1844

every day because she cannot accept these helps and tries to struggle on to do all of her own work.' Hosmer, she thought, 'has more done for her than anyone else – that is she lets the workmen advance her figure farther than any of the others – but she is right!'[30]

Hosmer's self-publicity included photographs. In one she is the artist at work, a diminutive figure poised on the scaffolding for her massive statue of the American senator Thomas Hart Benton. A second shows her at the centre of a group of workmen in the courtyard of her studio at 116 Via Margutta, a replica of *The Fountain of the Siren* (for Lady Marian Alford) placed behind the figures. Hosmer had long realised the promotional value of sending photographs of her work in various stages to advisers and potential clients. She now utilised it in the important business of image-making. Providing a witty rendition 'by way of a joke' the photograph, as Kathrin Hoffman-Curtius suggests, reverses and modernises representations of gentlemen connoisseurs contemplating the treasures of art (which include the female nude) as well as countering portrayals of the male members of the Royal Academicians gathered at the life class.[31] It also enters into dialogue with depictions of contemporary sculptors. Thomas Woolner was photographed with his workmen not in the studio, but on an excursion to the countryside and in a grouping reminiscent of a family party. His authority is familial and paternal.

Damaging allegations of the kind brought against Hosmer were not unknown, nor were libel suits over who had actually produced pieces of sculpture. Thomas Woolner's letters to his client and benefactor, Lady Pauline Trevelyan, were full of gossip about a rival's dependence on the work of others: Matthew Noble was vilified as 'a person who never touches the work that goes under his name. – This is true, for I know the sculptors who do his work.' Woolner himself certainly employed workmen, and he informed the same addressee that for the Trevelyan Group, 'two carvers [were] constantly employed from early till late at night'. The extent, however, to which public reputation rested on claims of authenticity was registered by Amy Woolner's assurance in her biography of her father that 'the surfaces of all his marble sculptures show the work of his own hand'.[32]

In her letter to *The Art Journal* Hosmer stated that 'a *woman* artist, who has been honoured by frequent commissions, is an object of peculiar odium'. Any intimations of unfair treatment were rebutted in an editorial statement: 'It is not "our way" to inflict injury: more especially in the case of a woman who is working her way to fame.'[33] Nevertheless the only specialist art magazine in Britain at this date was proactive in the gendering of critical languages which undermined the authority of women's art and devalued their successes.

A determination to secure the legitimacy of their practice may well have prompted other women artists based in Rome to undertake as much of their work as possible. When Edmonia Lewis arrived in 1866, she declined prolonged tuition from an established practitioner and employed neither studio assistants nor technicians. For Lewis anxieties about authorship would have

been intensified by her position as a woman of colour producing art for an almost exclusively white audience. Controversy and unproven accusations of poisoning and theft had beset her as a student at Oberlin College.[34] In the hot-house atmosphere of professional rivalry in Rome, Lewis could not risk any damaging allegations. Charges of unoriginality suggested that women's art was only imitation. Nathaniel Hawthorne's novel of 1860, *The Marble Faun*, pub-lished in Britain as well as America, contrasted two women working in Rome: Hilda, the pure, virginal and white copyist of Italian masterpieces, and the mys-terious Miriam (the daughter of a great Jewish banker and/or a South Ameri-can planter with 'one drop of African blood in her veins'), whose fertile imagination fills her portfolios with images of Jael or Judith from the Old Testament's 'stories of bloodshed' and revenge: inventive, independent, creative women were dangerous. Hawthorne's characterisations traded on familiar stereotypes in the literature which had developed in reaction to increasing numbers of women making a living as artists. Writing on American sculpture in Europe in *The Art Journal* in 1871, John Jackson Jarves gave them full play. Contending that women had achieved 'some distinction' and a 'superficial success', he continued,

> Few women as yet are predisposed to intellectual pursuits which demand wearisome years of preparation and deferred hope. Naturally they turn to those fields of Art which seem to yield the quickest returns for the least expenditure of mental capital. Having in general a nice feeling for form, quick perceptions and a mobile fancy, with, not infrequently, a lively imagination, it is not strange that modelling in clay is tempting to their fair fingers.[35]

The gendered category could prove a highly effective means of containment. When *Beatrice Cenci* was reviewed by *The Art Journal* in 1857, it was mentioned neither for its artistic skill nor its rendition of the subject, but 'as doing infinite honour to the efforts of a lady'.[36]

Art critics reviewing the International Exhibition debated Hosmer's position within contemporary sculpture. Frances Power Cobbe, a respected essayist, leader writer for *The Echo* (a national newspaper) and doughty feminist campaigner, hailed the artist and her statue in an article calling for university education and the opening of the professions. In an article entitled 'What shall we do with our old maids?' (published when *Zenobia* was on show in London), Cobbe pitched, once again, into fierce debates about 'redundant women' to campaign for increased opportunities and better pay for the 'thirty per cent of women now in England who never marry'. Rehearsing the by now familiar feminist arguments that 'it is desirable that women should have other aims, pursuits, and interests in life beside matrimony', she contended that a woman will be 'a larger, richer, nobler woman for art, for learning, for every grace and gift she can acquire'.[37] By the early 1860s campaigns for paid work

113

for women, improved schooling, university education and medical training were under way or just beginning: in supporting Hosmer and *Zenobia*, Cobbe engaged with some of the key feminist campaigns and debates of the decade. She wrote:

> Whether we consider the noble conception of this majestic figure, or the science displayed in every part of it, from the perfect *pose* and accurate anatomy, to the admirable truth and finish of the drapery, we are equally satisfied. Here is what we wanted. A woman – aye, a woman with all the charms of youthful womanhood – can be a sculptor, and a great one.

Cobbe defended *Zenobia* against the major points of criticism. She argued that the sculpture has an intellectual foundation and is the product of deep knowledge, the subject is worthy of representation, the depiction of the figure could not be bettered and the drapery is admirable. Deeming sculpture to be 'the noblest of the arts' and 'the sharpest test to which the question of a woman's genius can be put', Cobbe concluded that *Zenobia* provided 'definite proof that a woman can make a statue of the very highest order'. This commendation is placed within a broad assessment of women's contribution to the arts.

> No woman has written the epics, nor the dramas, nay, nor even the national songs of her country, if we may not except Miriam's and Deborah's chants of victory. In music, nothing. In architecture, nothing. In sculpture, nothing. In painting, an Elizabetta Sirani, a Rosabla, an Angelika Kauffmann – hardly exceptions enough to prove the rule. Such works as women did accomplish were all stamped with the same impress of feebleness and prettiness.

Cobbe's strong sense of sexual difference enabled her to excoriate 'feebleness and prettiness' and to advance new definitions of the modern woman who will become 'more womanly' as she develops in strength, rationality and intellectuality. Claiming a divine mandate, she is convinced that 'God means a woman to *be* a woman and not a man.' It is women's difference rather than their equality which for Cobbe underwrites the demands for paid work, higher education and vocational training.

But Cobbe runs headlong into the central problems in writing about women's art. She reiterates the feminine stereotype (well expressed in Jarves's essay already quoted), so retaining the critical terms by which most women artists were judged. In tokenising the few, she marginalises the many. The tendency in feminist criticism to create heroines was not without risk: Hosmer was already a feminist icon. This approach could so easily succumb to the dangers of immoderate and injudicious adulation, a tactic which Anna Jameson called 'bepraising' and against which she counselled.[38]

Cobbe's review of past incapacity provided a ground against which to stage a transformation in the present: 'This state of things is to undergo a change, and the works by women become remarkable for other qualities beside softness and weakness.' Citing as examples Elizabeth Barrett Browning, Rosa Bonheur and Harriet Hosmer, Cobbe elucidated that 'in the three greatest departments of art – poetry, painting, and sculpture' – women's work is now 'pre-eminently distinguished for one quality above all others – namely strength'. The reason for '[t]his new element of *strength* in female art' resided in contemporary women's rejections of gendered convention:

> Female artists hitherto always started on the wrong track: being per-
> suaded beforehand that they ought only to compose sweet verses and
> soft pictures, they set themselves to make them accordingly. . . . *Now,*
> women who possess any real genius, apply it to the creation of what
> they (and not society for them) really admire. A woman naturally
> admires power, force, grandeur. It is these qualities, then, which we shall
> see more and more appearing as the spontaneous genius of women
> asserts itself.

Cobbe raided the critical toolbox for those very attributes of 'power, force, grandeur' usually applied to art by men: these are, for her, the determinants of success. She warned, however, of the dangers: while there are 'true artists' who will recognise women's new-found strength 'with delight', there is a not inconsiderable number of men to whom it is 'obviously distasteful', perceiving strength as 'not quite feminine'. Her conclusion echoed Harriet Martineau's views, advanced three years earlier in an essay on women's work, that mascu-line jealously mitigated against (the recognition of) women's attainment.[39]

Cobbe reconsidered Hosmer in *Italics*, an assortment of recollections on 'pol-itics, people and places in Italy', published in 1864. In common with many women's volumes of recollections, pithy comments and thumbnail sketches are carried on an amiably picaresque narrative. This stream of comment and reflec-tion is interrupted by a lengthy and detailed account of Hosmer's achievements and her current work, designed to counteract the controversies of the previous year.

> Of course, Miss Hosmer's sculptures all show the result of Gibson's
> training . . . Yet, on the other hand, there is an amount of character and
> originality in them which render them almost a contrast to those of the
> master. Mischievous Puck and majestic Zenobia are as little like Gib-
> son's Venus and Psyche as any statues well could be. No one who
> studies them fairly could, I think, deny to their author that creative
> power which has certainly far more rarely been bestowed on women
> than on men – so rarely indeed that the doubt might be legitimate
> whether it were ever in a high measure possessed by a woman.[40]

The narrative tells of the dedication and hard work of 'a girl who has spent the bloom of her youth in voluntary devotion to a high pursuit, adding to unusual gifts scarcely less unusual resolution and perseverance'. Most importantly, it emphasises Hosmer's 'severe application to the theory and practice of her art, as few women are able or willing to give', thus drawing attention to the artist's intellectual abilities as well as her practical skills.

Cobbe's defence of *Zenobia* was written out of friendship with the artist, and in this, it shared a guiding principle of much nineteenth-century art reviewing and literary criticism.[41] The American sculptor came to the attention of British feminists shuttling between London, Paris, Algiers, Florence and Rome. Hosmer, like many of her compatriots, crossed continents to secure training and to compete in an international art market. For the mid-century sculptor, Rome's many attractions included its magnificent collections of classical, Renaissance and seventeenth-century sculpture, the remains of classical civilisation, libraries and studio spaces, the proximity of marble quarries, a well-established sculptural profession and the presence of highly skilled technicians. British feminists visited Rome as tourists on a European and Mediterranean circuit. Like the sculptors, they were independent women who enjoyed the privileges of wealth, class and tourism: travel provided a means for understanding self, society and nation, as Gayatri Spivak and Inderpal Grewal have indicated.[42] Interests of nation have also inflected accounts of 'that strange sisterhood of American "lady sculptors" who at one time settled upon the seven hills in a white marmorean flock'. While Henry James's comment, as Whitney Chadwick rightly remarks, has obscured differences between women in Rome, it has also overemphasised an American constituency.[43] Hosmer was encouraged by British artists, critics and collectors who visited Rome: her clients included Lady Ashburton and Lady Marian Alford, who commissioned substantial pieces for their country houses and gardens. Moreover, as Nancy Proctor has pointed out, the novelist's observations have given a mistaken impression that American women 'emigrated *en masse* and lived as a proto-women artists' support group'.[44]

Frequent travel and an extensive correspondence connected feminist sympathisers. Anna Jameson, who spent long periods in Italy, counselled Hosmer in person and by letter and sent news to her young women friends in London.[45] Bessie Rayner Parkes, who met the sculptor in Italy in May 1857, described Hosmer as 'such a bright little creature; bright hair, bright eyes . . . as busy as a bee'. Parkes was intrigued by the combination in Hosmer's dress of singularity and fashionability, and she was delighted by a likeness to her own appearance:

> She is the funniest little creature not at all rough or slangy but like a little boy. . . . There is much energy and spirit in a pair of splendid grey eyes, her face is that of an arch faun. . . . She lives with an old French lady, but conducts herself exactly as she chooses She has short curled hair like mine, & usually swept back from a very broad brow,

wears a black hat and little feather everywhere, concerts & all, seeming quite ignorant of bonnets; manages her petticoats with a certain extra-ordinary ease suggestive of trousers – but the finishing and funniest point of all is a very thin waist, & this strangely for a sculptor seems Hatty's weak point, for all her jackets fit quite tight & neat.

Hosmer's dedication, her 'sublime steadiness', impressed her.[46] Barbara Leigh Smith (Bodichon), who met her in October 1854, was struck by Hosmer's unconventionality, describing her as 'very sturdy, bright and vigorous', 'the most tomboyish little woman I ever saw'. Further, she commented:

> She looks more like a jolly little stone cutter than a lady, and yet she is very fascinating, being so uncommonly clever and lively. She does exactly what is most agreeable to herself and best for her work, and does not care what any one says in the very least.

When Hosmer visited London for the exhibition of *Beatrice Cenci*, she called on Parkes at the offices of the *Waverley Journal* and took out a subscription to the magazine.[47] Parkes was introduced by Matilda Mary Hays, an actress, novelist, translator of the works of George Sand and Charlotte Cushman's partner, who was to leave Rome to become joint editor of *The English Woman's Journal*; her essay on Hosmer was printed in July 1858. An invitation to Jameson to write on 'Hatty Hosmer's fountain' arrived too late for her to comply.[48]

Cobbe made several excursions to Italy between 1857 and 1862. In *Italics* she enthused about relocation and its especial benefits for working women who

> have had the courage to break away from the fetters of custom . . . There are in Italy a multitude of men and women, more or less gifted, who lead *real* lives – lives which they have carried out for themselves and not merely fitted into – lives which have a definite aim, and that a high one.

She drew attention to many 'young women in Florence and Rome thus admirably working their way; some as writers, some as artists of one kind or another, bright, happy, free and respected by all'. In Rome Cobbe met not only Hosmer but a Welsh sculptor, Mary Lloyd, who had studied and worked with Bonheur. When Cobbe, introduced by Lloyd, visited the French artist, she reported: 'Nothing I liked about her, so much, however, as her interest in Hattie Hosmer, and her delight in hearing about her *Zenobia (triumphans)* in the Exhibition.'[49] Cobbe and Lloyd returned to London in 1862 for what was to become a thirty-year partnership. Hosmer stayed with the couple on her visits to Britain, and joined them in support of women's enfranchisement: Hosmer, Cobbe and Lloyd were members of the London National Society for Women's Suffrage in the late 1860s.[50]

Supportive as this network was, it was fissured by perceptions of racial differ-ence. Travelling through London in 1865 on her way to Paris and then Florence and Rome, Edmonia Lewis does not seem to have come to the atten-tion of British feminists, although she had been taken up by white feminists and abolitionists in the United States: as Lynda Roscoe Hartigan notes, she 'offered a tempting opportunity to those eager to demonstrate their support of human rights'. Lewis was certainly known in Britain through an interview with the sculptor in *The Athenaeum*, in March 1866, and an article some months later in *The Art Journal* on women sculptors in Rome.[51] By the mid-1860s the interest in Rome among British feminists had dwindled. It may also have been the case that after abolition, an earlier philanthropic interest did not convert into support for an independent woman artist of colour.

At a simple level, allegations that Hosmer did not make her own work were easy ways of dismissing both the artist and the statue. In addition, the denial that Hosmer had made the sculpture refuted feminist affirmations that '[a] woman – aye, a woman with all the charms of youthful womanhood – can be a sculptor and a great one'. But hostility to Hosmer went beyond the refutation that she originated her work. She was refused the status of author. And this denial was made in articles written by those who often cloaked their identity and secured their authority in anonymity.

For Michel Foucault, the coming into being of the notion of 'author' consti-tutes 'a privileged moment of individualisation'. By the mid-nineteenth cen-tury, the 'author' in the figure of the artist was one of the principal categories governing art criticism, in exhibition reviews as well as biographical features. Foucault points out that the discursive category of the author name is not to be confused with the proper name of the historical individual, even when, as in Hosmer's case, the two took the same form. 'Harriet Hosmer Fecit Romae' is carved into the base of the surviving version of *Zenobia*. One of the functions of the 'author' was to provide for the work of art of an origin or source in 'this figure who is outside it and precedes it'. Foucault points out that with the entry into discourse of the 'author-function', authentication of a text depended on reference to the individual who had produced it and who stood as an index of its truthfulness. The author, therefore, doubly authorised the text.[52]

Questions about the authorship of *Zenobia* endeavoured to prise apart the artist and the work. But more than this, they challenged the value of Hosmer's signature. Jacques Derrida explains that the signature is a highly mobile and dynamic yet regulatory borderline moving between the object and the author, authenticating the first as the product of the second. But the signature does not only connect, it also acts as a promise and guarantee.[53] Under the charge of inauthenticity Hosmer's signature could no longer deliver the promise that she had made the work ('*fecit*'). In becoming detached from its author, characterised by Foucault as 'a person to whom the production of a text, a book or a work can be legitimately attributed', *Zenobia* became illegitimate.

If Hosmer's signature could be tainted with fraud, how could it be

(re)authorised? Derrida has indicated that the signatories to the American Declaration of Independence, not authorised by existing rules or conventions, appealed to a transcendent authority, the word of God. Hosmer made no claims for divine sanction, appealing to precedent (the studios of Canova and Thorwaldsen) and securing support from well-known male authorities. Her letter to *The Art Journal* was counter-signed by John Gibson, who lent his authority to Hosmer's declaration that she was the author of her own work. But if the authority of the word of God was not so easily contradicted, Gibson's could more readily be challenged, as it was in the pages of *The Queen.*

As Foucault indicates, the category of the author can be attached to discursive formations as well as to texts: 'One can be the author of much more than a book – of a theory, for instance, of a tradition or a discipline'; in this respect the 'function of an author exceeds the limits of her work'.[54] In attacking Hosmer's status as author, critics also took issue with her version of history and her representation of women's authority.

Warrior queen, savant and woman of colour

Zenobia has been one of the most discussed works in feminist art history. In 1981, the writers of *Old Mistresses* identified an ambivalence in the work:

> [*Zenobia*] shows a bold and impressive woman – but under duress, chained, bound and conquered. . . . Zenobia's noble bearing, her queenliness, is signified by the dignity with which she carries her chains, the sign of her captivity and defeat. . . . Hosmer's *Zenobia* manages to convince us of a woman's capacity for stoical strength, a feature only rarely attributed to women in male portrayals of such subjects. Yet here it is undermined by the fact that such courage and fortitude can only be shown in the face of calamity and captivity, a suggestive metaphor for the social bondage in which women lived.

Arguing that a work of art attained meaning within contemporary systems of representation, they compared the statue to Hiram Powers' earlier work, *The Greek Slave* (Figure 4.5): 'Powers played tantalisingly with youth, beauty and vulnerable availability to convey his notion of Christian virtue. Saleability and sexual possessiveness are bound into his sculpture of a female nude.' Hosmer's statue is paradoxical: an epic work on a monumental scale which portrays less a warrior queen and more a captive subdued by defeat.[55]

In a study of nineteenth-century American sculpture, Joy Kasson reaches similar conclusions. Invoking the same comparison she comments:

> In the colossal figure of *Zenobia* . . . Hosmer confronted directly the tradition of the female captive and also began a searching exploration

of the subject of female power. *Zenobia* told two overlapping and some-
times conflicting stories: an assertion of female power and an evocation
of female vulnerability.[56]

Reviewing the arguments in her invaluable *Women, Art and Society*, Whitney
Chadwick concludes that, 'although both figures are captive and not in control
of their fates, *Zenobia*'s resolute dignity stands as a rebuke to the *Greek Slave*'s
prurient, if allegorical, nudity.'[57] But concern has remained, Nancy Proctor
writing in 1996 of the co-existence of images of achievement and submission
in the work of American women sculptors in Rome:

> having conquered Syria, Bostra, and finally Asia Minor, her military
> acumen vied with that of Emperor Aurelian for supremacy over all
> the known world . . . [Hosmer] represents Zenobia in defeat, paraded
> in chains through the streets of Rome as part of a triumphal
> procession.[58]

Flickering at the edges of these commentaries is a 'positive' image of Zenobia as
a triumphant, militant warrior, a vision which Hosmer is chided for not providing,
the foil to the 'negative' portrayal perceived by late twentieth-century com-
mentators. But was this the response of Hosmer's contemporaries? Whereas
Palgrave judged that 'a proud, indolent woman' had usurped the place of 'the
gallant Queen of Palmyra',[59] others applauded the work. *The Art Journal* critic,
J.B. Atkinson, considered Zenobia to be 'a noble figure, of queenlike dignity' and
Cobbe was convinced of her majesty.[60] *Zenobia* was exhibited and interpreted at
a moment of intense discussion about women's rights and against profound
anxieties about the reigning monarch. When the authority of Queen Victoria
was called into question by her seclusion following the death of Prince Albert in
1861, how much more so was that of Zenobia? A Syrian ruler whose racial
origins were the subject of considerable speculation, her image would not easily
have escaped the heated arguments in Britain about slavery and racial difference.
 Zenobia's triumphs and her capture were told and retold. Classical accounts
included those by the Greek historian Zosimus and the Latin texts of Vopiscus
and Trebellius Pollio in the Augustan History.[61] Celebrated in Boccaccio's *De
Claris Mulieribus*, she appeared in Chaucer's *The Canterbury Tales* and in several
plays.[62] A figure of antiquarian and scholarly interest in the eighteenth century,
she featured in Wood and Dawkins's account of the ruins of Palmyra.[63] Her
history was magisterially recounted in the first volume of Edward Gibbon's
The History of the Decline and Fall of the Roman Empire. Sixty years later she had
become the romantic heroine of William Ware's fictional *Letters from Palmyra*
and one of the 'celebrated female sovereigns' discussed by Anna Jameson.[64]
Literary interest escalated in the nineteenth century and Hosmer may have
encountered an intriguing description in Tennyson's poem *The Princess* of a
sculpture gallery in the women's college:

> Look, our hall!
> Our statues! – not of those that men desire,
> Sleek Odalisques, or oracles of mode,
> . . . ; but she
> That taught the Sabine how to rule, . . .
>
> . . .
>
> The Carian Artemesia strong in war,
> The Rhodope, that built the Pyramid,
> Clelia, Cornelia, with the Palmyrene
> That fought Aurelian, . . .[65]

Although guidebooks and antiquarian studies proliferated, serious archaeological enquiry was not undertaken until after 1900.

Roman historians commended Zenobia as 'the noblest of all the women of the East, and . . . the most beautiful'. A stern disciplinarian of her troops, she was noted for her clemency, prudence and learning.[66] Basing his account on these texts, Gibbon extolled Zenobia's 'incomparable prudence and fortitude', her 'steady administration . . . guided by the most judicious maxims of policy', her learning, her fluency in several languages.[67] For Boccaccio she exemplified valour and chastity: a brave warrior who fought with her troops, 'at times acting as an officer and at others as an ordinary soldier', she was 'so virtuous, according to the testimony of ancient documents, that she must precede all other foreign women in fame'.[68] For him, as for most male writers, Zenobia was remarkable for her sexual restraint.[69] In *The Ruins of Palmyra*, however, 'Zenobia makes her appearance under the imputation of a crime.'[70] Said by some to have consented to murder, she was judged by many to have been responsible for the death of Longinus, betraying him to save herself. According to Gibbon, she 'ignominiously purchased life by the sacrifice of her fame and friends', but 'as female fortitude is commonly artificial, so it is seldom steady or consistent'.[71]

Anna Jameson's writings were undoubtedly important, as Susan Waller has convincingly argued.[72] Not only did Jameson provide a new account of Zenobia's appearance in Rome but she re-conceptualised her historical significance: a warrior queen and a learned intellectual. While following earlier descriptions of her subject's courage and fortitude, 'admirable prudence and policy', Jameson laid especial weight on her intelligence, 'passion for study', interest in architecture and her court, although she too reproached Zenobia for causing Longinus's death: 'her feminine terrors had perhaps been excusable if they had not rendered her base'. Whereas Gibbon's interests in imperial history placed Zenobia among 'several illustrious women who have sustained with glory the weight of empire', Jameson was preoccupied with 'the influence which a female government has had, *generally*, on men and nations, and . . . the influence which the possession of power has had *individually* on the female character'. Although good examples could be found, female government had been

'signally unfortunate'; 'women called to empire have been, in most cases, conspicuously unhappy or criminal'.[73]

Hosmer undertook extensive research on her visit to America in 1857 when Lydia Maria Child reported that her 'soul was filled with Zenobia' and her notebooks with studies for the sculpture. Searching libraries for 'every allusion to her, whether historic or romantic',[74] Hosmer continued her studies on her return to Italy, consulting material in the libraries in Florence as well as Rome. Recent feminist theory has emphasised that reading is a contradictory and often fragmentary process which allows women to read with and against the grain, to enter into dialogue and contestation. Suggesting that it involves far more than the collection of data or interpretation, Lynne Pearce considers reading to be an 'implicated process', an interaction which engages desire and pleasure, a 'romance' suffused with emotion.[75]

Zenobia challenged contemporary notions of women's art. Sculptors, like painters, generally made their reputations with portraiture and small 'fancy' pieces. Mary Thornycroft's two exhibits at the International Exhibition, *The Skipping Girl* and *The Knitting Girl*, were deemed by Beavington Atkinson to be 'two pretty works, worthy of all praise'. Trained by Gibson in Rome, Thornycroft founded her practice on portrait busts, allegorical figures of the children of the royal family and occasional funerary monuments for British churches (Figure 4.6). Major commissions were assigned to male artists, her husband's equestrian statue of Queen Victoria securing pride of place at the Great Exhibition of 1851. In 1863 *The Illustrated London News* reported that whereas Thomas Thornycroft was commissioned for a statue of the late Prince Consort for Wolverhampton, his wife had received the Queen's command for a bust of Princess Alexandra.[76]

One the most striking features of *Zenobia* was the portrayal of the female body. At this date, women rarely essayed the full-scale female nude for public exhibition; to do so would have risked accusations of impropriety. Hosmer had, however, already undertaken unclothed and partially draped figures: in *Oenone*, 1854–5, the torso is undraped although the legs are covered. Her first major exhibition piece, *Beatrice Cenci*, 1853–5, is an essay in differentiated weights and surfaces which demonstrates consummate skill (Figure 4.4). The immobility of the figure, asleep on the eve of her execution in 1599 for the murder of her incestuous and violent father, is conveyed through the deep folds of drapery suggesting the heaviness of her lower limbs, the fine rippling of the cloth covering her body contrasting with the silken surfaces of bare shoulders, left breast and arm. A *tour de force* in current neo-classical style, it makes the enveloping attire of *Zenobia*, with its simplicity and severity, all the more decisive.[77]

Zenobia did not conform to the repertory of sculptural subjects on view at the International Exhibition: assorted vignettes of domestic felicity accompanied scantily clad or nude nymphs, literary heroines and several Venuses, including Gibson's (Figure 4.3). There were few visual precedents. Although

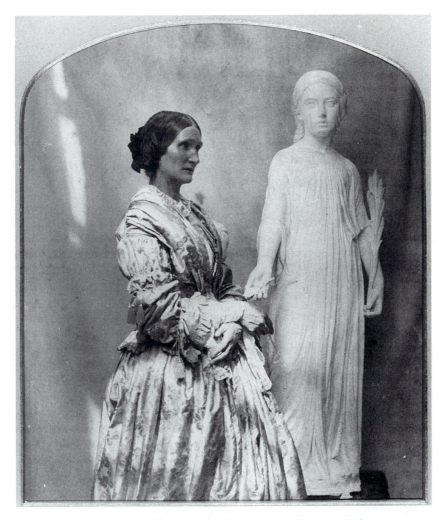

Figure 4.6 Mary Thornycroft with her statue of Princess Helena
in the guise of Peace, *c.* 1855

Tiepolo had portrayed Zenobia as a military leader rallying her troops, a more recent painting, William Bouguereau's *Zenobia Found on the Banks of the Araxis*, depicted the Palmyrene queen as helpless, almost lifeless, any authority drained out with the dripping clothes which cling revealingly to her body.[78] Deliberately eschewing this moment and image, Hosmer turned to classical precedents. In its scale and monumentality the statue places itself in rivalry to the traditions of Graeco-Roman sculpture, taking its references from antique forms, historical texts and earlier examples, including the massive statue of Zenobia in the colonnaded street at Palmyra, destroyed by the Romans.[79] Susan

123

Waller demonstrates that while Zenobia's straight back and her unwavering slow step are adapted from the *Athena Giustiniani*, the tilt of her head bears similarities to the *Barberini Juno*, also in the Vatican Museum. She also suggests that Hosmer looked to a fragment of an eighth-century mosaic of 'Mater Misericordie' in the Church of San Marco in Florence, which portrays the Virgin as the Queen of Heaven, wearing an elaborate crown and bedecked with jewels.[80] By sourcing her statue from ancient example and mythology (the references are to the goddess of wisdom and war and the queen of the Olympian gods) and in citing, even at a distance, the Queen of Heaven, Hosmer added an authority of lineage and form to her sculpture.

Any portrayal of a female ruler exhibited in Britain in the second half of the nineteenth century had to negotiate the image of Queen Victoria, the first British monarch whose image was extensively disseminated in consumer culture as well as high art. The Queen's portrait was reproduced on stamps and music covers, coins and medals, prints and engravings, pottery and china, and illustrated periodicals; her figure shape, deportment and glossy black hair graced fashion plates. Portraits depicted her as monarch and mother. Formal depictions in ceremonial robes were accompanied by carefree moments at home and happy holidays in Scotland. Winterhalter's magnificent portrait *The Royal Family in 1846* (Figure 4.7), a life-sized group in which Queen Victoria

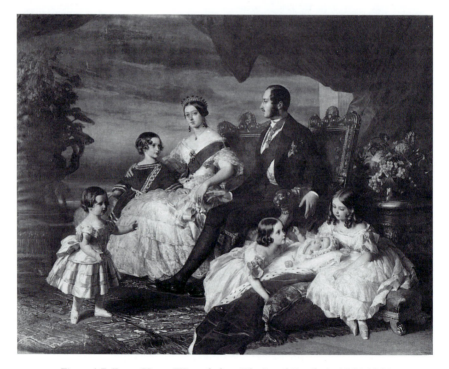

Figure 4.7 Franz Xaver Winterhalter, *The Royal Family in 1846*, 1846

124

and Prince Albert are seated on matching chairs, the Queen in evening dress and the ribbon and star of the Garter, her consort wearing court dress with the Garter and the ribbon and the star of the Order and the badge of the Golden Fleece, brilliantly combined the formal with the familial: the couple are surrounded by gambolling children.[81] While this painting set new terms for the depiction of a queen and definitively reinvented the monarchy as family values, the very excess of Victoria's visual imagery modernised and feminised an old idea of 'the king's two bodies'.

In *Discipline and Punish* Michel Foucault explains that from the medieval period onwards the actual body of the king was differentiated from his symbolic body, which represented the concept of enduring monarchy as well as the body politic. Put to spectacular use by Louis XIV of France, this idea of 'the king's two bodies' evolved for the male sovereign. The accession of Victoria demanded a major transformation, for not only was Victoria a constitutional rather than an absolutist monarch and thus at a distance from government, but also she was female. Reworking earlier traditions of female royal portraits and new notions of the family, the body of the queen was inscribed in terms of its reproductive capacity to generate a dynasty at the same time as it was invested as the somatic sign of sovereignty.[82]

In formal portraits and commemorative imagery, Victoria stares unwaveringly before her; at home and on holiday, in the countryside or royal gardens, she gazes fondly at her children and consort. These favoured locations were far distant from the public streets and sexualised encounters of modern metropolis, where a direct look could be construed as a sign of the prostitute or streetwalker or at the least as an indicator of an disreputable woman. Images of mid-century London were patterned by direct glances, oblique looks and sheltered eyes (Figures 1.3–5). The relays of power which shaped this sexual politics of looking were brought to visibility in Emily Mary Osborn's *Nameless and Friendless*. Endeavouring to sell her work, the artist does not regard the potential vendor but considers the floor. It is tempting to speculate that when Hosmer visited the Royal Academy in 1857 she noted this painting which was attracting considerable critical notice. Like her statue, Osborn's painting was selected for the International Exhibition of 1862, a major cultural event at which visitors viewed not only the exhibits but themselves, the surfaces of glazed cabinets and the exhibitionary spaces offering tantalising glimpses and reflections.[83] Zenobia's downward glance was inserted into these complex codes of vision. Whereas Gibbon had related that 'every eye, disregarding the crowd of captives, was fixed on the emperor Terticus, and the queen of the East', Jameson made it quite clear that, when the Roman crowd 'gaped and stared', Zenobia's eyes were 'fixed on the ground'.[84] For a queen who is portrayed walking through the streets of Rome, her feet placed to suggest movement, a lowered gaze could signify modesty and propriety as much as dejected captivity.

Hosmer's sculpture was exhibited at an event which marked both a national mourning and a public celebration. The International Exhibition had been

planned by Prince Albert, who died suddenly in December 1861. Victoria did not open the exhibition in May, nor did she appear in public for two years. Rumour about her was rife and she was soon accused of a dereliction of duty. Although interest in the royal family was maintained by events such as the wedding of the Prince and Princess of Wales in 1863, visual images of the Queen herself all but ceased for some years. The disappearance of the Queen's 'two bodies' coincided with the collapse of the mythology of family values precipitated by Albert's death. In the years in which *Zenobia* was exhibited and debated in London, not only was monarchy called into question and its continuity interrupted, but the topos of the queen and its means of signification were thrown into crisis. This crisis, deepened by the scandals over John Brown, was to be resolved by a re-invention of tradition, which repackaged Victoria for a return to public visibility in 1876 as Empress of India.[85]

Victoria's accession to the throne in 1837 prompted a vast literature and a not inconsiderable range of paintings of women rulers, giving writers, artists, readers, reviewers and spectators rich opportunities to meditate on women, power and authority. Although for some, historic queens were faint-hearted and ineffective and for others they were scheming and treacherous, a slow process of rehabilitation was under way. Henrietta Ward's *Queen Mary Quitted Sterling Castle . . .* (RA 1863) portrayed a queen whose acts of fortitude and resolution were undertaken in a domestic context: in the royal nursery at Sterling Castle Mary transfers to the Earl and Countess of Mar the care of her son, James VI of Scotland, who will become James I of England.[86] Mid-century feminism's response to the topos of the queen as much as to the actual monarch was deeply ambivalent. A dedication to Victoria was not uncommon in feminist publications and her name was selected for The Victoria Press, run by Emily Faithfull, and *The Victoria Magazine*, in print from 1863 to 1880.

Boudicca, like Cleopatra and Zenobia a warrior queen who challenged Rome, was a figure of some interest in the mid-1850s. In her study of warrior queens, Antonia Fraser points out 'a special link' between Boudicca and Zenobia, while noting certain differences.[87] Boudicca's rebellion was inspired by the rape of her daughters, punitive Roman taxation, the seizure of estates and the burning of land. In Thomas Thornycroft's sculpture of the ancient British queen and her daughters in a chariot charging forward, as in Tennyson's poem, Boudicca could become a valiant champion of British liberty.[88] Anna Mary Howitt's large painting of the same date, *Boadicea Brooding over Her Wrongs* (shown at the Crystal Palace exhibition of 1856), was perhaps less amenable to nationalist appropriation and may have suggested a feminist politics. Seated in a clearing in a wood, Boudicca was 'meditating vengeance', prompted less by land appropriation and financial exploitation than by the violation of her daughters: one critic highlighted 'the face of the agonised and revengeful mother'.[89] The painting provoked a devastating attack from the eminent critic John Ruskin, who dismissed her painting, 'What do *you* know about Boadicea? Leave such subjects alone and paint me a pheasant's wing.'[90]

While Ruskin tolerated, even praised in his published criticism, women artists whose work could be accommodated within a gendered hierarchy which prescribed the lowly art of still life to women, at issue was Howitt's vision of the past, her right to enter the contested domain of historical representation. With that interrogation 'What do *you* know . . .?' he dismisses her as an authority on her subject. His attack was not dissimilar to Palgrave's rejection of *Zenobia* as a sculpture of 'a proud, indolent woman, where we are led to expect a likeness of the gallant Queen of Palmyra'.[91]

Both Howitt and Hosmer eschewed militancy. The warrior's aggression, however, could be mitigated and feminised. *Hippolyta* (Figure 4.8), with the *Queen with a Sword*, was one of a series of embroidered hangings of Illustrious Women designed and worked by Jane Burden Morris and Elizabeth Burden in about 1861 to adorn the dining room at Red House. The queen of the Amazons is armed with a sword and spear; flowing voluminous robes do not conceal her full suit of armour. Equally at odds with her fighting attire is a garland of olives, sacred to Athena, goddess of wisdom and war, and an attribute of Peace.[92] A transgressive figure, the female warrior's militancy could be legitimated by imperialism. In September 1857, at a moment of rising nationalism and intense racism provoked by reports of the Indian National Uprising, *Punch* carried an image of Justice, armed with a sword, carrying a shield emblazoned with the scales held in balance and defined here, as so often, by the overthrow of her opponents (Figure 4.9). Supported by a phalanx of infantrymen with artillery in the background, she towers over and tramples afoot cowering, injured figures and dead bodies. Simple pictorial contrasts effect a racialised hierarchy. This imperialist assertion of white might displaces another warrior queen, the Rani of Jhansi, a formidable military leader against the British. Yet this is not an unconflictual image, for Justice is without that blindfold which ensures her impartiality. She has become Revenge and Retribution, as is suggested by an accompanying ditty which is also a call to arms: 'Englishmen charging, exchange the old cheer/ For "Remember the women and babes who they slew".' If the drawing and its verse allow an ambivalence, they also register an unease about the warrior woman during the reign of a female monarch. While Britannia as an image of the nation in its war-like aspect could be readily elided with the queen in person and as the sign of sovereign power, this allegory of a vengeful Justice might sit uneasily with the reinvention of royalty as family values.

Although Hosmer sidesteps the military action of Boudicca, the Rani of Jhansi, Britannia or even Zenobia herself, her image of the captive queen was not necessarily one of defeat. The sculpture may have been read as an allegory of captive Italy, her chains signifying the yoke of the Austrian empire. *Zenobia* was made during critical years in the Italian struggle for unification. Writers and artists were often well informed, and events were closely monitored in the British press. Anna Jameson's reflections on allegory, made in 1855, suggest possibilities for such an interpretation.

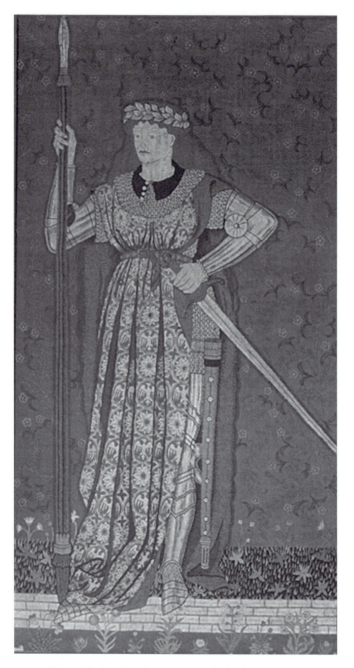

Figure 4.8 Jane Burden Morris and Elizabeth Burden,
Hippolyta, c. 1861

JUSTICE.

Figure 4.9 'Justice', *Punch*, 1857

[T]here is often a necessity for conveying abstract ideas in the forms of art. We have then recourse to allegory; yet allegorical statues are generally cold and conventional and addressed to the intellect merely. Now there are occasions, in which an abstract quality or thought is far more impressively and intelligibly conveyed by an *impersonation* than by a *personification*. I mean, that Aristides might express the idea of justice; Penelope, that of conjugal faith . . . Rizpah, devotion to the memory of the dead; Iphigenia, the voluntary sacrifice for a good cause; and so many others; and such figures would have this advantage, that with the significance of a symbol they would combine all the powers of a sympathetic reality.[93]

In place of a figuration in which the female form becomes Justice and appears with her attributes, Jameson suggests that allegory may be achieved by a figure whose narrative, already well known to the reader or spectator, will carry

additional allegorical meanings. Thus Penelope, who wove by day and unravelled at night to mislead the suitors who besieged her during the absence of Odysseus, could become an allegory of 'conjugal faith'. Jameson projects a complex layering in which several simultaneous, even conflictual meanings could be sustained. To read Hosmer's *Zenobia* as an allegory is therefore to engage not only with the historical figure but with an enriched signification in which Zenobia may be understood as a warrior queen and as a captive, as an image of sovereign power and as a figure of resistance. As an allegory of Italy, she embodied an abstract ideal which had yet to be achieved. And to propose an allegorical reading of *Zenobia* is to engage varying and even conflicting interpretations, none of which was necessarily intended or inscribed by the artist. It is to take up Craig Owens' suggestion that allegory's dense layering of meanings, images and texts foregrounds interpretation, ambiguity and deferral of meanings.[94]

Hosmer's statue made significant departures from the written accounts of the queen's appearance in Aurelian's triumphal procession. All accounts dwelt on the moment when Zenobia walked through the streets of Rome. The *Augustan History* stated:

> She was so adorned with gems so huge that she laboured under the weight of her ornaments; for it is said that this woman, courageous though she was, halted, very frequently, saying that she could not endure the load of her gems. Furthermore, her feet were bound with shackles of gold and her hands with golden fetters, and even on her neck she wore a chain of gold, the weight of which was borne by a Persian buffoon.

Pollio described her 'girt with a purple fillet, which had gems hanging from the lower edge, while its centre was fastened with the jewel called cochlis'; for Roman historians, the sumptuousness of her adornment contributed to Aurelian's triumph.[95] In Chaucer's *The Monk's Tale* Zenobia processes decked in her jewels, wearing her crown, and with 'gilt cheynes on hir nekke hanging'.[96] Boccaccio recounted how '[w]ith gold chains around her neck and fettered hand and foot with shackles of gold', Zenobia and her children preceded the chariot built in expectation of her own triumphant entry into Rome. 'She wore her crown and royal robes and was loaded with pearls and precious stones, so that in spite of her great strength she often stopped, exhausted by the weight.'[97] Gibbon elaborated on the display of animals, gladiators, captives including '[t]he wealth of Asia, the arms and ensigns of so many conquered nations' and reported on 'the magnificent plate and wardrobe of the Syrian queen . . . confined by fetters of gold'. Accompanied not by her children but by 'a slave [who] supported the gold chain which encircled her neck', Zenobia, he recounts, 'almost fainted under the intolerable weight of jewels'.[98] William Ware's fantastic account portrayed Zenobia 'toiling beneath the rays of a hot

sun' and of 'the weight of jewels, such as both for richness and beauty, were never before seen in Rome – and chains of gold, which first passing around her neck and arms, were then borne up by attendant slaves'.[99] It was again Anna Jameson who shifted the emphasis. Although Zenobia's attire ('her diadem and royal robes, blazing with jewels') was regal, she was weighed down by the chains of her captors: 'her delicate form drooping under the weight of her golden fetters which were so heavy that two slaves were obliged to assist in supporting them on either side'. Jameson's narrative implies the tyranny and mercilessness of an emperor who has caused this 'beautiful and majestic queen' to suffer. For Jameson, Zenobia was not so much burdened as 'blazing' with jewels. She described Zenobia as chained at her hands and feet, but, unlike other writers, she made no mention of neck restraints.[100] In Hosmer's sculpture Zenobia stands alone, neither adorned by blazing jewels nor bowed down by heavy chains.[101] She walks without faltering or fainting. A slender chain extends from her right wrist to her left hand; she is not bound at her neck or feet.

Hiram Powers' *The Greek Slave*, to which *Zenobia* has so often been compared, is credited with introducing the chained body of a white woman into high culture (Figure 4.5).[102] The narratives provoked by the sculpture of a young woman, her Christian faith indicated by the cross beside her, seized by Turks for sale in the slave markets of the Ottoman empire, played into Orientalist fantasies of masculine violence, Islamic barbarity and sexual exploitation in which the protagonist was hailed as a representation of a purity and a spirituality that were Christian as well as white. When the statue was exhibited at the Great Exhibition in London in 1851, links to American slavery became explicit in a cartoon in *Punch* in which a black woman was shackled to a post on which the stars and stripes were draped (Figure 4.10). William Wells Brown placed John Tenniel's cartoon adjacent to Powers' sculpture, proclaiming, 'As an American fugitive slave, I place this Virginia Slave by the side of the Greek Slave, as its most fitting companion.' This anti-slavery demonstration was attended by the black campaigners, Ellen and William Craft, as well as white supporters.[103]

Chains became key signifiers in the visual imagery of enslavement. Broken chains and manacles, effectively utilised in *The Freed Woman and her Child* of 1866 and *Forever Free* of 1867, two sculptures made by Edmonia Lewis soon after her arrival in Rome, came to signal emancipation. Nevertheless, as the black writer Freeman Henry Morris Murray indicated in 1916, a broken manacle or severed chain could still point back to fettering.[104] During the American Civil War (1861–5) an image of a chained woman may have evoked this visual culture. *Zenobia*'s exhibition in London coincided with Abraham Lincoln's Preliminary Emancipation Proclamation, issued in September 1862.[105] The dramatic events of the Civil War provided a touchstone for attitudes to race. Those who supported the South argued for the Confederacy's right to self-determination. Manufacturing interests put pressure on the British

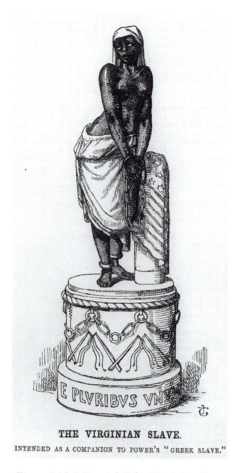

THE VIRGINIAN SLAVE,
INTENDED AS A COMPANION TO POWER'S "GREEK SLAVE."

Figure 4.10 J. Tenniel, 'The Virginian Slave.
Intended as a companion to Power's [*sic*]
"Greek Slave"', *Punch*, 1851

government to enter the war and break the blockade of the southern ports, which was hampering supplies of cheap southern cotton. For abolitionists who supported the Union, 'slavery was the great question which underlies the whole quarrel' and several feminists were outspoken on the issue.[106]

Artists were as partisan as anyone else. Richard Ansdell's *The Hunted Slaves* (RA 1861) was selected for the International Exhibition and reproduced in a print. Visitors to the Exhibition may have wandered between the displays, drifting from Ansdell's painting in which the fugitive displays a broken manacle to Hosmer's chained queen, pondering perhaps on what they had read or conversing about the American Civil War, the British cotton trade, slavery or emancipation. Drawing attention to a number of art works which tackled these

contentious issues, Jan Marsh concludes that 'the black presence was determined politically as well as pictorially, and that, whatever the artist's disclaimers, this interpretation was available to . . . viewers as well as to us.'[107] Eliza Fox's *St Perpetua and St Felicitas* (SFA, 1861), which depicted a black woman beside a white woman, the two facing death together, portrayed the early Christian martyrs, Felicitas and Vivia Perpetua, who were imprisoned and put to death in 203 CE. Although Fox acknowledged Anna Jameson's account of them as 'both young, both mothers, with nothing to sustain them but their faith',[108] she also would undoubtedly have known the lengthy dramatic poem *Vivia Perpetua* by Sarah Flower Adams, a feminist writer who was a member of her family circle and a mentor to her as a young woman. In Flower Adams's drama it is Felicitas, the black woman and Perpetua's slave, who converts her to Christianity: although Felicitas was enslaved on earth, it is argued that she has no master in the sight of God.[109] Fox's painting and the prominence of Felicitas attracted a lengthy review in *The English Woman's Journal* which indicates the unresolved tensions in feminist discourses on race:

> St Felicitas, the slave of St Perpetua, rendered . . . as an African, is beautiful in the extreme; the large, luminous, liquid eyes, with that pathetic expression of the dumb creation which the negro shares with the dog and the deer, the warm glow of the rich Eastern blood, the heavy masses of thick luxuriant hair – and over all, and through all, the pure, chastened and dignified expression.[110]

Nothing in Hosmer's statue suggests the coffling of ankles or neck restraints, although the chain would recall images of slavery. Zenobia's authority as a queen, warrior or captive, could be troubled or even undercut by these associations as well as the intensified debates about race generated by the American Civil War and the emergence of 'scientific racism'.

Historians and raconteurs scrutinised Zenobia's racial origins and fantasised about her appearance. Boccaccio and Gibbon considered that like Cleopatra, Zenobia was a descendant of Egypt's Ptolemaic kings, themselves descended from Alexander's Macedonian general Ptolemy. As well as proclaiming herself Augusta and queen, Zenobia promoted herself as the new Cleopatra and as an Aramaic princess. Anna Jameson was of the view that although Cleopatra was among her progenitors, Zenobia was a daughter of an Arab chief. Some identified her as Jewish.[111] Roman historians considered that '[h]er face was dark and of a swarthy hue, her eyes were black and powerful beyond the usual wont'. 'Her complexion was a dark brown; (a necessary consequence of her way of life in that climate) she had black sparkling eyes, of uncommon fire'. Boccaccio's eulogy on her beauty was matched by Gibbon, for whom Zenobia 'was of a dark complexion . . . and her large black eyes sparkled with uncommon fire, tempered by the most attractive sweetness'. For Jameson, '[s]he was eminently beautiful – with Oriental eyes and complexion'.[112]

How was this woman of colour to be represented in sculpture? Historians of the black presence in western art have noted a major transformation from the Renaissance image of a black king (portrayed in *The Adoration of the Magi*) to early modern and modern images of slaves, servants, freemen and free-women.[113] In portraying a queen, Zenobia reversed this process. In embodying her in white marble, Hosmer pushed neo-classical sculpture and its idealising values to their limit. When she was working on the model, Hosmer had consulted existing images of Zenobia. The queen had minted in her own name in Egypt, and several coins survive with her profile. Jameson obtained casts from a coin in Paris which she deemed to be 'so bad as to be utterly useless except to an antiquarian'. Instead she recommended 'the engraved coin [which] you will find more useful & you will find it in the collection of coins of the Roman Emperors under "Aurelian"'.[114] She also counselled Hosmer to consult her teacher: 'in classic sculpture Gibson is first & the purity of his taste to be depended on far more than mine'.[115] Her suggestion, not developed in detail, intimates that rather than striving for particularity, Hosmer should attend to neo-classical tenets of generalisation. Academic theory proposed that in order to convey universal truths, the human form should be idealised, removed from its own specificities of historical time and founded on antique examples taken from sculptures that provided examples of this ideal. With a heavy solidity of form, Zenobia's face, profile and body are rigorously contained within the neo-classical protocols of mid-nineteenth-century sculpture.

Yet this idealising brief for sculpture, as well as the preference for white marble, was thrown into confusion by archaeological investigation and the discovery of traces of paint on fragments of the Parthenon and from the 1830s onwards the introduction of polychromy into contemporary work. Adjacent to *Zenobia* at the International Exhibition was the most controversial example, Gibson's *Tinted Venus*, displayed in a temple designed by Owen Jones, a leading authority on and keen advocate of polychromy. Latin quotations adorning the temple associated colour with health, life, youth and beauty (Figure 4.3).[116] Polychromy challenged the aesthetic which associated white marble with purity, restated in *The Art Journal* in 1857: 'Nothing can be more chaste than the marble, but it is difficult to preserve the gilt from a meretricious tendency.'[117] Gibson's statue, in which the body was given a soft tint, the apple gilded and fabric edged with colour, was reviled by those who perceived such touches as 'a departure from the original high purpose of sculpture'.[118] A light coat of wax allowed the marble to shine through and gave the whole a shimmering, gleaming surface. For some this portrayed 'far too palpable flesh', and the *Tinted Venus* was considered to be immodest and indelicate, to risk sexual as well as aesthetic propriety and to hamper the aesthetic contemplation of sculpture with its requirement of distance and disengagement from worldly matters. Whereas Beavington Atkinson judged it 'not among the most successful' of his 'works', Palgrave dismissed it as hopelessly out of date: 'one fancies a healthy modern laugh would clear the air of these images'.[119] A cartoon in *Punch*

brought these responses together in a mocking visual form. The scene takes place in the exhibition. Mistaking the *Tinted Venus* for a living woman, Sarah Jane, whose name probably indicates that she is a servant, proclaims: 'Lawks! Why it's hexact like our Hemmer!' [Emma].[120] Concerns about polychromy's adverse effects may also have been related to anxieties about colour in the wrong place: in waxworks and women's cosmetics. Alison Yarrington has rightly surmised that colour placed sculpture 'under the spell of Madame Tussauds'. Mme Rachel's restorative products and face paints, introduced in the summer of 1862 and immediately deplored as improper and deceptive as well as 'French', were perceived as threatening to feminine purity.[121]

Hosmer's statue was not polychromatic.[122] Nevertheless its white marble was framed by widespread debates about polychromy and to the new uses to which it was put to signify racial difference, as for example in busts of Princess Gour-amma of Coorg and the Maharajah Dalip Singh by Carlo Marochetti in the 1850s. A recent interpretation has described these busts as '"human trophies" of British supremacy in India',[123] and a similar use of colour is to be found in a contemporaneous series made by the French artist Charles-Henri-Joseph Cordier. In 1856 Cordier was funded to visit Algeria 'in order to reproduce different types which are about to blend together into that of one and the same people'. He returned with twelve busts in which these types were encoded through facial features and though the use of bronze and/or coloured marbles; ten were purchased for a new ethnographic gallery at the Musée d'Histoire Naturelle in Paris. Four years later Cordier collected his works into an 'Anthropological and Ethnographic Gallery for the History of the Races'. While many of his busts went into private collections, bronze versions produced by the firm of Lerolle Frères (manufacturers of *bronzes d'ameublement*) were on show at the International Exhibition.[124]

The encoding of difference did not exclusively rely on polychromy. Jennifer DeVere Brody has written eloquently of the links between white marble, purity and norms of beauty, particularly evident in Gibson's *Tinted Venus*. She argues that 'when most Victorians . . . spoke about beauty of sculpture – of its pure white forms, smooth unblemished surfaces, and unchanging solid structure – they spoke simultaneously of an idealised form of white beauty that complimented their racialised nationalist ethos'.[125] Nevertheless white marble was deployed in the representation of women of colour in several other contributions to the International Exhibition, notably Joseph Mozier's *An Indian Girl*, William Story's *Sibilla Libica* and his *Cleopatra*. Mary Hamer has indicated the restless and unpredictable 'variety of the visual signs produced under the name Cleopatra': while she could embody a powerful challenge to authority, she also signified prodigality and an unrestrained sexual desire. Renowned for dissolving a pearl in her cup and for her extravagant feasting, she was famed as the seductively beautiful lover of Marc Antony.[126] In Story's *Cleopatra* the Egyptian queen's royalty is set at variance to her

languid pose: she reclines seated, her right hand supporting her head, one leg thrown out in front of her. Her robe slips down to reveal her left breast. Neither lounging nor disarray would have been considered appropriate in the representation of a female monarch. Zenobia's carriage is upright, her back straight, her robes enveloping. For some, Story's *Cleopatra* became a cipher of masculine desire.

> Queenly Cleopatra rests back against her chair, in meditative ease, leaning her cheek against one hand, whose elbow the rail of the seat sustains; the other is outstretched upon her knee, nipping its forefinger upon the thumb, thoughtfully, as though some firm wilful purpose filled her brain, as it seems to set those luxurious features to a smile as if the whole woman 'would'. Upon her head is the coif, bearing in from the mystic *uræus*, or twinning basilisk of sovereignty, while from its sides depend the wide Egyptian lappels, or wings that fall upon her shoulders.[127]

This promise of pleasure requires the denial of Cleopatra's authority and power, which she had exercised through her religion as well as her pursuit of war and conquest. Cleopatra's death, transformed into a tragic yet romantic final scene, became one of the most popular images of her. Yet as Hamer indicates, her suicide asserted her resistance to Roman imperialism and her refusal to appear in a triumphal procession as well as her royal and her divine status and her associations with Isis, the goddess of death and the after-life; death by snakebite could connote the embrace of the sacred. It is this moment when, as Plutarch narrated and Shakespeare dramatised, attired in her robes and wearing her crown, that she succumbs to the venom, that is represented in Edmonia Lewis's *The Death of Cleopatra* (Figure 4.11). While one breast was bared (as was by now conventional in depictions of the queen), Cleopatra is represented with a gravitas and majestic authority which exceeds the 'meditative ease' of Story's sculpture.

Story's *Sibilla Libica* was hailed as 'a work of unwonted power' (Figure 4.12). Although it was likened to the Libyan sibyl of the Sistine Chapel ceiling, who turns away from the pages of the open book before her, Story's sibyl is caught in meditation. She is seated on a rock, her left hand lightly holding a scroll, her right supporting her chin as she looks into the distance. Reviewers thought that the sculpture portrayed an enigmatic figure, 'holding the African mystery deep in the brooding brain that looks out through mournful warning eyes', and that the figure was visibly African: '[h]er face has a Nubian cast, her hair wavy and plaited, as is meet'.[128] Zenobia's authority is, by contrast, assisted by maintaining a distance from such specifications of racialised alterity.

As Jameson indicated in her published account, Zenobia was an intellectual and a warrior queen. She reiterated this doubled identity in a letter to Hosmer:

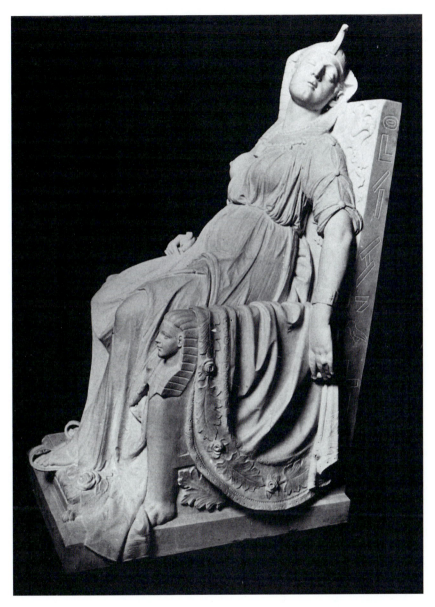

Figure 4.11 Edmonia Lewis, *The Death of Cleopatra*, c. 1872–6

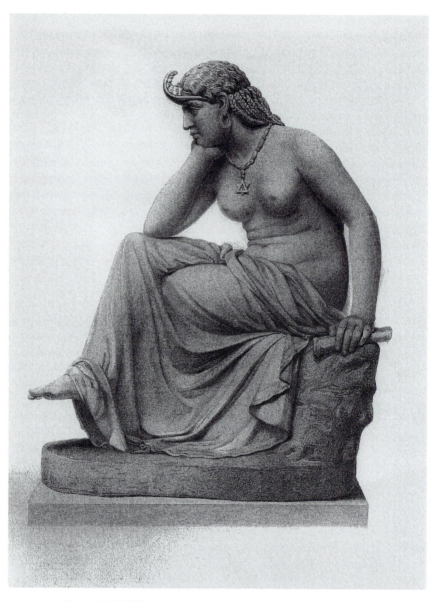

Figure 4.12 William Wetmore Story, *Sibilla Libica*, London 1862

the helmet-like Diadem pleases me much as suggesting the warrior Queen (& the cuirass for the same reason) . . . & that intellectual look which Zenobia had I suppose as indicative of her talents.[129]

Associations between Zenobia and women's learning were also intimated in Cobbe's discussion of the statue in an essay calling for the development of women's intellectual skills, higher education and medical training. Briefly to anticipate, the visual representation of the woman of learning could be managed through the sibyl, a figure with an extensive visual and literary representation from the classical periods to the Renaissance. Although the sibyls were often considered to be untutored visionaries with powers of divinely inspired utterance, by placing emphasis on study and interpretation, these figures became exemplary of the learned woman. The sibyl's powers of interpretation were indicated in Michelangelo's Sistine Chapel ceiling and Mantegna's *A Sibyl and a Prophet*.[130] Not only are there certain similarities between the pose of Hosmer's statue and Mantegna's sibyl, but Zenobia too bears a comparable diadem. Eusebius had conferred the diadem on the Erythraean or Persian sibyl (whose geographic province was Ionia and Asia, as was Zenobia's). The Erythraean sibyl of the Sistine Chapel ceiling has been perceived as a figure whose authority lies in her interpretation of sacred script. She contemplates the book in front of her, holding it as if turning the pages held between her finger and thumb.

The conjunction of the warrior queen and the sibyl could be found in a series such as the *Uomini Famosi* by Andrea del Castagno at the Villa Carduci (dating from the early fifteenth century), which includes the Cumaean Sibyl and Queen Tomyris. The Queen of the Massagetes who freed her people by her bravery wears a coat of mail and leans on her spear. Both bear a diadem.[131] A link between Zenobia and the sibyl also appears in the work of Joanna Boyce. The artist undertook intense research in preparation for a major painting to be shown at the Royal Academy in 1862 (Figure 5.6). The Cumaean Sibyl, consulted by Aeneus before his descent into the underworld, was said to have come to Italy from the east and in at least one depiction the Persian sibyl was represented as an African woman.[132] Whereas Story's figure is partially draped, Boyce's sibyl is fully clothed. Unlike her sculpted counterpart who looks into the far distance, Boyce portrays the sibyl engaged in an act of interpretation. Poised at a moment of intense thought, she consults the pages of a massive volume resting on a stand in front of her. In disrobing his figure, Story licenses an Orientalist exoticism. Boyce, by contrast, provides a rare image of a woman of colour as a figure of prophecy and learning.

Boyce's sketchbooks and albums of 1860–1 contain several pencil drawings of a woman or women with a columnar neck whose hair loosely brushed back is massed at the nape of her neck. It is possible that some or perhaps all of these studies, together with an oil study on paper laid down on linen, signed and dated 1861 (Figure 4.13), may portray a model identified as Mrs Eaton. This

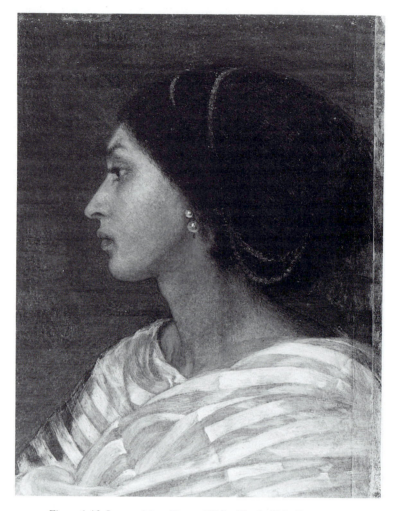

Figure 4.13 Joanna Mary Boyce Wells, *Head of Mrs Eaton*, 1861

delicately modelled and finely painted oil study of a head in profile facing left portrays a woman with a calm, meditative expression, set before a deep green ground. Threaded through her hair are strands of turquoise beads, pearls decorate her ears, and over her shoulders are draped swathes of a shimmering fabric striped with white and a dull gold. Mrs Eaton was one of several women and young girls of colour working as models in nineteenth-century London whose features can be distinguished in drawings and studies. Mrs Eaton is known to have worked for a select group of artists including D.G. Rossetti, Rebecca Solomon, Simeon Solomon and Albert Moore.[133] That she worked for Boyce is indicated by a lengthy note in the artist's papers about a 'Small head of Mrs

Eaton – on hot pressed white paper', dated November 1860, which may refer to this study of a head in profile. The artist's sketchbooks, which contain a finely drawn study of 'Madeline' wearing a loosely tied turban, testify to an earlier encounter with a woman of colour working in the Parisian ateliers when the artist was studying in France.[134]

A label on the back of Boyce's study of Mrs Eaton is inscribed, 'Head Mulatto woman/by Joanna M. Wells (née Boyce)/(from the same model as the Sibyl)/painted 1860–61)'. Although Pamela Gerrish Nunn considers this work to be related to the painting of *A Sibyl*, other possibilities might be considered. It might have been a free-standing study or related to other subjects that were being considered over the winter of 1860–1. The sketchbooks of this period are filled with notes and ideas as well as plans for exhibitions. Notes refer to a 'Life-sized head of Mrs Eaton (Zenobia)', while a 'Life-sized Mrs Eaton' is listed as the last of four contributions intended for the Royal Academy exhibition of 1862, the first of which was a 'Sibyl'. Although care must be taken not to elide written fragments with surviving works, three possibilities present themselves if this small-scale head in profile is detached from the painting of a sibyl. Considered as a portrait, it has similarities to a number of Pre-Raphaelite portraits in which the sitter is placed against a deep green ground. Conversely the study may have been undertaken in preparation for a life-sized study of the head of a woman, similar to *Elgiva* (RA 1855). Alternatively, this study might have been made preparatory to a projected painting of Zenobia which remained unfinished at the artist's death in the summer of 1861. What remains intriguing is a conjunction of Zenobia and the sibyl and their link through the model, Mrs Eaton.

Harriet Hosmer's *Zenobia* was exhibited at a watershed in debates over sculpture and at a critical moment in the history of women and women's art. The 1850s was the first decade in Britain in which considerable numbers of women practised as professionals rather than as amateurs. By 1862 they had a new public visibility, and sparked considerable public debate. Hosmer's *Zenobia* was one of many works to confound the stereotyping of women's art as domestic in subject and modest in scale. Although Zenobia is portrayed not at a moment of triumph but in captivity, the queen's capture did not delimit the statue's meanings. *Zenobia* negotiated the sexual politics of vision, images of slavery, criminality and street women, the invisibility of Queen Victoria, a crisis in the British monarchy, women's rights, and women's art. The sculpture was produced and perceived within a complex and contradictory matrix of contemporary politics, slavery, sovereign power and the protocols of sculpture, at the centre of which were troubling and unresolved questions of women's authorship and authority.

5

TACTICS AND ALLEGORIES, 1866–1900

Feminist politics and professional strategies

At the end of 1880s the artist Sophia Beale wrote to the suffrage leader Millicent Garrett Fawcett, explaining why she wanted the vote:

> I was thinking when I read the account of yr. meeting on W.S. that if you want a strong example of the utter stupidity & injustice of with-holding the franchise from us, you might instance my case, without my name perhaps –
>
> I pay rent & taxes £130 – I have nothing but what I earn by painting, teaching & writing – & naturally have to work exceedingly hard. (My stepmother, who lives with me, has enough for herself – but were she not here it w. make little or no difference to me) –
>
> We let out our ground floor unfurnished & reduce our rent, as the house is bigger than we want.
>
> My classes I hold on the *1st* floor – I paint in a studio above. Now here is the absurdity – My lodger, a young man of 26–30 doing abso-lutely nothing but moon about the town & amuse (!) himself – who is allowed an income by his mother – who gets up at 12, or 1 – & goes to bed at 2 or 3 am . . . passing his time smoking, dawdling & imbibing brandies & sodas . . . *has a vote* –
>
> The owner of the house, working early and late with all the responsibilities of a professional name, somewhat useful (I hope) in her generation at all events not useless . . . this individual because she is a woman is not capable of voting! Imagine my feelings!
>
> Again, I may vote for parish guardians of whom I know nothing: but for an M.P. of whose opinions I can judge I cannot! . . . I need not add that the vote the house has is Tory – what it *ought* would be radical!

Threaded through this text(ur)ing of a life is an appeal for enfranchisement intimately connected to a desire for the public recognition of the value of her professional endeavour, social contribution and moral probity. A figure painter

142

trained in London and Paris, Sophia Beale augmented her income by writing and teaching, opening an art school in Albany Street, near Regent's Park, and advertising herself as a pupil of Charles-Alphonse-Paul Bellay and Jules-Elie Delaunay, which gave a certain distinction in years when French technique was at a premium.[1] Beale had held strong views on women's suffrage since the early 1860s, when she considered:

> it will be years before we get the vote; but it must come as a mere act of justice and common sense. It is simply absurd that a woman with responsibilities and possessions should have no vote, and men, with very inferior qualifications, should be on the register.[2]

In 1889 a vehement debate took place over women's suffrage in the periodical press. Public declarations of support and opposition were issued, lists of names distributed, articles for and against printed. In setting out the debates for enfranchisement, Fawcett took up and modified Beale's letter, using her case to argue for the vote for independent, middle-class women who already paid rates and taxes and who could vote in local but not national elections.

> Women who have had to face the battle of life alone, to earn their living by daily hard work . . . generally feel the injustice of their want of representation. The weight of taxation falls upon them just as if they were men, and they do not see why representation should not go with taxation in their case.[3]

Fawcett was not the only reader to be impressed by the force of Beale's reasoning. Beatrice Webb, in 1889 neither in favour of suffrage nor persuaded by Fawcett's advocacy, transcribed the published version of Beale's letter in her diary, noting that it 'contains the pith of the argument in favour of women's suffrage, and as such is valuable. One must realize the strongest argument of one's opponent before one is fit to controvert the whole position.'[4]

Beale was one of many to argue that social responsibility and tax obligations were good enough reasons for enfranchisement. Barbara Bodichon declared in 1866:

> That a respectable, orderly, independent body in the State should have no voice, and no influence recognised by the law, in the election of the representatives of the people, while they are otherwise acknowledged as responsible citizens, are eligible for many public offices, and required to pay all taxes, is an anomaly which seems to require some explanation.[5]

In 1879 the watercolourist Helen Allingham had no doubts that 'women paying taxes ought to be able to vote as men do'. And Margaret Gillies argued, 'As holders of property and payers of rates and taxes, women who do so ought,

it seems to me, to have a vote in the choice of those who are their representa-
tives in Parliament.'[6] Successful careers and sometimes family wealth funded
artists as owners, leaseholders and occupiers of property. Sophie Beale, Barbara
Bodichon, Susan Dacre, Emily Ford, Eliza Fox, Elizabeth Guinness, Louise
Jopling, Mary Lloyd, Henrietta Ward and the art writer Emilia Dilke were
among those who drew attention in the 1880s to their eligibility to
enfranchisement on these grounds. Only a few went as far as tax resistance.
From 1870, already wearied of petitions, Charlotte Babb refused to pay taxes,
putting forward her arguments for 'no taxation without representation' in essays
and pamphlets. Although her studio properties, furniture and engravings were
regularly seized in payment, she maintained her resistance for thirteen years.[7]

These women were among the many painters and sculptors who from the
mid-1860s to the end of the century and beyond lent their support to the
campaigns for votes for women, not enfranchised in Britain until 1918 and
1928. As respected and respectable professionals with national, even inter-
national reputations, women artists could embody social responsibility, profes-
sional standing and propertied status. With the rejuvenation of an alliance
between high art and high society in the later decades, women artists came to
have a certain glamour and fashionability which could be turned to advantage.
This class exclusivity as well as the emphasis on constitutional tactics has led to
an assessment of the nineteenth-century movement as 'the parliamentary
lobbying activities of an élite group of middle-class women'.[8] Time and again,
suffrage publications drew attention to women's social class. *Opinions of Women
on Women's Suffrage* of 1879 included 'Women engaged in Literature and Art'
alongside those in education, philanthropy and temperance, elected to school
boards and as Poor Law guardians, and women following 'scientific and profes-
sional careers'.[9] In two *Letters* (coinciding with the Reform Bill of 1884),
women 'engaged in professional, literary and artistic pursuits' were but one
constituency highlighted in making a case for the enfranchisement of 'so large
a proportion of the property, industry and intelligence of the country'.[10] A
Declaration in Favour of Women's Suffrage published in 1889 was arranged to
demonstrate the breadth of women's contributions to national life, public ser-
vice and the professions as well as the Treasury. Well-known names were
needed and those listed included figure painters Lucy Madox Brown, Margaret
Dicksee, Louise Jopling, Jessie Macgregor, Evelyn de Morgan, Emily Mary
Osborn and Henrietta Ward, the animal painter Maud Earl and the sculptor
Mary Redmond.[11] *Some Supporters of the Women's Suffrage Movement* of 1897
included many of the 1889 signatories, adding Anna Alma-Tadema, Rose
Barton, Elizabeth Armstrong Forbes, Mary Gow, Mary Grant, Kate Perugini,
Henrietta Rae, Dorothy Tennant (Stanley), and Elizabeth Thompson, Lady
Butler and the classical scholar and art historian Jane Harrison, alongside
women in medicine, education, literature, social and political work.[12] The
prominence accorded to artists in suffrage publications was pronounced: those
who endorsed calls for higher education did so as teachers or as signatories to a

general list.[13] Equally distinctive was the attention to public work; signatories of anti-suffrage statements usually signed in a private capacity.

Support for suffrage varied from lending a name for a declaration to joining a society, public speaking, writing articles and pamphlets or arranging events. Elizabeth Guinness was one of several to host meetings in her studio.[14] Barbara Bodichon was a key figure in the first suffrage petition presented to Parliament by John Stuart Mill in June 1866. Soon after her arrival in London in May, she began to gather support, as a contemporary noted: 'Mme Bodichon, fresh from Algiers, . . . is in great request and earnest about a petition to Parliament to grant votes to women.' She initially accepted the secretaryship, although she doubted her suitability 'being legally a French woman and having a French name' and by the autumn she formally withdrew, promising however to 'work as an outside skirmisher'.[15] While Bodichon's advocacy of working with men ran into collision with the women-only committees favoured by Helen Taylor, her letters suggest something of the complexities in negotiating between a career and campaigning. Although only in London for the summer months, Bodichon joined the National Society for Women's Suffrage in 1868, gave lectures, wrote pamphlets, hosted soirées and put her name to several declarations while pursuing a career as a painter. Her electioneering for J.S. Mill's parliamentary seat in 1865, when she 'hired a carriage and covered it with placards, and in this carriage she and Emily Davies and Bessie Parkes and Isa Craig drove about Westminster', may well have anticipated later suffrage promotions: in the early twentieth century horse-drawn vehicles placarded with 'Votes for Women' advertised the paper of the Women's Social and Political Union.[16] Lillie Stacpoole (Haycraft), a society portrait painter who secured at least one royal commission for a portrait of Princess Victoria of Teck in 1886, was a member of the Executive Committee of the National Society in the 1880s and a signatory of the 1889 *Declaration*. She attended and addressed drawing-room meetings in this decade and was, perhaps, one of the speakers at a large public meeting held at St James's Hall in London on 5 July 1883.[17] Janice Helland has drawn attention to the activism of women painters in Scotland. A figure and landscape painter based in Edinburgh and London, Mary Burton was active in the Edinburgh suffrage society, helping to organise the 1884 Scottish National Demonstration of Women.[18] If some could combine painting and politics, others deferred. Henrietta Ward, well known in the 1850s and 1860s for her modern-life subjects and historical paintings, did not became involved in suffrage until her painting career was in decline. Convinced of the importance of the vote, she affirmed her 'strong opinion on the subject' and the reasons 'which would make it *most desirable* for women in my own profession'.[19]

A few took to the platform. The interior designers Rhoda and Agnes Garrett earned reputations as celebrated and effective speakers (Figure 5.1). Bodichon's electrifying performance in Manchester in 1866 is said to have inspired Lydia Becker to take up the cause. Emily Ford, a painter who spoke on women's education and suffrage, recollected that it was 'sufficiently terrifying

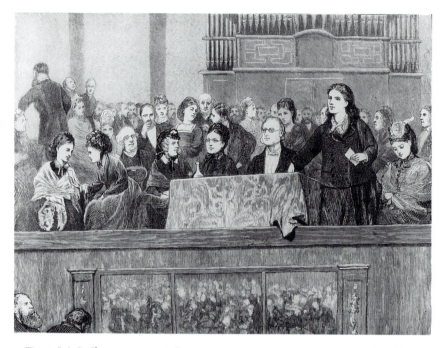

Figure 5.1 Suffrage meeting at the Hanover Square rooms, London, *The Graphic*, 25 May 1872. From left to right on the platform, Millicent Garrett Fawcett, Frances Strong Pattison [the art critic Emilia Dilke], Ernestine Rose, Lydia Becker, Dr Lyon Playfair and, speaking, Rhoda Garrett

to a young and highly-strung girl like myself to have to get up and speak, sometimes with a paid bully lounging against the lorry ready to smash your meeting, if not your jaw'. Although Quakers like Ford may have spoken in Friends meetings, this was little preparation, and with few other opportunities for public address, women often experienced profound terror on the platform. A novelty in the 1860s and 1870s, platform women encountered particularly violent opposition when speaking on suffrage, temperance, and for the repeal of the Contagious Diseases Acts.[20] By the early 1880s they were less of a novelty and those who attended public meetings would have seen and heard many female orators (see Figures 5.1, 5.27 and 5.28).

Artists were among those who contributed funds through subscriptions, major donations and occasional gifts. While Bodichon could extravagantly promise £50 for the special fighting fund for women's suffrage in 1884, others like Charlotte Babb, whose paintings of mythological and modern-life scenes attained little recognition, modestly pledged £5.[21] Signing the 1866 petition, Babb joined the National Society in 1868 and for nearly thirty years paid a regular subscription.

Whereas Babb, Agnes Garrett and Ward all took an active role in the London suffrage societies,[22] for others signing a petition or endorsing a declaration registered a limit to their contact within the movement. The first suffrage petitions included signatories who had long been active in feminist politics: Anna Mary Howitt, Rebecca Solomon, Margaret Gillies and Emma Novello, as well as Bodichon and Eliza Fox, who shared so much in the 1860s (visits to Algeria, exhibitions in London, a circle of friends, membership of the National Society).[23] For the watercolourist Constance Phillott, the 1866 petition marked a beginning; she became a member of a London suffrage society and declared in favour in 1889, adding the prestige of her membership of the Royal Watercolour Society.[24]

Identification from published lists is, however, fraught with uncertainty. A Miss Durant listed in the membership records of the London National Society in the 1870s might refer to the sculptor Susan Durant, who from the early 1860s supported educational reform, joining London School Boards Committee.[25] Surviving documentation is uneven and its interpretation has been hazardous for at least a century. Compiling *Some Supporters of the Women's Suffrage Movement* in 1897, Helen Blackburn admitted that although 'this publication contains only such names as have already appeared in published records and public memorials', '[s]uch a list of names, however carefully compiled, must necessarily be more or less incomplete.'[26] Nevertheless a broad range of artists is to be found in suffrage archives. Across this diversity, certain genealogies can be traced. Traditions of radicalism, social reform and professional work were sustained within families and across generations. Helen Thornycroft, a figure painter and suffragist, was the daughter of the sculptor Mary Thornycroft who had signed the 1859 Royal Academy petition. Helen Allingham stayed with her aunt Laura Herford when she came to study in London in 1867.[27] Jessie Macgregor and her aunt Margaret (Mrs A.W.) Hunt (one of several female relatives who taught her to paint)[28] were both suffragists, as were the cousins, Agnes Garrett and Rhoda Garrett, and the sisters Clara and Ellen Montalba. Constance Phillott was a cousin by marriage to Evelyn de Morgan. The activism of Emily Ford, her mother Hannah Pease Ford, her sisters, Isabella and Elizabeth (Bessie), and her sister-in-law Helen Coxfield Ford was shaped by local geographies and family connections in Leeds and Manchester.

The Fords were a prosperous Quaker family. Emily Ford's parents encouraged their children to make independent lives shaped by moral principle, social responsibility and active intervention. When each reached the age of 16, their father, a solicitor, encouraged Emily, Isabella and Bessie to become involved in a night school for working women and girls, an experience which Emily regarded as formative.[29] Hannah Pease Ford had been involved in the anti-slavery movement and she became a prominent local activist in the campaigns to secure the repeal of the Contagious Diseases Acts which, in providing for the forcible apprehension, examination and medical treatment of prostitute

women, were viewed by many feminists as licensing masculine vice and promoting a double standard of sexuality.[30] The historian of these campaigns, Judith Walkowitz, has emphasised that while their supporters were overwhelmingly non-conformist and middle-class, the leadership cadre of the Ladies' National Association was composed of mature, affluent women with long family traditions of reform, who took up a decisively moral stance.[31] Emily Ford's feminist preoccupations were thus shaped by her family, religion and locale. While Isabella became a prominent campaigner for the rights of working women and Bessie became a musician, Emily studied at the Slade School of Art from 1875 and established her career as a painter and a dramatist.

From 1873 to its demise in 1881 Emily Ford was a committee member of Leeds Ladies' Educational Association, which debated university education, provided lectures and courses, supervised the Cambridge Local Examinations and worked with other local bodies for the founding of the Leeds Girls' High School. She attended meetings fairly regularly, and for several years acted as secretary, taking the minutes and presenting the annual report at meetings held in the Mechanics Institute in Leeds. In 1879 she was among those who backed a series of lectures on the laws relating to women's property and the custody of infants; the major controversy which arose over these lectures split the association and contributed to its demise.[32] The association had strong links to women's suffrage: one of its most active members was Alice Scatcherd, by 1880 a prominent public speaker who addressed major demonstrations and, like the Ford women, a member of the Manchester Suffrage Society (Figure 5.27).[33]

A dynamic centre of activity in the 1880s, the Manchester National Society for Women's Suffrage attracted members across the North of England. It also developed strong links with local women artists, whose association in 1880 made a donation to the suffrage society. The Manchester Society of Women Painters was a short-lived but successful tactical move initiated from 1879 to 1883 to secure the visibility and professional rights of women artists in the city. Its president Susan Dacre (who served on the executive committee for ten years) as well as members Annie Swynnerton and Jessie Toler Kingsley were active in suffrage locally or nationally, all three with Emily Ford signing the 1889 *Declaration*.[34]

In the late 1880s, possibly as early as 1887, Emily, Isabella and Bessie Ford became highly involved in the movement for an independent labour politics in Leeds, engaging with a socialism which addressed the inequalities of capitalism, class and gender.[35] Emily Ford joined the Leeds Socialist League to help tramway men improve their conditions and, with her sisters and Alice Scatcherd, she supported a series of strikes in 1888 and 1889, notably those of the women weavers and the tailoresses, giving practical assistance as well as money for the strike fund. At the same time the sisters continued their educational work: the *Yorkshire Factory Times* reported in November 1889 that the 'three sisters are, and have been for some considerable time, engaged in the work of educating the poorer of the children living in the Mill Hill district'.[36] In the early 1890s,

however, Emily Ford's religious convictions, feminist and socialist politics all underwent profound change. She resigned her membership of the Society of Friends and converted to Anglicanism.[37] Although she abandoned socialism, she retained her support for women's suffrage (transferring her membership to London) and maintained a life-long commitment to social purity.[38] Concerned about the conditions of women's labour, with Isabella she became a strong opponent of protective regulation.[39]

Emily Ford's participation in a number of causes was by no means uncommon. Judith Walkowitz's chart of the interests of LNA activists includes suffrage, higher education, temperance, legal reform, social purity and anti-vivisection.[40] While this mapping provides evidence of a broad alliance of social reform, it equally testifies to an overlapping of feminist concerns and their dispersal into related campaigns. Phillipa Levine notes that in the later decades 'feminist analysis was not wholly confined to the specifics of *women's* grievances ... but encompassed a broader moral critique'.[41] Louisa Starr, an artist who sprang to fame when still a student at the Royal Academy and pursued a successful career as a history painter, was described in an obituary as taking 'an interest in all movements concerning women'. An advocate of social purity, she publicly declared in favour of suffrage in 1889. A member of the societies for the Regulation of Abuse in Public Advertising and for Suppressing Street Noises (consistent with vigilance concerns), she was also in favour of dress reform and opposed to domestic violence and child abuse. A concern for animal welfare led to her opposition to fur and feathers in dress and decoration.[42] Rhoda Garrett was active in suffrage and the repeal of the Contagious Diseases Acts.[43] Louise Jopling was a keen suffragist, a tax resister, and in the early 1890s a successful campaigner for equal rights for women members of the Society of Portrait Painters.[44] Janice Helland points out that Mary Burton was a fervent advocate of women's education and right to work as well as suffrage; she was present on the platform at a meeting held in Glasgow in 1888 to facilitate the organisation of women's unions. Such activism did not preclude party politics: during the early 1890s Burton was president of the Edinburgh Women's Liberal Association.[45] Eliza Fox was among those who supported suffrage and opposed vivisection. The anti-vivisection movement drew strong support from artists. Well-known painters and sculptors were among the distinguished signatories who headed two anti-vivisection petitions of 1877. Whereas professionals and tradespeople indicated their occupation and James Sant inscribed with a flourish his appointment as 'Painter in Ordinary to the Queen', the flower painters Annie Mutrie and Martha Mutrie, so protective of their lives that Ellen Clayton had been unable to solicit any personal information from them, signed the petition giving only their address.[46]

When Millicent Garrett Fawcett proudly claimed in 1886 that '[t]here is hardly any distinguished Englishwoman of the latter half of the nineteenth century who has made an honourable name through the work she has done in literature, science, education, or philanthropy who has not expressed her

sympathy with the movement', she made two telling omissions: she excluded art and, in listing twenty individuals who had given 'warm help and support', she named only two artists, Clara Montalba and Barbara Bodichon.[47] Clara Montalba was a highly successful painter of landscape and marine views who, like Constance Phillott and Helen Allingham, received professional recognition with election to membership of the Royal Watercolour Society. At the same time, working for suffrage (or trade unionism, or social purity) became a full-time occupation entailing vast amounts of daily correspondence as well as the organisation of public events and attendance at committee meetings. Alongside the regular production of paintings or sculptures for annual exhibitions on which an artist's livelihood depended, it may have been difficult for artists to write letters and articles, solicit signatures, deliver speeches, manage a suffrage society, chair a committee or canvass opinion, to undertake the time-consuming work which Bodichon undertook for a short period in 1866. Catherine Maude Nichols, in 1889 elected to the newly formed Society of Painter-Etchers, admitted in an interview that same year that although she was interested in the women's movement, she had neither the time nor the inclination to be an active campaigner:

> While men have all the power they make laws in their own favour, I feel that. Still I think that men and women have different parts to play in the world, only you cannot draw a hard and fast line. . . . It is certainly a good thing if women's interests should be looked after, but I do not feel I can take up that subject.[48]

The contemporary critic, Jane Quigley, considered that it took the magnificent spectacle and collectivity of the early twentieth-century suffrage movement for artists, 'by temperament individualists', to discover a cause 'more absorbing than the mere struggle for individual success'.[49]

The pursuit of a career in fine art increasingly demanded a strict professionalism and an exclusively artistic identity. An association with women's rights may have been perceived as at best distracting and at worst polluting: either way women might be regarded as amateurs whose interests were dispersed in the social field rather than focused on the practice of art. Moreover, the cultural values of the period and an emphasis on 'art for art's sake' may well have prompted a distance from politics. A number of well-known painters, notably Sophie Anderson, Alice Havers, Anna Lea Merritt, Marianne Stokes and Lucy Kemp-Welch, did not lend their names to the cause. Their absence is not conclusive, since supporters sometimes worked behind the scenes, concerned that public allegiance might prove detrimental to the pursuit of a profession which had been taken up as a feminist strategy. The physician Elizabeth Garrett offered her drawing room as a campaign base for the suffrage petition of 1866 but declined to become a committee member, considering 'that it would prejudice the cause of women in medicine to be too openly associated with politics'.[50]

Political activism seems to have been more easily accommodated with a career in design: not only did this work carry a less elite status than fine art but it was supported by and accommodating to political activism. In the 1889 *Declaration*, Agnes Garrett was listed as a 'House Decorator' among 'Women engaged in Business and Working Women'. Although the Arts and Crafts movement renegotiated an old divide between artisan and artist, associations with trade remained. Lynne Walker has indicated the political sympathies shared by the Garretts and the clients of their art decoration firm, while Anthea Callan has drawn attention to Esther Bensusan Pissarro's engagement with radical politics, Annie Cobden-Sanderson's militant suffragism, May Morris's socialism and the contradictions for women between Arts and Crafts, socialism and feminism.[51] By 1885 May Morris took full responsibility for the embroidery department of Morris and Co. and often executed commissions herself, particularly the 'show pieces' sent to the Arts and Crafts exhibitions. In this same decade she took a strong interest in socialist politics, attending meetings of the Social Democratic Federation and becoming one of the breakaway group which formed the Socialist League. A founding signatory of its manifesto of revolutionary socialism, which proclaimed the common ownership of the means of production and advocated the abolition of 'modern bourgeois property-marriage', she supported the League by embroidering a number of banners, flyposting announcements and appearing with Eleanor Marx and George Bernard Shaw in fund-raising entertainments. She also appeared on a socialist platform in a rally in support of Irish nationalism. Whereas socialism attracted a number of prominent writers and designers who openly supported its concerns, far fewer women artists have, as yet, been linked to the movement. One of the best-known later Pre-Raphaelite artists, Marie Spartali Stillman, subscribed to the socialist paper, *Commonweal*, and arranged theatrical outings in support.[52]

Bridget Elliott and Jo-Ann Wallace have noted that 'women associated with various avant-gardes publicly and privately distanced themselves from any sort of political engagement, particularly feminism'.[53] It is certainly the case that young women enrolling in art schools in the 1890s, such as Gwen John, Edna Clarke-Hall, Ursula Tyrwhitt, Gwen Salmond and Vanessa Bell, did not lend public support to the women's movements. While such distance can be attributed in part to the enervation of the campaigns in the 1890s and family traditions (Bell's mother was a signatory to an 1889 declaration against women's suffrage), these women equally distanced themselves from the spectacular campaigns of 1907–14. The issue lay, perhaps, in contested definitions of modernity, feminism and femininity. In a self-portrait of 1899 Gwen John, at the outset of her career, dramatically stages herself as a 'new woman'; she wears modern separates, with a blouse with full sleeves and a dashing bow at the neck (Figure 5.2). For Alicia Foster this self-portrait, by combining 'the modern dress of a middle-class New Woman … with the bravura and pose of old master paintings and contemporary grand manner portraiture', asserts 'the

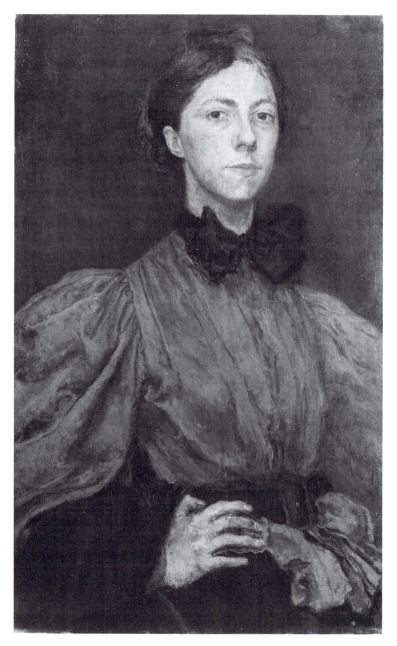

Figure 5.2 Gwendolen Mary John, *Self-portrait* [1899]

audacity, independence and creativity of [a] woman artist disrupting artistic tradition to claim her own place'.[54] This self-portrait countered a welter of popular depictions of new women with unruly hair and radical dress, surrounded by advanced books, plays and pamphlets, images which, as Viv Gardner demonstrates, both portrayed and parodied the tastes of young independent women of the 1890s.[55] The subject of numerous novels, plays, short stories and cartoons, the 'new woman' was highly contested at the end of the century. She condensed in a single figure a range of responses to the increasing autonomy of middle-class women, from fears and anxieties to pleasures and enthusiasm. At once a journalistic fantasy and a role model, the 'new woman' has been defined by Lucy Bland as 'a young woman of principle . . . concerned to reject many of the conventions of femininity and live and work on free and equal terms with the opposite sex'. The distinctive characteristics of the 'new woman' were personal freedom, individualism and the making of an independent life organised around work, socialising unchaperoned in mixed company, and living in rented accommodation rather than the family home. For Lucy Bland, although 'new woman' and 'feminist' were not terms of equivalence, 'the self-defined new woman was likely to have held feminist convictions'.[56] The relations between feminism and 'new womanhood' were, however, highly ambivalent: if the new woman was 'modern' in her independence, individuality and often flamboyant unconventionality, her personal rebellion often took place outside formal organisations and reforming movements. Her assertive individualism tended to be concerned more with personal development than public campaigning and Lisa Tickner has concluded that the 'idealistic, frequently neurotic and explicitly sexual non-conformity' of the 1890s new woman was to prove 'a very bad model for the respectable, responsible and collective politics of the suffrage campaign' of the early twentieth century.[57]

Two woman artists, Laura Alma-Tadema and Marie Spartali Stillman, can be identified among those who endorsed *An Appeal against Female Suffrage* in 1889, also signed by the writers Eliza Lynn Linton, Christina Rossetti and Mrs Humphrey Ward. The *Appeal* rejected enfranchisement on the grounds that it would bring about 'a total misconception of woman's true dignity and special mission' which was to participate in social action but not in government. A supplement repudiated the vote as 'a measure distasteful to the great majority of the women of this country – unnecessary – and mischievous both to themselves and to the State'.[58] Fawcett dismissed its signatories as 'ladies to whom the lines of life have fallen in pleasant places' and Emily Davies judged them not 'the best and ablest women . . . not distinguished women, but wives of distinguished men'.[59] While these comments applied to the wives of Edward Poynter, Walter Bagehot and Matthew Arnold, Laura Alma-Tadema was contradictorily placed. A painter who had won international recognition early in her career and was well respected by the end of the 1880s for her scenes of home and hearth set in the seventeenth-century Dutch republic, she was

married to the neo-classical painter, Lawrence Alma-Tadema, who was to be knighted in 1891 and created baron in 1900. Marie Spartali Stillman, however, was not among this social group and there is some evidence to suggest a change of heart by 1911 when, with Swynnerton, she headed the Women's Coronation Procession.[60]

The historian Jane Lewis has succinctly stated: 'To be anti-suffrage was not necessarily to be anti-feminist; many opponents . . . campaigned for better educational opportunities for women.'[61] Antipathy to suffrage could be prompted by a concentration on another campaign, dissenting beliefs on the nature of femininity and gender relations. Writing in 1851, Harriet Taylor was in no doubt that aspirations for success could inhibit speaking out on women's rights when she accused 'the literary class of women' of being

> ostentatious in disclaiming the desire for equality or citizenship . . . it is the personal interest of these women to profess whatever opinions they expect will be agreeable to men.[62]

A few male artists and art critics spoke out in favour. The eminent animal painter and Royal Academician, Edwin Landseer, was a signatory of the second suffrage petition of 1867. In the 1870s Edward Matthew Ward (a history painter whose reputation was moribund) joined his wife Henrietta Ward on the General Committee of the Central Committee of the National Society, and John Staines Babb (a landscape and figure painter) accompanied his sister Charlotte Babb. Art critics William Michael Rossetti and F.T. Palgrave – who often chided women artists for not attaining professional standards – were also suffrage supporters. William de Morgan, husband of Evelyn, became a vice-president of the Men's League.[63]

Escalating numbers of women artists were in practice in the later decades of the nineteenth century. No longer the extraordinary phenomenon of the 1850s, they exhibited and sold their work in an art world which had changed considerably since the mid-century. Smart money was invested in art and a conspicuous artistic consumption. Renewed cultural alliances with the aristocracy were marked by patterns of patronage, the creation of peers from ranks of artists and new artistic institutions like the Grosvenor Gallery. Founded in 1877 and managed by Sir Coutts and Lady Blanche Lindsay, this 'palace of art' in London's west end brought professional artists in contact with the leaders of fashionable society and titled amateurs, for whom the practice of art was a sign of social status. Its exhibitors included Emily Ford, Margaret Gillies, Louise Jopling, Clara Montalba, Evelyn de Morgan, Emily Mary Osborn, Kate Perugini, Constance Phillott, Louisa Starr, Henrietta Rae and Annie Swynnerton, all well known for their painting and for their support of the women's movement. Paula Gillett has argued that the conspicuous presence of feminism was crucial to the Grosvenor's success and 'likely to have attracted fellow suffragists who knew some of these artists'.[64] It is also tempting to speculate that

not only the Grosvenor's exhibition rooms but its restaurant, which specifically catered for 'ladies', and the Library and Club, which from 1880 offered the use of a Ladies' Drawing Room, provided stylish meeting places for activists and sympathisers. The Grosvenor in turn lent suffrage a certain fashionability. The pursuit of a successful career required skilful socialising with clients and reviewers 'at home' and at west end venues like the Grosvenor, as well as the adroit management of dress and appearance. Millais' spectacular portrayal of Louise Jopling, highly acclaimed when shown there in 1880, presents the sitter as an elegant and assured social actor, resplendent in a magnificent gown by a Parisian couturier. Her only attribute is a spray of flowers: there is no hint that she is an artist working for her livelihood (Figure 5.3). By appearing as exhibitors and as sitters for fashionable portraitists, Louise Jopling and Kate Perugini promoted themselves as talented painters, pretty women, chic dressers and members of that elite society which patronised the gallery and its artists.[65]

A rapid increase in the number of exhibiting venues and an expansion of the commercial art market was accompanied by an extraordinarily wide discussion of art and artists in newspapers, general interest and illustrated journals, comic magazines, and art papers such as *The Magazine of Art* and *The Studio*. Interviews, features and profiles, photographs, *cartes-de-visite*, monographs, solo shows and retrospectives, and the launch of a new publishing phenomenon – the lavishly produced, well-illustrated, often two-volume biography – all fashioned the artist as of compelling interest. But in this welter of interviews and features in the art press and women's magazines, little mention was made of feminism. Only three of the entries in Ellen Clayton's *English Female Artists* of 1876, in many cases based on autobiographical information, mentioned any connection to women's rights. Bodichon was acknowledged as a 'philanthropist' who was 'instrumental in founding' Girton College Cambridge. Susan Gay, a landscapist, admitted 'having always taken the greatest interest in all that may aid the advancement of women . . . convinced that such a cause is involved with the highest human interests'.[66] Meanwhile the still-life painter Emma Wren Cooper testified to 'the warmest interest in the higher education of women and in the welfare of her sex'.[67]

Petitions and declarations relied not only on securing signatures but on obtaining those that added lustre and respectability (Figure 5.4). A signature was not just a written or designed form of an artist's proper name, for as Jacques Derrida has reminded us, 'writing out one's name is not yet signing'. It was a trademark, a distinctive logo, an 'author name' which authorised the product and tied it to a specific maker. To be accepted and recognised, a signature adopted a form that was unique yet reproducible. As Derrida explains, its legitimacy and authority were assured by repetition and citation: 'to be legible a signature must have a repeatable, iterable, imitable form'.[68] In the nineteenth century, the 'author name' became, as Michel Foucault has demonstrated, a primary means by which discourse was classified and organised.[69] The circulation and preferment of author names was neither arbitrary nor accidental but

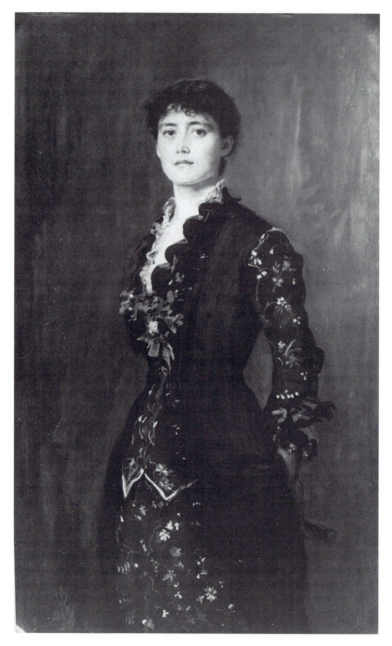

Figure 5.3 J.E. Millais, *Louise Jopling*, 1879

Figure 5.4 Memorial to the Schools Enquiry Commission
for a Ladies College, July 1867. Signatories include the flower
painters and art teachers, Harriet Harrison and Emily Harrison
of Hyde Park College, London, and below Dorothea Beale,
Principal of Cheltenham Ladies College. The petition rolls
were compiled by pasting together small strips of signed
paper; the joins are visible

secured by the institutions of culture, relations of power and formations of
difference. By no means a neutral or unmarked category, the 'author name' was
indispensable in the making of a professional reputation.

For women, the making of an author name was entangled in and disrupted
by sexual asymmetry. Its form and circulation often registered sexual difference.
Those who married had to negotiate a change of family name and either re-
establish their career with a second or sometimes third name or retain that by
which they were already known. The feminist writer and suffragist, Florence
Fenwick Miller, dwelt on these dilemmas in her 'Ladies Column' for *The Illus-
trated London News*, pointing out that '"Henrietta Rae" is one of the many
illustrations among women workers of an ever-recurring inconvenience – the

loss of the name in marriage. This celebrated artist is *alias* Mrs Normand.' Art critics were uncertain, some using both names and others referring to 'Mrs Henrietta Rae'. The artist's 'author name' came to have a heightened status in the intense debates over copyright provoked by the reproduction of paintings in advertisements, and in the consumer culture in the 1880s and 1890s, brand-names became increasingly popular to differentiate manufactured goods and processed products in a highly competitive global market. The significance of the brand-name was not lost on Fenwick Miller, who reminded her readers that

> It was stated in another column of this paper last week that Lord Leighton, when raised to the Peerage, retained his own name for his title because, as he said, 'the name is the trade-mark that the worker cannot afford to lose'.[70]

Consistency was also important for feminist politics: the artistic signature was deployed in suffrage letters, declarations and petitions. These documents could be disqualified by forgery. Highly damaging to the probity of middle-class campaigners, forgery broke the connective work of the signature to move between art and life. A highly mobile and dynamic borderline shuttling between the corpus of the work and the body of its producer, the signature connected the historical personage, the author name and the opus.[71]

This connective work may help to explain why suffragists, like other nineteenth-century petitioners, placed such faith in the often bulky and weighty rolls formed by gumming together innumerable slips of signed papers. Petitionary signatures were not so much a written inscription of the verbal demand as a registration of a physical presence. Derrida explains in 'Signature Event Context' that if the signature implies 'the actual or empirical non-presence of the signer . . . it also marks and retains his [or her] having been present in a past now'.[72] The signature thus implies that the person was present but is present no longer. On occasion this representational function was openly acknowledged: a suffrage petition calling for the enfranchisement of women made by the inhabitants of Bristol assembled at a public meeting in 1877 was signed by Anna Gore Langton, president of the meeting, 'on behalf of the meeting'.[73] When a petition was presented, all the signatures were present but few of the signatories. Rather, the bulk of the petition stood in for the support given to a cause. Suffragists placed great store by both the numbers of petitions sent to the Houses of Parliament and the numbers of signatures on them, the London society triumphantly reporting in 1869 that '[d]uring this session, we have pelted Parliament with petitions', some 75 with 50,000 signatures being presented.[74]

The petitionary signature's ability to stand in for the bodies of those who had signed was a useful feminist strategy in the 1850s and 1860s when although women were claiming a political presence, by no means would they have

appeared in public *en masse*. But in the early 1880s the introduction of spectacular national demonstrations and processions decorated with banners temporarily dislodged the primacy of the signed petition. By marching on the streets and attending and speaking at large public meetings, women campaigners secured a visibility which was enhanced through their visual representation in illustrated papers and magazines (see Figures 5.1 and 5.28). Although campaigners soon returned to petitioning and pamphleteering, when in 1907 prominent British politicians alleged that they had no evidence that women desired the vote, thousands turned out on the streets. As Emmeline Pethwick Lawrence rightly surmised, 'Petitions go into parliamentary waste-paper baskets. They cannot put a procession of fifteen thousand women into waste-paper baskets. They cannot ignore them and pretend that they are not there.'[75] Petitions were indeed unregarded and discarded; proportionally few now remain in the archives of the Houses of Parliament or elsewhere.

The convergence between artists and militants which had been so sustaining at the mid-century was reconfigured in the later decades of the century. Professional success and individual achievement became key features of feminist campaigning, the hallmarks of 'feminist individualism in the age of imperialism'.[76] An increasing emphasis on professionalism demanded an intense commitment to the practice of art as well as the assiduous cultivation of clients, critics and dealers. Yet it was during these same decades that many women artists publicly declared their support for women's suffrage and negotiated complex relations between painting and politics.

Women, power, knowledge: the image of the learned woman in the 1860s

Recent feminist scholarship has drawn attention to the many Pre-Raphaelite images of witches and sorceresses which were produced between the 1860s and the end of the century. Towards the end of *Pre-Raphaelite Women*, published in 1987, Jan Marsh comments that

> The closest that Pre-Raphaelite art comes to presenting femininity in wicked or ugly guise is in the delineation of woman as enchantress or witch. But even here, womanhood is almost never shown as contemptible or base, and the images of the ensnaring sorceress are as idealised and beautiful as those of the courtly lady.[77]

Pursuing this theme in greater detail, Susan Casteras argued that although 'the female with uncommon creative or intellectual ability was a decided outsider and anomaly' in Victorian art, 'the woman endowed with superior creativity typically found a visual equivalent in the witch or the sorceress'.[78] Developing Casteras's arguments and taking up her suggestion that such imagery 'served as spectacles for erotic consumption by men (both artists and spectators) as well as

manifestations of masculine fears, desires and fantasies',[79] Beverly Taylor's compelling essay reconsidered the 'erotic charge' of 'female savants':

> Represented with iconic tomes of obscure learning, cauldrons and potions, prophetic mirrors, globes, or magician's weeds, these figures are conspicuously erotic, their sexual appeal and threat graphically displayed in their abundant, loose hair, transparent or clinging garments, or accentuated erogenous zones. While these images in some instances may express fear of sexuality and power, they also pose a potent challenge to the pervasive Victorian discourse opposing women's learning.[80]

What is striking though unremarked by these authors is the preponderance of such imagery in the 1860s, a decade which saw the effective organisation of the women's movement on a national scale. Exemplary is Edward Burne-Jones's watercolour of 1860, *Sidonia von Bork*, inspired by Johann Wilhelm Meinhold's tale of a sorceress who wreaked havoc and destruction in the ducal courts of northern Germany between 1560 and her execution as a witch in 1620 (Figure 5.5).[81] In a claustrophobic interior dense with detail and incident, Sidonia contemplates her next outrage. This image of a beautiful young woman whose power derives from her occult knowledge was quickly followed by *Merlin and Nimuë* (1861) in which the latter, with a spell derived from an ancient tome, imprisons the former beneath a stone.[82] Arthurian stories also offered Morgan le Fay, pictured by Frederick Sandys (1862–3/4) preparing a toxin with which to infect Arthur's cloak and so murder him. Rossetti depicted Lucrezia Borgia washing her hands after administering a fatal dose of poison to her husband (1860–1), while Sandys's *Medea* (1866–8) showed the sorceress, renowned for murdering her children and destroying a rival, casting spells. Cassandra, the ancient prophetess whose fate was not to be heard, was the subject of several studies.[83] All these images and many others portrayed women with rare powers and/or occult knowledge. In Marie Spartali's *Brewing the Love Philtre* (Dudley Gallery, London, 1869) two women brew a magic potion in a deserted garden. According to one contemporary viewer,

> It represented two Greek girls on the outskirts of a wood at twilight, concocting their charm with a transfixed heart, and a pair of dead doves: an owl, whom Pallas Athene would not have disowned, would be soon growing wakeful in the thicket.

He noted on first seeing the watercolour, the organ was a 'Lamb's heart but stands for Man's'.[84] Casteras indicates that while magic signals danger, entrapment and even death to men, it could be empowering for women:

> it radically alters and redresses the standard equation of femininity with powerlessness . . . these female wizards are more than dissidents; they

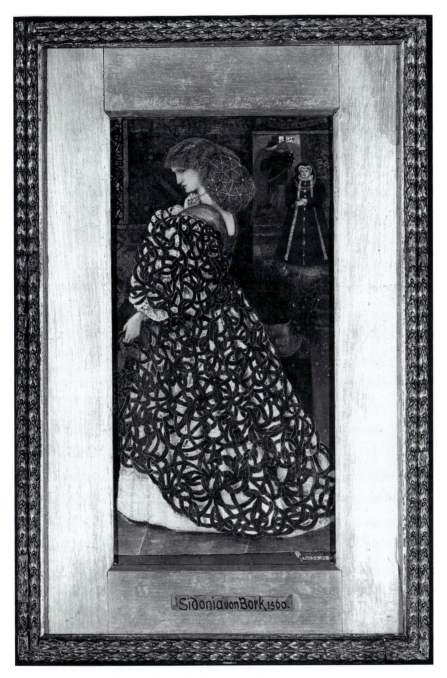

Figure 5.5 Edward Burne-Jones, *Sidonia von Bork*, 1860

are women whose gifted temperaments defy the rhetoric of masculine control both in literal and metaphoric terms.[85]

More often, however, care was taken to distance women's learning from the occult powers of witchcraft. In *Aurora Leigh*, Elizabeth Barrett Browning's epic poem (published in 1857), the protagonist's attempts to educate herself are ridiculed by her cousin, Romney.

> Here's a book I found!
> No name writ on it – poems by the form;
> Some Greek upon the margin, – lady's Greek
> Without the accents. Read it? Not a word,
> I saw at once the thing had witchcraft in't,
> Whereof the reading calls up dangerous spirits:
> I rather bring it to the witch.[86]

Paintings of witches and sorceresses were among the many images in high art and popular culture to negotiate the representation of the learned woman and thus to participate in ferocious and at times violent contestations over middle-class women's education and professional training. In oil paint, water-colour, pen and ink, pencil, print and marble diverse portrayals of contemporary women, historical and mythical savants, witches and sorceresses brought into tension and collision two highly contested concepts, womanhood and knowledge. Women artists were, perhaps unsurprisingly, active in this arena. Joanna Boyce's studies for *A Sibyl*, watercolours by Marie Spartali, photographs by Julia Margaret Cameron, Laura Herford's portrait of the physician and surgeon, Elizabeth Garrett, and Harriet Hosmer's *Zenobia* addressed and countered a tendency for the woman of learning and/or creative power to be identified as a witch or a sorceress (Figures 4.1, 5.5–9). Allegory's power 'to speak of other things' and to offer visual strategies which were indirect and oblique assisted the visualisation of the learned woman in that decade of seismic change.

The 1860s were characterised by the struggles about femininity and masculinity, articulated in relation to violent debates over race, fought out in relation to slavery and the American Civil War as much as in relation to British colonial administration and imperial expansion.[87] Shifts in the relations of sexual difference had been provoked by the emergence of the organised women's movement in the previous decade. Initiated with a public campaign for the reform of the property laws relating to married women, the movement soon broadened its concerns to encompass paid employment, secondary and tertiary education, women's suffrage and the repeal of the Contagious Diseases Acts. The Ladies' National Association for the repeal of these acts, launched in 1869, put into public discourse a strong critique of masculine sexuality and the relations of gender and power accruing around medical knowledge.[88] The founding of

public day schools and private colleges for girls to deliver an academically rigorous curriculum, the formation of a powerful pressure group to promote higher education and to supervise the sitting of local examinations, the training of women doctors, women's election to school boards and the establishment of two university colleges for women, Girton and Newnham at Cambridge, were all put in place by the end of 1872.[89] This movement facilitated the institutionalisation of women's learning within an expanded system of higher education and it marked a shift away from the independent scholar and intellectual woman, the 'blue-stocking' of an earlier generation. Educational advances facilitated women's access to specific middle-class professions and enhanced their status and visibility in public life: suffrage petitions, as has been argued, highlighted women's professional and educational work. Yet such achievements were not secured without major opposition and considerable debate which embraced not only questions of womanhood but issues of pedagogy and a broad movement to rewrite the curriculum for men and boys. Masculinity too was subject to change at the mid-century and its historians have remarked on 'the flight from domesticity' to same-sex institutions, the formation of a distinctly homosexual culture and the extension of what Eve Kofosky Sedgwick has called the 'homosocial continuum'.[90]

Equally important were crises in visual representation related to disquiet about contemporary womanhood. By 1860 if not before, visual demarcations in femininity were becoming blurred. Anxieties clustered around the phenomenon of 'the girl of the period', a figure who belonged to the respectable classes but who looked like one of the demi-monde, a young woman who, in the words of her castigator Eliza Lynn Linton, made herself 'the bad copy of a worse original'. Published in *The Saturday Review*, perhaps the most conservative periodical of the period and a consistent opponent of the women's movement, Lynn Linton's offensive cast the 'girl of the period' as 'a creature who dyes her hair and paints her face', berating her enjoyment of pleasure, her independence, her disregard for authority and conventional morality, her indifference to duty and domesticity. Lynn Linton's alarm was triggered not only by women's increasing autonomy and their 'mannish' ways but also by the difficulties in deciphering the visual signs of their appearance: outer form could no longer be relied upon as a secure, visually legible index of inner character. Ambivalence and uncertainty were displacing what had been understood as clear-cut, visible distinctions. As much in play as anxiety about class and gender difference was a disquiet about racial differentiation. If the girl of the period's fashions imitated those of the demi-monde, her hairstyling resembled 'certain savages in Africa . . . and she thinks herself all the more beautiful the nearer she approaches in look to a negress or a maniac'.[91]

At the same time, discourses on art's moral function were under strong challenge from those which prioritised visual sensation and aesthetic pleasure. Writing at the outset of the decade, William Holman Hunt considered Rossetti's *Bocca Baciata* (1859) to be 'very remarkable in power of execution – but still

more remarkable for gross sensuality of a revolting kind . . . I see Rossetti is advocating as a principle mere gratification of the eye', that is, its visual sensation. In castigating Rossetti for 'dressing up the worst vices in the garb only deserved by innocence and virtue', Hunt voiced worries about moral equivocation and visual ambiguity.[92] By 1873, Pater could declare in his introduction to *The Renaissance* that the critic's task was to assess personal response by searching for answers to such questions as 'What is this song or picture, this engaging personality presented in life or in a book to *me*? What effect does it really produce on me?'[93] In different ways these discussions generated uncertainty and ambivalence in deciphering visual culture.

Over the winter months from 1860 to 1861 Joanna Boyce worked on a study for *A Sibyl*, which was to be acclaimed as one of her most important if incomplete works (Figure 5.6). *The Critic* considered 'the head exceedingly grand, and bearing the direct impress of mental elevation and force in the

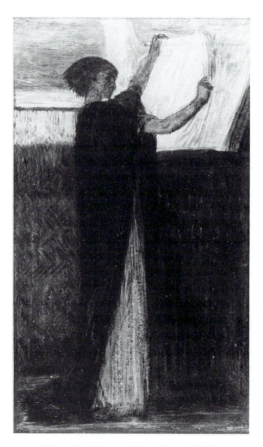

Figure 5.6 Joanna Mary Boyce Wells,
A Sibyl, 1860–1

artist'.[94] *The Athenaeum* ranked it 'amongst the finest of these [unfinished paintings] . . . masterly and grandly mysterious', and *The Art Journal* deemed it 'very successful in elevation of expression'.[95] Working concurrently in a small sketchbook and on larger sheets which were mounted into an album, the artist considered various poses, most of which have a right-facing orientation: seated on a chair, gazing meditatively; seated on the floor, hands clasping her knees; and standing with her right arm extended from the shoulder, a pose sketched in several modulations. Drawings were made for the altar and for the arrangement of the drapery, one of which shows a female model partially draped. These, together with visual and written notes on hieroglyphs, jewellery, footwear, fringing and furniture, made on visits to the British Museum in March 1861 (when she was several months pregnant), suggest an intensity of focus in preparation for a major painting to be exhibited at the Royal Academy in 1862.[96] It is not known whether the artist embarked on a large canvas, now untraced, or whether the project was cut short by her death in July 1861 following complications after giving birth to her third child. A small oil sketch, undertaken perhaps to determine the colour and composition, shows a female figure attired in a dark blue over-mantle and paler blue robe, standing lost in thought before an enormous volume, one of the sibylline books. As she steadies the volume with her left hand, her right hand rests on a blank page, turning the pages. A contemporary photograph records a somewhat larger preparatory study which was destroyed: broadly similar in composition, the figure wears a lighter over-mantle and darker robe.

The sibyls were perceived as women of intense and considerable mental power and were ascribed particular authority from their proximity to the divine, their utterances being deemed to be divinely inspired. Edgar Wind has explained: 'that these mantic women preached divine word without preparation by Mosaic disciples seemed only to secure their prophetic stature'.[97] In Virgil's *Aeneid* Aeneus consults the Cumaean sibyl, whom he deems '*sanctissima vates, praescia venturi*' [most holy prophetess, who foreknowest the future], before his descent into the underworld. He finds her in a cavern hewn into the Euboean rock, 'whither lead a hundred wide mouths, a hundred gateways, whence rush as many voices, the answers of the Sibyl'. Entering an enraptured trance, she 'chants from the shrine her dread enigmas and echoes from the cavern, wrapping truth in darkness'.

> As thus she spake before the doors, suddenly nor countenance nor colour was the same, nor stayed her tresses braided; but her bosom heaves, her heart swells with a wild frenzy, and she is taller to behold, nor has her voice a mortal ring, since now she feels the nearer breath of deity.

The sibyl's utterances are opaque and enigmatic, no more than 'signs and symbols'. When Aeneus's visit is foretold earlier in the *Aeneid*, the seer describes

how the winds blow through the desolate cave disordering the leaves inscribed with her words:

> Whatever verses the maid has traced on leaves she arranges in order and stores away in the cave. These remain unmoved in their places and quit not their rank; but when at the turn of a hinge a light breeze has stirred them, and the open door scattered the tender foliage, never does she thereafter care to catch them, as they flutter in the rocky cave, nor to recover their places, nor to unite the verses.[98]

The collection of the sibylline leaves and the publication of first eight sibylline books in 1545 (the last four appearing in 1828) contributed to a regeneration of interest in the sibyls. Numerous images by Italian artists, including Michelangelo, Guercino, Domenichino and Guido Reni, displaced Virgil's picture of frenzied possession and disorder by emphasising contemplation and interpretation as much as prophecy. Well-travelled artists like Boyce, in Italy from 1857 to 1858, had the opportunity to study such works, which were also well known through engravings and commentaries.[99] Joanna Boyce and Julia Margaret Cameron both rejected the rocky underground cavern and the flurry of sibylline leaves described by Virgil. Whereas Boyce portrays the sibyl consulting a weighty volume in an interior, in Cameron's photograph of the *Cumaean Sibyl*, Lady Elcho, Countess of Wemyss, swathed in draperies, sits composedly outdoors, her hands clasping her knees.[100] The selection of an older woman, unusual for the photographer, lent the authority of age. Boyce follows a suggestion that the Cumaean sibyl had come from the east to portray a woman of colour with lustrous hair and warm brown skin tones, probably taking as her model Mrs Eaton, much in demand in this decade (Figure 4.13).

Neither Boyce's study nor Cameron's photographs have the interior gloom or clutter associated with witches and sorceresses. In Burne-Jones's *Sidonia* the enclosed space suggested by the small dark Tudor apartments of Hampton Court Palace provides, as John Christian indicates, 'the perfect *mise-en-scène*' for Sidonia's contemplation of her crimes.[101] Sandys's Morgan Le Fay is surrounded by alchemical vessels and books and a loom on which she has been weaving a garment that will burst into flames when worn. Frenzied and murderous spell-making kinetically charges her hair, garments and facial features: Casteras has suggested that such corporeal disturbance might have been linked to hysteria, both an index of disorder and a means of empowerment.[102] Frenzied possession was also attributed to Cassandra, whose prophetic vision of the fall of Troy was disregarded. The sibylline figures of Boyce and Cameron are carefully distanced from any associations of deviancy or derangement. Far from entering a divine rapture or frenzied possession, they are poised, calm and contemplative. Boyce's sibyl inhabits a well-lit cell, a luminous blue sky visible through the aperture. A strong, clear light (with resonances of

biblical luminist imagery as well as western rationalist connections between enlightenment and knowledge) illuminates the upper half of her body and the massive volume. The convent-like architecture is not dissimilar to that in renowned Pre-Raphaelite compositions such as Rossetti's *Ecce Ancilla Domini!*, exhibited in spring 1850, when Boyce was pursuing her studies at a London art school and undoubtedly visiting the major shows.[103] The sibyl's powers of interpretation were highly valued, for without her explication the volumes remained mute and closed. An open book, gesture of consultation and mood of contemplation signal her powers. Michelangelo portrayed the Erythraean sibyl with her hand turning the pages of a volume, accompanied by a putto lighting a lamp, indicative of the enlightenment she brings, and the Libyan sibyl holding a weighty tome, following that utterance which will 'illuminate the density of darkness'.[104] For Cameron, Michelangelo provided irrefutable precedent: her photograph of *The Sibyl* of 1864 was closely modelled on the Erythraean sibyl of the Sistine Chapel.

Reviewed in the Renaissance in relation to Christian doctrine, the sibyls were attributed the gift of interpretation of sacred text; in Andrea Mantegna's painting of *A Sibyl and a Prophet*, the latter holds a scroll which the former interprets. Although Christian iconography differentiated, on an oppositional axis of sexual difference, the male prophets of the Old Testament from the female sibyls, classical texts had assigned communication with the divine and the gift of prophecy to women while Renaissance precedence assigned superiority to the former over the latter. Virgil, it will be remembered, called the sibyl '*sanctissima vates, praescia venturi* [most holy prophetess, who foreknow-est the future]. Boyce's sibyl may also be perceived as an intervention into 'sage discourse', which included claims for the authority of the feminine in public speech.[105] That the sibyls continued to exert a considerable fascination was indicated by Emily Ford's monumental depictions. Presenting them with other works to the University of Leeds, the artist requested that they be displayed 'where they could speak'. Hanging high above the platform in the Great Hall, these female figures of knowledge and power presided over the university's ceremonial events and degree ceremonies.[106]

Cameron's was an art of performance which involved posing, dressing up and make-overs. Each photograph demanded careful and lengthy preparation, a judicious selection of properties, the artistic arrangement of draperies, much searching through literature for subjects and characters, the consultation of engravings for visual precedents, and not a little inspiration from *tableaux vivants* and private theatricals. Models reappear time and again in various (dis)guises. In the later 1860s one of Cameron's performers was a young painter, Marie Spartali, then in her mid to late twenties, who seems to have begun working with the photographer in 1867, the year that she made her artistic debut in London. The two embarked, for about three years, on a venture in which the artist was as much engaged as the photographer: if in the photographic sessions Cameron directed proceedings, there is much to suggest reciprocity and

collaboration and the artist's watercolours were equally caught up in this shared project. In the photographs, Marie Spartali appeared as various characters: the ancient goddess Mnemosyne, the neo-Platonic scholar, teacher and orator Hypatia (Figure 5.7), the imperial Eleanor, or 'The Spirit of the Vine'. In part such associations may have accrued to the sitter, Mrs Comyns Carr remembering her in later years as 'once a dryad, now a sibyl'.[107] But although the photographic mounts proclaim 'from life', the performance blurs the distinctions

Figure 5.7 Julia Margaret Cameron, *Hypatia*, 1868

between the model and the role, the one supplementing, that is adding to and displacing, the other.

To suggest as performative Cameron's photographs of Spartali and Spartali's early watercolours is to take up the now well-known propositions by Judith Butler that gender identity is by no means stable or abiding, but 'performatively constituted', 'tenuously constituted in time', that it is produced through 'a stylized repetition of acts' and 'the stylization of the body'.[108] Gender is thus 'corporeal style', an 'act which is both intentional and performative, where performative suggests a dramatic and contingent construction of meaning'. Butler insists not only on repetition but equally on that 'occasional *discontinu-ity*' which can give rise to 'the parodic proliferation and subversive play of gendered meanings'.[109] In their rendition of women of high intellectual and creative powers, the photographs of Spartali register such an occasional discontinuity, colliding and abutting in Cameron's *opera* with images which, in the words of Amanda Hopkinson, positioned women not in relation to 'politics, intellect or power, but beauty, maternity and spirituality'.[110]

In contrast to the repetition of Julia Jackson, Spartali's imagery is remarkably heterogeneous. From meditative reflection to dramatic solicitation of the spectator's gaze, she is pictured seated and standing, in contemporary and 'studio' dress, her hair coiled on the crown of her head, loosely drawn back or flowing over her shoulders. Attired in a loose, unstructured gown with a low neck and high waist secured with a narrow ribbon, her long hair streaming over her shoulders, a tendril of ivy encircling her head and another held loosely between her hands, a string of beads wrapped around and hanging from her right wrist, Mnemsoyne or Memory, stands before a heavy, dark curtain. Beyond and behind this figure, clearly visible on the right edge of this photograph and intensifying the dramatic performance centre stage, is a space flooded with light. In another photograph of this sitter Cameron draws attention to the working machinery of the studio, the poles and pulleys supporting a curtain, the furniture veiled by its transparent fabric.[111]

For *Hypatia* of 1868 Spartali is seated in a high-backed chair in front of a curtain; to her right, in a lighter area where the curtain is pulled back, is a pile of books. Placed three-quarter view to a camera very near her, Spartali turns to face the photographer. Her hair, softly tied back from her face, falls loosely from the crown. The image consciously recalls the portrait of Isabella d'Este at Hampton Court, now attributed to Guilio Romano, not only in its presentation of the figure and three-quarter length format, but in the sumptuous dress adorned with ribbon decoration, bows pinned at the intersections, which belonged to the artist herself. Any similarities to Rossetti's watercolours may be due to a shared source for a late fifteenth-century Italian dress in Bonnard's *Costumes Historiques*, a volume much consulted by mid-century painters. Although one of the sitter's relatives indicated that Hypatia's robe was based on *Sidonia*, it has neither the intricacy of the dress in Burne-Jones's watercolour nor the elaborate knots of Isabella d'Este's *camora*.[112] Whereas the powerful and

cultivated Italian holds in her right hand a blue-beaded rosary, her gloves resting under her left, Spartali holds a fan, a distinctive skein of beads (which probably belonged to the artist) encircling the left wrist. The pile of books which suggests Hypatia's intellectual work also offers a reminder of the disappearance of her treatises, lectures and dialogues.

Cameron's 'pre-text' has been identified as Charles Kingsley's *Hypatia: or New Foes with an Old Face*, serialised in *Fraser's Magazine* in 1851 and published as a novel two years later.[113] As Voula Lambropoulou indicates, Kingsley's account, suffused with eroticism, fails to do justice to a philosopher, mathematician and astronomer admired by Socrates and Gibbon and hailed in a long tradition of Greek literature as an 'ornament of learning [and] stainless star of wise teaching'.[114] By the later 1860s Hypatia had become a recognisable figure in the exhibition rooms, a subject who could represent not only martyrdom but women's learning. Rebecca Solomon's watercolour shown at the Dudley Gallery in 1865 had been commended by *The Art Journal*: 'The stately stiffness in the heroine's bearing has quite the air of originality.'[115] Rachel Levison, one of the signatories to the Royal Academy petition of 1859, had sent to that institution's exhibition of 1857 a sculpture of 'Hypatia, daughter of Theon, celebrated for talent, beauty, and tragical end, in the reign of Theodosius II, about 415'. That these associations had some currency is indicated by a drawing made for *Punch* some years later mocking Miss Hypatia Jones, 'Spinster of Arts', by George du Maurier, well-known in artistic circles.[116] Feminist significations for this figure were maintained well into the twentieth century, Dora Russell entitling her commanding analysis of feminism and sexual difference *Hypatia or Woman and Knowledge*.[117]

A dedicated artist since childhood, who had begun her artistic training with Ford Madox Brown in 1864, Spartali launched her exhibiting career in 1867, contributing three watercolours to the Dudley Gallery which specialised in this medium and had a reputation for advanced taste. Several of her early works, produced before her marriage in 1871, take up a theme of the aspiration for public recognition. *Korinna the Theban Poetess*, which according to one contemporary was a self-portrait, depicted Korinna who five times defeated her pupil and rival Pindar, acclaimed as the greatest lyric poet in Greece.[118] *Procne in Search of Philomena* (1869) portrayed the woman who was transformed into a nightingale and became famous for her song. An as yet unidentified picture '[r]epresenting herself mid fields, sitting with a treatise of mathematics on her lap & a laurel-crown on it' was celebrated in a contemporary poem.[119] *The Lady Prays Desire* (Dudley Gallery, London, 1867) depicts a green-robed, auburn haired figure bearing a close resemblance to the artist's self-portraits (Figure 5.8). The watercolour took its title from a character in Spenser's *Faerie Queene* who 'by well doing sought honour to aspire', and two lines from book 2, canto 9 were included in the catalogue: 'Pensive I am and sad of mien/ Though great desire of glory and of fame'. In working out her subject, Spartali completely recast the iconography, towards a complex representation of

Figure 5.8 Marie Spartali Stillman, *The Lady Prays Desire*, 1867

women's knowledge through references to Athena. It is not therefore, as Casteras suggests, that this goddess appears in very few Victorian paintings, rather that she appears in unexpected guises.[120] A preparatory drawing settled the pose and began to construe the allusions: a book fingered in her left hand and olive leaves gracing her hair replace the Lady's poplar branch (sacred to Hercules).[121] These, together with the owl (Athena's sacred bird and her symbol on coins) and the Greek inscription, both included in the exhibited work, signify the goddess who, as patroness of agriculture, gave the olive branch to Athens, the city which bears her name. While 'Σοφια σπαρτῶυ κρατɛι' may be translated as 'Sophia [Wisdom] is mistress of the corn'/ Sophia [Wisdom] holds a sheaf of corn', a play with words links this allegory of Athene to the artist, 'σπαρτῶυ/spartón/of the corn' resonating with her name: Σπαρταλι/Spartali. In interpreting the watercolour as an image of female learning, the allusions to Athena, goddess of wisdom and war, are layered with the semantic field of 'Sophia'. In *Monuments and Maidens: The Allegory of the Female Form*, Marina Warner has linked Sophia, whom she identifies as the feminised aspect of Christian godhead, to allegories of 'Wisdom' and Sapientia, leader of the seven Liberal Arts.[122] The importance to the artist at this date of a Greek identity was reaffirmed in her choice of subject for a large-scale watercolour painted in 1870 and exhibited the following year at the Royal Academy: *Antigone Gives Burial Rites to the Body of her Brother Polynices*. The painting depicts a moment (reported in the play and taking place offstage) in which the heroine, who may be perceived as a figure of resistance to patriarchal authority and an enactor of divine law, performs an act which has been expressly forbidden and which provokes her punishment and, in Sophocles' tragedy, her suicide.

The Lady Prays Desire and *Korinna*, like Cameron's photographs of Spartali, participate in a double session of representation in which the imaged figure simultaneously represents a living and recognisable woman ('From Life' is inscribed at the borderline in Cameron's handwriting) and a historical personage (or literary character) who comes to represent a constituency. These photographs and watercolours may be said to oscillate between 'portrait' and 'proxy', to take up Gayatri Spivak's distinction between *Darstellung* and *Vertretung*, which will help to explain the double session. Explaining *Darstellung* as 'portrait' and *Vertretung* as the political representation of a constituency ('stepping in someone's place') and noting that in 'the act of representing politically, you actually represent yourself and your constituency in the portrait sense, as well', Spivak concludes that in the play between them the two are intertwined, complicit in one another. In the photographs and watercolours under discussion, the double session is achieved through performance: *Darstellung* was helpfully glossed by Spivak on another occasion as 'the philosophical concept of representation as staging'.[123] It is also put into play through allegory, an increasingly preferred visual mode in the 1860s in which concepts such as Hope or the seasons were figured by a model who was recognisable to a select audience.[124] At one level these works may be situated in the traditions of allegorical

portraiture in which the attributes of a goddess – the chastity of Diana, the beauty of Hebe, the oratory of Hypatia, the wisdom of Athena – were conferred on the sitter, although this transfer could be unresolved and equivocal. Yet much will elude such a simple reading of allegory. Tracing its etymology from *allos*, 'other', and *agoreuein*, to 'speak openly', to harangue in the *agora*, Marina Warner has emphasised allegory's oscillation between public declamation and the veiling of meaning, its 'double intention . . . to tell something which conveys one meaning, but which also says something else'.[125] In speaking other things, allegory-like sibylline utterance is indirect and opaque; it demands interpretation. Yet it was this art of ambivalence and uncertainty which enabled women to speak of and to represent women's learning in the years before and during which they entered higher education.

For Craig Owens allegory is an art of appropriation in which 'the allegorist does not invent images but confiscates them'. The artist 'does not restore an original meaning that may have been lost or obscured' but rather 'adds another meaning', allegorical meaning supplanting and supplementing antecedent ones.[126] In fashioning images of women of learning, women appropriated antecedent images, recasting and reworking them, not to restore previous meanings but in borrowing to add new ones. Cameron and Spartali worked within a well-developed visual rhetoric of columnar necks, well-modelled features, thick, streaming hair and sumptuous dresses to achieve a highly stylised performative corporeality. They wove their images with eclectic and prolific reference to literature, history and the art of their predecessors. Allegory became part of a visual strategy that generated dissonance, dissent and 'occasional *dis*continuity'.

In 1865, after an arduous training in which sympathy and support were matched by opposition and at times violent hostility, Elizabeth Garrett (Anderson) was awarded a licence from the Society of Apothecaries and the following spring she established her practice as a doctor in London.[127] A flood of comic drawings greeted these events, portraying the female doctor either as a sweetly smiling pretty young woman, whose appeal for her patients lay in her physical attractions, or as a hardened harridan whose devotion to her profession disrupted, if not destroyed, family life. These cartoons participated in already familiar visual language for depicting middle-class women professionals and campaigners for women's rights.

Garrett's entrance into a domain whose recent professionalisation was considered by some to depend upon the exclusion of women was also marked by a portrait by Laura Herford (Figure 5.9). Nothing is known of the circumstances of the painting, although it is likely that the transaction was shaped by feminism's double dynamic of friendship and politics. That the portrait remains in the sitter's family may well indicate a gift from the artist or a commission by the sitter. The portrait refigures the conventions of a visual field developed for professional masculinity to produce an image of gravity, decorum and authority and to factor an appearance which evidently drew on the sitter's own views on the dress and deportment of professional women.[128] Turned contrapposto,

173

Figure 5.9 Photograph taken in the 1890s of Laura Herford's portrait
of Elizabeth Garrett [Anderson] painted in 1866

Garrett looks directly at the spectator. She wears a plain dress of a rich but dark
fabric, adorned only with lace and a circular brooch pinned at the neckline.
The luminous painting of her face, one side flecked with shadow, offsets the
rich brown colouring of her hair, neatly twisted from her crown to the nape of
her neck.[129] Her gaze is alert, serious, steady. As much as the sitter's composure
and the effective simplicity of her dress, the tonal sobriety creates for Garrett,
then aged 30, that air of gravity, decorum and authority befitting the medical
practitioner.

Laura Herford's portrait was not only framed by the visualisation of medical practitioners but produced against the ground of suffrage agitation which accelerated in 1866 with the petition to Parliament on 7 June. Although a supporter of enfranchisement, Garrett declined on professional grounds to enrol in suffrage organisations. Her caution may also have been prompted by the relentless travesty of the woman doctor by the comic press. Du Maurier's 'Success in Life. Dr Elizabeth Squills has barely time to snatch a hurried meal and a hasty peep at the periodicals of the day in her husband's boudoir' which appeared in the *Punch Almanack* of 1867 has all the domestic and somatic disorder of Leech's earlier depiction of a woman Member of Parliament (Figures 5.10, 1.9) or Cruikshank's drawing of *The Scribbling Woman: Mrs E.D.E.N. Southworth*, in which the protagonist, wearing dark glasses, attends to her books while her children threaten each other with a poker and her husband looks on in dismay. In Du Maurier's drawing the husband pours the tea, the girl roars on her rocking horse, the boy cradles a doll, and the doctor, heavy-jowled, sharp-featured and eccentrically dressed, gives her attention to her breakfast and the medical paper, *The Lancet*. These visual tactics were not limited to medical women. They encompassed suffrage campaigners (Figure 5.11) and women barristers, 'the next absurdity',[130] and included a relentless ageism.[131] Despite 'sweet girl graduates', the learned

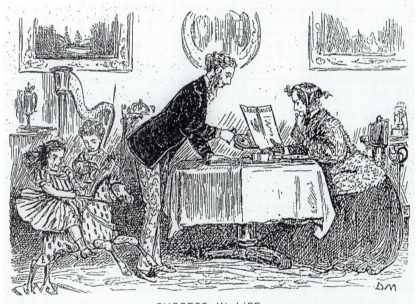

SUCCESS IN LIFE.

DR. ELIZABETH SQUILLS HAS BARELY TIME TO SNATCH A HURRIED MEAL AND HASTY PEEP AT THE PERIODICALS OF THE DAY IN HER HUSBAND'S BOUDOIR.

Figure 5.10 George du Maurier, 'Success in Life', *Punch Almanack*, 1867

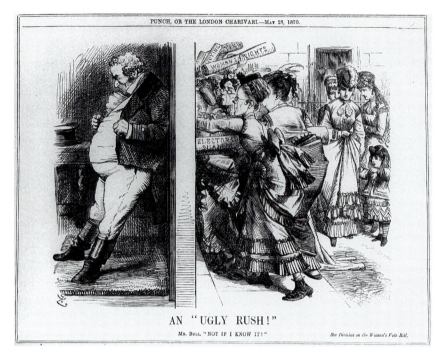

PUNCH, OR THE LONDON CHARIVARI.—May 28, 1870.

AN "UGLY RUSH!"

Mr. Bull. "NOT IF I KNOW IT!"

See Division on the Woman's Vote Bill.

Figure 5.11 John Tenniel, 'An "Ugly Rush"', *Punch*, 1870

woman was all too often portrayed as unyouthful and unlovely: *Punch*'s bespectacled Miss Muddleworth (*Almanack*, 1871) is introduced by her hostess as 'So clever. Wrote that capital article on spontaneous cerebrosity in the last sixth-monthly'. The title, 'Terrible Situation', evidently points to the predicament of the hapless young man, although the viewer might equally have sympathy for a clever woman faced with a partner whose expression might best be described as vacant. Some years later, in the equally ambivalent 'Terrible Result', 'Miss Hypatia Jones (Spinster of Arts)' comments to a woman professor that 'young men do very well to look at, or to dance with, or even to marry, and all that kind of thing!' but 'as to enjoying any rational kind of conversation with any man over fifty, *that* is completely out of the question.'[132]

Garrett was careful to avoid anything hinting at a 'strong-minded' appearance, which she thought was 'a serious mistake' for 'a respectable woman'. Writing of a Langham Place associate, she commented,

> I do wish, as you said, that [she] dressed better. . . . she looks awfully *strong minded* in walking dress. . . . She has short petticoats and a close round hat and several other dreadfully ugly arrangements.

In 1864 she affirmed, 'I am very careful to dress well habitually, rather more richly in fact than I should care to do if I were not in some sort defending the cause by doing so.'[133] Garrett explains her attire not only as a sign of respectability and professional status but also as a badge of association. While Herford's portrait took issue with the comic press, it equally maintained a distance from the short jackets, cropped hair and sturdy boots preferred by the Langham Place set (see Figures 1.10, 2.1). Herford's portrait factored an image which dovetailed with one that Garrett cultivated for herself and which she considered to be as much a part of the feminist project as essential for her medical practice. Quickly becoming an object of curiosity and a celebrity, Garrett rapidly refashioned her appearance. Herford's painting marks a moment of transition from an earlier style which favoured softer lines and artistic beads. The numerous portraits of this sitter map not so much a set of somatic changes as the transformations by which the physician, surgeon and hospital director refashioned her style to achieve the increasingly tailored appearance of her maturity.

Reforms to women's education challenged what Hélène Cixous has identified as the realm of the '*propre*', a masculine domain of culture, knowledge and power.[134] Throughout the 1860s and beyond questions were raised about what it was 'proper' for women to know, the propriety of their deportment and dress, the ownership of knowledge, and the fitting location for their education. Dissension raged about the appropriate curriculum, women's admission to classes and buildings, medical training and the appropriate areas of practice, the awarding of qualifications and professional recognition. Middle-class women's academic and medical education undoubtedly reshaped conventions of bourgeois femininity and the relations of sexual difference. The significance of information and education for all classes of women was well understood by the union activist, Mary Macarthur, who in the early twentieth century proclaimed 'Knowledge is power'. And using one of the most familiar feminist metaphors of the period she concluded: 'Knowledge and organisation mean the opening of the cage door'.[135]

Feminism and the tactics of representation

What relations were engaged between women's art and their campaigning to change their position in society and culture and to transform the relations of sexual difference? And to what extent could they intervene in or transform visual representation? Artists who declared in favour of suffrage or other campaigns worked in a variety of media (sculpture, oil painting, watercolour and print-making), and a wide range of artistic categories (history painting, modern-life subjects, portraiture, landscape, military subjects and still life). While some specialised in a chosen field, others worked simultaneously or consecutively in different genres. Such heterogeneity precludes any simple conclusions about the relationship between an artist's choice of subject,

medium and style. While it may be tempting to perceive career patterns or output as the expression of an artist's political beliefs, there is much to resist such an interpretation. A recognition that subjectivity was contingent, fixed only fleetingly and subject to change will assist a move away from a notion of a centred, essential self which can be seamlessly transferred from 'life' into 'art'. It will also help to explain the non-coincidences or dissonances between a woman's politics and her art. Moreover, each work which an artist made, exhibited or sold was shaped by and viewed within formal aesthetic conventions, critical writings on art and a tangle of contending contemporary discourses. Its legibility and its meanings for contemporary audiences depended on its intertextuality, its relations to a web of references and texts from which it was woven. If print culture seems to have dealt directly with feminism, in elite forms these relations were slippery and ambivalent. As one of the most contested movements of the period, feminism offered a shifting set of 'framings' within which images were produced and perceived. These framings generated fields of force in which feminism and visual culture were mutually defining as well as held in tension. In this formulation, which is borrowed from Mieke Bal's elegant discourse on framing, art and artist 'talk to' feminism, and framing is shot through with a highly volatile charge in which all are transformed.[136]

In a thoughtful essay on women artists, Susan Casteras concludes that 'with few exceptions, [they] did not challenge and transform prevailing canons of imagery' and 'rarely strayed far from accepted norms of representation'.[137] One of the pictures which she discusses at some length is 'Miss Angel' – Angelika Kauffmann, introduced by Lady Wentworth, visits Mr Reynolds' Studio (RA 1892), Margaret Dicksee's rendition of an incident in the life of Angelika Kauffmann, an internationally renowned artist who settled in London in 1766 and became two years later one of two women founders of the Royal Academy (Figure 5.12). Soon after her arrival in the British capital, Kauffmann was accompanied by her sponsor, Lady Wentworth, the wife of the British ambassador to Venice, to meet the city's leading portrait painter. The portrayal of Kauffmann prompts Casteras to comment that the painting is interesting 'for what it does *not* depict': in her view, Kauffmann is not portrayed as a serious artist, but as a fashionable and frivolous socialite.

Casteras indicates that nineteenth-century biographers viewed 'Miss Angel' (the appellation given to her by Reynolds in his notebooks) as a woman dedicated to flirtation rather than art. A gushing commentary in *The Art Journal* of 1897 accompanying a reproduction of this painting lamented the fate of a sentimental coquette who, having unsuccessfully tried to ensnare Reynolds, contracted a disastrous marriage and several affairs. 'Poor Angelica! most unhappy of all unhappy women. Who can read her story without tender compassion for her blighted life and wasted hopes? This day, however, there is no trace of the shadow that is to fall.'[138] But while Kauffmann is stylishly dressed, she is visibly differentiated from the elegant aristocrat who lounges fanning herself. Poised between the painting and its painter, Kauffmann engages in

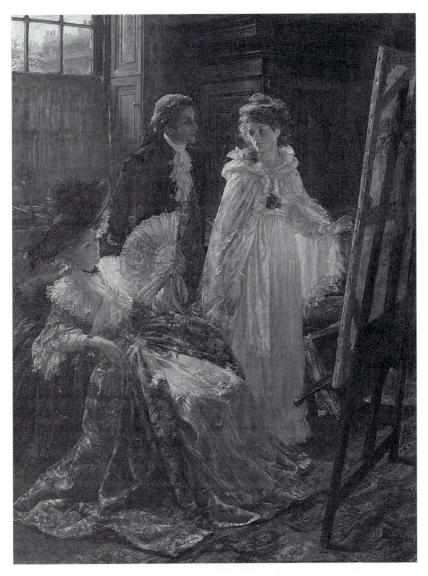

Figure 5.12 Margaret Isabel Dicksee, *'Miss Angel' – Angelika Kauffmann,*
introduced by Lady Wentworth, visits Mr Reynolds' studio, 1892

conversation, her left hand gesturing towards the easel, her head turned towards Reynolds, so demonstrating those social graces that were a necessary part of her success.

Dicksee took up the mantle of Henrietta Ward, exhibiting each year at the Royal Academy a major historical painting accompanied by a lengthy quotation or explanation. Her predilection in the 1890s for these later eighteenth-century subjects was part of a widespread re-evaluation of the previous *fin-de-siècle*. A signatory in 1889, Dicksee was one of several suffragists to make a living with history painting and it was this limited measure of success within the professional establishment which was valued by the movement. Casteras considers that women's need to make an income and to become successful members of the art world was responsible for a certain conventionality in their approach and subject matter. If this was the case, then artists like Dicksee were caught in a contradiction: petitioning for a wider public role for women, yet producing images that might visually counter that claim. *'Miss Angel'* undoubtedly plays into the myths, fabricated by the artist herself, of her youth, beauty and vulnerability. Whether or not Dicksee's image went beyond contemporary representations of this artist as fashionable, frivolous and flirtatious, it was undoubtedly subject to contending readings, not all of which would have been articulated within the published conduits of art criticism.

As an artist Kauffmann may be classed among those knowledgeable woman whose imagery so troubled visual culture. Dicksee's eighteenth-century scenes included *Sheridan at the Linleys* (RA 1899), in which Elizabeth and Mary Linley, two sisters renowned for their musical abilities and their beauty, sing to the accompaniment of their father. Trained from childhood by their father, the sisters sang in Thomas Linley's concerts in Bath, Elizabeth becoming known for oratorio. Both sang at the Three Choirs Festivals from 1771, where Elizabeth, the leading soprano, earned one hundred guineas per festival. The quotation with which the painting was exhibited – 'The admiration which Sheridan first conceived for Eliza, the elder, speedily resulted in their romantic marriage' – prompted spectators to discern an amorous encounter. Those familiar with the sisters' story and perhaps with Gainsborough's double portrait (RA 1772), which had entered the collection of Dulwich College in 1831, would have known of the abrupt halt to Elizabeth's performing career after her elopement and marriage to Sheridan in 1773 (she continued to sing in private subscription concerts) and of Mary taking her place on the platform until her own marriage in 1780. Some would have considered Elizabeth's withdrawal entirely appropriate; by 1911 Clementina Black, otherwise a staunch supporter of women's work, condoned her antipathy to publicity. Others would have deplored what was perceived as the dramatist's prohibition.[139] The 1880s and 1890s witnessed heated discussions about marriage and its compatibility with women's needs for self-fulfilment.[140] Tensions between men and women, dramatised on the stage and flooding the pages of novels and magazines, may well have carried into the viewing of pictures.

The ambivalence of late nineteenth-century history paintings is also indicated by *In the Reign of Terror* (RA 1891) by Jessie Macgregor, who declared in favour of suffrage two years earlier. As well as eliciting a range of views about Revolutionary France, the painting would also have been perceived within current debates about motherhood and its status for an imperial nation. The depiction of a woman anxiously guarding a cradle in a dimly lit interior could be viewed as an example of a mother's courage and as a definition of the proper interests of an interiorised, domestic femininity. Feminist emphases on maternal authority and 'social motherhood', which justified the extension of women's moral guidance into the political arena, would have enlarged the potential significance of the image.[141] Many women staked their reputations on history painting, in academic terms the most prestigious form of art. Louise Jopling's repertory included romantic suicides such as *Elaine of Astolat*, drowned for love of Lancelot (RA 1875), and *Salome*, one of the most contested figures in the late nineteenth-century imaginary, a figure of sexual ambiguity, a sign of feminine evil and decadence and for some, it has been argued, a feminist icon. Jopling pictures the Jewish princess bearing the head of John the Baptist rather than performing the dance in which she unveiled herself. Commenting on the subversion which Salome might imply, Elaine Showalter notes that '[w]hen women appropriated the image of Salome in art . . . public reaction was often hostile.'[142] At the Royal Academy in 1885 *Salome* was said to be cold and cruel. The strongest criticism came from the *Jewish World*, which took issue with the artist's orientalising, deeming the figure to be 'rather too vigorous in conception, as such a form hardly realises the exquisite grace of the famous Eastern siren whose poetry of motion entranced Herod'. Jopling's *Queen Vashti Refusing to Show Herself to the People* of 1872 portrayed the queen divorced for disobeying her husband. Years later the artist claimed that the painting portrayed 'the originator and victim of women's rights'.[143]

Countering a contemporary regime of representation would depend as much on a politics of reading as a politics of image making. Egalitarian discourse focused on women's individual and collective attainment, attending to matters of skill and quality, and speaking out against discrimination and 'obstacles' to their success. Reviewing paintings by men and women, only rarely was subject matter a topic for discussion. In 1887 Florence Fenwick Miller brought these issues into provocative conjunction in her 'Ladies Column' for the *Illustrated London News*.

> Mr Lawrence Alma-Tadema's picture is to my thinking *the* picture of the year. . . . But can it be true . . . that the artist who has lavished such care on painting women, in so noble an attitude as these matrons, and of so lovely an aspect as that of these girls, can be in practice accustomed to exert all his influence against the admission of women's work to the Academy, and against its prominence of place? Surely it cannot be so.[144]

In *The Women of Amphissa*, a group of matrons hasten to protect the mae-nads, sacred to Dionysius, awakening after a bacchanal (Figure 5.13). What disturbs Fenwick Miller is not Alma-Tadema's vision of women (which might be of concern to present-day feminism) but his obstruction of women artists and his opposition to feminism's project for professional endeavour. That Fenwick Miller does not take issue with paintings of 'noble' matrons or 'lovely' girls suggests the mobility of this imagery in the late nineteenth cen-tury and its potential for appropriation, and the rich multivalency of feminism in these years. Artists who declared in favour of women's rights could produce academic history paintings or work within the visual rhetoric of what has been termed 'late Pre-Raphaelitism' to produce images of languorous, dreamy women which do not appear to challenge conventional concepts of femininity.

It was within the languages of social purity and vigilance that visual culture became a matter of intense concern for feminists as for many others. Formed initially to secure the repeal of the Contagious Diseases Acts, by the mid-1880s social purity had developed into a broad-based movement. Recent historians have drawn attention to the political turmoil and moral panic of this decade, the tensions within the purity alliance which included Anglican clergy, social reformers and popular journalists, and the disagreements which arose over 'vigilance', or the public policing of (im)morality in its high cultural and popu-lar forms.[145] The National Vigilance Association attempted to police 'the *sights and sounds* of vice which we are constantly exposed to in our principal streets' and to regulate the appearance and dress of prostitute women and music hall artistes, whose near nakedness was charged with 'indecency'.[146] A rhetoric of outrage was levelled at a wide range of targets, from selected exhibitions to *tableaux vivants*, popular entertainments, photographs and pictorial advertising, as well as what were deemed to be obscene publications. Between 1885 and 1890 the National Vigilance Association secured the closure of an art exhib-ition of works by a French artist condemned as 'grossly indecent' and 'foreign filth', and the withdrawal of 'objectionable' pictorial hoardings. During the same period numerous prosecutions for indecency were directed against photographs, picture postcards and Japanese prints. The association also spoke out against performances in which 'large numbers of semi-nude girls had to perform every afternoon in broad daylight, in the open air, and often in the most inclement weather'.[147] A major debate over the nude in high art was launched in 1885, a year of dramatic revelations in which a nationwide purity campaign was launched following a sensationalist exposé of juvenile prostitu-tion in the 'Maiden Tribute of Modern Babylon' published in early June, numerous public rallies and the passage of the Criminal Law Amendment Act, which raised the age of consent for girls to 16, gave increased powers to the police to prosecute streetwalkers and brothel-keepers, and made illegal 'indecent' acts between consenting adults. In late May, under the pen name of 'A British Matron', J.C. Horsley, a painter and Royal Academician, initiated an

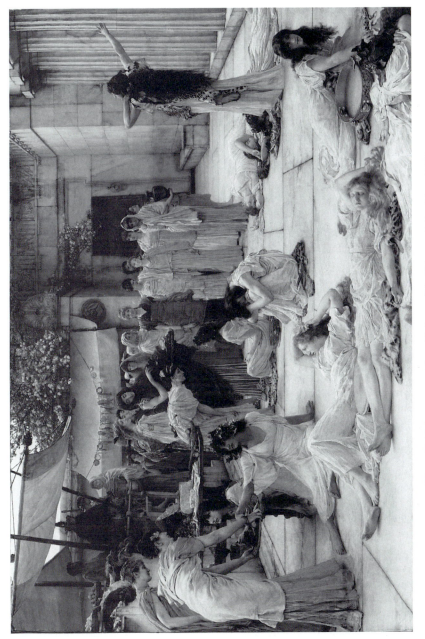

Figure 5.13 Lawrence Alma-Tadema, *The Women of Amphissa*, 1887

attack on 'the indecent pictures which disgrace our exhibitions'. Deploying the language of vigilance, he referred to 'a noble crusade of purity that has been started to check the rank profligacy that abounds in our land'. Prominent male artists like John Brett, Eyre Crowe, Edward Martin and Edwin Long rejected Horsley's tirades. Edward Poynter defended his own practice as an academic painter of the nude, and the wrangle was sustained well into October.[148] Women artists were inevitably drawn into this controversy, since Horsley contended that study of the life model was unwomanly, offensive to Christian principles and inappropriate. He denounced female artists as 'trained at public expense to assist in the degradation of their sex'.[149]

In feminist discourse, purity ideals ran into collision with the pursuit of women's professional practice. Horsley's assertion that life-study was 'quite inapplicable to the forms of art within the compass of their powers to execute successfully' was echoed in an essay in *Work and Leisure*, a magazine which promoted women's work, temperance and vigilance.

> It must be unflinchingly stated that no woman need have, or ought to have, the same unlimited opportunities for studying the human figure as are given to men; ought not, because the end (for her) is not worthy of the means – need not, because boundless other subjects remain open to her short of what is thought to be the highest – and that highest seldom in this country cultivated even by men. . . . The female student does not require the nude for such art as she can attempt.[150]

The writer was, however, forced to admit that without life-study women were 'hampered from competition for the highest prizes of art' and insufficiently qualified for history painting. It was on the grounds of equal opportunity that Emilia Dilke and Florence Fenwick Miller upheld women's rights to study and depict the nude. The latter consistently publicised the 'constant quiet agitation maintained by the lady students to secure admission' to the life class at the Royal Academy.[151]

Lucy Bland has rightly argued that social purity debates enabled women to 'speak out' about sexuality and to voice a diversity of concerns about morality. Social purity initiatives launched in 1885 to rescue young women 'seduced' into modelling carried with them accusations of impropriety against women who employed them as undraped models.[152] The languages of social purity could also be put to work in women's defence. In 1899 Louisa Starr, then president of the art section of the International Congress of Women, presented a paper on 'The spirit of purity in art and its influence on the well-being of nations'. In a carefully constructed argument Starr refuted charges that women's depiction of the nude was improper, unfeminine, indecent or offensive. Much was at stake, since allegations of impropriety could jeopardise a woman's reputation. Henrietta Rae's *Psyche before the Throne of Venus* (RA 1894, Figure 5.14), a highly ambitious painting with numerous nude and semi-draped

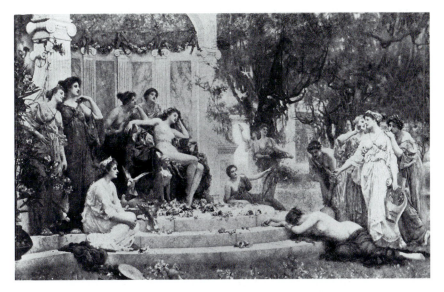

Figure 5.14 Henrietta Rae, *Psyche before the Throne of Venus*, 1894

female figures, was so judged, *The Athenaeum* claiming no surprise 'at finding that here nymphs and goddess resemble ballet girls, while Venus's court is like an opera scene', and the *Magazine of Art* considering that 'the figures with all their charms are not the inhabitants of Olympus, but denizens of an ungodly earth'.[153]

Starr repeated well-rehearsed arguments for vigilance against vulgarity and indecency before calling on 'all women to join in a crusade in which every influence shall be used to suppress – entirely suppress – immoral advertisements, periodicals, and photographs'. She then set out the conditions in which the nude was acceptable.

> The nude, to be admissible, must be treated in the grand style. It is the spirit of the *Venus de Milo* we need and of Watts' *Daphne*. It is a human figure, robust and mellowed by air and sun, with firm limbs, frank eyes, innocent and severe, and joyful in the life of woodland and mountain. There is nothing demoralising here.[154]

Refuting charges of corruption (this is the force of 'demoralising' here), Starr argued that the female nude must be portrayed within the visual codes of high art and the classical tradition: these alone will authorise its representation. For Starr, the sylvan setting as well as appropriate visual conventions distance the nude from any association with male vice or the women of urban pleasure. Starr's ideal form, however, has the body of a modern woman honed by rigorous physical activity and unconstrained by corseting, the bodily form advocated

185

by dress reformers, proponents of hygiene and sports promoters as well as by Starr herself, who deplored tight lacing and judged beauty to be 'the expression of a beautiful mind, a beautiful body[,] . . . perfect health and ease of natural delight in movement'.[155] Furthermore, Starr drew attention to 'the spirit in which a work is conceived', contending that the artist's 'purity of spirit' would be imprinted in the work of art. This was a classic vigilance argument, as was her emphasis on the effect on the viewer; the National Vigilance Association endorsed those images which 'not only excite our admiration of the artistic merit', but which 'stimulate our appreciation of the beauties of nature unadorned, while imparting to the beholder no suggestion of lasciviousness'. Warning of the moral dangers and ambiguities of 'art-for-art's sake', Starr emphasised women's role as guardians of artistic and social purity and their duty to 'uphold the right in Art, as well as the right in life'.[156] Unspoken here yet threaded through a speech concerned with 'the well-being of nations' is an ellision between the nude and the white body, an assumption of racial superiority made lightly through the references to *Venus de Milo*, antique example and white marble. Lynda Nead has persuasively argued that the female nude regulates the borderlines between high culture and obscenity.[157] But more than this, in the late nineteenth century the portrayal of white corporeality played into an imperial mission in which 'white' was not so much a category but a benchmark, a standard from which other categories could be judged.

Characteristic of the 1880s and 1890s were the 'new social actors' whose 'spectacle', 'enterprise' and cultural exchanges, according to the historian Judith Walkowitz, transformed urban identities and the urban environment. London became an 'enigmatic and contested site for class and gender encounters'. Middle-class women took up work in city management as factory inspectors, Poor Law guardians and social investigators. Advanced political women served on school boards, registered their votes in local elections and spoke at public meetings.[158] Although these new social actors regularly appeared in print culture and photography (Figures 5.1, 5.27, 5.28), they were rarely portrayed in modern-life painting or what has been termed 'the new painting' of the 1880s and 1890s, which reworked identifiably French techniques, concerns and subjects. Elizabeth Armstrong Forbes's *School is Out* (RA 1889) is, in many ways, an exceptional painting (Figure 5.15). Adopting a modulation of tone and touch that was distinctly French and identifiably 'modern', Forbes portrays a modern woman at work, depicting the newly professionalised teacher of the state education system surrounded by her pupils and accompanied by a pupil-teacher, at the end of the school day. The image marks a departure from the older woman of Osborn's *Home Thoughts* (Figure 1.6) or the tired governess of Louisa Starr's *Hardly Earned* (RA 1875).[159] The scene takes place in the village school at Paul on the outskirts of Newlyn, the Cornish fishing port where the artist was based. The 'new painting' of the 1880s and 1890s embarked on a sustained investigation of urban modernity, and its highly

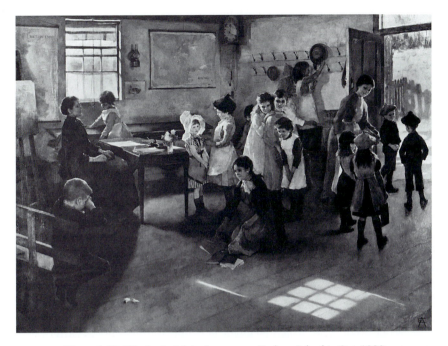

Figure 5.15 Elizabeth Adela Armstrong Forbes, *School is Out*, 1889

sexualised codes of visuality were founded on masculine cross-class pleasures enjoyed in the new forms of urban entertainment, such as the music hall favoured by Sickert. Its visual project was in tension with the changing sexual geographies of the modern city, increasingly populated by middle-class women working, walking, shopping and lecturing, and whose vision was profoundly changed by professional endeavour and social investigation, as well as their sense of public responsibility. While the 'new painting' visualised independent female performers of the music hall, it could not accommodate platform women, professionals or feminist campaigners. To shift the ground, Forbes places her teacher in an isolated rural setting, far distant from the pollutant dirt, squalor and agitation of the city. It is this distance which secures the respect-ability of artist and teacher. The assured experimentation in the handling of paint and textures and the careful modulation of tone and palette produce a painting that is as modern in its clarification of form and rendition of light as in its protagonist. Yet *School is Out* was an anomaly within the artist's *opera*: one of two women painters settled at Newlyn, Elizabeth Forbes intervened in an iconography of fishing, fishermen and fish-markets by painting children and cottage interiors. In her early years in Cornwall she took up the identifiably modern form of etching to capture scenes in life of the fishing community. By the later 1890s, when her support of the vote was formally recorded, she had

shifted ground yet again, from agricultural scenes to fairy tales and folklore, clothing her figures in imaginative re-creations of historical dress.[160]

If the 'new painting' exhibited a resistance to visualising public and professional women, their portraiture also posed distinct problems. How were these women to be represented in a culture in which the formal portrayal of academic, professional and political men was well established? How were they to be depicted in high culture when their visual appearance was the target of so many comic prints? Could portraiture, *par excellence* an art about the individual, convey the collectivity on which feminism depended? Portraiture was involved in the fabrication of a subject that did not yet exist: the woman with full civil and legal rights. Without democratic rights, nineteenth-century women were engaged in lengthy and at times bitter struggles which were fought out at the level of visual culture as well as in political and social arenas. The 1880s marked the inception of a period of crises and challenges to the British state, in which the socialism, independence and anti-colonialist movements and the women's movement struggled at times in alliance, at times in opposition, for representation within it.[161] Gains made in any one area (such as the reforms to property law) did not bring entrance into full political subjecthood. Lilian Lewis Shiman has drawn attention to the profound debates about citizenship which took place in the later nineteenth century between older claims founded on property and new concepts, which included all people of the polity as citizens with rights and duties.[162] While for suffragists the right to vote was integral to the rights of citizenship, for others enfranchisement was unnecessary. The idea of the Englishwoman as one who had rights, powers and capabilities was, as Inderpal Grewal has indicated, steeped in imperialism.[163]

The portraits considered here are hybrid works, fabricated from disparate elements to fashion a new imagery for prominent public women who challenged and changed the social and political order. Little is known about the commissioning of these works or their hanging, although in all cases location was significant, as was their place outside the national gallery of portraiture.

Women had won the right to the municipal franchise in 1869 and through the 1870s and 1880s they steadily secured positions in local government. In January 1889 Jane Cobden and Lady Margaret Sandhurst became the first two women to serve as councillors on the London County Council. Cobden was elected on a platform of 'no coal tax, better homes for the poor, fair wages and no sweating'.[164] Emily Mary Osborn's painting of Cobden (Figure 5.16) may have coincided with the election, the artist being selected on account of her friendship with the sitter. Cobden wears a resplendent yellow satin gown with white fur borders in an Artistic style, much favoured by intellectual and artistic women; her hair is arranged softly, lightly held in place by a black band.[165]

Cobden's position as a councillor, like that of Sandhurst, was challenged by her political opponents, who claimed that although women were qualified to vote, they were not qualified to act as members of the council. Despite the passage of legislation in 1882, which entitled every person 'to be a councillor,

Figure 5.16 Emily Mary Osborn, *Jane Cobden Unwin* [1880s]

who is qualified to elect the office of councillor', no women had previously
been elected to municipal office. In the court case against Cobden, it was ruled
that the action had been brought 'with the *bona fide* object of testing the right
of women . . . to act as members of the London County Council' and that
although 'her election must be held to be valid and could not be set aside, she
was disqualified'. Cobden, like Sandhurst, was unseated and in February 1892,
after three years' service, she was required to stand down.[166] Through several
overlapping strategies, Osborn's portrait fabricates an identity which, though
temporary and contested, was historic. The small commemorative label
attached to the lower edge of the frame which reads 'Jane Cobden/(Mrs Fisher
Unwin)/Member for the Bow and Bromley Division/First London County

Council' acts as a textual borderline setting a limit to the proliferation of meanings of an image of an elegantly dressed woman.

In its shimmering surface, richness of colour, tactility of texture, three-quarter placing of the head, half-length format and plain ground, the image deliberately echoes Venetian *seicento* painting, notably portraits by Titian and the followers of Giorgione which the artist would have seen on visits to Venice.[167] Why were these associations activated, and to what effect? For spectators, these painterly echoes may well have prompted reflections on the changing reputation of Venice and its government. After Venice joined the new Kingdom of Italy, the city soon became a fashionable resort for tourists, artists and writers: Clara Montalba was one of many British painters who flocked to the city to paint its canals, boats and architecture. Although its republican government had been praised by Rousseau, by the early nineteenth century it was reviled as corrupt, cruel and despotic. Although for some Venice's sinister reputation remained, its fall being linked to its decadence, degeneration and Orientalism, by the mid-century revision was under way, the French historian Michelet commending its tolerance, economic prudence and concern for public welfare, others extolling the impartiality of a wise and professional patriciate and an exemplary politics of anonymity. John Stuart Mill perceived a wise government of public functionaries 'remarkable. . . for sustained mental ability and vigour in the conduct of affairs'. For the British, comparisons between Britain and Venice were inevitable, as evidenced by Ruskin's *Stones of Venice* (1851–3), which opened with a meditation on the fate of maritime empires. Venetian art and architecture were also re-evaluated, not only in the writings of Ruskin, Pater and Berenson, but more widely in the periodical press. For a writer in *The Builder* in April 1889, Venice had fostered the union of commerce and the arts,

> Those who built Venice, as it now stands, were men who had the greatest respect for and made the most brilliant successes in trade and manufacture. . . . The archives of ancient Venice show conclusively that so far from mercantile and commercial enterprise and industry being incompatible with art, the two ends were pursued by the Venetians with equal devotion and success.[168]

Osborn's painting portrays its sitter with the artistic means, splendour and revitalised prestige of Venetian painting, its effect heightened by the extravagance of the carved and gilded frame, a particularly striking example of the later nineteenth-century vogue for Renaissance revival frames. Although not square, it echoes the Renaissance *cassetta* frame, its decoration based on Italian and Spanish sixteenth-century architectural and decorative precedents. Inside a fluted outer moulding, the frieze, with squared and foliate corners, has carved and gilded scrolling foliage with ornaments laid on a black ground.[169] But more than this, Osborn's visual strategy associates Cobden, and by implication the Council, with a Venice now renowned for its probity and professional service.

The ensemble of the portrait and its frame effectively forges an image of a modern woman with a position in metropolitan administration and a stake in the management of a democratic state. Initially a matter between friends, the portrait was presented to the Council by the sitter's husband in 1926. Entering what was to become a distinguished collection of portraits assembled to grace oak-panelled corridors and committee rooms, it was hung with portraits of the other women councillors.[170]

Lydia Becker, founder and first secretary of the Manchester Suffrage Society and editor of *The Woman's Suffrage Journal* from 1870, was one of the most renowned suffrage activists and public speakers. Susan Isabel Dacre's portrait was produced within the friendship networks of artists and suffragists in the city (Figure 5.17). A substantial three-quarter length, it provides both 'the description of an individual and the inscription of a social identity'.[171] Becker is attired in a deep black mourning dress, considered by many (but by no means all) suffragists to be the most suitable attire for platform speaking, and her shapely, well-corseted figure and smooth coiffure are in line with a contemporary severity.[172] This portrait of a woman then nearly 60 by an artist many years her junior does not conceal Becker's age, seen in the pouches at her jawline, the lines by her mouth, and the crumpled neck; nor does it disguise the toll that activism and illness had taken. Painted in 1886, perhaps to mark twenty years of energetic campaigning, Dacre's portrait deals head-on with the imagery of the sitter which had paralleled her reputation as a formidable campaigner. Unlike most other female portraits painted for public exhibition, Becker wears a pair of spectacles with light wire frames which do not interrupt her direct gaze or obscure the view of her eyes. Construed as excessive to conventional femininity because of their connotations of learning and study, in print culture wire-framed glasses quickly became a distinctive characteristic of the feminist, the female artist and the learned woman. They graced the faces of Osborn's independent teacher, Du Maurier's artist, Lavinia Brounjones, and his Miss Muddleworth and any number of campaigners (Figures 1.6, 5.11).[173] Markedly different to Millais' portrait of Louise Jopling or Kate Perugini (Figure 5.3), Dacre's painting takes up the visual language of the gallery of great men painted by J.E. Millais and G.F. Watts in which an isolated figure, drably attired, stares ruminatively into the distance or thoughtfully at the spectator.[174] Sharing a common simplicity of composition in which the figure is set against a plain ground and a restricted palette, this portrayal is factored from refashioned components and invented elements to depict a woman usually beyond the frame of high culture. The only concessions to the restraint which signals respectability and propriety are the lace, jewellery and roses; painted in white and red, they provide a visually striking contrast to the dark dress and a conspicuous sign of class status, at the same time softening any undesirable impression of hardness.

In the later 1890s Helen Blackburn, a prominent activist and from 1881 editor of *The Englishwoman's Review*, commissioned a posthumous portrait of Becker from Elizabeth Guinness, a painter and suffragist, for inclusion in an

Figure 5.17 Susan Isabel Dacre, *Lydia Becker*, 1886

imposing mahogany bookcase which she designed to house a collection of books, pamphlets, images, periodicals and newspaper cuttings amassed with Caroline Ashurst Biggs and Lydia Becker and which she gathered together in their memory in 1897: Biggs had died in 1889 and Becker a year later in 1890.[175] The two watercolour portraits were to be set into a front panel. A decision was made (by the artist or the owner) to base the portrait of Becker on a formal image taken by Mayall, a west end photographer, in 1888 or 1889. Standing beside a table laden with books and a potted plant, the sitter is attired in a magnificent black dress with elaborate beaded decoration; her hair is pulled tight across her brow, an intricate circle of plaited braids piled high on her

crown.[176] Discarded were several other images in Blackburn's collection: a photograph in which a fugitive smile plays over Becker's face and a studio portrait taken in Dundee in which she wears a soft enveloping cape, loosely folded over her body, and her hair is softly draped over her ears. Guinness 'appropriates' Mayall's photograph and reworks it: cropping it and transforming the studio setting into a figured ground, she emphasises, even over-emphasises, the puckered flesh above Becker's raised eyebrows and the square set to her jaw. The body sheered away and hair compressed against the upper edge, the face dominates the painted space. This is not just Becker but (a commemoration of) a commanding and imperious leader of a national movement, an individual who comes to stand for a larger constituency: 'portrait' and 'proxy'.[177]

Becker's imagery is protean, not only because she did change her appearance, but also because each appearance in visual culture was transitory, a fleeting moment in representation rather than a continuous and enduring register of a fully formed, autonomous self. Psychoanalytic and post-structural accounts have proposed that subjectivity is a contradictory and messy process that is never fully or finally achieved. Formed in and by a tangle of often conflicting representations, the subject is fragmentary, contradictory and decentred. While substantially differing in their emphases on the formation and psychic investments of the subject, both accounts have challenged liberal humanism's notions of a unified subject who develops to become fully accountable for and explicable by his or her actions, motives and personal history.[178] In this version, the portrait offers access to an inner self which may be revealed.[179] Although portraiture could provide a public staging of the centred, autonomous self as feminine, this was only a temporary fixing of the subject constituted in and by representation, a visual strategy.

Becker was the target for many humorous drawings and cartoons. As feminist demands escalated, the figure of the ill-dressed, often bespectacled and frequently middle-aged agitator with a body that was extravagantly fat or excessively thin came to displace the pretty young women of the 1860s.[180] 'An "Ugly Rush"' of 1870 (Figure 5.11) portrays women importunate in their claims and indecorous in their behaviour stoutly refused by a corpulent John Bull. *Punch* cartoons certainly provoked discussion. *The Gateshead Observer* of 11 June 1870 opened a somewhat sardonic article with a commentary on this same cartoon, considering that '[a]t present there is a rush – we would despise ourselves if we designated it an "ugly rush"'.

> According to our facetious contemporary *Punch*, John Bull has sturdily set his back against the door of Parliamentary representation, and has determined, that if he knows it, women shall not be allowed to enter. Resolute and strong as he may be[,] the pressure may possibly become too much for him, and, willing or not, he may have to open the door and allow the ladies to enter. . . . The wisest, and therefore the best, thing is to yield at once.

That both 'An "Ugly Rush"' and comments in *The Gateshead Observer* were pasted into cuttings books probably assembled by a member of the Manchester Suffrage Society indicates a more than passing interest in visual culture.[181] Somewhat later, an assemblage of material relating to a 'Great Demonstration of Women' held in Bradford on 22 November 1881 included a ticket, columns of newsprint, an advertisement calling 'Women of Bradford, Come in Thousands!!!' and a handful of illustrations, one of which mocked the event even as it was being organised. Another avid compiler of extracts, Millicent Garrett Fawcett, came to hold firm views on the illustrated press. When inserting a page from *Punch* in 1892 into her cuttings books, she gave a forthright opinion on the image and those that had preceded it (Figure 5.18). Beside 'The Political Lady-Cricketers', which depicts two statuesque, commanding figures with neo-classical proportions and profiles, she noted, 'This is the first time that Punch has ever represented the political woman otherwise

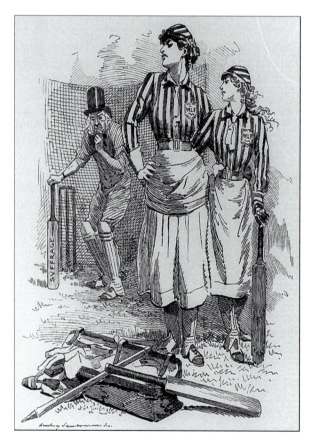

Figure 5.18 Linley Sambourne Jnr, 'The Political
Lady-Cricketers', *Punch*, 1892

than as a red nosed, misshapen, repulsive looking harridan.'[182] A heightened awareness of contemporary visual culture undoubtedly informed an attention to dress and appearance. Feminist papers and journals were full of advice and comments on the attire and deportment of platform women. More than this, concerns with visual matters may well have prompted an intervention into the institutions of high culture.

In 1891 an alliance of feminists, organised under the auspices of the National Society for Women's Suffrage, headed by Helen Blackburn and promoted by *The Englishwoman's Review*, put pressure on the National Portrait Gallery to accept Dacre's portrait of Becker.[183] Its founding in 1856 endowed portraiture with a national significance, that of the representation of the nation and its subjects. Controversial from its inception, its policies were fraught with contradiction. The refusal to accept portraits of living persons ran headlong into the aim to portray 'eminent persons in British history'.[184] As well as acquiring portraits, the Gallery also amassed extensive archives of prints and reproductions, which provided a broad visual framing for the core collections. In sticking firm by its rule that sitters should have been dead for at least ten years, the Gallery's rejection repudiated any public interest in the sitter and denied Becker's national reputation; but more than this it disclaimed women as agents of history and excluded them from the communal body of the polity and the 'imagined community' of the nation staged by the Gallery's collections.[185]

Informal collections of portraits, whether family albums, published galleries of worthies or albums of 'beauties', paralleled this national institution. Feminist women assembled 'galleries' of predecessors and peers. Mimicking the collections of exemplars amassed by intellectuals and rulers from the Renaissance onwards and the 'blue-stockings' of the previous century, these collections created a visual genealogy of authoritative and powerful women which countered illustrated profiles of masculine high achievers and public figures and challenged exhibitions such as 'A Dream of Fair Women' held in London in 1894, whose grand manner portraits offered, according to a recent analysis by Margaret Maynard, an 'illusion of uncomplicated beauty, couched in terms of traditional conventions'.[186] Helen Blackburn was an avid collector, lending to exhibitions and selecting portraits for her *Record of Women's Suffrage*, the first major history of the movement published in 1902. By the early 1890s she had assembled a 'portrait gallery of eminent women' for exhibition in the women's building of the World's Colombian Exposition held in Chicago in 1893, previewing it in the offices of the Women's Suffrage Society. Including abbesses, peeresses, intellectuals, educationalists and other notable women and several living women, on its return Blackburn presented the collection to University College, Bristol for display in the Women Students' Room.[187]

The new university colleges for women followed Oxbridge precedents by adorning their rooms and corridors with portraits and art work. In the early years when the colleges undertook extensive building programmes, as Virginia Woolf rightly surmised, '[t]o raise bare walls out of the bare earth was the

utmost they could do'.[188] The interiors, even at Newnham which was decorated by Agnes and Rhoda Garrett, could be sparse and spartan.[189] At Girton, Bodichon provided furniture and her own pictures for the walls and offered to pay towards the decoration. With Gertrude Jekyll she devised a scheme for painting and papering the whole college, and the two designed planting for the gardens.[190] With the major funding she provided (a £1,000 foundation pledge in 1867, a gift of £5,000 in 1884 and a legacy of £10,000), Bodichon could claim to be a major donor.

In 1884 this claim was put into print and paint. When a portrait of her by Emily Mary Osborn was shown at the Grosvenor Gallery (Figure 5.19), the definitive publication on the exhibition, perhaps using a text provided by the artist or the sitter, asserted that the picture represented 'Madame Bodichon, herself a landscape artist of considerable repute, [who] is best known in England by her philanthropic work in connection with the education of women, and as one of the founders of Girton College Cambridge.'[191] In going further than Clayton's comment in 1876 that Bodichon was 'instrumental in founding' Girton, this statement refuted Emily Davies's claim to be the exclusive founder of the college, advanced by Constance Jones, an ex-student and later

Figure 5.19 Emily Mary Osborn, *Sketch after her Portrait of Barbara Bodichon*, 1884

Mistress of the college. In January 1883 Davies made her views known to Bodichon, forcefully repudiating the latter's assertion that 'the beginning of the College dates from my visit to you at Scalands [Bodichon's country cottage] in August 1867. That is not the case.' In Davies's account, which she claimed she could support from her diaries,

> The idea of starting a new College suggested itself to me on Oct. 6th 1866. . . . By February 1867 I had arrived at a printed Programme. . . . You see, these preliminary steps were being taken while you were in Algiers or somewhere abroad.[192]

A letter from Bodichon to a close friend indicates that this dispute gave rise to the idea for a presentation portrait: '[i]t will be a great thing to get my portrait in Girton' she wrote, but she feared rejection: 'Unless my portrait is done soon the Committee will forget I ever did anything & will not accept it as a gift.'[193] It is not known when or by whom Osborn was approached. The two artists were friends of long-standing: they had campaigned together in 1859, and more recently Osborn had taken up Algerian subjects. Following the Grosvenor Gallery exhibition, a subscription was raised to offer the portrait to Girton 'that it may serve as a remembrance of the great interest that Madame Bodichon has always taken in the College'. Having recently accepted £5,000 from her for the building funds, the Executive Committee duly received the painting in October 1885.[194]

This debate was also fought out on the college walls. Rudolph Lehmann's painting of the first Mistress, paid for by the students, exhibited at the Grosvenor Gallery and presented in 1880, portrays Davies as conventional and even old-fashioned. Seated demurely, her hands folded in her lap, she is neat and demure, a white cap framing her face; the portrayal has nothing to differentiate it from family portraiture of the period. This precise respectability was distinctive to the sitter and her attitude to her position as first Mistress. Before the end of the century the two paintings were hung in the dining hall, inviting comparison. Osborn depicts Bodichon not as a prominent campaigner or public speaker but in the studio, putting the final touches to a framed work on the easel.[195] Although Bodichon had made her reputation with watercolours, oil painting, even in the later decades of the century, had the higher status. In showing her sitter with palette and brushes, Osborn's image equally takes issue with Millais' portrait of Louise Jopling as a fashionable and assured socialite (Figure 5.3). Bodichon's artistic identity is accentuated by her costume. Artistic gowns were favoured by creative and intellectual women as well as feminist campaigners; Jane Cobden wears one in her portrait by Osborn (Figure 5.16). Jane Harrison, the eminent scholar of classical art, was renowned for her embroidered tunics. With their simple, flowing lines, Artistic gowns did not require rigorous corseting; they were comfortable and pleasurable to wear, permitted relatively easy movement and could be individualised through a

choice of accessories, such as a draped scarf, to signal a cultivated taste. Strong, deep and brilliant dyes, velvets and silks and 'rich harmonies of colour and line' were favoured, as an American student at Newnham in the early 1880s recollected.

> Those were the days of 'high art', when the vogue among the initiates was for the beautiful silks and velvets to be had from Liberty or from the theatrical supply shop of Burnet. Instead of the prevailing fashions we copied the long graceful lines of costumes in old paintings.[196]

Their artistic arrangements, moreover, could be put to good use: in another, possibly later, portrait by Osborn, Bodichon wears an elaborate olive-green robe with brown fur borders, distinctive in the 1880s, arranged to echo official robes.[197] In the presentation portrait, a simpler gown has a soft scarf arranged, as Kate Perry has suggested, to echo the lines of an academic hood. In so doing it adds a hint of academic standing at a time when women did not wear academic dress, were not admitted to degrees, were not full members of the university and were excluded from university posts and administration.[198] Unlike Dacre's image of Becker, the presentation portrait, as far as can be ascertained from the surviving drawing, presents a youthful figure, registering few of those 'lines of life' (to recall the words of Millicent Fawcett) inscribed on the face and the body by age, stress or illness. In 1877 Bodichon had suffered a stroke and although she had recovered sufficiently to resume painting, her professional career was largely over. A tactical intervention into the politics of representation, the portrait is perhaps more about memory than likeness.

Neither the portrait of Bodichon nor the painting of Davies could provide an image of a learned woman. At one level this was personal, for neither were scholars; at another it was institutional, for the new women's colleges were established to train future generations. With few contemporary examples, the visual syntax for their representation was under-developed. Osborn's portrait thus took up an artistic challenge, making a bid for the visual factoring of women, power and knowledge framed within a collegial space in which viewing was, to draw on Lynne Pearce's formulation of a feminist politics of reading, 'an *interactive and implicated* process' which engages at complex and contradictory levels emotionality, pleasure and desire.[199]

Towards an allegorical reading

In 1890 Philippa Fawcett, a student at Newnham College Cambridge, was awarded the highest place in the Mathematical Tripos examinations. The event was proudly reported by Helen Blackburn in *The Englishwoman's Review*:

> In remembrance of her daughter's success at Cambridge, Mrs Fawcett has presented Newnham College with a painting of the 'Rising Dawn'

Figure 5.20 Emily Ford, *Towards the Dawn*, 1889

Figure 5.21 Emily Ford, *The Soul Finding the Light* [*c.* 1888–89]

by Miss Emily Ford, a fine allegorical figure with the light rising behind. The picture will . . . be hung in the Common Room of the College.[200]

Though the painting has not been located, a photograph of it has survived, dating it to 1889, the year of the *Declaration in Favour of Women's Suffrage* (Figure 5.20). A female figure wrapped in the silken folds of a light diaphanous fabric flies across a cloudy sky, billowing drapery and clouds behind her: body, cloth and ground pulsate in movement. On the reverse of the photograph is an inscription by the artist, identifying this as the 'Painting in Newnham College . . . (One of the Sphere of Suffering)'.[201] Rather than commissioning a new work, Millicent Garrett Fawcett purchased, from the studio or elsewhere, a recently completed painting of *The Soul Finding the Light*, one of a series entitled 'The Sphere of Suffering' on which the artist worked from the early 1880s for some twenty-five years or more. Another variation portrays a female figure in deep blue robes floating across a screen of luminescent blue and gold with neither cloudscape nor horizon: suffused with light and colour, the figure is both contrasted to it and illuminated by it (Figure 5.21).[202] More substantial in its rendition of form and fabric and without the trailing swathes of drapery, this surviving painting has none of the seeming evanescence or lightness of flight of the Newnham picture.

When the painting was transferred to Newnham College, it was retitled, relocated and resignified. Craig Owens's well-known essay on allegory will help in understanding something of what was engaged in this reframing. In 'The allegorical impulse: toward a theory of postmodernism', first published in 1980, Owens specified the conditions of allegory's occurrence – 'whenever one text is doubled by another' – and he defined its structure: 'one text is *read through* another, however fragmentary, intermittent, or chaotic their relationship may be.' His considerations are worth returning to once more,

> Allegorical imagery is appropriated imagery; the allegorist does not invent images but confiscates them. He lays claim to the culturally significant, poses as it interpreter. And in his hands the image becomes something other (*allos* = other + *agoreuei* = to speak). He does not restore an original meaning that may have been lost or obscured . . . Rather, he adds another meaning to the image. If he adds, however, he does so only to replace: the allegorical meaning supplants an antecedent one; it is a supplement.[203]

This double reading, somewhat akin to Derrida's 'double session', gives priority not just to the artist but to the reader/viewer and the work's 'site-specificity'. Owens's carefully modulated account of recent art practices offers rich possibilities for understanding later nineteenth-century painting: it has already been suggested that Elizabeth Guinness's memorial portraits readily

appropriated antecedent photographic imagery and that Ford's painting was appropriated for its new setting. But more than this, Owens's propositions of allegory as a way of reading enable new understandings of late nineteenth-century painting and sculpture. This is not to claim that there is a match or equivalence between historical imagery and a visual theory devised for the recent past. But it is to propose interpretations and readings that go beyond more familiar interpretations of symbolism or allegory. And it is, to return to the propositions advanced in the previous section, to allow feminism and visual imagery to 'talk to' one another.[204]

Ford's paintings were made within a visual culture in which allegory and symbolism were familiar, in the iconographies of socialism as well as the elite forms of painting and sculpture. George Frederic Watts's *Hope* (Figure 5.22) reworks an allegorical figure with a long visual lineage as one of the three Christian virtues, setting aside the more usual anchor to seat Hope on a globe.[205] In this version, painted by the artist for presentation to the nation, the

Figure 5.22 George Frederic Watts with an assistant, *Hope*, 1886

figure, isolated in space, is set in and against a deep blue atmospheric sky, misty clouds rising from below. A single brilliant star gleams above her head. Swathed, almost bandaged in draperies tinged with green, her head is bowed and her body tense (her left leg is twisted round her right) as she holds a lyre with all but one of its strings broken. The fabric wrapped over her eyes renders her as blind and perhaps as fickle as Fortune. More sombre and solemn than the first version, exhibited at the Grosvenor Gallery in 1886, in which a hint of an enigmatic smile playing over her lips may be discerned, neither the title nor conventional allegorical lore set limits to the possible meanings of a painting charged with ambiguity. Frederic Leighton's murals *The Arts of Industry as Applied to War* and *The Arts of Industry as Applied to Peace* (completed 1886) also deployed allegory, this time for the public spaces of the South Kensington museum. Tim Barringer gives a persuasive account of their location in an institution devoted to the history of design:

> Although they evoke the historically distant material culture of Renaissance Italy (*War*) and classical Greece (*Peace*), the frescoes are primarily concerned with a problem central to late nineteenth-century modernity: the libidinous relationship between people and things; the curious fascination of the commodity.[206]

Made at a particularly bellicose period of imperial expansion, the murals may also be interpreted as allegories of modern Britain. Whereas *War* provides a flamboyant display of masculine corporeality in its scene of Florentine noblemen arrayed for battle, *Peace* presents, centre stage, a group of high-born women admiring themselves, their clothes and jewellery while they dress (Figure 5.23). In both strong gender contrasts are effected: in the first by a group of women sewing in the left foreground, and in *Peace* by the muscular male bodies of the flanking sections, busy with making and delivering luxury goods. Attended by servants, the wealthy women who dedicate themselves to luxury and consumption could signify that national wealth and prosperity secured through imperial trade: as Marina Warner has argued, women's bodies become allegorical form. Leighton's mural provides, moreover, a familiar image of women as indolent and self-regarding, women whose indolence slides, as in his own later paintings, *The Garden of the Hesperides* (1892) or *Flaming June* (1895), into sleepy reverie, beyond the activity of self-decoration or the mental work of scholarship.

If Watts's painting and Leighton's murals may be identified as allegorical, Burne-Jones's paintings, shown at the Grosvenor Gallery, signal even more allegory's diffuseness and slipperiness. *The Golden Stairs* portrays a fleet of young women, some said to be recognisable, and most carrying musical instruments, descending a semi-circular stair (Figure 5.24). When exhibited in 1880, this large picture was thought to be without subject, narrative or directly

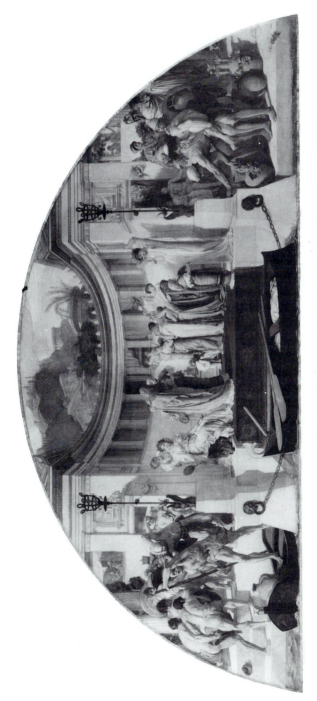

Figure 5.23 Frederic Leighton, *The Arts of Industry as Applied to Peace*, monochrome cartoon 1872–3

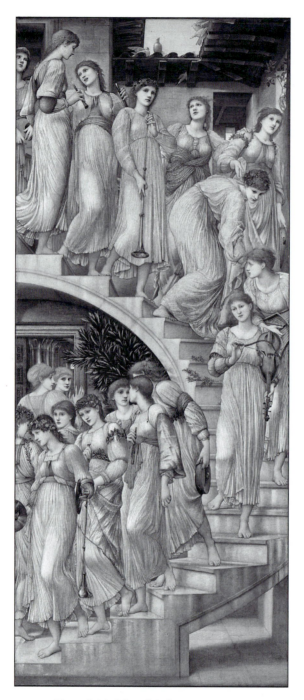

Figure 5.24 Edward Coley Burne-Jones,
The Golden Stairs, 1872–80

explicable content, F.G. Stephens commenting in *The Athenaeum*, 'What is the place they have left, why they pass thus before us, whither they go, who they are, there is nothing to tell.' While the *Saturday Review* saw it as 'a beautiful design without any purpose', *The Artist* explained that 'the seeker for definite subjects will be inclined to grumble that this picture tells no story and suggests no meaning'; it was instead 'decorative'. The painting may be read as an allegory of contemporary womanhood, from its inception to a youthful maturity in which, if the viewer were able to recognise the models, are included single and married, independent and dependent women, members of fashionable society, practising artists and art lovers. But *The Golden Stairs* is evasive; pointing only to the location, its title gives little indication of potential meaning. Burne-Jones's paintings provoked heated debates about the melancholy morbidity, enervated form, unhealthy appearance and androgyny of his figures.[207] Criticism provided a forum for airing anxieties concerning femininity, feminism and sexual difference.

Recent attempts to include the art produced in Britain from 1860 to 1910 within a pan-European Symbolist movement depend upon an interpretative strategy which proposes that the symbol unites an abstract idea to a visual form.[208] This notion of the symbol's bond between image and meaning is to be differentiated from critical theories of signification, deconstruction and allegory, all of which argue for the slipperiness and deferral of meaning, the non-equivalence of the signified and signifier. Owens proposed a clear distinction between his theory of allegory and conventional notions of symbolism: 'If the symbol is a motivated sign, then allegory, conceived as its antithesis, will be identified as the domain of the arbitrary, the conventional, the unmotivated.'[209] Allegorical reading moves beyond familiar ideas of allegory which depend on a pre-given, fixed content for the sign for an attention to the instabilities of meaning, secured only temporarily in specific spaces.

When bordered by its first title, *The Soul Finding the Light*, Emily Ford's painting took its place in the artist's series tracing the passage of the soul from the darkness of the abyss to light which included 'The soul entering the sphere', 'The soul in the abyss', 'The soul finding the light' and 'An ascension of souls'.[210] Reflecting in later life on her artistic development, Ford considered that this series marked a change in direction.

> In the conceptions of my student days, the etchings and peasant subjects – I sought to discover the meaning of life in humanity alone. In a later series – 'Coming of night', 'Life', 'Dawn', 'Ascension of Souls' etc., I strove to express it by symbolism of the life of the soul.[211]

Yet such a progression was by no means so clear-cut and the artist may well be veiling her associations with independent labour politics. The 'etchings and peasant subjects' to which she refers have not survived. Of one, *Weary Way*, a reviewer remarked in 1885: 'One feels the wild winds of the Yorkshire moors

blowing about and hindering the steps of an old woman who struggles along under a heavy load.'[212] In creating a new visual culture for socialism, on the streets and in publicity material, which would be generally intelligible to a broad public, reproducible in the new media, and shape and sustain socialism's moral and political beliefs, Walter Crane took up and reworked allegory for the representation of 'Liberty', 'Labour', 'Peace', or 'Capitalism'.[213] Walter Langley at Newlyn in Cornwall is among those painters whose representation of working-class figures and communities has been connected to their left-wing beliefs.[214] But the elite form of painting was contradictorily positioned in relation to socialist politics, and new research on the socialist sympathies of Marie Spartali indicates the complexities. During the 1880s, Spartali made a successful reputation for herself with her large watercolours of subjects drawn from Italian literature, portraying cultivated and assured women. It was at this time that she appeared at Grosvenor openings in spectacular outfits, as if she had just stepped out of the frame of one of her own pictures, and was celebrated as a model for Burne-Jones. Yet this was the era when Spartali subscribed to *Commonweal* and took a party to the Socialist League play, *The Tables Turned*.[215]

In these years Emily Ford was active in independent labour politics in Leeds and a keen suffragist. She retained her membership of the Society of Friends until 1890 and she joined the Society for Psychical Research, being elected an associate member in January 1885.[216] Earlier in the decade she had had some contacts with the British National Association of Spiritualists. In a paper on the 'Religious bearings of Spiritualism', read in November 1881 and published in *Light*, she admitted that during the past eighteen months in which she had been 'practically acquainted' with spiritualism she had 'never attended a physical phenomena séance', had heard a few 'trance mediums', and had experimented a little with 'table-turning'. Sceptical of this 'mere wonder-seeking' and of discredited mediums and uncertain about the morality of spiritualism, her enquiries were motivated by her interest in 'whether Spiritualism has more than a special or scientific meaning, whether, in fact, it has a general or religious bearing'. Addressing its possibilities for accessing the 'highest truth' and hoping that it might be the means of leading 'a purer and holier life', she concluded,

> Consciousness of Spiritual life, the perception of Spiritual truth, are the first aims of all religions. Let us as far as we can prepare ourselves for this wider consciousness, by living the best life we can, by following our highest soul, but constantly seeking Spirit Communion to aid us in worthy action and above all, if it be possible to us, that highest form of Spirit Communion, prayer.[217]

With its focus on the workings of the mind, emphasis on rational and scientific investigation, and doubts about seances and mediums, the Society for Psychical Research would have proved more sympathetic. Its journal, which

published Freud and Breuer's early investigations into hysteria, included enquiries into telepathy, automatic utterances and subliminal consciousness. Its scientific stance attracted numerous middle-class professionals. Moreover, as Janet Oppenheim has indicated, because it was not perceived by its middle-class adherents as undermining or contradicting Christianity, spiritualism was embraced by non-conformists and Anglicans as well as freethinkers. Under the presidency of Henry Sidgwick, professor of Moral Philosophy at Cambridge, the society attained prestigious intellectual and social status.[218] Founded in 1882, it had by 1895 some 900 members; amongst the many intellectuals, writers and artists were Ruskin, Tennyson, Leighton, Watts, Frank Dicksee and Dorothy Tennant.[219] Theresa Thornycroft's vision of her cousin at the moment of his death, experienced in 1874, was published in its accounts of 'phantasms of the living'. The daughter of the sculptor Mary Thornycroft, Theresa Thornycroft was introduced in the journal as 'a lady whose artistic powers are well-known, and in whose experience, as we understand, mere visualisation is often so vivid as to become itself hallucinatory'. The conclusion that 'persons thus gifted (artists, for instance), would be rather more likely than other people to be subjects of these *incipient* and still almost wholly *subjective* forms of visual hallucination' indicates some of spiritualism's attractions.[220] Artists were considered to have special capacities. And, as several historians have noted, spiritualism, in all its many forms, had a particular appeal to women: not only did it draw on feminine qualities of receptivity and intuition, but in its subversions of gendered conduct women exercised significant power and authority.[221]

Psychical research had connections to feminism: notable campaigners such as Agnes Garrett, Anna Swanwick, Elizabeth Blackwell and Charlotte Despard joined the Society. Eleanor Mildred Sidgwick, one of the most active researchers and publishers on this subject, was elected to membership in 1884 and became president in 1908. Sidgwick was equally renowned in women's higher education: treasurer for nearly forty years, she was vice-principal and later principal of Newnham College Cambridge. Although her academic position contributed to an initial reluctance to join the society, the influence of her association with psychical research permeated the college in its early years, as is testified by a student's recollection of discussions with Eleanor Sidgwick: 'It was during my stay at Newnham that the Society for Psychical Research was formed and we talked often of it and its possibilities.'[222]

From the scientific stance of psychical research to purported communication with spirits and angels, table-rapping, mediums and seances, spiritualism was broadly defined, and the interest of writers such as Charles Dickens and Henry James is well known. Scholars have also noted the impact of theosophy on visual culture at the *fin-de-siècle*.[223] Although not a member of the Society for Psychical Research, Emily Ford's close friend, Evelyn de Morgan, was also preoccupied with psychical investigation, pursuing an interest in automatic writing and publishing anonymously in 1909 over 200 automatic scripts. Judy

Oberhausen has argued persuasively that de Morgan's spiritualist concerns prompted an address to some of the key issues of her times, from materialism to modern warfare. There was, she contends, 'a striking correspondence between the spiritualist-influenced ideas expressed metaphorically in the de Morgans' automatic writings and the allegorical depiction of spiritual evolution found in many of Evelyn de Morgan's paintings'.[224]

Ford and de Morgan shared interests in painting, suffrage and spiritualism. Both portrayed the spiritual journey of the soul which, in common with their contemporaries, they identified as feminine and embodied as a white woman. While they were working within and shaping the visual languages of the period, reciprocities may have arisen from their mutual concerns.[225] De Morgan drew on biblical luminist imagery and the mystical writings of Emmanuel Swedenborg to develop strongly held beliefs in the evolution of the soul from the physical to the spiritual and finally the celestial plane: at death the soul moves from earthly existence to an intermediate state in which it is tested and from which it may progress towards divine light or descend into darkness. For Judy Oberhausen, 'light became the visual metaphor for a divine presence in the universe that counteracts evil by instilling hope, love and wisdom in the soul', whereas 'darkness became symbolic of the malevolent forces of despair, egotism and ignorance'.[226] *The Soul's Prison House*, executed during de Morgan's early ventures in spirit writing, was exhibited at the Grosvenor Gallery in 1888 with a prayer, attributed to St Augustine of Hippo: 'Illuminate, oh illuminate my blind soul that sitteth in darkness and the Shadow of Death.'[227] An association of this plea for illumination with an image of a female figure wrapped in green robes and seated in a prison cell suggests the soul's incarceration on the terrestrial plane. To embark on its spiritual progress, the soul must be released through death from its corporeal form and, as the prayer indicates, receive the redemptive power of that spiritual light which illuminates the cell and its incumbent in de Morgan's *Hope in the Prison of Despair*.[228]

A similar journey is proposed in Ford's series of 'The Sphere of Suffering'. A painting for an intermediate stage, identified by the artist as 'The naked Soul in the Storm Abyss', portrays an unclothed female figure plunging perilously through space, her hair and swathes of blue fabric swirling round her.[229] In this greyish-yellow void, a female nude is buffeted between billowing clouds below and strong shafts of light breaking through the clouds above. Put to many uses in late nineteenth-century feminist discourse – as a marker of women's artistic achievement or their over-ambition, deployed in the languages of social purity – here the female nude signifies complexly in terms of spirituality, vulnerability and the nakedness of the soul before God. For spiritualists and theosophists colour was highly significant in invoking spiritual and emotional states and sensations.[230] Emily Ford emphasised that 'people must learn to see Spiritual truth as an artist must learn to see colour'.[231]

Ford's flying figure is not dissimilar to the dark-robed figure of Night in de

Morgan's earlier *Aurora Triumphans*, exhibited to acclaim at the Grosvenor Gallery in 1886 (Figure 5.25). Although nothing is known of the colour of Ford's Newnham picture, in the surviving version the blue robes echo Christian conventions for the depiction of the Virgin Mary, intercessor between heaven and earth; an association with night would also be appropriate for the soul in transition. While the title of de Morgan's painting invokes the goddess who rides her chariot though the heavens to announce the coming light of day, it also invokes the protagonist of Elizabeth Barrett's well-known poem, *Aurora Leigh*, and her quest for learning and self-determination. In de Morgan's resplendent painting, Aurora's bonds fall away as Night flees and three trumpeters, their wings fused with the red of the rising sun, their draperies heightened with gold, sound the arrival of dawn. More than a phase of temporal duration, night was identified by Emily Ford as the first stage of the soul's journey, initiated by death. It is also possible that her intensity of work on 'The

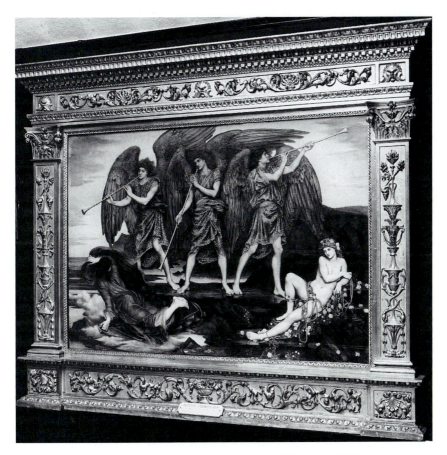

Figure 5.25 Evelyn de Morgan, *Aurora Triumphans*, 1886

209

Sphere of Suffering' in the later 1880s offered a coming to terms with the death of her mother in 1886.

The motif of a spiritual journey has a wide resonance in Judaeo-Christian iconography as well as in the Christian literature on the pilgrim's progress. Light has associations with Christ, heightened in the later nineteenth century by the diffused if contentious vision of Christ as 'The Light of the World'. Equally significant may have been Quaker beliefs about light as a sign of divine energy or as an operative power, terrible or gentle, yet a safe guide through life. The Quaker historian, John Punshon, indicates that while the key belief that '[s]alvation occurs when the repentant individual turns to the light' remained, the authority of an inward experience of an inner light was challenged by views that Christ's atonement was a precondition for the avail-ability of light and thus the possibility of salvation.[232] Light also had signifi-cance in spiritualist and feminist discourses. In the former, its prominence was indicated by the title of the journal of the British National Association of Spiritualists, and papers in spiritualist journals are suffused with luminist imagery. By no means a 'pre-text' for her series 'The Sphere of Suffering', Emily Ford's paper on the 'Religious bearings of Spiritualism' draws on luminist metaphors to represent the spiritual journey and to question the validity of the new movement:

> What if modern spiritualism be indeed but the mere reflections of the dawn of a wider life which is coming to us? The night has been long; what if its darkest hour be upon us now? What though it crush us to the earth with its thick blackness, may not its very gloom be a sign that the might is far spent, for is it not the darkest hour which comes before the dawn?[233]

In late nineteenth-century feminism, light was a sign of the transformations wrought by the movement. On the cover of *Shafts*, issued in the early 1890s, a female figure, attired in neo-classical attire, draws her bow with an arrow bear-ing 'Wisdom', 'Justice' and 'Truth' (Figure 5.26). A pennant fluttering over-head proclaims 'Light comes to those who dare to think'. The rising sun at the horizon heralds the dawn and the verse reiterates the passage from dark to light:

> Oh, swiftly speed, ye shafts of light,
> While hosts of darkness fly
> Fair breaks the dawn: fast rolls the night
> From woman's darkened sky.

In this striking visual image allegory and neo-classicism were extended to a readership defined as 'women and the working classes'.

The flight of a luminous figure across a sky modulated from dark to light

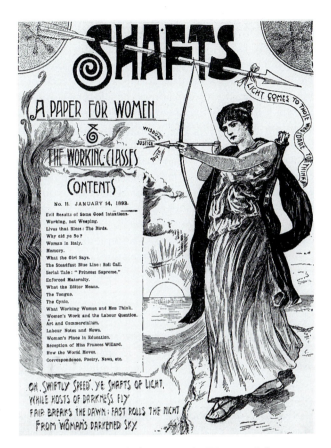

*Figure 5.26 Shafts: A Paper for Women and the
Working Classes*, 14 January 1893

depicted in the Newnham painting could have thus sustained a range of mean-
ings with both individual and collective application: the acquisition of know-
ledge; the accession of spiritual light; the passage from suffering to illumination;
a moment of spiritual discovery. When Ford's painting was 'appropriated' for
Newnham, a fresh title – 'Rising Dawn' or 'Towards the Dawn' – along with
the physical enclosure of the college provided new thresholds to and set fresh
limits on interpretation. The new title displaced a sense of closure ('finding the
light') with a sense of deferral ('towards the dawn'). The image could have
taken meaning in relation to women's higher education, light playing into
long-standing associations in the west of the enlightenment of knowledge.
Spiritualist beliefs would also have been in play in a location and for a com-
munity who were undoubtedly aware of Eleanor Sidgwick's eminence in the
field. All these possibilities abutted, jostled, overlapped and confronted each
other: if location at Newnham enhanced particular legibilities, antecedent

readings and meanings were not necessarily dispelled, as any closure was only temporary. Paul de Man explains in *Allegories of Reading* the coexistence of 'two entirely coherent but entirely incompatible readings'. Resisting the view that the two meanings simply coexisted, and refusing to prioritise one over the other, he argues that '[t]he two readings have to engage with each other in direct confrontation'.[234] In the doubled readings of allegory advanced by Owens, 'entirely coherent but entirely incompatible readings' may be sustained synchronically or diachronically; working to the 'logic of supplement' they add to and replace each other.

It is this supplementarity of allegory which enables feminist readings to be sustained alongside and in confrontation with others. Feminist politics and women's art can be brought into a conjunction which is not construed as causal or originary. Ford's painting is not judged to be feminist because of any pre-given content or intention. Rather feminism, spiritualism and Christianity, their articulation heightened by the Newnham location, provided frames for viewing the picture. In an allegorical reading the meanings of the work of art, no longer expressed by or deposited within the object, were actively consti-tuted and contested by its communities of viewers.

For Marina Warner, allegory is declamatory. Tracing its etymology from *allos*, other + *agoreuein*, to speak openly, to harangue in the *agora*, she character-ises it as 'an open declamatory speech which contains another layer of mean-ing'.[235] Allegory's declamatory power might find an echo in Emily Ford's desires that her works should be hung 'where they could speak'.[236] It was outside the institutions of culture and scholarship that women's art was at its most declamatory. Beyond the frame of high culture and on the streets of major cities, performative spectacle embodied women's demands for political representation.

Women's suffrage banners came to prominence in the wave of public meet-ings and major demonstrations convened throughout Britain to call for wom-en's suffrage to be included in the Reform Bill of 1884, which was to enfranchise nearly two-thirds of the male population. Speakers in demand trav-elled widely to address audiences drawn from all over the country (Figure 5.27) and halls were 'packed from floor to ceiling with women of all ranks and occupations'.[237] In Sheffield, as elsewhere: 'The great hall was crowded to over-flowing with women of all ranks and conditions of society. Not only was every seat filled, but the gangways were packed with women who remained standing during the whole of the proceedings.'[238] Banners created a backdrop or fore-ground to the speakers: on the platform at St James's Hall in 1880 in front of the resplendent banner made of yellow silk were Rhoda Garrett, Helen Taylor and Lydia Becker. On occasion banners might be held by participants. Frances Mary Stirling remembered a meeting at St James's Hall in London (held before 1890) when Lydia Becker was on the platform 'holding up a long banner with a noble sentiment on it'.[239] Banners indicated the geographical spread of a movement with strong national and local organisation. At St

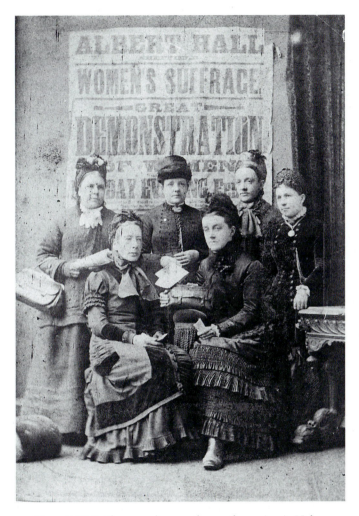

Figure 5.27 Suffrage speakers on the northern circuit: Helena
Downing, Mrs Colbick Ellis, Mrs McCormick, Mrs David R. Vero,
Alice Scatcherd, Miss Carbutt, Sheffield, 1882

James's Hall in London in July 1883, and again a year later (Figure 5.28),
'[b]anners, representing delegates from nearly all the large towns in the coun-
try, were arranged round the platform'. Banners played an important part in
the meetings. In July 1883 '[s]hortly before 8 o'clock a procession of women,
trades unions, entered the hall with another banner, and mounted the plat-
form.'[240] Eye-catching spectacle, marches to and processions inside the halls
and community singing helped to create a sense of common cause across a
very wide constituency of women. In May 1880 members of the London and

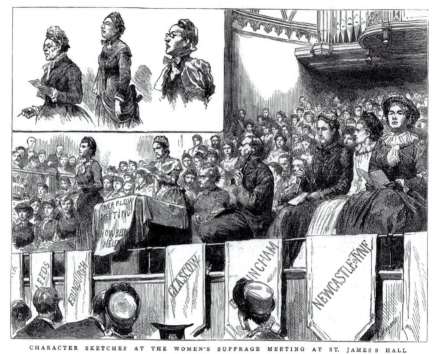

CHARACTER SKETCHES AT THE WOMEN'S SUFFRAGE MEETING AT ST. JAMES'S HALL

Figure 5.28 Suffrage meeting at St James's Hall, London, *The Graphic*, 28 June 1884

Westminster Tailoresses' Society processed from Pimlico and Whitechapel to St James's Hall carrying their magnificent yellow silk banner. A call to attend the National Demonstration of Women accompanied the motto declaring their resistance to paying taxes. The Great National Demonstration of Women in Edinburgh on 22 March 1884 (which the painter Mary Burton helped to organise) opened with the March of Reform and closed with 'Scots Wha Hae'.[241]

Contemporary accounts suggest that the banners were emblazoned with mottoes announcing meetings, calling for the vote, proclaiming key beliefs and advocating action. At Newcastle in May 1884 in front of the platform, a banner bearing the inscription 'Women claim equal justice with men' was displayed; 'others of a similar description were hung in various parts of the hall'. One month beforehand the same banner, or at least one with an identical text, was suspended above the platform at Edinburgh along with others with 'appropriate mottoes'.[242] Smaller hangings also adorned the meeting halls. In central London the previous July 'scrolls containing quotations . . . in favour of women's suffrage' floated down from the galleries.[243] An illustration in *The Graphic*

of the meeting calling for the extension of the franchise to householders and rate-payers held in St James's Hall in July 1884, chaired by Elizabeth Garrett Anderson and addressed by Lydia Becker and Alice Scatcherd among others, is one of the few surviving visual images of these impressive visual spectacles of the 1880s (Figure 5.28).

Suffrage banners were usually made by hand. Those that came out of the local associations would have been stitched by middle-class women whose general education included needlework. 'A large white-and-gold banner made . . . by the Bristol Suffrage Society under . . . Helen Blackburn's direction', unfurled for procession in 1910, probably dated from these years.[244] Others, like the London and Westminster Tailoresses' banner, were made by women unionists. In selecting silk, if the reporter is correct here, they used a preferred material for nineteenth-century trades banners although canvas, generally bordered with silk or poplin, was a favourite alternative.[245] Although there are numerous occasions on which women were credited with making union banners at home, instances of the collective manufacture attributed to the London and Westminster Tailoresses is much rarer.[246] In what sense did the London and Westminster Tailoresses make their banner, and what concept of 'authorship' might this imply? Since reports do not give any detail of the banner's making, it cannot be ascertained if it was painted (as were many nineteenth-century banners) or, like many of the later suffrage banners, embroidered, stitched or appliquéd. The tailoresses, with their sewing skills, could certainly have undertaken the needlework, though they may have employed a local sign-writer to paint or cut out the letters of their motto. Margaret Bondfield recalled the shared making of a banner for the Shop Assistants' Union in about 1891.

> An old ticket writer was found, who for a shilling cut out the white glazed letters, which mother stitched onto a heavy red twill which made a patch of glory on high, mounted on the alderwood poles which my father had made.[247]

Impromptu banners, simple in style and materials, could readily be produced for a variety of causes. Soon after the founding of the Tea Operatives' and General Labourers' Association in 1887 a simple banner was made: 'a linen sheet on which was thickly painted in black, [with] the name of our organisation', a call to join the union and to 'defend the rights of manhood in a practical and direct manner'.[248] It is unlikely that a small women's union would have commissioned banners from George Tutill, whose workshops, according to John Gorman, provided 'more than three-quarters of all trade union banners made from 1837 onwards'.[249] Gwyn Williams notes that Tutill banners 'were large scale enterprises in public declaration, display and advertisement. It was a serious business for a branch to order a Tutill banner; it represented a major commitment.'[250] And if Tutill's banners were expensive, weighty with

decoration and pictorial designs, they were also large and heavy; hand-made banners could be made to suit those who carried them.

Textual banners addressed both participants and audience. If Frances Mary Stirling did not commit to memory the motto on the banner she had seen, she did recall that it put forward 'a noble sentiment'.[251] The selection of mottoes was undoubtedly important and that of the London and Westminster Tailoresses related to the tax resistance campaigns initiated by the early 1870s. Banner mottoes became legible within an urban environment in which advertisements and handbills offered the pleasure of the text, a pleasure jostled by the visual culture of the period and the image revolution of the 1890s. Echoing the speeches and recycled time and again in pamphlets and journals, mottoes made demands, signalled presence and exhorted action, their oratory matching that of the platform women and charging the individual and the body politic.[252] Suffrage pageantry was, to some extent, created for the news media; speakers and banners were given an enhanced visibility in illustrated magazines which circulated nationally (Figures 5.1 and 5.28).

The visual culture of women's suffrage in the 1880s was certainly dramatic. It took place within and contributed to a late nineteenth-century urban pageantry of spectacular demonstrations and banner-bedecked marches and meetings organised by temperance campaigners, trade unions, the unemployed, the Mothers' Union and church groups, labour protesters, socialist groups and miners' galas and inventors of national tradition.[253] Out of an alliance between unionism and suffrage came precedents for the early twentieth century. But in taking up this inheritance some twenty years later in a profoundly changed political and social climate, suffrage spectacle became a largely middle-class affair. The modest textual banners of women's unionism, glimpsed in occasional photographs, were outnumbered by the magnificent art banners whose pageantry, as Lisa Tickner has so meticulously documented, 'dignified womanly skills while making unwomanly demands'.[254]

In an allegorical reading text and image are construed as having a special relationship which is not one of dependency or priority. The allegorical image does not illustrate a text that comes before it and 'motivates' its meaning. Rather allegory emphasises the doubling and 'reciprocity' between image and text, the visual and the written.[255] To restate one of Owens's propositions: 'One text is read through another, however fragmentary, intermittent or chaotic their relationship may be.' Taking up these definitions, it becomes possible to stage the encounters in which women's art is 'read through' a feminist politics, while maintaining distinct registers of cultural and political practice. Allegory's double readings place text and image, art and politics, in reciprocal connection, in a relationship that implies exchange and mutual transformation rather than causality or antecedence.

Many of the objects discussed in *Beyond the Frame* have been lost without trace. It seems unlikely that any of the women's suffrage banners of the 1880s

have survived: hand-made and fragile, they had none of the resilience of profes-
sional manufacture which has ensured the longevity of a good number of
union banners. Neither the suffrage societies nor women's unions had the
means, resources or national standing to secure the institutional preservation of
their materials. Family collections of paintings have often been dispersed. Mas-
sive marble statues have disappeared, although Edmonia Lewis's *The Death of
Cleopatra* has recently resurfaced and is now housed in a national museum.
Women's donations to women's colleges have vanished over time: the historian
Carol Dyhouse has noted the hijacking of endowments, the insecurities of
donations, the loss of gifts, and the difficulties in establishing continuity.[256] The
reasons for these disappearances undoubtedly lie within the twentieth century's
uneasy relationship to its immediate past, its trajectories of feminism, its histor-
ies of sexual difference and class struggle, its changes in artistic taste and public
policy. Two other explanations may be offered.

Allegory is treacherous. Its slipperiness and deferrals give rise to uncertainty,
even unintelligibility; it promises meaning but provides no guarantees.
Demanding engagement and knowledge, it is, as Anne McClintock has writ-
ten, 'paradoxical and perilous'.[257] In allegory it is all too easy for signification
and therefore significance to drain out, for the image to slip away, beyond the
frame. City squares and public museums are full of figures devised in the second
half of the nineteenth century whose identity and meaning are now barely
discernible. Craig Owens warned that allegorical works are 'impermanent,
installed in particular locations for a limited duration, their impermanence pro-
viding a measure of the circumstantiality'. He also observed that '[b]ecause of
its impermanence, moreover, the work is frequently preserved only in photo-
graphs.'[258] Many of the art objects considered here are known only through an
unlike double. Plates in illustrated papers, the form in which many outside
London came to see works exhibited in the capital, now stand in for pictures
and sculptures that have vanished. Hosmer's magnificent exhibition piece has
been displaced by a compressed replica and an indistinct photograph. Anna
Mary Howitt's *Boadicea*, Margaret Tekusch's *The Wife* or Rebecca Levison's
Hypatia can be summoned only through cursory reviews. The portrait of
Becker was cut down by the artist in late 1919 as a condition of its presentation
by the Manchester Branch of the National Union of Women's Suffrage to the
collections of Manchester City Art Gallery; the three-quarter length is pre-
served in an archive photograph.[259] Osborn's later portrait replaces the presen-
tation portrait removed from Girton College by the sitter's descendants; now
missing, it is registered in a drawing and a photograph showing it hanging in
the college dining hall. Never formally de-accessioned, *Towards the Dawn*
cannot now be located, its existence caught fleetingly in a fading photograph.

Hélène Cixous has differentiated the realm of the gift, associated with the
feminine, from the realm of the *propre*, which she defines as a masculine libid-
inal economy, in which everything must be returned and all must have a return.
The *propre*, as she points out, is intimately linked to notions of what is 'proper',

fitting and appropriate, as well as to concepts of 'property'; gifts are dangerous since they destabilise the entire system.[260] The cultural objects discussed in this book may be said to have disturbed, even contradicted, the 'proper' relations of power/knowledge. Given in the realm of the gift, they were donated to and held by those whose authority to hold property was insecure and rarely legitimised: matrilineal family lines, women's friendships, colleges or unions. Signifying an excess in the feminine, these objects came to stand for dead women and defunct causes; they slipped out of record and official memory. By the 1920s, when Osborn's portrait was removed from Girton, it was no longer recollected that it had been presented to 'serve as a remembrance of the great interest that Madame Bodichon has always taken in the College'. Appropriate no longer, neither demanding nor receiving a return, these works simply ceded place. Let me conclude with the words of Walter Benjamin quoted at the opening of Craig Owens's essay on allegory:

> For every image of the past that is not recognised by the present as one of its own concerns threatens to disappear irretrievably.[261]

APPENDIX
Selected publications on Algeria, 1857–68

Barbara Leigh Smith Bodichon, *Women and Work*, London: Bosworth & Harrison, 1857.

—— (ed.), *Algeria Considered as a Winter Residence for the English* (with contributions from Barbara Bodichon, Eugène Bodichon, and Annie Leigh Smith), London: published at the *English Woman's Journal* Office, 14a Princes Street, Cavendish Square, 1858, priced 2/6.

—— 'Algiers, first impressions', *The English Woman's Journal*, September 1860, 21–32.

—— 'Cleopatra's Daughter, St Marciana, Mama Marabout, and other Algerian women', *The English Woman's Journal*, February 1863, 404–14.

—— 'Kabyle pottery', *The Art Journal*, 1865, 45–6.

—— 'Australian forests and African deserts', *Pall Mall Gazette*, 1868.

Eugène Bodichon, 'Society in Algiers', *The English Woman's Journal*, October 1860, 95–106.

—— 'Algerine notes, part 1: Algerine animals', *The English Woman's Journal*, VIII, September 1861, 31–7.

—— 'Algerine notes, part 2: Algerine animals', *The English Woman's Journal*, October 1861, 90–6.

Bessie Rayner Parkes, 'French Algiers', *Waverley Journal*, 7 February 1857.

—— 'Mme Luce's school in Algiers', *Waverley Journal*, 7 February 1857.

—— 'An Englishwoman's notion of Algiers: how hard it was to get there', *Illustrated Times*, 14 March 1857, 164–5 [illustrations by the author, or Barbara, Annie or Bella Leigh Smith].

—— review of *Algeria Considered. . .*, *The English Woman's Journal*, March 1859, 64–6.

—— 'Algerine Interiors', *Once a Week*, 23 March 1861, 356–61 [with unattributed illustrations].

—— 'Mme Luce of Algiers', *The English Woman's Journal*, May 1861, 157–68.

—— 'Mme Luce of Algiers', *The English Woman's Journal*, June 1861, 224–36.

—— 'Mme Luce of Algiers', *The English Woman's Journal*, July 1861, 296–308.

—— 'The condition of working women in England and France', *The English Woman's Journal*, September 1861, 1–9.

—— 'Moustapha's House', *The English Woman's Journal*, November 1861, 173–9.

—— *Mme Luce: A Memoir* [with an addendum by Barbara Bodichon], London, 1862.

NOTES

INTRODUCTION

1 G. Pollock, *Differencing the Canon: Feminist Desires and the Writing of Art's Histories*, London and New York: Routledge, 1999, 33.

2 *Magazine of Art*, 1884, 98.

3 M. de Certeau, *The Practice of Everyday Life*, Berkeley: University of California Press, 1984.

4 A.S. Rossi, *The Feminist Papers*, New York: Columbia University Press, 1977.

5 G.C. Spivak, 'Three women's texts and a critique of imperialism', *Critical Inquiry*, 12, autumn 1985, 243–61.

6 G.C. Spivak, 'Political economy of women as seen by a literary critic' in Elizabeth Weed, ed., *Coming to Terms: Feminism, Theory, Politics*, New York and London: Routledge, 1989, 219.

7 C. Jenks, *Visual Culture*, London and New York: Routledge, 1995, 16. A useful compilation on this subject is N. Mirzoeff (ed.), *The Visual Culture Reader*, London and New York: Routledge, 1998.

8 I. Rogoff, ' "Other's others": spectatorship and difference' in T. Brennan and M. Jay, eds, *Vision in Context*, London and New York: Routledge, 1996, 189–99, 189–90.

9 See two collections edited by N. Bryson, M.A. Holly and K. Moxey, *Visual Theory: Painting and Interpretation*, Middletown, Conn.: Wesleyan University Press, 1990 and *Visual Culture: Images and Interpretations*, Middletown, Conn.: Wesleyan University Press, 1994.

10 Brennan and Jay, eds, 1996, 3–4.

11 L. Mulvey, *Visual and Other Pleasures*, London: Macmillan, 1989. M.A. Doane, *The Desire to Desire: The Woman's Film of the 1940s*, London: Macmillan, 1987. J. Rose, *Sexuality in the Field of Vision*, London: Verso, 1986.

12 M. Jay, *Downcast Eyes: The Denigration of Vision in Twentieth-Century French Thought*, Berkeley: University of California Press, 1993. See also Hal Foster, ed., *Vision and Visuality*, Seattle: Bay Press, 1988.

13 Stuart Hall, 'Introduction' in S. Hall and B. Gieben, *Formations of Modernity*, Cambridge: Polity, 1992. David Harvey, *The Condition of Post-Modernity*, Oxford: Blackwell, 1989.

14 An extensive bibliography is given in R. Benjamin, ed., *Orientalism: Delacroix to Klee*, Sydney: Art Gallery of New South Wales, 1997. E. Said, *Orientalism*, Harmondsworth: Penguin, 1978; L. Nochlin, 'The imaginary Orient' in L. Nochlin, *The Politics of Vision: Essays on Nineteenth-Century Art and Society*, London: Thames & Hudson, 1991, 33–59.

15 R. Chow, *Writing Diaspora: Tactics of Intervention in Contemporary Cultural Studies*, Bloomington: Indiana University Press, 1993, 43, 49–52.

16 R. Lewis, *Gendering Orientalism: Race, Femininity and Representation*, London and New York: Routledge, 1996. M. Roberts and J. Beaulieu, eds, *Orientalism's Interlocutors*, Durham, NC and London: Duke University Press, forthcoming. A. Burton, *Burdens of History: British Feminists, Indian Women and Imperial Culture 1865–1915*, Chapel Hill: University of North Carolina Press, 1994. J. Sharpe, *Allegories of Empire, The Figure of Woman in the Colonial Text*, Minneapolis: University of Minnesota Press, 1993.

17 E. Said, *Culture and Imperialism*, London: Vintage [1993], 1994, 5. W.J.T. Mitchell, ed., *Landscape and Power*, Chicago: Chicago University Press, 1994 provides a nuanced account of 'imperial landscape'.

18 G.C. Spivak, 'The Rani of Sirmur: an essay in reading the archives', *History and Theory*, 24, 1985, 247–72. G.C. Spivak, *A Critique of Postcolonial Reason: Toward a History of the Vanishing Present*, Cambridge, Mass. and London: Harvard University Press, 1999. Gayatri Spivak's essays have been collected in G. Spivak, *In Other Worlds*, London: Routledge, 1988; G. Spivak, *The Post-colonial Critic*, ed. S. Harasym, London and New York: Routledge, 1990; G. Spivak, *Outside in the Teaching Machine*, London and New York: Routledge, 1993: G. Spivak, *The Spivak Reader*, ed. D. Landry and G. Maclean, London and New York: Routledge, 1996.

19 J. Derrida, *The Truth in Painting*, trans. G. Bennington and I. Macleod, Chicago: University of Chicago Press, 1987.

20 G.C. Spivak, *Outside in the Teaching Machine*, London and New York: Routledge 1993, 217.

21 W.J.T. Mitchell, *Picture Theory: Essays in Verbal and Visual Representation*, Chicago: Chicago University Press, 1995. L. Nead, *Victorian Babylon*, London and New Haven, Conn.: Yale University Press, forthcoming.

22 E. de Soja, *Post-Modern Geographies: The Assertion of Space in Critical Social Theory*, London: Verso, 1989, 2.

23 Craig Owens, 'The allegorical impulse: toward a theory of postmodernism' [part 1], 1980 in S. Bryson, B. Kruger, L. Tillman and J. Weinstock, eds, *Beyond Recognition: Representation, Power and Culture*, Berkeley: University of California Press, 1992, 52–69.

24 L. Pearce, *Feminism and the Politics of Reading*, London: Arnold, 1997, 15 (italics in original).

25 E. Welch, 'Engendering Italian Renaissance art', *Papers of the British School at Rome*, forthcoming.

26 For an outstanding account of the multicultural present, see Ella Shohat, *Talking Visions: Multicultural Feminism in a Transnational Age*, Cambridge, Mass.: MIT Press, 1999.

27 W. Benjamin, 'Theses on the Philosophy of History' in W. Benjamin, *Illuminations*, ed. Hannah Arendt, trans. H. Zohn, London: Jonathan Cape, 1970, 255–66, 255.

1 ARTISTS AND MILITANTS, 1850–66

1 Quoted in A. Watts, *Helen Allingham's Cottage Homes Revisited*, self-published, 1994, 88.

2 G.C. Spivak, 'Three women's texts and a critique of imperialism', *Critical Inquiry*, Autumn 1985, 243–61, 244–6. E. Fox-Genovese, *Feminism without Illusions*, Chapel Hill: University of North Carolina Press, 1991.

3 M. Foucault, 'What is an author?', trans. D. Bouchard, *Screen*, 20:1, 1979, 13–33.

4 Quoted in F.A. Hayek, *John Stuart Mill and Harriet Taylor: Their Correspondence and Subsequent Marriage*, London: Routledge, 1951, 122.

5 Catherine Hall, *White, Male and Middle Class: Explorations in Feminism and History*, Cambridge: Polity, 1992, 172–202.

6 Quoted in J. Marsh, 'Art, ambition and sisterhood' in C.C. Orr, ed., *Women in the Victorian Art World*, Manchester: Manchester University Press, 1995, 33–48.

7 *Eastern Daily Press*, 14 October 1910.

8 M. Bohm-Duchen in *Solomon: A Family of Artists*, London: Geffrye Museum, 1985, 8–9.

9 B. Harrison, 'A genealogy of reform in modern Britain' in C. Bolt and S. Drescher, eds, *Anti-Slavery, Religion and Reform*, Folkestone: Wm Dawson, 1980, 119–48, 135. Jane Rendall. 'A moral engine? Feminism, liberalism and the *English Woman's Journal*' in J. Rendall, ed., *Equal or Different: Women's Politics, 1800–1914*, Oxford: Blackwell, 1987, 112–38. A.M. Grieve, *Clara Novello, 1818–1908*, London: Godfrey Bles, 1955. M. Tuke, *A History of Bedford College for Women, 1849–1937*, London: Oxford University Press, 1939. F. Hullah, *Life of John Hullah*, London: Longmans, 1886.

10 E.C. Clayton, *English Female Artists*, London: Tinsley, 1876, II, 2–3, 84.

11 *EWJ*, February 1864, 361.

12 R. Garnett, *The Life of W.J. Fox: Public Teacher and Social Reformer, 1786–1864*, London: John Lane, 1910.

13 JS to Julia Pertz, November [1849], 4 August [1852], Garnett-Pertz papers bMS Eng 1304.1. By permission of Houghton Library, Harvard University.

14 S. Alexander, *Becoming a Woman and Other Essays in Nineteenth and Twentieth Century Feminist History*, London: Virago, 1994, 133. B. Taylor, *Eve and the New Jerusalem: Socialism and Feminism in the Nineteenth Century*, London: Virago, 1983.

15 *The Lady*, 2 September 1886, 183.

16 Liz Stanley, *Feminism and Friendship*, Manchester: Manchester University Sociology Department, 1985; Jane Rendall, 'Friendship and politics: Barbara Leigh Smith Bodichon and Bessie Rayner Parkes' in S. Mendus and J. Rendall, eds, *Sexuality and Subordination: Interdisciplinary Studies of Gender in the Nineteenth Century*, London: Routledge, 1989, 136–70.

17 Untraced, see Garnett, 1910, 310. AMH to BRP [1855], PP, VII, 4. BB to ME, 14 January 1856, GEGHLC.

18 BRP to BB [1850] and 'Ode on the C.C.C. or Cash Clothes Club', PP, V, 165 and X, 75.

19 A.M. Howitt, *An Art Student in Munich*, London: 1853, 88–9, 15. *The Illustrated Examiner and Magazine of Art*, 1852.

20 Howitt, 1852, 286–8; Howitt, 1853, 91.

21 E. Fox-Genovese, 1991.

22 C. Hall, 1992, 263.

23 *Westminster Review*, October 1856, 336–8.

24 J. Johnson, *Anna Jameson, Victorian, Feminist, Woman of Letters*, Aldershot: Scolar, 1997, 226.

25 V. Sanders, ed., *Selected Letters of Harriet Martineau*, Oxford: Clarendon Press, 1990, 133.

26 A. Callan, *Angel in the Studio: Women in the Arts and Crafts Movement*, London: Astragal, 1979.

27 *The Athenaeum*, 12 March 1859, 361–2; 29 March 1859, 394; 30 April 1859, 581. *EWJ* 1859, 287.

28 J.L. Roget, *A History of the Old Watercolour Society*, London: Longmans 1891. The president admitted that the schools 'were really in a very disorganised condition and

no longer reflected credit on the Royal Academy', *General Assembly Minutes*, VI, 51, ARAA.

29 'Female industry', *The Edinburgh Review*, April 1859, 293–336, 333–4. Sanders, 1990, 334, 174.

30 *Sisters of Charity and the Communion of Labour: Two Lectures on the Social Employment of Women. A New Edition*, London: Longmans, 1859, xliv. *EWJ*, July 1859, 343–52. *AJ* 1859, 194; 1860, 286. *The Athenaeum*, 8 September 1860, 330.

31 V. Surtees, *Sublime and Instructive*, London: Michael Joseph, 1972. E.R. Hays, *Those Extraordinary Blackwells*, New York: Harcourt Brace, 1967, 130.

32 F. Corbaux to BB, 10 April 1861, BP.

33 *EWR*, 1871, 101. Clayton, 1876, II, 2. E.S. Canziani, *Round about Three Palace Green*, London: Methuen, 1939, 20 attributes the achievement to Louisa Starr.

34 S.C. Hutchison, *The History of the Royal Academy, 1768–1968*, London: Chapman and Hall, 1968. Paula Gillett, *Worlds of Art: Painters in Victorian Society*, New Brunswick: Rutgers University Press, 1990.

35 *AJ*, 1857, 215. I. McAllister, *Henrietta Ward: Memories of Ninety Years*, London: Hutchinson, 1924, 58.

36 AMH to BB, *c.* 1848–52, Cambridge University Library, Add ms. 7621.

37 *The Athenaeum*, 30 April 1859, 581.

38 Jameson, 1859, xliv.

39 Martineau, 1859, 333–4.

40 *EWJ*, May 1858, 207.

41 S.S. Beale, *Recollections of a Spinster Aunt*, London: Heinemann, 1908, 140–1. Ascribed to the pseudonymous 'Jane', these are written by Beale.

42 Lynne Walker, 'Vistas of pleasure: women consumers of urban space in the west end of London 1850–1900' in C.C. Orr, ed., 1995, 70–85, 71.

43 BRP to HH, 30 December 1857, PP, IX, 32.

44 Johnson, 1997, 231.

45 *EWJ*, XIII, March 1864, 17.

46 PP, XI, 33–5.

47 BRP to BB, 30 January 1859, and 30 August [1859], PP, V, 87, 89. Advertisement for a display of Bodichon's watercolours at 14a Princes Street, bound with *Algeria Considered*, Girton College Library.

48 BRP to BB, 8 January 1860, PP, V, 95; Parkes, XI, 33. Walker, 1995. The premises may have provided lavatories.

49 BRP to BB [8 January 1860], PP, V, 95, refering to the all-male Whig King of Clubs. Martha Vicinus, *Independent Women: Work and Community for Single Women, 1850–1920*, London: University of Chicago Press, 1985.

50 BRP to MM, 26–8 January 1857; BRP to BB, 19 May 1857; BRP to BB, 5 January [1859]; PP, VI, 72, V, 85, V, 86.

51 Rendall, 1987, 131.

52 BRP to A. Leigh Smith, 24 December 1863, PP, VI, 67: 'There has been a very friendly article in the London Review, ascribing all the credit to "the Ladies of Langham Place"!!!!!!!!!!!!!!'.

53 Walker, 1995, 75, 83.

54 Clayton, 1876, II, 43. Fitzrovia lies between Tottenham Court Road, Oxford Street, Marylebone Road and Portland Place. For a later mapping see J. Beckett and D. Cherry, 'Modern spaces, modern women' in K. Deepwell, ed., *Women Artists and Modernism*, Manchester: Manchester University Press, 1996. Addresses from exhibition catalogues may refer to a studio rather than a dwelling.

55 'A whole history remains to be written of *spaces* – which would at the same time be a history of *powers* (both of these terms in the plural) – from the great strategies of

geopolitics to the little tactics of the habitat.' 'The eye of power' in M. Foucault, *Michel Foucault: Power/Knowledge. Selected Interviews and Other Writings 1972–77*, ed. C. Gordon, Brighton: Harvester, 1980, 146–65, 149.

56 Watts, 1994, 88.

57 The Folio Club (1853/4) and the Portfolio Club (*c.* 1859–62) were mixed-sex groups for the discussion of poems and drawings,. The Kensington Society, a feminist discussion group started in 1865, included Bodichon, Emily Davies (secretary), Helen Taylor, Elizabeth Garrett Anderson, Sophia Jex-Blake, Dorothea Beale, Frances Mary Buss, Frances Power Cobbe and perhaps Ellen Clayton. It engaged in heated debates over women's suffrage and 'the moral justification of the pursuit of the fine arts'. DP, IX, Ken., 1–3.

58 D. Hudson, ed., *Munby: Man of Two Worlds. The Life and Diaries of Arthur J. Munby, 1828–1910*, London: John Murray, 1972, 265.

59 Walker, 1995, 72. Clayton, 1876, 2, 2–3, 83–4.

60 Sketchbook [1852–6], British Museum London, 1995–4–1–6.

61 Clayton, 1876, II, 324ff.; Hullah, 1886, 78. *EWR,* January 1907, 56 and October 1909, 283.

62 *The Lady*, 2 September 1886, 183.

63 E.F. Bridell-Fox, 'Memories', *Girls Own Paper*, 1890, 659. Clayton, 1876, II, 43, 164, 259. C. Yeldham, *Women Artists in Nineteenth Century France and England*, New York and London: Garland Publishing, I, 1984.

64 Tuke, 1939, 323; Watts, 1994, 87.

65 Smith was a member of the council in 1849, a student in the first year, a lady visitor and secretary to the lady visitors for five years. Jameson was a member of the provisional council in 1849 and a lady visitor for a year; see Tuke, 1939, 45.

66 Clayton, 1876, II, 317. H. Morgan, 'History of the Royal Academy schools' typescript, ARAA.

67 J. Helland, *Professional Women Painters in Nineteenth-Century Scotland*, London: Ashgate, forthcoming.

68 PP, XI, 33–5.

69 AJ to BRP [1856?], PP, VI, 43.

70 S.S. Beale, 1908, 66, 134, 148–50. *EWJ*, August 1858, I, 413–16.

71 M. de Certeau, *The Practice of Everyday Life*, Berkeley: University of California Press, 1984, 92–3.

72 J. Donald, 'Metropolis: city as text' in R. Bocock and K. Thompson, eds, *The Social and Cultural Forms of Modernity*, Cambridge: Polity Press with the Open University, 1992, 418–59.

73 L. Nead, *Victorian Babylon: The Culture of Modernity in Nineteenth-Century London*, forthcoming.

74 *AJ* 1857, 167. *The Spectator*, 4 July 1857, 715. In the 1850s middle-class women could comply with chaperonage requirements by taking along a young boy.

75 *EWJ*, February 1863, 416. Parkes, XI, 33–5.

76 L. Nead, 'Mapping the self: gender, space and modernity in mid-Victorian London', *Environment and Planning A*, 1997, 659–72.

77 *The Daily Telegraph*, 17 June 1857, 3, quoted in Nead, 671.

78 J.R. Walkowitz, *City of Dreadful Delight: Narratives of Sexual Danger in Late Victorian London*, London: Virago, 1992, 41–2.

79 Henri Lefebvre, *The Production of Space*, trans. D. Nicholson-Smith, Oxford: Blackwell, 1991. E. Grosz, 'Bodies /cities' in Beatriz Colomina, ed., *Sexuality and Space*, Princeton: Princeton School of Architecture, 1992.

80 A. Vickery, 'Golden age to separate spheres? A review of the categories and chronology of English women's history', *The Historical Journal*, 36: 2, 1993, 383–414, 383.

81 G. Pollock, *Vision and Difference: Femininity, Feminism and the Histories of Art*, London and New York: Routledge, 1988, 68.

82 J. Tosh, 'Domesticity and manliness in the Victorian middle-class' in M. Roper and J. Tosh, eds, *Manful Assertions: Masculinities in Britain since 1800*, London: Routledge, 1991, 44–73.

83 E. Wilson, *The Sphinx in the City: Urban Life, the Control of Disorder and Women*, London: Virago, 1991 and 'The invisible flâneur', *New Left Review*, January/February 1992, 90–110.

84 L. Nead, *Victorian Babylon*, forthcoming; L. Nead 1997.

85 Walker, 1995, 70.

86 Michel Foucault, 'Of other spaces', trans. Jay Miskowiec, *diacritics*, spring, 1986, 22–7, 24.

87 Autograph collection, BP, folio 24. A prospectus in H. Blackburn, *Women's Suffrage*, London: Williams and Norgate, 1902, 248 indicates that subscription was one guinea a year, with '[p]rofessional ladies half price'.

88 *AJ*, 1858, 143.

89 *AJ*, 1863, 48, considered that the Pall Mall location in 1860–2 was 'so early in the season as to be disadvantageous'.

90 Four of the seven founding shareholders of The English Woman's Journal Company Ltd, registered 13 February 1858, were unmarried women; see Rendall, 1987, 119. The SFA's finances were perilous; in 1864 Harriet Grote paid 'the smart money for cancelling the lease of the Gallery, £120 out of my own pocket resolving however to commit no more benevolent follies', T.H. Lewin, *The Lewin Letters . . ., 1756–1884*, London: Constable, 1909, II, 253.

91 De Certeau, 1984, 92–3.

92 B. Colomina, 'Introduction', *Sexuality and Space*, Princeton: Princeton Series on Architecture, 1992, n.p.

93 *Sunshine and Shadow: The David Scott Collection of Victorian Paintings*, Edinburgh: National Gallery of Scotland, 1991, no. 12.

94 Spivak, 1985, 246.

95 *c.* 1508–10, Paris, The Louvre.

96 E.M. Osborn, Study for *Nameless and Friendless*, oil on panel, 225 × 292mm, York City Art Gallery. There is sufficient evidence to suggest in this period the making of a highly-finished, small-scale study in relation to an exhibited picture; see also Figure 5.6.

97 E.M. Osborn, *The Governess*, Yale Center for British Art, New Haven.

98 *AJ*, 1857, 167.

99 In *Sunshine and Shadow*, no. 13, Lindsey Errington suggests that the picture is based on Mary Burton's novel *Self-Control* (1810, reprinted 1832–55). Laura, a self-reliant young woman, sets out to sell her paintings to redeem her improvident father. A dealer she visits remarks that a picture by a 'Painter no name' will not sell.

100 Institute of Fine Arts, London, 1861, no. 316. Unsold, it appeared in Liverpool in 1862 with a price tag of £40.

101 J. Marsh and P.G. Nunn, *Pre-Raephaelite Women Artists*, Manchester, 1997, 10.

102 S. Casteras, 'From "safe havens" to "a wide sea of notoriety"', in S. Casteras and L.H. Peterson, *A Struggle for Fame: Victorian Women Artists and Authors*, New Haven, Conn.: Yale Center for British Art, 1994, 7–34, 27–9. S. Casteras, 'The necessity of a name' in A.H. Harrison and B. Taylor, eds, *Gender and Discourse in Victorian Art and Literature*, De Kalb: Northern Illinois University Press, 1992, 207–32.

103 *SR*, 10 April 1858, 369–70.

104 *SR*, 28 June 1862, 746 observed, 'We must literally read an incident-picture as we must read a novel'. Jacob Bell, purchaser of Frith's *Derby Day*, wrote to the artist in May 1858 that 'the picture requires a close inspection to read, mark, learn and inwardly digest it'. *The Art Review* was one of several papers to consider it 'a long story, rather than a picture of the usual kind'. See M. Cowling, *The Artist as Anthropologist*, Cambridge: Cambridge University Press, 1989, 2–3.

105 *Mr W.P. Frith's Celebrated Picture of the 'Derby Day'*, published by Gambart. Tom Taylor's descriptive pamphlet accompanied the exhibition of *The Railway Station* in 1862; the painting and its copyright were owned by the dealer Flatou.

106 *EWJ*, February 1860, 360–75.

107 Casteras, 1992, 229, identifies the landscapist Rosa Brett on the grounds that Claxton may have known her. Rosa Bonheur with her international reputation seems more likely.

108 *EWJ*, May 1858, 208. *The Athenaeum*, 3 April 1858, 439, commended 'the child drawing from the looking-glass, the studio with the strong-minded woman, and the rejected picture'.

109 Casteras, 1992, 228.

110 As in D.G. Rossetti's studies for *Found*.

111 See also Mary Lowndes, 'Justice – at the door', poster, NUWSS, 1912,

112 Casteras, 1992, 229; 1994, 29.

113 L. Hutcheon, *A Theory of Parody: The Teachings of Twentieth-Century Art Forms*, London and New York: Methuen, 1985, 109, 47.

114 *Les Romains de la décadence*, Salon 1847, Paris, Louvre.

115 *EWJ*, April 1859, 144; Martineau, 1859, 333–4.

116 V. Ware, *Beyond the Pale: White Women, Racism and History*, London: Verso, 1992, 126–7.

117 See L. Nead, *Myths of Femininity: Representations of Women in Victorian Britain*, Oxford: Blackwell, 1988.

118 *EWJ*, May 1858, 207. Law-copying was promoted by Langham Place.

119 *ILN*, 2 June 1860, 541. W.E. Fredeman, 'Pre-Raphaelites in caricature', *The Burlington Magazine*, December 1960, 523–9.

120 D. Atkinson, *Funny Girls: Campaigning for Equality*, London: Penguin, 1997.

121 *The Comic Almanack*, second series, 1844–53, with illustrations by G. Cruikshank, London: J.C. Hotten, n.d.

122 Jameson remarked: 'If you speak to some people of the necessity of finding better and higher employment for women, they inquire merrily how you would like a female house of parliament? [O]r they congratulate themselves that ladies are not likely to act as constables' (Johnson, 1997, 57).

123 *Letters of Anne Thackeray Ritchie*, London: John Murray, 1924, 66.

124 S.M. Newton, *Health, Art and Reason, Dress Reformers of the Nineteenth Century*, London: John Murray, 1974, 3–10.

125 John Leech, *Punch Almanack*, 1859, n.p. A poster advertised 'A perfectly unbroken husband next Wednesday'.

126 W. Chadwick, *Women, Art and Society*, London: Thames & Hudson, 1990, 186.

127 J. Leech, 'The great boon', *Punch*, 5 June 1858, 232. The Matrimonial Causes Act of 1857 maintained almost unchanged the conditions upon which women could sue: adultery (sufficient cause for a man) for women obtained when accompanied by 'aggravating circumstances' such as cruelty (physical violence, rape, bigamy, desertion, or incest).

128 Clayton, 1876, II, 44.

129 Florence Claxton, *The Adventures of a Woman in Search of Her Rights*, London: Graphotyping Co., 1871.

130 Newton, 1974, 59–63.

131 *Punch*, 22 July 1865, 23; 29 September 1855, 130.

132 *The Spectator*, 30 March 1861, 333.

133 *AJ*, 1860, 170.

134 Kristin Luker, *Dubious Conceptions: The Politics of Teenage Pregnancy*, London and Cambridge, Mass.: Harvard University Press, 1996, 19–20, explains that 'In English law an out-of-wedlock child was legally *filius nullius*, literally a "child of no one" with no legally recognised relatives.' Thanks to Nancy Meaker for this reference.

135 Philippa Levine, 'The humanising influences of five o'clock tea: Victorian feminist periodicals', *Victorian Studies*, winter 1990, 293–306.

136 *EWJ*, September 1858, 4–5.

137 D.M. Craik, *A Woman's Thoughts about Women*, London: Hurst & Blackett, 1858, 50.

138 Quoted in Rendall, 1987, 115, note 16.

139 *EWJ*, September 1858, 4–5.

140 *EWJ*, May 1858, 206.

141 *EWJ*, May 1858, 207.

142 *The Spectator*, 3 April 1858, 379, 378.

143 *EWJ*, March 1859, 53.

144 Ibid.

145 *EWJ*, May 1858, 206. *EWR*, April 1868, 467.

146 B.R. Parkes, *Essays on Woman's Work*, London: Alexander Strachan, 1865, 114–31.

147 'Pictures by women', *Victoria Magazine*, July 1866, 246–8.

148 *EWR*, October 1893, 276.

149 *EWJ*, May 1858, 206.

150 *EWR*, July 1890, 304; *EWR*, 1893, 276.

151 *Alexandra Magazine*, I, 1864.

152 *ILN*, 12 October 1889, 480.

153 *AJ*, 1893, supplement, xv.

154 *ILN*, 5 June 1897, 790.

155 *EWR*, July 1894, 212.

156 A.B. [Anna Blackwell], 'Rosa Bonheur: an authorised biography', I, June 1858, 227–43, by-lined 'Paris, May 15, 1858'. M.M.H. [Matilda M. Hays], 'Harriet Hosmer', *The English Woman's Journal*, I, July 1858, 295–306. I.B. [Isa Blagdon], 'Félicie de Fauveau', 2 October 1858, 83–94. Exiled because of her Royalist sympathies, Félicie de Fauveau (1802–68) was based in Florence where she may have come to the notice of Isa Blagdon who lived at Bellosguardo. [Anna Blackwell], 'Henriette Browne', V, April 1860, 85–92.

157 *AJ*, 1864, 357–9, 261–3. On the former, 'The Pictures of Mr and Mrs E.M. Ward', *AJ*, 1863, 97.

158 Blackwell, 1858, 229, 238.

159 *EWJ*, May 1858, 205.

160 Hays, 1858, 298–9. Joy Kasson, *Marble Queens and Captives: Women in Nineteenth-Century American Sculpture*, New Haven, Conn. and London: Yale University Press, 1990, 145, quotes *AJ*'s description of Hosmer: 'with her little artist-cap jauntily stuck on one side of her dead, her glowing, beaming eyes bent upon her work, and her delicate little hands labouring industriously on the clay'.

161 Blackwell, 1858, 242. Blagdon, 1858, 92, 85.

162 Blackwell, 1860, 88–9, 85–6.

163 Reina Lewis, *Gendering Orientalism: Race, Femininity and Representation*, London and New York: Routledge, 1996, 98.

164 *Westminster Review*, 1858, 163–85, 164.
165 Blackwell, 1858, 230–6. Hays, 1858, 305. Blagdon, 1858, 90.
166 E. Ellet, *Women Artists in All Ages and Countries*, London: Richard Bentley, 1859, preface, iv–v.
167 Clayton, 1876. Germaine Greer, *The Obstacle Race*, London: Secker & Warburg, 1979. Ellet, 1859, 209, wrote of the 'obstacles in the way of [a woman's] devotion to study and the exercise of her talents'.
168 Circular, 1860, in Blackburn, 1902, 249. Vicinus, 1985.
169 Ellet, 1859, v.
170 BRP to Elizabeth Parkes, 21 April 1857, PP, II, 7.
171 Garnett, 1910, 313. Sarah Ellen Blackwell may have studied at the Public Drawing School headed by Bonheur. E. Gaskell to EF on her admiration for Bonheur, J.A.V. Chapple and A. Pollard, eds, *The Letters of Mrs Gaskell*, Manchester: Manchester University Press, 1968, 286. *Le Marché au cheval de Paris* (1853–55, Metropolitan Museum of Art, New York) was shown at the Paris Salon in 1855, where it was purchased by the dealer Ernest Gambart, who exhibited it at his French Gallery in London and hosted the artist's visit to Britain. Haight, II, 377.
172 AJ to BRP, 19 July [1858], PP, VI, 25.
173 Ellet, 1859, iv, 209–10.
174 *AJ*, 1869, 82.
175 *AJ*, 1860, 168. Untraced.
176 *AJ*, 1861, 169.
177 *The Athenaeum*, 11 May 1861, 635. The painting was with Roy Miles, London.
178 *The Athenaeum*, 27 June 1857, 825.
179 *ILN*, 3 April 1858, 351.
180 *AJ* 1868, 46; 1869, 82.

2 IN/BETWEEN THE COLONIAL THEATRE

1 E.W. Said, *The World, the Text and the Critic*, London: Faber, 1983, 226.
2 I. Grewal, *Home and Harem, Nation, Gender, Empire and the Cultures of Travel*, Leicester: Leicester University Press, 1996, 2.
3 M.L. Pratt, *Imperial Eyes*, London and New York: Routledge, 1992, 1–10, 204–5.
4 J. Urry, *The Tourist Gaze*, London: Sage, 1990, 4. J. Urry, *Consuming Places*, London: Routledge, 1995.
5 Grewal, 1996, 2–4, quoting Pratt, 1992, 6.
6 C. Midgley, *Women against Slavery: The British Campaigns, 1780–1870*, London: Routledge, 1992. *EWJ*, October 1858, 94–100 [by E. Bodichon?]; March 1860, 42–8; October 1861, 111–18, November 1861, 179–87, December 1861, 261–6.
7 ED to BB, December 3–4 [1862], BP, B 302.
8 B. Melman, *Women's Orients: English Women and the Middle East, 1718–1918*, Basingstoke: Macmillan, 1992, 104ff., 137–62.
9 G.C. Spivak, 'Three women's texts and a critique of imperialism', *Critical Inquiry*, 12, 1985 [1985a], 243–61.
10 Spivak, 1985a, 244–5, With the phrase 'not quite/not male' Spivak rewrites, as she acknowledges, Homi Bhabha's 'not quite/not white', in 'Of mimicry and man: the ambiguity of colonial discourse' [1984], *The Location of Culture*, London and New York: Routledge, 1994, 85–92.
11 Spivak, 1985a, 244. On cathexis as 'to occupy with desire', see G.C. Spivak, 'Poststructuralism, marginality, postcoloniality and value' in P. Collier and H. Geyer-Ryan, eds, *Literary Theory Today*, Cambridge: Polity, 1990, 219–44, 241 note 13.

12 J. Derrida, *La Dissémination*, Paris: Éditions du Seuil, 1972, 124, 126, author's translation.

13 G.C. Spivak, 'The Rani of Sirmur: an essay in reading the archives', *History and Theory*, 24, 1985 [1985b], 247–72, 251.

14 T. Mitchell, *Colonising Egypt*. Cambridge: Cambridge University Press, 1998, 57.

15 A. Laroui, *History of the Maghrib: an Interpretative Essay* [1970], trans. R. Manheim, Princeton: Princeton University Press, 1977, 294ff.

16 GE to Sara Hennell on Barbara's sister [18 October 1856], *The George Eliot Letters*, ed. G.S. Haight, London: Oxford University Press, 1954, II, 267.

17 R.A.J. Walling, ed., *The Diaries of John Bright*, 1931, New York: Krauss, 1971.

18 W. Hinde, *Richard Cobden: A Victorian Outsider*, New Haven, Conn.: Yale University Press, 1987.

19 P. Lorcin, *Imperial Identities: Stereotyping, Prejudice and Race in Colonial Algeria*, London and New York: I.B. Tauris, 1995, 38–9, 64–7.

20 B. Bodichon, *Women and Work*, 1857 in C. Lacey, ed., *Barbara Leigh Smith Bodichon and the Langham Place Group*, London: Routledge, 1987, 23–73, 41.

21 Lorcin, 1995, 64–7.

22 D. Prochaska, *Making Algeria French: Colonialism in Bone, 1870–1920*, Cambridge: Cambridge University Press, 1990.

23 O. Benchérif, *The Image of Algeria in Anglo-American Writings, 1785–1962*, New York: University Press of America, 1997, 104, 157.

24 P. Hirsch, *Barbara Bodichon*, London: Chatto, 1998, 132. H. Burton, *Barbara Bodichon*, London, 1949, 138, 153. B. Anderson, *Imagined Communities*, London: Verso, 1983.

25 BB to BRP [November–December 1856], PP, V, 176. BB to GE, 21 November and 8 December 1856, GEGHLC.

26 BB to GE, 21 November–8 December 1856, GEGHLC. B. Bodichon, ed., *Algeria Considered*, London, 1858, 82.

27 M. Betham Edwards, *A Winter with the Swallows*, London: Hurst & Blackett, 1867, 27.

28 Burton, 1949, 154. Clayton, 1876, II, 172–3.

29 Identified by Hirsch, 1998.

30 Rey Chow, *Writing Diaspora: Tactics of Intervention in Contemporary Cultural Studies*, Bloomington: Indiana University Press, 1993, 43–52.

31 L. Thornton, *The Orientalists: Painter Travellers, 1828–1908*, Paris: ACR editions, 1983, 70.

32 R. Lewis, *Gendering Orientalism: Race, Femininity and Representation*, London and New York: Routledge, 1996, 146. Burton, 1949, 86.

33 Burton, 1949, 54, 86. Clayton, 1876, II, 375–85. Ellen Allen and BB to JS [February 1859], A.L.C. Hirsch, 1998, 140.

34 Lorcin, 1995, 38–40, 124–7. Lorcin explains the fictitiousness of the nineteenth-century category 'Kabyle'.

35 J. Mackenzie, *Orientalism: History, Theory and the Arts*, Manchester: Manchester University Press, 1995, 53. Thornton, 1983, 19.

36 A. Appadurai, *The Social Life of Things: Commodities in Cultural Perspective*, Cambridge: Cambridge University Press, 1986, 28.

37 Notably, William Wyld, *Voyage pittoresque dans la régence d'Alger éxecuté en 1833*, Paris, 1835. David Roberts, *The Holy Land, Egypt, Arabia and Syria*, London: F.G. Moon, 1840, 1842–9, David Wilkie, *Sketches in Syria and Egypt in 1840 and 1841*, 1843, Eugène Fromentin, *Un été dans le Sahara*, 1856 and *Une année dans le Sahel*, 1858. Henry Blackburn, *Artists and Arabs: or Sketching in Sunshine*, London, 1868.

38 Hirsch 1998, 134.

39 *ILN*, 26 July 1864, 55, locates Bodichon's show in the 'upper rooms'.

40 Mackenzie, 1995, 48.
41 BB to HT, undated [1866], TMP, XII, 43.
42 Clayton, 1876, II, 86. Governor of Algeria from 1864–70, Marshal MacMahon was hospitable to the English, inviting them to receptions at the summer palace.
43 *AJ*, 1868, 46.
44 *ILN*, 1867, 87. *From Elgin to the Alhambra: The Watercolours of Sophia Lady Dunbar, 1814–1919*, Aberdeen: 1987. Clayton, 1876, II, 373–93.
45 Quoted in B. Stephen, *Emily Davies and Girton College*, London: Constable, 1927, 28–9.
46 BRP to MM, 26–8 January 1857; BRP to BB, 19 May 1857; PP, VI, 72, V, 85. BRP to BB, 5 January [1859]; PP, V, 86.
47 Mitchell, 1988.
48 BB to MM, 26–8 January 1857; BRP to BB, 19 May 1857; BRP to MM, 11 January 1857; PP, V, 85; PP, VI, 71, 72.
49 'Family Chronicle', 1861, 214, D.P. H. Allingham and E. Baumer Williams, eds, *The Letters of William Allingham*, London: Longmans, 1911, 79–80.
50 Haight, 1954, II, 337; III, 402.
51 K. Perry, *Barbara Bodichon, 1827–1881*, Cambridge: Girton College, 1991, 16. Both pictures are at Girton.
52 J. Marsh, *Christina Rossetti: A Literary Biography*, London: Cape, 1994, 252, 274, 297. 'Financial records and memoranda addresses to the executor of Christina Rossetti's will', Bodleian Library. Oxford, Ms Facs d. 285, fol. 75. A list of sixty-one paintings owned by C.G. Rossetti included *Cactus*, a framed watercolour, and *Cornfield*.
53 BRP to BB, 30 January 1859; 30 August [1859]; [1863]; 10 April 1861; 19 April 1861; 2 May 1861; PP, V, 87, 89, 124, 103–5.
54 C.G. Rossetti to BB [1862–4], transcript, Ashmolean Museum, Oxford.
55 ED to BB, 31 January 1870 and 25 February 1870, BP, B 39 and 40. Girton College Executive Committee Minute Books, 4 April 1891.
56 Perry, 1991, 14; BRP to BB, 2 May 1861; PP, V, 105.
57 E/LS/1, LSEP. L. Holcombe, *Wives and Property: Reform of the Married Women's Property Laws in Nineteenth-Century England*, Buffalo: University of Toronto Press, 1983. Soon after her marriage and before her father's death in 1860, Bodichon considered that staying in Algiers depended on the sales of pictures and writings. This suggests that she relied less on inherited wealth, Hirsch 1998, 134. *EWR*, July 1891, 148.
58 The account is similar to Parkes's essays in the *EWJ*.
59 Bodichon, 1987, all quotations from 47–52. Melman, 1992, 104. J. Zonana, 'The sultan and the slave: feminist orientalism and the structure of *Jane Eyre*', *Signs*, spring 1993, 592–617.
60 J. Rendall, 'Friendship and politics' in S. Mendus and J. Rendall, eds, *Sexuality and Subordination*, London and New York: Routledge, 1989, 136–70, 154–5.
61 *EWJ*, November 1861, 177; July 1861, 298.
62 C. Midgley, 1992. S. Suleri, *The Rhetoric of English India*, Chicago: University of Chicago Press, 1992, 77.
63 F. Fanon, *Studies in a Dying Colonialism* [1959], London: Earthscan, 1989, 63.
64 W. Woodhull, 'Unveiling Algeria', *Genders*, 1991, 112–31.
65 Chow, 1993, 52.
66 Suleri, 1992, 109.
67 Melman, 1992, 111–21. BRP to E. Parkes, 18 February 1857, PP, II, 5. *EWJ*, November 1861, 173–4. *Once a Week*, 23 March 1861, quotations from 356–60.
68 Lewis, 1996, 148, who discusses the harem pictures of Henriette Browne, an artist praised in the journal.

3 THE 'WORLDING' OF ALGERIA

1 BB to GE, 21 November and 8 December 1856, GEGHLC.
2 GE to S.S. Hennell, 16 April [1857], G.S. Haight, ed., *The George Eliot Letters*, London: Oxford University Press,1954, II, 320.
3 The concept is developed from M.L. Pratt, *Imperial Eyes*, London and New York: Routledge,1992, 200–16.
4 Most recently considered in R. Benjamin, *Orientalism: Delacroix to Klee*, Sydney: Art Gallery of New South Wales, 1997. See also Janice Helland, 'Locality and pleasure in landscape', *Rural History*, 1997, 8: 2, 149–64 and on 'an uneasy alliance between feminist and post-colonial critiques of European cultural authority', Z. Çelik and L. Kinney, 'Ethnography and exhibitionism at the Expositions Universelles', *Assemblages*, 13, 1990, 35–59.
5 G.C. Spivak, 'Criticism, feminism and the institution' [1984], in *The Post-Colonial Critic, Interviews, Strategies, Dialogues*, ed. S. Harasym, London and New York, Routledge, 1990, 1. It must be emphasised that Spivak has not presented 'worlding' as a unified concept. For a critique see Benita Parry, 'Problems in current theories of colonial discourse' [1987] in B. Ashcroft, G. Griffiths, H. Tiffin, eds, *The Post-Colonial Studies Reader*, London and New York: Routledge, 1995, 36–44.
6 G.C. Spivak, 'The Rani of Sirmur: an essay in reading the archives', *History and Theory*, 24, 1985, 247–72. M. Heidegger, 'The origin of the work of art' [1935–6] in *Poetry, Language, Thought*, trans. A. Hofstadter, New York: Harper & Row, 1971, 15–81, 63.
7 Nicholas Green, *The Spectacle of Nature*, Manchester: Manchester University Press, 1990, 4–6. J. Urry, *Consuming Places*, London: Routledge, 1995.
8 E.W. Said, *Culture and Imperialism*, London: Vintage [1993], 1994, 5.
9 A. Laroui, *The History of the Maghrib, An Interpretative Essay*, 1970, trans. R. Manheim, Princeton: Princeton University Press, 1977, 302–52. M. Benoune, *The Making of Contemporary Algeria, 1830–1987*, Cambridge: Cambridge University Press, 1988. C.A. Ageron, *Histoire de l'Algérie Contemporaine, 1830–1966*, Paris: PUF, 1968.
10 A. Horne, *A Savage War of Peace, Algeria 1954–62*, Harmondsworth: Penguin, 1977, 30. C.A. Julien, *Histoire de l'Algérie contemporaine . . . 1827–1871*, Paris: PUF, 1964, 389–90. Laroui, 1977, 301.
11 Private collection.
12 V. Shiva, *Staying Alive, Women, Ecology and Development*, London: Zed Books, 1988, 80. A.W. Crosby, *The Biological Expansion of Europe, 900–1900*, Cambridge: Cambridge University Press, 1986. N. Smith, *Uneven Development, Nature, Capital and the Production of Space*, Oxford: Blackwell, 1984.
13 Bennoune, 1988, 43–5.
14 T. Porterfield, *The Allure of Empire*, Princeton, 1998.
15 *EWJ*, March 1859, 64.
16 Benjamin, 1997, 7–31.
17 BRP to MM, 11 January 1857; PP, VI, 71.
18 R.A.J. Walling, ed., *The Diaries of John Bright* [1931], New York, Krauss, 1971, 206–7.
19 H. Blackburn, *Artistic Travel: A Thousand Miles towards the Sun*, London: Sampson Low, 1895, 300.
20 Zeynep Çelik, *Displaying the Orient: Architecture of Islam at Nineteenth-Century World's Fairs*, Berkeley: University of California Press, 1992, 125.
21 A. Appadurai, *The Social Life of Things: Commodities in Cultural Perspective*, Cambridge: Cambridge University Press, 1986.
22 G. Spivak 1985, 253.
23 Spivak, [1984], 1990, 1.

24 L. Nochlin, 'The Imaginary Orient' [1983] in *The Politics of Vision*, London: Thames & Hudson, 1991, 33–59, 50–4.

25 W.J.T. Mitchell, 'Imperial landscape' in *Landscape and Power*, Chicago: Chicago University Press, 1994, 5–34, 9–10.

26 *EWJ*, March 1859, 64. February 1863, 416.

27 *Algeria Considered as a Winter Residence for the English*, London: offices of *EWJ*, 1858, 34.

28 *EWJ*, March 1859, 64.

29 E. Broughton, *Six Years' Residence in Algiers*, London, 1839. J.R. Morell, *Algeria* [1854], London: Dare Publishers, 1984. J.W. Blakesley, *Four Months in Algeria, with Maps and Illustrations after Photographs*, Cambridge: Macmillan, 1859.

30 *EWJ*, March 1859, 64.

31 *Algeria Considered*, 95, 80–7, 93–8, 100–1.

32 S. Mills, *Discourses of Difference: An Analysis of Women's Travel Writing and Colonialism*, London and New York: Routledge, 1991.

33 H. Burton, *Barbara Bodichon*, London: John Murray, 1949, 84.

34 BRP to Bella Leigh Smith, 3 September 1854; PP, VI, 66.

35 *Algeria Considered*, 75, 77, 80, 84, 76, 78, 79, 90 (my italics).

36 *EWJ*, September 1860, 23. She refers *A Thousand and One Nights*.

37 C. Desprez, *L'Hiver à Alger: lettres d'un compère à sa commère*, Meaux: Imprimerie Carro, 1861 (and earlier). This 'esquisse nouvelle' has views out of windows and first-hand accounts of days spent writing, drawing, reading and walking. For *esquisse* and *croquis* in art, see A. Boime in *The Academy and French Painting in the Nineteeth Century*, London: Phaidon, 1971.

38 P. de Noirfontaine, *Algérie: un regard écrit*, Le Havre: A. Lemale, 1856, préface, 202, 6–7, my translations. *Algeria Considered*, 78.

39 *Ingres*, London: National Gallery, 1999.

40 *EWJ*, September 1861, 1–9.

41 *EWJ*, February 1863, 416 (my italics).

42 H. Bhabha, 'Signs taken for wonders' in *The Location of Culture*, London and New York: Routledge, 1994, 109.

43 Ibid.

44 Spivak, 1985, 263–4.

45 *ILN*, 16 July 1864, 55.

46 *EWJ*, August 1859, 432. *Cactus Grove, Algiers*: Hastings Museum and Art Gallery, *Tlemcen, Oran*, 1864: Girton College Cambridge. Locations are given where known.

47 Edward Said, *Orientalism*, London, Penguin [1978], 1991, 23.

48 Engravings of mining settlements and the bay, some distributed by Gambart, are in the Département des Estampes et de la Photographie at the Bibliothèque Nationale.

49 Z. Çelik, 'Colonialism, Orientalism and the canon', *The Art Bulletin*, June 1996, 202–5, 202–3.

50 BRP to MM, 6 January 1857 and 26–8 January 1857; PP, VI, 71, 72.

51 D. Harvey, *The Condition of Post-Modernity*, Oxford: Blackwell, 1989, 240. D. Massey, 'Power geometry and a progressive sense of place' in Jon Bird *et al.*, eds, *Mapping the Futures: Local Cultures, Global Change*, London and New York: Routledge, 1993, 59–69.

52 *AJ*, 1869, 82.

53 *EWJ*, February 1863, 409.

54 *EWJ*, June 1860, Lacey, 1987, 344.

55 M. Betham Edwards, *Through Spain to the Sahara*, London: Hurst & Blackett, 1867, 251; a gift copy to Bodichon: Girton College Cambridge.

56 Girton College Cambridge.

57 E.M. Osborn, *Algiers*, location unknown, *Grosvenor Notes*, 1882, no. 168. A. McClintock, *Imperial Leather: Race, Gender and Sexuality in the Colonial Conquest*, New York: Routledge, 1995, 252–3, points out that this discourse is a 'realm of contestation' and a mark of resistance.

58 *Near Algiers*: Hastings Museum and Art Gallery.

59 Lewis, 1996.

60 *Algeria Considered*, 89.

61 Bhabha, 1994, 81.

62 Lorcin, 1995.

63 *EWJ*, September 1860, 21–2. *Algeria Considered*, 68.

64 Spivak, 1985, 264–5. A.E.S. Coombes, *Reinventing Africa: Museums, Material Culture and Popular Imagination in Late Victorian and Edwardian England*, London and New Haven, Conn.: Yale University Press, 1994.

65 *The Spectator*, 20 April 1861, 417–18.

66 *AJ*, 1863.

67 *The Athenaeum*, 13 April 1861, 502.

68 Lewis, 1996, 176–7.

69 Morell, 1984, 62 and 114–15.

70 BRP to MM, 26 January 1857; PP, V, 72.

71 *The Athenaeum*, 3 April 1858, 439; 19 February 1859. *EWJ*, 1858, 207; 1859, 423. *The Observer*, 14 April 1861, 6; *The Athenaeum*, 13 April 1861, 502; *AJ*, 1868, 46.

72 S. Raven, *Rome in Africa*, London and New York: Routledge, 3rd edn, 1993, 55–7. P. Mackendrick, *The North African Stones Speak*, London: Croom Helm, 1980, 207.

73 *EWJ*, February 1863, 412.

74 *The Spectator*, 20 April 1861, 417.

75 J.A. Hobson, *Richard Cobden: The International Man* [1919], reprinted, London: E. Benn, 1968, 286.

76 Nochlin, 1991, 38.

77 O. Benchérif, *The Image of Algeria in Anglo-American Writings 1785–1962*, New York: University Press of America, 1997.

78 Bhabha, 1994, 110.

79 The phrase is from G.C. Spivak, 'Sex and History in "The Prelude" ' in *In Other Worlds: Essays in Cultural Politics*, London and New York: Routledge, 1988, 46–76, 58.

80 *Roman Aqueduct, Algeria*: Girton. C. Pace, *Claude the Enchanted*, London: British Museum, 1969. D. Solkin, *Richard Wilson*, London: Tate Gallery, 1982. D. Howard, 'Claude and English art', *The Art of Claude Lorrain*, London: Hayward Gallery, 1969.

81 Giradon's *Algiers* and Lamet's *Algiers with a Camel* are listed in the insurance policy documents for 5 Blandford Square, LSEP, E/LS/5.

82 J. Fabian, *Time and the Other: How Anthropology Makes Its Object*, New York: Columbia University Press, 1983, 103.

83 Bhabha, 1994, 111. S. Suleri, *The Rhetoric of English India*, Chicago and London: University of Chicago Press, 1992.

84 J. Derrida, *The Truth in Painting*, trans. G. Bennington and I. Macleod, Chicago: University of Chicago Press, 1987, 69–74.

85 Ibid., 45.

86 Ibid., 73.

87 Ibid., 63, 55.

88 J. Simon, *The Art of the Picture Frame*, London: National Portrait Gallery, 1996.

89 BRP to BB, 10 April 1861; PP, V, 103.

90 Derrida, 1987, 69–74.

91 Bhabha, 1994, 112.

4 HARRIET HOSMER'S *ZENOBIA*

1 I. Browning, *Palmyra*, London: Chatto, 1979. R. Stoneman, *Palmyra and Its Empire*, Ann Arbor: University of Michigan Press, 1992. The authorship of the letter is attributed to both Zenobia and Longinus.

2 The exhibited *Zenobia* was sold to Almon Griswold of New York; versions were ordered by Mrs Potter-Palmer of Chicago, Robert Emmons of Boston and Alexander T. Stewart of Boston. J.S. Kasson, *Marble Queens and Captives: Women in Nineteenth-Century American Sculpture*, New Haven, Conn. and London: Yale University Press, 1990.

3 On *Zenobia* in America 1864–5, see D. Sherwood, *Harriet Hosmer: American Sculptor, 1830–1908*, Columbia and London: University of Missouri Press, 1991, 230; Kasson, 1990, 144–65; and S. Waller, 'The artist, the writer and the Queen: Hosmer, Jameson and Zenobia', *Women's Art Journal*, spring/summer 1983, 22–30.

4 *AJ*, 1862, 230. *The Art Journal Catalogue of the International Exhibition*, London, 1862, 322; F.T. Palgrave, *Descriptive Handbook to the Fine Art Collections in the International Exhibition of 1862*, London, 1862 quoted in *The New Path*, April 1865, 53. 'Introduction' to *The International Exhibition, 1862: Official Catalogue to the Fine Art Department*, London, 1862. Following letters to *The Times*, in which Palgrave's friendship with Woolner was disclosed, his handbook was withdrawn though a revised edition was published.

5 K.B. Jones, *Compassionate Authority: Democracy and the Representation of Women*, London: Routledge, 1993, 4.

6 G.C. Spivak, *Outside in the Teaching Machine*, London and New York: Routledge, 1993, 217–18.

7 *The New Path*, April 1865, 50. The niches were painted Pompeian red. Also on show were *Medusa*, lent by Lady Marian Alford, and *Puck*, from the collection of the Prince of Wales.

8 AJ to HH, 10 October [1858], HHP; in Cornelia Carr, ed., *Harriet Hosmer: Letters and Memories*, New York: Moffat, 1912, 149–51, where dated 1859.

9 *The Lady's Newspaper: The Queen and Court Chronicle*, 18 July 1863, 38–9. ED to A. Leigh Smith, 2 January 1863; DP, B 304.

10 *AJ*, September 1863, 181. *The Queen*, 12 December 1863, 387.

11 *AJ*, 1857, 124. Gibson contacted the president 'to secure for it a good place in the Exhibition (which he has already promised to do)'. HH to W. Crow, 15 February [1857], HHP. Hosmer had featured earlier in *AJ*, December 1854, 354.

12 *The Crayon*, 4 December 1857, 379. The accusations against Hosmer were repeated 1874, file 'Alleged art frauds', HHP. For her defence of Vinnie Ream Hoxie, see J.A. Lemp, 'Vinnie Ream and Abraham Lincoln', *Women's Art Journal*, 6, fall 1985/winter 1986, 24–9.

13 HH to AJ, Waller, 1983, 26. HH to W. Crow, 21 November [1863], HHP.

14 *The Queen*, 26 December 1863, 423; 18 June 1864, 475.

15 H. Hosmer, 'Miss Hosmer's *Zenobia*', *AJ*, January 1864, 27 [1864a].

16 W.W. Story, *The Athenaeum*, 19 December 1863, 840. J.B. Atkinson to W.W. Story, 23 October 1863, and to F.P. Cobbe, 28 February 1864, HHP.

17 R. Wittkower, *Sculpture: Processes and Principles*, London: Allen Lane, 1977.

18 HH to W. Crow, 15 February [1857], HHP. She enclosed photographs of *Beatrice Cenci* and *Puck*, and one 'from a very rough sketch' for the monument to Mlle Falconnet, promising mounted photographs later.

19 HH to W. Crow, 11 March [1858], HHP. Carr, 1912, 124. AJ to BRP [October 1858], PP, V, 26. AJ to HH, 10 October [1858]. HH to W. Crow, 2 December [1858] HHP.

20 Nathaniel Hawthorne, *The French and Italian Notebooks*, 15 March 1859; *The*

Centenary Edition of the Works of Nathaniel Hawthorne, ed. T. Woodson, Columbus: Ohio State University Press, 1980, XIV, 508–10.

21 HH to AJ, 10 August [1859]; HH to W. Crow, 16 August [1860], HHP. Correspondence indicates that Hosmer selected the marble herself.

22 HH to W. Crow, 15 February [1857], HHP. A smaller version of *Beatrice Cenci* (Art Gallery of New South Wales, Sydney) was in Hosmer's studio in 1857. The monument to Falconnet is in S. Andrea della Frate, Rome.

23 Linda Hyman, 'The Greek Slave by Hiram Powers: high art as popular culture', *College Art Journal*, spring 1976, 216–23.

24 HH to W. Crow, 10 December [1864]. HHP reported that she had available *Zenobia* small at $1,200 and *Zenobia* (bust and pedestal) at $1,000. A marble bust, height 430mm, is in Watertown Free Public Library, Watertown, Mass.

25 L.R. Hartigan, *Sharing Traditions: Five Black Artists in Nineteenth-Century America*, Washington: National Museum of American Art, 1985, 89, 94–5.

26 HH to W. Crow, 11 March [1858], HHP.

27 B. Read, *Victorian Sculpture*, London: Yale University Press, 1982, 66–78.

28 Story, 1863, 840 (my italics).

29 Wittkower, 1977, 224–8. In 'The Process of Sculpture', *Atlantic Monthly*, December 1864 [1864b], 734–7, 737, Hosmer distinguished between 'the labor of the brain' and 'the labor of the hand'; sculpture was 'an intellectual art, requiring the exercise of taste, imagination, and delicate feeling' and the small-scale model represented the artist's idea.

30 CC to E. Crow, 5 April 1862; 19 February 1863; 9 March 1864; 4 February 1864, CCP.

31 Photograph: HHP. HH to W. Crow, 10 November [1867], HHP. Hoffman-Curtius, Berlin, October 1997. J. Zoffany, *The Academicians of the Royal Academy of Arts*, 1771–2, Tate Gallery, London and *The Tribuna of the Uffizi*, 1772–1777/8, Collection of Her Majesty the Queen.

32 Read, 1982, 64–7. Photograph: A. Woolner, *Thomas Woolner R.A., Sculptor and Poet*, London: Chapman and Hall, 1917.

33 Hosmer, 1864a, 27.

34 *The Revolution*, 20 April 1871. G. Blodgett, 'John Mercer Langston and the case of Edmonia Lewis, Oberlin, 1862', *Journal of Negro History*, July 1968, 201–18. Hartigan, 1985, 83.

35 N. Hawthorne, *The Marble Faun* [1860], Harmondsworth: Penguin, 1990, 20–3, 43–4. J.J. Jarves, 'Progress of American sculpture in Europe', *AJ*, 1871, 6–8, 7.

36 *AJ*, 1857, 176.

37 F.P. Cobbe, 'What shall we do with our old maids?', *Fraser's Magazine*, November 1862, 594–610, quotation from 602–5. Cobbe's *Essays on the Pursuits of Women*, London: Emily Faithfull, 1863 were dedicated to '3 dear and honoured friends', one of whom was 'the Sculptress of Zenobia'.

38 AJ to BRP, 19 July [1858], PP, VI, 25.

39 H. Martineau, 'Female industry', *Edinburgh Review*, April 1859.

40 F.P. Cobbe, *Italics*, London: Trubner & Co., 1864, 412–13.

41 F.G. Stephens's friendship with Rossetti resulted in coverage in *The Athenaeum*. For Palgrave and Woolner, see above.

42 G.C. Spivak, 'The Rani of Sirmur: an essay in reading the archives', *History and Theory*, 24, 1985, 247–72. I. Grewal, *Home and Harem, Nation, Gender, Empire and the Cultures of Travel*, Leicester: Leicester University Press, 1996.

43 Whitney Chadwick, *Women, Art and Society*, London: Thames & Hudson, 1990, 198. See also S.F. Parrott, 'Networking in Italy: Charlotte Cushman and "The White Marmorean Flock"', *Women's Studies*, XIV, 1988, 305–38.

44 N. Proctor, 'Travelling between the borders of gender and nationality', *Prospero: Rivista di Culture Anglo-Germaniche*, 2, 1996, 46–55, 47.

45 AJ to BRP, Rome [May 1857], PP, V, 20.

46 BRP to E. Parkes, 29 March 1857; 21 April 1857; PP, II, 6, 7. BRP to BB, Florence, 19 May 1857, PP, V, 84.

47 H. Burton, *Barbara Bodichon, 1827–1891*, London: John Murray, 1949, 77. BRP to HH, 30 December 1857, PP, IX, 32.

48 AJ to BRP in Paris, 3 July 1858, PP, V1, 24.

49 Cobbe, 1864, 374, 398. B. Atkinson, *Life of Frances Power Cobbe*, London: Swan Sonnenshein, 1904, 393–4.

50 Leaflet LNSWS [1867]: General Committee lists 'Miss Harriet Hosmer, Rome', Cobbe and Lloyd. NSWS Members [1867]: Hosmer and Lloyd. NSWS members [1868]: Hosmer. NSWS leaflet [1868–9] 'Movement in favour of female franchise': Hosmer, Cobbe. WSC M50 1/9/1.

51 Hartigan, 1985, 88. *The Athenaeum*, 3 March 1866, 302. *AJ*, June 1866, 177–8.

52 M. Foucault, 'What is an author?', 1969, trans. D.F. Bouchard, *Screen*, spring 1979, 13–29, 14, 20.

53 J. Derrida, 'Otobiographies: the teaching of Nietzsche and the politics of the proper name' in *The Ear of the Other*, ed. C.V. McDonald, trans. P. Kamuf and A. Ronell, Lincoln: University of Nebraska Press, 1984, revised 1988. 'Ulysses gramophone: hear say yes in Joyce', trans. T. Kendall and S. Benstock in P. Kamuf, ed., *A Derrida Reader: Between the Blinds*, Hemel Hempstead: Harvester, 1991, 571–98.

54 Foucault, 1979, 24. Ann Radcliffe 'did not simply write *The Mysteries of Udolpho . . .* but made possible the appearance of Gothic Romances'.

55 R. Parker and G. Pollock, *Old Mistresses: Women, Art and Ideology*, London and New York: Routledge,1981, 103–4.

56 Kasson, 1990, 151.

57 Chadwick, 1990, 204.

58 Proctor, 1996, 52.

59 Palgrave, 1865, 53.

60 Atkinson, 1862, 230. Cobbe, 1862, 604–5.

61 Zosimus, *New History*, trans. F. Pashoud, Paris: Société d'édition, 1971. Arab sources include the Universal History of al-Tabari (839–923).

62 *The Complete Works of Geoffrey Chaucer*, ed. W.W. Skeat, 1894, Oxford: Clarendon Press, 1958, 224–68.

63 R. Wood and J. Dawkins, *The Ruins of Palmyra*, 1753, Farnborough: Gregg, 1971, 7–13.

64 W. Ware, *Letters of Lucius Manlius Piso from Palmyra*, New York: C. Francis, 1837 reprinted as *Zenobia: or the Fall of Palmyra*, London, 1837. A. Jameson, *Memoirs of Celebrated Female Sovereigns*, 1831, London: Saunders and Otley, 1834.

65 A. Tennyson, *The Princess*, II, 62–72.

66 *Scriptores Historiae Augustae* (SHA) [*The Augustan History*], trans. D. Magie, London: Heinemann, 1968, *Tyr. Trig.*, XV, 6, XXX, 14–22.

67 E. Gibbon, *The History of the Decline and Fall of the Roman Empire*, I [1776], ed. D. Womersley, London: Allen Lane, 1994, 312–22.

68 G. Boccaccio, *Concerning Famous Women*, 1355–59, trans. G.A. Guarino, London: Allen & Unwin, 1964, 226–30.

69 SHA, *Tyr. Trig.*, XXX, 12. Chaucer, 1958, 4: lines 3468–85. Boccaccio,1964, 226–8. Gibbon, 1994, 313.

70 Wood and Dawkins, 1753, 7. Gibbon and Jameson asserted Zenobia justly avenged her husband's murder.

71 According to L.M. Child, 'She was so much in love with her subject that she

rejected, as unworthy of belief, the statement that the fortitude of Zenobia was ever shaken by her misfortunes. To her imagination she was superbly regal, in the highest sense of the word, from first to last' (Carr, 1912, 192).

72 Waller, 1983.
73 Gibbon, 1994, 319. Jameson, 1834, 57. SHA, *Vita Aurel.*, XXX, 2–3.
74 Carr, 1912, 127, 192.
75 Lynne Pearce, *Feminism and the Politics of Reading*, London: Arnold, 1997.
76 *ILN*, 1863, 206.
77 Gallery of Art, Steinberg Hall, Washington University, St Louis, Missouri. Mercantile Library Association, St Louis.
78 National Gallery of Art, Washington. Musée de l'École National Supérieure des Beaux-Arts, Paris.
79 Browning, 1979, 160.
80 Waller, 1983, 25–6.
81 Sir Oliver Millar, *The Victorian Paintings in the Collection of Her Majesty the Queen*, Cambridge: Cambridge University Press, 1992, I, 293–4.
82 M. Foucault, *Discipline and Punish: The Birth of the Prison*, Harmondsworth: Penguin, 1982. E. Kantorowicz, *The King's Two Bodies*, Princeton: Princeton University Press, 1953.
83 Tony Bennett, 'The exhibitionary complex' in R. Greenberg, B.W. Ferguson and S. Nairne, eds, *Thinking about Exhibitions*, London and New York: Routledge, 1996.
84 Gibbon, 1994, 321. Jameson, 1834, 59.
85 D. Thompson, *Queen Victoria: Gender and Power*, London: Virago, 1990. D. Cannadine, 'The context, performance and meaning of ritual: the British monarchy and the 'invention of tradition', *c.* 1820–1977' in E. Hobsbawm and T. Ranger, eds, *The Invention of Tradition*, Cambridge: Cambridge University Press, 1983, 101–64. M. Homans and A. Munich, eds, *Remaking Queen Victoria*, Cambridge: Cambridge University Press, 1997.
86 Untraced.
87 A. Fraser, *The Warrior Queens*, London: Mandarin [1988], 1994, 108ff.
88 Thornycroft's *Boadicea*: begun 1856, cast in bronze 1897, sited on the Embankment 1902. Tennyson's *Boadicea*, 1859.
89 *The Spectator*, 7 June 1856, 614. *The Athenaeum*, 7 June 1856, 718. Painting: untraced.
90 A. Lee, *Laurels and Rosemary: The Life of William and Mary Howitt*, Oxford: Oxford University Press, 1955, 217. Margaret Howitt, ed., *Mary Howitt: An Autobiography*, London: Isbister, 1889, II, 117.
91 Palgrave, 1865, 53.
92 Worked in silks, wools and bullion thread on coarse holland, *Hippolyta, Queen with a Sword* and *Flammae Troiae* (Helen of Troy) were cut out and applied to a green or blue wool serge ground; after the Arts and Crafts exhibition of 1888 they were mounted together as a screen and sold to the Earl and Countess of Carlisle. Others in the series are *St Catherine, Guenevere, Penelope* and *Aphrodite*, Kelmscott Manor.
93 A. Jameson, *A Commonplace Book of Thoughts, Memories and Fancies*, London: Longmans, 1855, 331.
94 C. Owens, 'The allegorical impulse: toward a theory of postmodernism' [part 1], *October*, spring 1980, 67–86 and in Scott Bryson *et al.*, eds, *Beyond Recognition: Representation, Power and Culture*, Berkeley: University of California Press, 1992, 52–69.
95 SHA, *Tyr. Trig.*, XXX, 24–6, 14.
96 Chaucer, 1958, lines 3553ff.
97 Boccaccio, 1964, 229.
98 Gibbon, 1994, 320–1.

99 Ware, 1837, II, 247–8.

100 Jameson, 1834, 59.

101 Seeing the mosaic of 'Mater Misericordie' in San Marco in Florence in autumn 1857, Hosmer declared: 'The ornaments are quite the thing; very rich and Eastern, with just such a girdle as is described in [Pollio].'

102 V.M. Green, 'Hiram Powers's Greek Slave: emblem of freedom', *The American Art Journal*, autumn 1982, 31–9. It is predated by J.-B.-J. Debay, *Jeune Esclave*, Paris Salon 1836, Musée de Valence; see A. Le Normand, *La Tradition classique et l'espirit romantique. Les sculpteurs de l'Académie de France à Rome de 1824 à 1840*, Rome: Edizione de l'Elefante, 1981, plate 57.

103 D. Sterling, *Black Foremothers: Three Lives*, New York: The Feminist Press [1985], 41–2.

104 Location unknown. Howard University Art Gallery, Washington DC. Murray quoted in A. Boime, *The Art of Exclusion: Representing Blacks in the Nineteenth Century*, London: Thames & Hudson, 1990, 153ff.

105 R.P. Basler, M.D. Pratt and L.A. Dunlop, eds., *The Collected Works of Abraham Lincoln*, New Brunswick: Rutgers University Press, 1953, V, 433ff. The Edict of Freedom, issued on 1 January 1863, ended slavery except in certain southern states. The Thirteenth Amendment was passed by Congress in 1865 and ratified by the states between 1865 and 1870.

106 Harriet Martineau, quoted in C. Midgley, *Women against Slavery: The British Campaigns, 1780–1870*, London: Routledge, 1992, 179. Barbara Bodichon, 'Accomplices', *EWJ*, 1864, 394–400.

107 Walker Art Gallery, Liverpool. See Jan Marsh, '"For the wolf or the babe he is seeking to devour . . .": The hidden impact of the American Civil War on British Art' in E. Harding, ed., *Reframing the Pre-Raphaelites*, London: Scolar, 1996, 115–26.

108 Painting: untraced. *Girls Own Paper*, 19 July 1890, 657.

109 S.F. Adams, *Vivia Perpetua, A Dramatic Poem in Five Acts*, London: privately printed, 1893.

110 *EWJ*, March 1861, 59–60.

111 K.W. Harl, *Civic Coins and Civic Politics in the Roman East*, Berkeley: University of California Press, 1987, 93. For Zenobia as the new Cleopatra, see SHA, *Tyr. Trig*, XXX, 1, *Vita Aurel.*, XXVII, 3, *Vita Prob.*, IX, 5. Boccaccio, 1964, 226. Gibbon, 1994, 313. Jameson, 1834, 50. S.W. Stevenson, C.R. Smith and F.W. Madden, *A Dictionary of Roman Coins*, Hildesheim: Georg Olma, 1969, 922. Stoneman 1992, 150–1.

112 SHA, *Tyr. Trig*, XXX, 15. Wood, 1753, 8. Gibbon, 1994, 313; Jameson, 1834, 51.

113 D. Dabydeen, *Hogarth's Blacks*, Manchester: University of Manchester Press, 1900. H. Honour, *The Image of the Black in Western Art*, Cambridge and London: Harvard University Press, Part IV, 1989.

114 AJ to HH, 10 October [1858], HHP. Waller, 1983, 23. On Zenobia's coinage see Stevenson, Smith and Madden, 1969, 922–3. H. Matingly and E. Sydenham, *Roman Imperial Coinage*, London: Spink, 1927, V, 573 consider coins ascribed to her as of 'doubtful authenticity'.

115 AJ to HH, 10 October [1858], HHP.

116 Jones's drawings for the temple are in the Victoria and Albert Museum, London. Jones supervised the polychromatic displays of sculpture at the Crystal Palace which opened in South London in 1854. On the aesthetics of white marble, Alex Potts, *Flesh and the Ideal*, New Haven, Conn. and London: Yale University Press, 1994.

117 *AJ*, 1857, 124.

118 *AJ*, 1862, 161, 321.

119 Palgrave, 1862, 89.

120 *Punch*, 25 October 1862, 170.

121 A. Yarrington, 'Under the spell of Mme Tussauds' in A. Blum, ed., *The Colour of Sculpture*, 1840–1910, Amsterdam: Van Gogh Museum and Leeds: Henry Moore Institute, 1996, 82–92. *Punch*, 12 July 1862, 18.

122 In America it was reported that Zenobia had 'a rosy tint' and caught 'the better part of Gibson's idea of tinting the marble', Sherwood, 1991, 216.

123 A. Blum, 1996, 168.

124 Honour, 1989, 100–6. See also J. Durand-Revillon, 'Un promoteur de la sculpture polychrome sous le Second Empire: Charles-Henri-Joseph Cordier', *Bulletin de l'Histoire d'Art Français*, 1982, 181–98.

125 J.D. Brody, *Impossible Purities: Blackness, Femininity, and Victorian Culture*, Durham, NC and London: Duke University Press, 1998, 69.

126 M. Hamer, *Signs of Cleopatra: History, Politics, Representation*, London and New York: Routledge, 1993, xvi.

127 *Athenaeum*, 10 May 1862, 631. Several versions survive: marble, 1869, Metropolitan Museum of Art, New York.

128 *AJ*, 1862, 230. *Athenaeum*, 10 May 1862, 631. Story's notion that the theme was 'Slavery on the horizon' is quoted in Boime, 1990, 158. Hosmer's *African Sibyl*, 1860s (untraced) depicted a black female figure with a small boy at her feet. *Sibilla Libica*: marble, 1868 after original of *c.* 1861, National Museum of American Art, Smithsonian Institution, Washington.

129 AJ to HH, October 10 [1858], HHP.

130 Cincinnati Art Museum.

131 The frescoes, transferred to plaster, are now at the Uffizi art gallery in Florence.

132 E. Wind, *Michelangelo's Prophets and Sibyls*, London Oxford University Press, 1960, plate xxv.

133 P.G. Nunn, 'Artist and model: Joanna Mary Boyce's *Mulatto Woman*', *Journal of Pre-Raphaelite Studies*, fall 1993, 12–14.

134 Sketchbook no. 6, 1852–6. British Museum, Prints and Drawings, 1995–4–1–6, 39/40, dated 'Nov. 11'. Boyce attended Thomas Couture's ladies' classes from November 1855 to February 1856.

5 TACTICS AND ALLEGORIES, 1866–1900

1 S. Beale to M.G. Fawcett, 26 July [1888] and undated flyer, MGFC, M 50/2/26/2, II, 94.

2 S.S. Beale, *Recollections of a Spinster Aunt*, London: Heinemann, 1908, letter [*c.* 1862], 74.

3 M.G. Fawcett, 'The appeal against female suffrage: a reply, 1', *The Nineteenth-Century*, July 1889, 86–96, 89.

4 N. & J. MacKenzie, eds, *The Diary of Beatrice Webb*, London: Virago, 1982, I, 288. Although 'at present I am anxious to keep out of lists', Webb signed *An Appeal* (see note 58).

5 Opening words of B.L.S. Bodichon, *Reasons for the Enfranchisement of Women*, London: Social Science Association, 1867, 2.

6 *Opinions of Women on Women's Suffrage*, London: CCNSWS, 1879, 14, 20. *Letter from Ladies*, 1884, *WSJ*, 1884, 125; MNSWS *Annual Report*, 1885, 7–10, H. Blackburn, *Women's Suffrage*, London: Williams & Norgate, 1902, 264–8. *Women Householders' Declaration*, *WSJ*, 1889–90.

7 *EWR*, January 1874, 60; January 1907, 56; October 1909, 283.

8 S.S. Holton, quoted in P. Levine, *Victorian Feminism, 1850–1900*, London: Hutchinson, 1987, 70.

9 *Opinions*, 1879.

10 *WSJ*, June 1884, 125. MNSWS *Annual Report*, 1885, 7–11. Blackburn, 1902, 265.

11 *Fortnightly Review*, July 1889, 123–39. *A Declaration in Favour of Women's Suffrage*, London: NSWS, 1889. *WSJ*, July 1889, 90.

12 H. Blackburn, *Some Supporters of the Women's Suffrage Movement*, London: CCNSWS and Central NSWS, 1897.

13 Memorial to the Schools Enquiry Commission for a Ladies College, July 1867, DP. Bodichon and Beale were among the many signatories to *The Appeal to the Vice-Chancellor and Senate of the University of Cambridge to admit duly qualified women to degrees*, MGFC, M50/3/3/3.

14 *WSJ*, May 1889, 70.

15 D. Hudson, *Munby: Man of Two Worlds*, 1972, London: Abacus, 1974, 225. BB to H. Taylor, 9 May 1866, 21 October [1866], 2 November 1866, TMP, XII, 40, 43, 48, 49; folios 105–39. Taylor drafted and Bodichon revised the 1866 suffrage petition.

16 R. Strachey, *The Cause: A Short History of the Women's Suffrage Movement in Britain*, 1928, London: Virago, 1978; 102–3. E. Davies, 'Family Chronicle', 427, DP.

17 *WSJ*, June 1881, 92; 1882 *passim*; 19 July 1883, 122. Undated leaflet CCNSWS, MGFC, M50/2/26/2, 77. CCNSWS *Annual Report*, 1881.

18 J. Helland, *Professional Women Painters in Nineteenth-Century Scotland*, London: Ashgate, forthcoming.

19 CCNSWS, *Annual Report,* 1872, leaflets CCNSWS [1871–8], HBC. *Opinions*, 1879, 29.

20 Strachey, 1978, 267. R. Strachey, *Women's Suffrage and Women's Service*, London, 1927, 11. Strachey, 1978, 106. Emily Ford, quoted in 'Obituary', *Yorkshire Post*, 5 March 1930. L.L. Shiman, *Women and Leadership in Nineteenth-Century England*, London: Macmillan, 1992.

21 *WSJ*, August 1884, 207, September 1884, 219.

22 Leaflets, NSWS [1867/8–71]; CCNSWS leaflets [1871–8], HBC, and *Annual Reports. WSJ*, 1879, January 1889, 7–8, February 1889, 18

23 HBC, 396.3 W84/1. Signatories who may be identified as artists: Eliza Fox, Mary Charlotte Lloyd, Constance Phillott, Elizabeth Mitchell, Emma Corfield and Ellen Cantelo. Howitt quoted in *Opinions*, 1879, 30. Fox: NSWS leaflets [1868–9], WSC, M/50/1/9/1. London NSWS, Subscriptions, 1870–1, HBC. Bodichon: London NSWS leaflets [1867]-71, HBC. CCNSWS, *Annual Reports*, 1879–82. Gillies and Novello signed the 1867 petition presented by Russell Gurney and H.A. Bruce, WSC, M50/1/9/1. See also *EWR*, 15 August 1887, 369–70 and Blackburn, 1902, 267.

24 London NSWS, *Annual Reports* and *Lists of Subscribers* 1871, 1891, HBC.

25 London NSWS, *List of Subscribers* 1870–1, HBC.

26 Blackburn, 1897.

27 H.C. Morgan, 'History of the Royal Academy schools', typescript, 483, ARAA.

28 Hélène Postlethwaite, 'Some noted women painters', *Magazine of Art*, 1895, 17–22, 21.

29 E.S. Ford, 'I.O. Ford', FC, Ms 371/2.

30 H. Ford was a signatory of the 'Ladies Protest' and in 1883 the president of the Ladies' Local Committee in Leeds, *The Shield*, 1883.

31 J.R. Walkowitz, *Prostitution and Victorian Society: Women, Class and the State*, Cambridge: Cambridge University Press, 1980.

32 The LLEA was set up in the mid-1860s and was formally established in 1869 when

Hannah Pease Ford was involved. Emily Ford was a member from 1873 and secretary from April 1878. An account in the *Leeds Mercury* tells of her reading the 1879 annual report. Minute books 1873–81. West Yorkshire Archive Service, Leeds, A 1097–56.

33 Scatcherd joined the LLEA in April 1873. MNSWS *Annual Reports*, WSC, M/50/4/ 1–13. Members, 1883: Scatcherd, Emily Ford, Mrs Ford, Miss P.O. Ford, Mrs J.R.[Helen Coxfield] Ford. 1884: Scatcherd. 1886: The Misses Ford, Mrs J.R. Ford, Mrs R.L. [Hannah Coxfield] Ford. 1887: Miss Ford. 1889: The Misses Ford.

34 S. Martin, *Manchester Women Artists 1880–1940*, Manchester: City Art Galleries, 1985. MNSWS, *Annual Reports*, 1885–6 to 1894–5: Dacre, member and on the executive committee, Swynnerton and Kingsley, members. 1880: 1 guinea donation from the Manchester Society of Women Painters. Swynnerton headed the Women's Coronation Procession of 1911, *Votes for Women*, 23 June 1911, 633.

35 J. Hannam, *Isabella Ford*, Oxford: Blackwell, 1989.

36 *Yorkshire Factory Times*, 5 July 1889, 1.

37 Leeds Preparative Meeting, A List of the Members of the Leeds Meeting, records her resignation on 9 April 1890, Records of Society of Friends, Brotherton Library, University of Leeds. H. Ford, 'Emily Ford: a painter of religious pictures', FC, Ms 378.

38 Her portrait drawing of Josephine Butler, Leeds City Art Gallery. E.S. Ford, 'Reminiscences of Josephine Butler', FC, Ms 371/2, *Women and the Regulation System*, published by the LNA 1909. She designed membership cards for the Leeds Suffrage Society and became vice-chair of the Artists' Suffrage League.

39 Her 1908 poster against protective legislation of women's work, 'They *have* a cheek, *I've* never been asked', was published by the Artists' Suffrage League. Labour Party Library, London, and in J. Beckett and D. Cherry, eds, *The Edwardian Era*, Oxford: Phaidon, 1987, plate 111 and *Maandblad van de Vereeniging voor Vrouwen Kiesrecht*, 15 June 1911, 8.

40 Walkowitz, 1980, 125–7.

41 Levine, 1987, 150 (italics in original).

42 *EWR*, July 1909, 208–9. E.S. Canziani, *Round about Three Palace Green*, London, 1939, 36–8.

43 Strachey, 1928, 267.

44 Lisa Tickner, *The Spectacle of Women: Imagery of the Suffrage Campaign, 1907–14*, London: Chatto & Windus, 1987, 246. Louise Jopling, *Twenty Years of My Life: 1867– 87*, London: John Lane, 1925, 220.

45 Helland, forthcoming.

46 Petitions, 13 April 1877, House of Lords Record Office, London, box 3, nos. 63 and 64, includes Louis Desanges, a military painter; Helen Coleman Angell and William Duffield, still-life artists, and Alfred William Hunt, landscape painter. E. Clayton, *English Female Artists*, London: Tinsley, 1876, II, 289.

47 M.G. Fawcett, Ms, 'Women's suffrage', 1886, MGFC, M 50/2/26/6.

48 *Women's Penny Paper*, 13 July 1889, artist's file in Norwich Museums.

49 J. Quigley, 'Some leading women painters and craft workers', *EWR*, July 1909, 145–56.

50 J. Manton, *Elizabeth Garrett Anderson*, London: Methuen [1965], 1987, 171–2.

51 L. Walker, 'Architectural education and the entry of women into the profession' in N. Bingham, ed., *The Education of the Architect*, London: Society of Architectural Historians of Great Britain, 1993, 39–46. A. Callan, *The Angel in the Studio: Women in the Arts and Crafts Movement, 1870–1914*, London: Astragal Books, 1979, 214–21.

52 *May Morris, 1862–1938*, London: William Morris Gallery, 1989, 19. J. Marsh, *Jane and May Morris*, London: Pandora, 1900, 167–70, 179–85, 199. M. Stillman to

Commonweal Office, 11 and 27 October 1887 and undated. She purchased 12 tickets for the *Commonweal* concert of 15 October 1887 which included a performance of Morris's *The Tables Turned*. Archives of the Socialist League, 3463.5/2863–5 and 3456. Internationaal Instituut voor Sociale Geschiedenis, Amsterdam.

53 B. Elliott and J.-A. Wallace, *Women Artists and Writers: Modernist (Im)positionings*, London and New York: Routledge, 1994, 153.

54 A. Foster, 'Self-representation and constructions of femininity in the work of Gwen John, c. 1895–1912', PhD, University of Manchester, 1996, 84–6.

55 V. Gardner, 'Introduction' in V. Gardner and S. Rutherford, eds., *The New Woman and Her Sisters: Feminism and the Theatre*, London: Harvester, 1992, 1–13.

56 L. Bland, 'Marriage laid bare: middle-class women and marital sex, 1880s to 1914' in J. Lewis, ed., *Labour and Love: Women's Experience of Home and Family*, Oxford: Blackwell, 1986, 133.

57 Tickner, 1987, 184.

58 *Nineteenth Century*, 1889, 355–84.

59 M.G. Fawcett, 1889, 89. P. Hollis, ed., *Women in Public 1850–1900: Documents of the Victorian Women's Movement*, London: G. Allen & Unwin, 1979, 322–31.

60 *Votes for Women*, 23 June 1911, 633. Signatories to the supplementary list included schoolteachers and women from Girton and Lady Margaret Hall. Beatrice Webb regretted her signature as 'a false step' related to her 'anti-feminist' and 'anti-democratic' views; see N. and J. MacKenzie, eds, *The Diary of Beatrice Webb* 1982, I, 233–4.

61 J. Lewis, *Women in England, 1870–1950: Sexual Divisions and Social Change*, Brighton: Harvester Wheatsheaf, 1984, 97.

62 H. Taylor, 'The enfranchisement of women', 1851, reprinted 1868, 21. A. Rossi, ed., *Essays on Sex Equality: John Stuart Mill and Harriet Taylor Mill*, Chicago: University of Chicago Press, 1970, 91–121, 119.

63 Landseer :'List of signatures from the second petition' [1867], HBC. E.M. Ward, J.S. Babb and W.M. Rossetti: NSWS, List of Members of the Central Committee [1871]. Leaflets CCNSWS [1875–8], HBC. CCNSWS, *Annual Reports*, 1872–82. Palgrave: Leaflet CCNSWS [1871/2], HBC. *The Men's League for Women's Suffrage*, London 1912, proclaimed the 'widespread feeling among prominent men in all walks of life' and included: T.J. Cobden Sanderson, John Collier, Walter Crane, Joseph Farquharson, Henry Holiday, W.R. Lethaby, E. Lutyens, D.S. MacColl, P. Wilson Steer and Hamo Thornycroft. See also A. John and C. Eustance, *The Men's Share? Masculinity, Male Support and Women's Suffrage, 1890–1920*, London: Routledge, 1997.

64 Paula Gillett, 'Art audiences as the Grosvenor Gallery', *The Grosvenor Gallery: A Palace of Art in Victorian England*, eds, S.P. Casteras and C. Denney, New Haven, Conn.: Yale Center for British Art, 1996, 39–58, 55. Exhibitors included Sophie Anderson, Ellen Gosse, Lady Blanche Lindsay, Anna Lea Merritt, Marie Spartali Stillman and Marianne Stokes.

65 Henry Blackburn, *Grosvenor Notes*, London, 1880, 18, 1881, 28. L. Jopling, *Twenty Years of My Life*, London: Bodley Head, 1925, 139–44, 158, 306. *Kate Perugini*, 1880–81, collection Mr and Mrs Richard Mellon, Blackburn states it was shown as a companion to the portrait of Jopling.

66 Gay: CCNSWS *Annual Report*, 1878.

67 Clayton, 1876, II, 167–77.

68 J. Derrida, 'Ulysses gramophone: hear say yes in Joyce', trans. T. Kendall and S. Benstock in P. Kamuf, ed., *A Derrida Reader: Between the Blinds*, Hemel Hempstead: Harvester, 1991, 571–98, 577. 'Signature Event Context', *Margins of Philosophy*, trans. A. Bass, Chicago Chicago University Press, 1982, 330.

69 M. Foucault, 'What is an author?', trans. D.F. Bouchard, *Screen*, spring 1979, 13–33.

70 *ILN*, 21 January 1897, 126; thanks to Meaghan Clarke for this reference.

71 J. Derrida, 'Otobiographies: the teaching of Nietzsche and the politics of the proper name', *The Ear of the Other*, ed. C. V. McDonald, trans. P. Kamuf and A. Ronell, Lincoln: University of Nebraska Press, 1984, revised 1988, 5–6.

72 Derrida, 1982, 328.

73 15 March 1877, House of Lords Record Office, London, box 3, no. 32.

74 London NSWS, *Annual Report*, 1869, 3.

75 E. Pethwick Lawrence, 'An army of banners', *Votes for Women*, 15 July 1910, 689. B.J. Enright, *Public Petitions in the House of Commons: A Historical Survey*, typescript, 1960, 80–5, House of Lords Record Office.

76 G.C. Spivak, 'Political economy of women as seen by a literary critic' in Elizabeth Weed, ed., *Coming to Terms: Feminism, Theory, Politics*, New York and London: Routledge, 1989, 219.

77 J. Marsh, *Pre-Raphaelite Women: Images of Femininity in Pre-Raphaelite Art*, London: Weidenfeld & Nicolson, 1987, 109.

78 S.P. Casteras, '*Malleus Malificarum* or *The Witches' Hammer*: Victorian visions of female sages and sorceresses' in T. Morgan, ed., *Victorian Sages and Cultural Discourse*, New Brunswick: Rutgers University Press, 1990, 142–70, 142.

79 Casteras, 1990, 143.

80 B. Taylor, 'Female savants and the erotics of knowledge in Pre-Raphaelite art' in M.F. Watson, ed., *Collecting the Pre-Raphaelites: The Anglo-American Enchantment*, London: Scolar, 1997, 121–35, 122–3.

81 J.W. Meinhold, *Sidonia von Bork, die Klosterhexe*, trans. Mrs W.R. Wilde, *Sidonia the Sorceress: The Supposed Destroyer of the Whole Reigning Ducal House of Pomerania*, London: The Parlour Library, 1847.

82 Victoria and Albert Museum, London; the text from Malory's *Morte d'Arthur* is inscribed on the frame.

83 V. Surtees, *Dante Gabriel Rossetti, 1828–1882: The Paintings and Drawings, A Catalogue Raisonné*, Oxford, Clarendon Press, 1971, 77, no. 124, indicates that a watercolour of 'a dark-haired purposeful Lucrezia, attired in heavy robes' was executed in 1860–1 but disappeared in a later repainting; H.C. Marillier, *Dante Gabriel Rossetti*, London, 1899, 105, illustrates the first version. Rossetti's *Cassandra*, 1861: British Museum, London. Sandys's *Medea* and *Morgan le Fay*: Birmingham City Museum and Art Galleries; *Cassandra*, 1865: Ulster Museum Belfast, *Cassandra and Helen*, 1866: Birmingham Museums and Art Galleries. See S. Wildman, *Visions of Love and Life: Pre-Raphaelite Art from the Birmingham Collection*, Alexandria VA: Arts Services International, 1995.

84 W.M. Rossetti, 'English painters of the present day', *Portfolio*, 1871, 81–119, 118; W.M. Rossetti's notes on a list of works enclosed with a letter to him from Marie Spartali, 2 November [1869].

85 Casteras, 1990, 170.

86 E. Barrett Browning, *Aurora Leigh* in *Aurora Leigh and Other Poems*, introduced by Cora Kaplan, London: The Women's Press, 1978, lines 74–9.

87 V. Ware, *Beyond the Pale: White Women, Racism and History*, London: Verso, 1992; C. Hall, 'The economy of intellectual prestige: Thomas Carlyle, John Stuart Mill, and the Case of Governor Eyre', *Cultural Critique*, no. 12, spring 1989.

88 J. Walkowitz, *Prostitution and Victorian Society: Women, Class and the State*, Cambridge: Cambridge University Press, 1980.

89 S. Delamont, *Knowledgeable Women: Structuralism and the Reproduction of Elites*, London: Routledge, 1989. C. Dyhouse, *No Distinction of Sex? Women in British Universities, 1870–1939*, London: University College Press, 1995.

90 E.K. Sedgwick, *Between Men: English Literature and Male Homosexual Desire*, New York: Columbia University Press, 1985. E. Showalter, *Sexual Anarchy*, London: Virago, 1989. J. Tosh and M. Roper, eds, *Manful Assertions: Masculinities in Britain since 1800*, London: Routledge, 1991.

91 E. Lynn Linton, *The Girl of the Period and Other Social Essays* [1883] in J. Gardner, ed., *The New Woman*, London: Collins Brown, 1993, 55–60.

92 Surtees, 1971, I, no. 114; W.H. Hunt to T. Combe, 12 February 1860, quoted here.

93 W. Pater, *The Renaissance: Studies in Art and Poetry, the 1893 Text*, Berkeley: University of California Press, 1980.

94 *The Critic*, 27 July 1861, 109–10.

95 *The Athenaeum*, 27 July 1861, 121. *AJ*, 1861, 273.

96 A small sketchbook, inscribed inside the front cover 'Joanna M. Wells Aug.–Nov. 1860', British Museum, London, 1995–4–1–10; on the inside back cover (23r) is a note headed '1862 exhibition' listing '1 Sibyl' and '4 Life sized Mrs Eaton'.

97 E. Wind, *Michelangelo's Prophets and Sibyls*, London: Oxford University Press, 1960.

98 Virgil, *Aeneid*, trans H. Rushton Fairclough, London: Heinemann, 1916, 1978, book VI, lines 42–123; book III, lines 443–52.

99 Examples include the well-known and much copied *Sibilla Cumana con un putto*, see G. Finaldi and M. Kitson, *Discovering the Italian Baroque: The Dennis Mahon Collection*, London: Yale University Press, 1997, no. 48. I am greatly indebted to Kim Sloan for a stimulating discussion of sibyls. Boyce travelled to Italy in late spring 1857, visited Florence and Tuscany, was married in Rome in that December, subsequently travelled to Naples, and returned to London by late March 1858. See also L. Østermark-Johansen, *Sweetness and Strength: The Reception of Michelangelo in Late Victorian England*, London: Ashgate, 1998.

100 1864, albumen print, Royal Photographic Society, Bath; 1865, albumen print, Victoria and Albert Museum, London 311–45139, also known as *A Dantesque Vision*.

101 J. Christian in L. Parris, ed., *The Pre-Raphaelites*, London, Tate Gallery, 1984, 292.

102 Casteras, 1990, 154. On women and madness see S.M. Gilbert and S. Gubar, *The Madwoman in the Attic: The Woman Writer and the Nineteenth-Century Literary Imagination*, New Haven, Conn.: Yale University Press, 1978 and E. Showalter, *The Female Malady: Women, Madness and English Culture, 1830–1980*, London: Penguin, 1987.

103 Tate Gallery, London.

104 'Behold there will come the day and illuminate the density of darkness', quoted in Wind, 1960, 71.

105 T.E. Morgan, 'Victorian sage discourse and the feminine' in T.E. Morgan, ed., *Victorian Sages and Cultural Discourse*, New Brunswick: Rutgers University Press, 1990, 1–18.

106 Ford to Michael Sadler, 23 October 1913, Leeds University Art Gallery. A 'List of works by Miss Emily Ford presented by the artist to the University of Leeds, September 1923' indicates that 'Three paintings in Tempera, Sibyls' were 'hanging over the dais in the Great Hall'. A photograph of the Great Hall *c.* 1925–30, shows them *in situ*, both University of Leeds Art Collection. Material kindly supplied by Hilary Diaper. Now restored, these three tempera paintings hang in the Great Hall.

107 Quoted in R. Ormond, 'A Pre-Raphaelite beauty', *Country Life*, 30 December 1965.

108 J. Butler, *Gender Trouble*, London: Routledge, 1990, 25, 140. A. Parker and E.K. Sedgwick, eds, *Performativity and Performance*, London and New York: Routledge, 1995.

109 Butler, 1990, 139, 33, 141.

110 A. Hopkinson, *Julia Margaret Cameron*, London: Virago, 1986, 110.

111 S. Wolf, *Julia Margaret Cameron's Women*, New Haven, 1998, plates 10 and 20.

112 Shearman, *Early Italian Paintings in the Collection of Her Majesty the Queen*, Cambridge: Cambridge University Press, 1983, no. 116. Christian, 1984, 292. Spartali wears the same dress in 'The Spirit of the Vine'. H. Gernsheim, *Julia Margaret Cameron*, London: Fountain Press, 1948, 58. A.I. Greive, *The Art of Dante Gabriel Rossetti: 3*, Norwich: Real World Publications, 1978, 53.

113 Wolf, 1998, p. 230. For discussion of the 'pre-text', see M. Bal, *Reading Rembrandt: Beyond the Word–Image Opposition*, Cambridge: Cambridge University Press, 1991, 19–20.

114 V. Lambropoulou, 'Hypatia, the Alexandrian philosopher', *Feminist Studies: Hypatia*, Athens, 1984, 3–11, 3.

115 Untraced. *AJ*, 1865, 111.

116 Levison, *Hypatia*: untraced. 'Terrible Situation', *Punch Almanack*, 1871. L. Ormond, *George Du Maurier*, London: Routledge, 1969.

117 Dora Russell, *Hypatia or Woman and Knowledge*, London: Kegan Paul, 1925.

118 W.M. Rossetti's notes on a list of works enclosed with a letter to him from Marie Spartali, 2 November [1869]: 'This is a portrait of herself on a moderate scale – good but not elaborate . . . red drapery'.

119 F.M. Brown, 'On a painting by Marie Spartali' [November 1869].

120 Casteras, 1990, 144.

121 Phillips, London, 3 November 1986, lot 72.

122 M. Warner, *Monuments and Maidens: The Allegory of the Female Form*, London: Vintage 1985, 1996, 177–209.

123 G.C. Spivak in *The Post-Colonial Critic: Interviews, Strategies, Dialogues*, ed. S. Harasym, London and New York: Routledge, 1990, 108. Spivak is reconsidering the distinctions she made in 'Can the subaltern speak?' in C. Nelson and L. Grossberg, eds, *Marxism and the Interpretation of Culture*, Urbana: University of Illinois Press, 1988, 271–313, 278.

124 Georgiana Burne-Jones for example was the model for E. Burne-Jones, *Winter*, Roy Miles Gallery, London.

125 Warner, 1985, xix.

126 C. Owens, 'The allegorical impulse: toward a theory of postmodernism' [part 1], reprinted from *October*, no. 12, spring 1980, 67–86 and in Scott Bryson, Barbara Kruger, L. Tillman and Jane Weinstock, eds, *Beyond Recognition: Representation, Power and Culture*, Berkeley: University of California Press, 1992, 52–69, quotations 54–6.

127 J. Manton, [1965], 1987, 162–3; L. Garrett Anderson, *Elizabeth Garrett Anderson*, London: Faber 1936.

128 See L. Jordanova, 'Medical men, 1780–1820' in J. Woodall, ed., *Portraiture: Facing the Subject*, Manchester: Manchester University Press, 1997, 101–115.

129 See also Manton, 1987, facing 230, *c*. 1860.

130 'Probably the next absurdity', *Punch*, 18 January 1868, 30.

131 'Register! Register!', *Punch Almanack*, 1869; '"A Brave Lady" . . .', *Punch*, 23 November 1872, 216.

132 'Terrible Situation', *Punch Almanack*, 1871; 'What we hope to see: "Prudes for Proctors, Dowagers for Dons, and Sweet Girl Graduates" – Tennyson', *Punch Almanack*, 1866. G. du Maurier, 'Sweet Girl Graduates: Afternoon tea vs. wine', *Punch Almanack*, 1873. In 'Lady physicians', *Punch*, 23 December 1865, 248 and 'Our pretty doctor', 13 August 1870, 68, du Maurier lampooned the pretty, young Dr Arabella Bolus.

133 E. Garrett to ED, 12 October 1860, ALC. E. Garrett to E. Blackwell, 10 April 1864, quoted in P. Levine, *Victorian Feminism, 1850–1900*, London: Hutchinson, 1987, 48.

134 H. Cixous, 'Castration or decapitation' in R. Ferguson, M. Gever, Trinh T. Minh-ha and C. West, eds, *Out There: Marginalisation and Contemporary Cultures*, Cambridge, Mass., and London: MIT Press, 1990, 345–56.

135 M. Macarthur, *The Woman Worker*, June 1908, quoted in J. Beckett and D. Cherry, *The Edwardian Era*, Oxford: Phaidon, 1987, 168.

136 M. Bal, *Hovering between Thing and Event: Encounter with Lillie Dujourie*, London: Lisson Gallery, 1998, 38.

137 S.P. Casteras, '"The Necessity of a Name": portrayals and betrayals of Victorian women artists' in A.H. Harrison and B. Taylor, eds, *Gender and Discourse in Victorian Art and Literature*, DeKalb: Northern Illinois University Press, 1992, 207–32, 217–18, 208, 219. Her title is taken from Harriet Gouldsmith Arnold's essay, *A Voice from a Picture by a Female Artist of the Present Day*, London, privately printed for the author, 1839.

138 *AJ*, 1897, 82.

139 C. Black, *The Linleys of Bath*, London: Secker, 1911, 119; *Gainsborough and His Musical Friends*, London: Greater London Council, 1977.

140 L. Bland, 'Marriage laid bare: middle-class women and married sex, 1880s to 1914' in J. Lewis, ed., *Labour and Love: Women's Experience of Home and Family, 1850–1940*, Oxford: Blackwell 1986, 123–46.

141 A. Davin, 'Imperialism and motherhood', *History Workshop Journal*, 5, 1978.

142 E. Showalter, *Sexual Anarchy: Gender and Culture at the Fin de Siècle*, London: Virago, 1992, 156.

143 *Elaine, Salome, Vashti*: untraced; L. Jopling, *Twenty Years of My Life, 1867–87*, London: John Lane, 1925, 220.

144 *ILN* 7 May 1887, 516 (italics in original). *'He loves me, he loves me not'*, New Gallery 1887, two women lounging on a terrace: destroyed.

145 No women artists signed 'The Ladies Appeal and Protest', *The Shield*, 14 March 1870, 1–2.

146 L. Bland, 'Feminist vigilantes of late-Victorian England' in Carol Smart, ed., *Regulating Motherhood*, London: Routledge, 1992, 33–52. *The Vigilance Record*, July 1888, 41 (my italics). L. Bland, *Banishing the Beast: English Feminism and Sexual Morality, 1885–1914*, London: Penguin, 1995.

147 National Vigilance Association, *Work Accomplished* [1902], 4–6; *Annual Report*, 1888, 6.

148 *The Times*, 1885: John Brett, 22 May, 5; Eyre Crowe, Edward Martin, 25 May, 1; E.J. Poynter, 28 May, 4; Edwin Long, 13 October, 6. See also A. Smith, *The Victorian Nude: Sexuality, Morality and Art*, Manchester: Manchester University Press, 1996. Paula Gillett, *Worlds of Art: Painters in Victorian Society*, New Brunswick: Rutgers University Press, 1990, 176–91.

149 *The Times*: 20 May 1885, 10; 8 October 1885, 10; 13–19 October 1885. *Punch*, 24 October 1885, 195 unmasked him as the outraged 'British Matron'.

150 *Work and Leisure*, May 1886, 117–18.

151 K. Israel, *Names and Stories: Emilia Dilke and Victorian Culture*, New York: Oxford University Press, 1999. *ILN*, 21 December 1889, 795.

152 Smith, 1996, 221–2.

153 *The Athenaeum*, 2 June 1894, 716, *Magazine of Art*, 1894, 274.

154 L. Starr, 'The spirit of purity in art and its influence on the well-being of nations' in I.M. Gordon, ed., *Women in the Professions: Being the Professional Section of the International Council of Women: Transactions, 1899*, London: Fisher Unwin, 1900, I, 86–7.

155 E.S. Canziani, *Round about Three Palace Green*, London: Methuen, 1939, 36–7, 43–4.

156 Starr, 1900, 86. National Vigilance Association, *Annual Report*, 1890, 20.

157 L. Nead, *The Female Nude*, London and New York: Routledge, 1992.

158 J.R.Walkowitz, *City of Dreadful Delight: Narratives of Sexual Danger in Late Victorian London*, London: Virago, 1992, 41–80.

159 *Hardly Earned*: untraced. *The Times*, 24 May 1875: 'after her wearisome day's trudge through the muddy streets, and her more wearisome day's work of hammering "scales" in her pupils, [she] comes home to her shabby lodging house parlour to fall asleep from sheer exhaustion by her cold fireside'.

160 See D. Cherry, *Painting Women: Victorian Women Artists*, London and New York: Routledge, 1993, 183–6. I am indebted to Anna Robins for illuminating discussions on Sickert and the 'new painting'.

161 M. Langan and B. Schwarz, eds, *Crises in the British State*, 1880–1920, London: Hutchinson, 1985.

162 L.L. Shiman, *Women and Leadership in Nineteenth-Century England*, London: Macmillan, 1992, 171–2.

163 I. Grewal, *Home and Harem: Nation, Gender, Empire and the Cultures of Travel*, London: Leicester University Press, 1996, 60.

164 Election leaflet, 1889, Max Nettau archives, N315. Internationaal Instituut voor Sociale Geschiedenis.

165 She wears a similar gown in a photograph taken with Jane Morris, T.J. Cobden Sanderson and Annie Cobden-Sanderson in Italy in the early 1880s, National Portrait Gallery Archives, London, x 6953.

166 Jane Cobden Unwin was taken to court by LCC member, Sir William de Souza, a Tory. *EWR*, January 1891, 43. On the legal challenges to three women Sandhurst, Cobden and Emma Cons, see P. Hollis, *Ladies Elect: Women in English Local Government, 1865–1914*, Oxford: Oxford University Press, 1987, 306–17, and her essay 'Women in council: separate spheres, public space', in J. Rendall, ed., *Equal or Different? Women's Politics, 1800–1914*, Oxford: Blackwell, 1987, 192–213. *In the Service of London*, London: Greater London Council, 1985, 50, points out that the LCC fought these judgments.

167 *The Lady*, 2 September 1886, 183.

168 J. Pemble, *Venice Rediscovered*, Oxford: Oxford University Press, 1995, 171.

169 L. Roberts and P. Mitchell, *Frameworks: Form, Function and Ornament in European Portrait Frames*, London: Merrell Holberton, 1996, 19–22; P. Mitchell and L. Roberts, *A History of European Picture Frames*, Cambridge, Mass.: MIT Press, 1990; Jacob Simon, *The Art of the Picture Frame*, London: National Portrait Gallery, 1996. Eva Mendgen, ed., *In Perfect Harmony, Picture + Frame 1850–1920*, Zwolle: Waanders Uitgevers, 1996. I am indebted to Jan Marsh for bringing the portrait to my attention, to Nigel Llewellyn and Maurice Howard for discussing the painting and its frame, and to Gerry Alabone, Guildhall Art Gallery frame conservator, for information.

170 Clerk of the Council to T. Fisher Unwin, 20 October 1926, CP, 1103, folio 93. Portraits of Sandhurst and Cons no longer survive.

171 J. Tagg, *The Burden of Representation: Essays on Photographs and Histories*, London: Macmillan, 1988, 37. The plate is taken from a photograph laid into *Descriptions of Portraits*, 5, no. 11, National Portrait Gallery archives.

172 S.M. Newton, *Health, Art and Reason: Dress Reformers of the Nineteenth Century*, London: John Murray, 1974, 122.

173 *Punch*, 1866, 78. *Punch Almanack*, 1871.

174 G.F. Watts: *The Hall of Fame*, London: National Portrait Gallery, 1977.

175 When she retired from the secretaryship of Bristol and West of England Suffrage Society in 1895 a crayon portrait was ordered from Guinness,

reproduced, *EWR*, April 1903, facing 72. On the bookcase see *EWR*, April 1903, 80.

176 H. Blackburn, *Women's Suffrage*, London: Williams & Norgate, 1902, facing 125. *Becker* is based on Mayall and Co., HBC, Ph 13/1 30/1/. Kate Perry pointed out this indebtedness to me.

177 Spivak, 1990, 108.

178 C. Weedon, *Feminist Practice and Post-Structuralist Theory*, Oxford: Blackwell, 1987. E. Grosz, *Jacques Lacan: A Feminist Introduction*, London: Routledge, 1990. S. Alexander, *Becoming a Woman and Other Essays in Nineteenth and Twentieth-Century Feminist History*, London: Virago, 1994, 225–30, 243–7.

179 J. Woodall, *Portraiture: Facing the Subject*, Manchester: Manchester University Press, 1997.

180 A sketch of Becker, *Comus*, October 1877 in R. Strachey, *The Cause*, 1928, London: Virago, 1978. In *Punch*, 22 July 1865, 23, pretty young women accost Mr Punch, waving a placard calling for 'Votes for Women'.

181 WSC M 50/1/9/2. The Principal Archivist, Ann Heath, indicates that 'there is no evidence readily available to suggest who compiled these volumes other than as they were part of the [Manchester Suffrage] Society's archives, they were presumably compiled by a member', letter 25 November 1998. In 1870 a suffrage bill introduced by Radical MP John Bright failed in committee.

182 M.G. Fawcett's cuttings book, MGFC, M/50/2/26/2.

183 *EWR*, January 1891, 55; supporters included Elizabeth Garrett Anderson, Frances Power Cobbe, Susan Dacre, Millicent Garrett Fawcett, Emily Ford and Annie Swynnerton. After refusal, the portrait was on show at the CCNSWS offices, *EWR*, January 1892, 11.

184 P. Barlow, 'Facing the past and the present: the National Portrait Gallery . . .' in Woodall, ed., 1997, 219–38.

185 B. Anderson, *Imagined Communities*, London: Verso, 1983.

186 M. Maynard, 'A Dream of Fair Women: revival dress and the formation of late Victorian images of femininity', *Art History*, September 1989, 322–41. On the blue-stockings, see M. Pointon, *Strategies for Showing*, Oxford: Oxford University Press, 1997.

187 *EWR*, January 1893, 68. University College Bristol, *Report of the Council*, 1893–94, 13. Blackburn was a student, 1886–8, University College Bristol *Calendar*, 1887–8; thanks to Michael Liversedge for this information.

188 V. Woolf, *A Room of One's Own* [1929], Harmondsworth: Penguin, 1993, 21.

189 E.S. Sidgwick, *Mrs Henry Sidgwick*, London: Sidgwick & Jackson, 1938, 74.

190 K. Perry, *Barbara L.S. Bodichon*, Cambridge: Girton College, 1991, 23; ED to BB, 31 January 1870, 25 February [1870], DP, B 39,40.

191 Henry Blackburn, *English Art in 1884: Illustrated by Facsimile Sketches by the Artists*, New York: Appleton, 1885, 159.

192 E.C. Clayton, *English Female Artists*, London: Tinsley, 1876, II, 173. ED to BB, 14 January 1883, DP, B221.

193 Quoted in P. Hirsch, *Barbara Bodichon: Feminist, Artist and Rebel*, London: Chatto, 1998, 306.

194 Minutes of the Executive Committee, IX, 23 October 1885, 85. Girton College Archives. Subscribers included Lady Stanley of Alderley, Emily Davies, Jane and Ellen Cobden, Margaret Cobden, Mrs Cobden Sanderson and Anne Leigh Smith, with thanks to Kate Perry for these references.

195 Photograph: Girton College Archives. Henry Blackburn, *Grosvenor Notes*, London, 1880, 25.

196 M.A. Wilcox in Ann Phillips, ed., *A Newnham Anthology*, Cambridge: Cambridge University Press, 1979, 14–15.

197 Possibly SFA 1899 and rejected by the National Portrait Gallery in 1902, *Description of Portraits*, vol. 11, no. 40. In 1913 it was donated by Annie Leigh Smith to Hastings Museum and Art Gallery, which presented it to Girton College in 1963.

198 R. McWilliams Tullberg, *Women at Cambridge*, Cambridge: Cambridge University Press, 1998. C. Dyhouse, *No Distinction of Sex? Women in British Universities, 1870–1939*, London: UCL Press, 1995.

199 L. Pearce, *Feminism and the Politics of Reading*, London: Arnold, 1997, 15 (italics in original).

200 *EWR*, 15 January 1891, 56. *Newnham College: Record of Benefactors*, Cambridge: Cambridge University Press, 1921, n.p. records the painting was presented in 1890.

201 Photograph: FC, MS 376, item 19. An inscription in a second hand reads: 'Towards the Dawn/ Emily Ford'.

202 When given by the artist to Leeds University, Ford referred to it as 'the flying figure', letter to M. Sadler, 27 October 1913, University of Leeds Art Collection. In a 'List of works by Miss Emily Ford presented by the artist to the University of Leeds, September 1923' this same painting is also called *Towards the Dawn*.

203 Owens, 1992, 54–6.

204 Bal, 1998, 38.

205 A. Wilton and R. Upstone, eds, *The Age of Rossetti, Burne-Jones and Watts: Symbolism in Britain, 1860–1910*, London: Tate Gallery Publishing, 1997, 201–2; on Watts's 'symbolical' paintings (the designation was the artist's) see B. Bryant, 'G.F. Watts at the Grosvenor Gallery' in S. Casteras and C. Denney, eds, *The Grosvenor Gallery: A Palace of Art in Victorian England*, New Haven, Conn.: Yale Center for British Art, 1996, 109–28.

206 T. Barringer, 'Leighton in Albertopolis' in T. Barringer and E. Prettejohn, eds, *Frederic Leighton: Antiquity, Renaissance, Modernity*, London and New Haven, Conn.: Yale University Press, 1999, 135–68, 135.

207 Wilton and Upstone, 1997, 189–90. A. Anderson, 'Soul's Beauty: Burne-Jones and the girls on *The Golden Stairs*', *Nineteenth Century: Journal of the Victorian Society in America*, spring 1998, 17–23. *The Golden Stairs* may make distant reference to Reynolds's allegorical portrait, *Three Ladies Adorning a Term of Hymen*, Tate Gallery, London. B. Bullen, *The Pre-Raphaelite Body: Fear and Desire in Painting, Poetry and Criticism*, Oxford: Clarendon Press, 1999.

208 Wilton and Upstone, eds, 1997.

209 F. de Saussure, quoted in Owens, 1992, 63.

210 In a letter of 27 October 1916 to Sadler (then Vice-Chancellor), University of Leeds Art Collection, Ford wrote, the 'idea of my having one room [which] is very attractive – & exceedingly kind – I have been thinking how *at last* I might do all the ideas I had planned for "The Sphere of Suffering"'. She then lists: 'Death (that seated figure in charcoal I showed you) the Sybil of it – / The Soul entering the Sphere / The naked Soul in the Storm abyss – / The Soul finding the Light (the flying figure that is coming) & / An Ascension of Souls'.

211 J. Quigley, 'A Yorkshire artist', *Yorkshire Homes*, January 1928, 18.

212 *WSJ*, April 1885, 70.

213 C. Waters, *British Socialists and the Politics of Popular Culture, 1884–1914*, Manchester: Manchester University Press, 1990. I. *Britain, Fabianism and Culture: A Study of British Socialism and the Arts, 1884–1918*, Cambridge: Cambridge University Press, 1982. G. Smith, 'Developing a public language for art' in *Walter Crane, 1845–1915: Artist, Designer, Socialist*, London: Lund Humphries, 1989.

214 R. Langley, *Walter Langley*, Penzance: Penlee House Gallery, 1997. Thanks to Jane Beckett and Mike Tooby for an enlightening discussion.

215 Thanks to Jan Marsh.

216 Elected associate member, January 1885, *Journal of the Society for Psychical Research*, London, 1884–5, 222. Her mother is listed as a member in 1884.

217 E. Ford, 'Religious bearings of Spiritualism', *Light*, 26 November 1881, 373–4. I am greatly indebted to Lois Drawmer for information here. The BNAS became the London Spiritual Alliance.

218 J. Oppenheim, *The Other World: Spiritualism and Psychical Research in England, 1850–1914*, Cambridge: Cambridge University Press, 1985. A. Gauld, *The Founders of Psychical Research*, New York: Schocken, 1983. R. Hayes, *The Society for Psychical Research*, New York: Macdonald, 1982 and R. Brandon, *The Spiritualists*, New York: Knopf, 1983.

219 Agnes Garrett, member 1884; G.F. Watts, honorary member March 1884; Dorothy Tennant, June 1884; Tennyson, honorary member, July 1884; Constantine Ionides, October 1884; W.J. Stillman, November 1884; Frank Dicksee, ARA, April 1885; Anna Swanwick, October 1888; Elizabeth Blackwell, April 1889; Frederic Leighton, honorary member, July 1890; Charlotte Despard, April 1892; Constance Wilde, October 1892. See *Journal of the Society for Psychical Research*, I–VI, London, 1884–5 to 1893–4: members are listed on joining, not each year. Agnes Garrett was on the Committee on Physical Phenomena until it was disbanded in 1885. Susan Elizabeth Gay also published in defence of spiritualism.

220 *Journal*, August 1884, 114–15. *Light* published a series of essays on art and spiritualism in the 1880s.

221 A. Owen, *The Darkened Room: Women, Power and Spiritualism in Later Victorian England*, London: Virago, 1989. J.R. Walkowitz, *City of Dreadful Delight, Narratives of Sexual Danger in Late-Victorian London*, London: Virago, 1992, 171–89.

222 Eleanor Mildred Balfour (1845–1936) married Henry Sidgwick in 1876, and was a member of the society by 1884, *Journal*, 1, 1884, 12. Her recollections are quoted in E. M. Sidgwick, *Mrs Henry Sidgwick: A Memoir*, London: Sidgwick & Jackson, 1938, 92. M.A. Wilcox in Phillips, 1979, 15.

223 J. Berkhauser, *Glasgow Girls: Women in Art and Design, 1880–1920*, Edinburgh: Canongate, 1990. J. Helland, *The Studios of Margaret and Frances Macdonald*, Manchester: Manchester University Press, 1997.

224 [E. and W. de Morgan], *The Result of an Experiment*, London, 1909, which includes letters from spirits known to mediums when in the flesh, letters purporting to come from angels, and letters from spirits brought by angels. Evelyn de Morgan's mother-in-law, Sophia Frend de Morgan, was a confirmed spiritualist. J. Oberhausen, 'Evelyn de Morgan and spiritualism' in C. Gordon, ed., *Evelyn de Morgan: Oil Paintings*, London: De Morgan Foundation, 1996, 33–52, 34–7, suggests that the arguments for the artist as a mediator and seer in her anonymously published *From Matter to Spirit* of 1863 may have influenced the artist. Oberhausen, 1996, 33–5.

225 Quigley, 1928, 18.

226 Oberhausen, 1996, 38–9.

227 Oberhausen, 1996, 40. Gordon, 1996, no. 32. Attributed to St Augustine of Hippo, the text has not been traced in his writings.

228 Institute of Painters in Oil Colours, London, 1887/8. Gordon, 1996, no. 28.

229 *The Soul in the Abyss*, 1889, University of Leeds Art Collection. The artist's (incomplete) record of her work includes photographs of the following drawings mounted on to card with inscriptions: 'Series of the Sphere of Suffering', not dated; 'The Soul in the Abyss no. 3', drawing dated '1889' (related to the painting

under discussion); 'No. 5 The Ascension of Souls'; 'No. 1 The Coming of ~~entrance~~ Night', drawing dated '1881', or 'The Soul entering the Sphere of Suffering', drawing dated '1905' The artist's record of her work, inscribed inside the front cover by the artist, FC Ms 373, items 22–6.

230 See J. Beckett, 'Colour theory and formations of the Dutch avant-garde, 1900–26', PhD thesis, University of London, 1997.

231 Ford, 1881, 374.

232 J. Punshon, *Portrait in Grey: A Short History of the Quakers*, London: Quaker Home Service, 1984, 1986, 174. I am indebted to Marcia Pointon here.

233 Ford, 1881, 374.

234 P. de Man, *Allegories of Reading: Figural Language in Rousseau, Nietzsche, Rilke and Proust*, New Haven, Conn.: Yale University Press, 1979, 12.

235 Warner, 1985, xix.

236 Ford to M. Sadler, 23 October 1913, University of Leeds Art Collection.

237 Blackburn, 1902, 153.

238 MNSWS, *Annual Report*, 1882, 8–9.

239 F.M. Stirling to R. Strachey, undated, ALC.

240 *WSJ*, 19 July 1883, 122. *EWR*, 14 July 1883, 317.

241 *WSJ*, April 1884, 63. J. Helland, *Professional Women Painters in Nineteenth-Century Scotland*, London: Ashgate, forthcoming.

242 *WSJ*, May 1884, 97, April 1884, 63.

243 *WSJ*, July 1883, 122. These decorations were sufficiently familiar for them to be satirised in an account of a meeting at Bradford in November 1881, where it was reported that '[t]he chandeliers were profusely decorated with pink fly-papers, and round the walls were nailed illuminated scrolls, strictly appropriate to the occasion: – "No surrender", "Let cradles be abolished", "Death to Tyrants" and similar inspiriting sentiments illustrative of the cause' (*The Yorkshireman*, 26 November 1881, front page).

244 *The Common Cause*, 1910, 385, quoted in L. Tickner, *The Spectacle of Women: Imagery of the Suffrage Campaign, 1907–1914*, London: Chatto, 1987, 289, note 31. Tickner is of the view that '[p]robably there were few suffrage banners in existence before 1908.'

245 B. Loftus, *Marching Workers: An Exhibition of Irish Trade Banners and Regalia*, Dublin and Belfast: Arts Councils of Ireland, 1978, 60.

246 G. Williams, 'Introduction' in J. Gorman, *Banner Bright: An Illustrated History of Trade Union Banners*, Buckhurst Hill: Scorpion Publishing, 1973, 1986, 17, notes popular union folklore that 'Mother made the first banner the branch had'. Tickner, 1988, 62, emphasises this tradition, pointing out that women 'designed and embroidered many of the most striking emblems' for the Chartist demonstrations of the 1840s.

247 Quoted in Gorman, 1986, 47.

248 Ben Tillett, founder of the union, quoted in Gorman, 1986, 38. Carried in the Dock Strike of 1889 and for some years afterwards, it is reproduced in Gorman, 1986, 87.

249 Gorman, 1986, 47.

250 Williams, 1986, 17.

251 F.M. Stirling to R. Strachey, undated, ALC.

252 On textual banners, see J. Beckett and D. Cherry, 'Spectacular women', *Art History*, March 1989, 121–8 and Smith, 1989, 87–8.

253 T. Campbell, *100 Years of Women's Banners*, Women for Life on Earth, 1988, 7–9.

254 Tickner, 1987, 63.

255 Owens, 1992, 57.

256 In discussion with the author, Sussex, 1998.
257 A. McClintock, *Imperial Leather: Race, Gender and Sexuality in the Colonial Conquest*, New York: Routledge, 1995, 279–80. W. Benjamin, *The Origin of German Tragic Drama*, trans. John Osborne, London: New Left Books, 1977.
258 Owens 1992, 56.
259 Letters from curator to Mrs Conway, 7 March 1919, and to Caroline Herford, 27 November 1919. Archives, Manchester City Art Galleries.
260 Hélène Cixous, 'Castration or decapitation' in R. Ferguson, M. Gever, Trinh T. Minh-ha, and C. West, eds, *Out There: Marginalisation and Contemporary Cultures*, Cambridge, Mass.: MIT Press, 1990, 345–56.
261 W. Benjamin, 'Theses on the Philosophy of History', *Illuminations*, ed., Hannah Arendt, trans. H. Zohn, London: Jonathan Cape, 1970, 255–66, 255. Owens, 1992, 52. On Benjamin's return to allegory, see T.M. Kelley, *Reinventing Allegory*, Cambridge: Cambridge University Press, 1998.

SUGGESTIONS FOR FURTHER READING

As the notes provide concise textual references, this short section offers some suggestions for further reading.

The literature on British art of the nineteenth century is extensive. Recent significant publications include

T. Barringer, *Reading the Pre-Raphaelites*, London and New Haven, Conn., Yale University Press, 1999

S.P. Casteras and C. Denney, eds, *The Grosvenor Gallery: A Palace of Art in Victorian England*, New Haven, Conn.: Yale Centre for British Art, 1996

L. Lambourne, *Victorian Painting*, Oxford: Phaidon, 1999

D.S. Macleod, *Art and the Victorian Middle-Classes*, Cambridge: Cambridge University Press, 1996

P. Nunn, *Problem Pictures: Women and Men in Victorian Painting*, Aldershot: Scolar, 1995

E. Prettejohn, ed. *After the Pre-Raphaelites*, Manchester: Manchester University Press, 1998

M. Warner, *The Victorians: British Painting 1837–1901*, New York: Harry Abrams, 1997

C. Wood, *Victorian Painting*, London: Weidenfeld, 1999.

Increasing attention has been paid to women artists and their work. Key publications are

S. Casteras and L. Peterson, *A Struggle for Fame: Victorian Women Artists and Authors*, New Haven, Conn., Yale Center for British Art, 1994

D. Cherry, *Painting Women: Victorian Women Artists*, London and New York: Routledge, 1993

J. Helland, *Professional Women Painters in Nineteenth-Century Scotland*, London: Ashgate, 2000

J. Marsh and P.G. Nunn, *Pre-Raphaelite Women Artists*, Manchester: Manchester University Press, 1997

C.C. Orr, ed., *Women in the Victorian Art World*, Manchester: Manchester University Press, 1995

Biographical entries are to be found in

D. Gaze, ed., *Dictionary of Women Artists*, London: Fitzroy Dearborn, 1997

C. Wood, *Dictionary of Victorian Painters*, London: Antique Collectors' Club [1978], 1995

and the new

Dictionary of National Biography, Oxford: Oxford University Press, 1996.
An annotated bibliography of women in Victorian painting is offered in
E. Harris and S.R. Scott, eds, *A Gallery of Her Own*, New York: Garland, 1997.

Nineteenth-century feminism has a growing literature which charts and accounts for its
complexities. Among the accounts consulted here are
S. Alexander, *Becoming a Woman and Other Essays in Nineteenth and Twentieth-Century
 Feminist History*, London: Virago, 1994
L. Bland, *Banishing the Beast: English Feminism and Sexual Morality, 1885–1914*, London:
 Penguin, 1995
E. Crawford, *The Women's Suffrage Movement: A Reference Guide 1866–1928*, London:
 UCL Press, 1999
C. Hall, *White Male and Middle-Class: Explorations in Feminism and History*, Cambridge:
 Polity, 1992.

The gendering of space has been foregrounded in a number of recent studies,
particularly
B. Colomina, ed., *Sexuality and Space*, Princeton: Princeton Studies in Architecture, 1992
D. Massey, *Space, Place and Gender*. Cambridge: Polity, 1994
Jane Rendall, B. Penner and I. Borden, *Gender, Space and Architecture*, London and New
 York: Routledge, 1999.
Women in the city figure in
L. Nead, *Victorian Babylon*, London and New Haven, Conn.: Yale University Press, 2000
D.E. Nord, *Walking The Victorian Streets: Women, Representation and the City*, Ithaca, NY:
 Cornell University Press, 1995
J.R. Walkowitz, *City of Dreadful Delight: Narratives of Sexual Danger in Late Victorian
 London*, London: Virago, 1992.

Several collections provide introductions to post-colonial studies, notably
B. Ashcroft, G. Griffiths and H. Tiffin, eds, *The Post-Colonial Studies Reader*, London and
 New York: Routledge, 1995
P. Williams and L. Chrisman, eds, *Colonial Discourse and Post-Colonial Theory: A Reader*,
 London and New York: Harvester, 1993.
Visual imagery is considered in
J. Codell and D.S. Macleod, eds, *Orientalism Transposed: The Impact of the Colonies on
 British Culture*, London: Ashgate, 1998
R. Lewis, *Gendering Orientalism: Race, Femininity and Representation*, London and New
 York: Routledge, 1996
Shearer West, ed., *The Victorians and Race*, London: Scolar, 1997.
Noteworthy among studies of women, gender and imperialism are
A. Burton, *Burdens of History: British Feminists, Indian Women and Imperial Culture
 1865–1915*, Chapel Hill: University of North Carolina Press, 1994
C. Midgley, ed., *Gender and Imperialism*, Manchester: Manchester University Press, 1998
J. Sharpe, *Allegories of Empire: The Figure of Woman in the Colonial Text*, Minneapolis:
 University of Minnesota Press, 1993.
Cultural institutions are discussed in
A.E.S. Coombes, *Reinventing Africa: Museums, Material Culture and the Popular Imagination*,
 New Haven and London: Yale University Press, 1994.

INDEX

Note: page numbers in *italics* indicate illustrations

ʿAbd al-Qādir, Amir 62, 71, 87
Adams, Sarah Flower 133
Adventures of a Woman in Search of her Rights, The (Claxton) 45–6
Albert, Prince Consort 126; death 120, 126; portrait of 124–5, *124*
Alexander, Sally 12
Alexandra Magazine 51
Alford, Lady Marian 112, 116
Algeria 6, 24, 59–74 *passim* 135, 197; photography 5, 62, 64–5, *64*; 'worlding of' 6, 75–100
Algerian Burial Ground, An (Bodichon and Annie Leigh-Smith) 94
Algerian Mirror, An (Osborn) 91, 92
allegory 7, 127, 129–30, 173, 198–218
Allen, Ellen 99
Allingham, Helen 143, 147, 150
Almanach des femmes 55
Alma-Tadema, Anna 144, 153–4, 181–2
Alma-Tadema, Lawrence: *Women of Amphissa* 182, *183*
America 107, 110; artists from *see in particular* Hosmer; slavery in 60, 104, 131–2, 162
Anderson, Elizabeth *see* Garrett (Anderson)
Anderson, Sophie 150
Ansdell, Richard: *Hunted Slaves, The* 132
Antigone Gives Burial Rites to the Body of her Brother Polynices (Spartali) 172
Appadurai, Arjun 66
Appeal Against Female Suffrage, An (1889) 153
Arab Marriage, An (Fox) 92
Arab Tomb near Algiers (Bodichon) 69, 88, 95
Arabs *see* Algeria

Arabs at Prayer (Fox) 92
Arnold, Mrs Matthew 153
Art and Crafts movement 151
Art Journal, The 32, 58; founded 2; and Bodichon 90; on Dicksee 178; and Hosmer (*Zenobia*) 90, 101, 106–8, 112–13, 119, 120; on marble 134; on Orientalism 67–8; on Osborn 37; pictures in 33–4; profiles of women artists in 53; on sculpture in Europe 113, 118; on Solomon 57, 170; on Wells 165
artefacts, cultural 65–7
Artist, The 205
Artist Choosing between Music and Painting, The (Kauffmann) 41
Arts of Industry as Applied to Peace/War, The (Leighton) 202, *203*
Ashburton, Lady 116
Athena Giustiniani 124
Athenaeum, The 49, 95, 118; on Bodichon 95; on Burne-Jones 205; on Hosmer 108; on Lewis 118; on Rae 185; on Society of Female Artists 57; on Solomon 57; on Wells 165
Atkinson, Diane 43
Atkinson, J. Beavington 101, 102, 108, 120, 122, 134
Augustine of Hippo, Saint 208
Aurora Triumphans (de Morgan) 209, *209*
authorship/authority 101–5, 118, 119, 155; *see also* signature
Aziya Bent Yahia 71

Babb, Charlotte 16, 25; and women's suffrage 144, 146–7, 154
Babb, John Staines 154
Bagehot, Mrs Walter 153

255